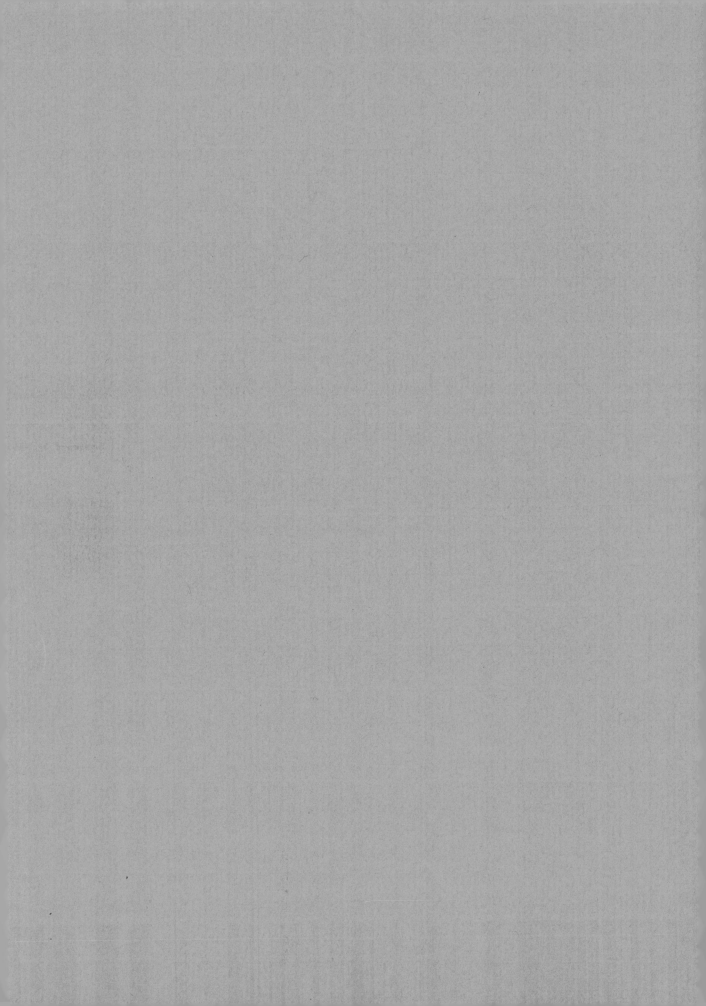

Art at Auction
1970-71

A Hellenistic gold wreath with twenty sheet gold
leaves with incised markings and three pairs of
Hellenistic earrings, all 4th–3rd century B.C.
London, the wreath £1,100 ($2,640) the earrings
from top to bottom £95 ($228), £90 ($216),
£115 ($276). 12.VII.71.
These objects were all found together.

German enamelled gold and jewelled
necklace. 17th century. 24 in.
London £25,000 ($60,000).
From the Arturo Lopez-Willshaw Collection.

Opposite page: A Clichy rose weight. 3⅜ in.
London £8,000 ($19,200). 14.IV.71.

Art at Auction

The Year at Sotheby's & Parke-Bernet

1970-71

Two hundred and Thirty-Seventh Season

A Studio Book · The Viking Press · New York

Published in 1972
by The Viking Press, Inc.
625 Madison Avenue,
New York, N.Y. 10022

Distributed in Canada by
The Macmillan Company
of Canada Limited

Edited by Philip Wilson
and Annamaria Macdonald
Jacket photograph
by Norman Jones, A.M.P.A.

SBN 670-13402-3

Library of Congress catalog card
number: 67-30652

Printed and bound in Great Britain
by W. S. Cowell Ltd, Ipswich

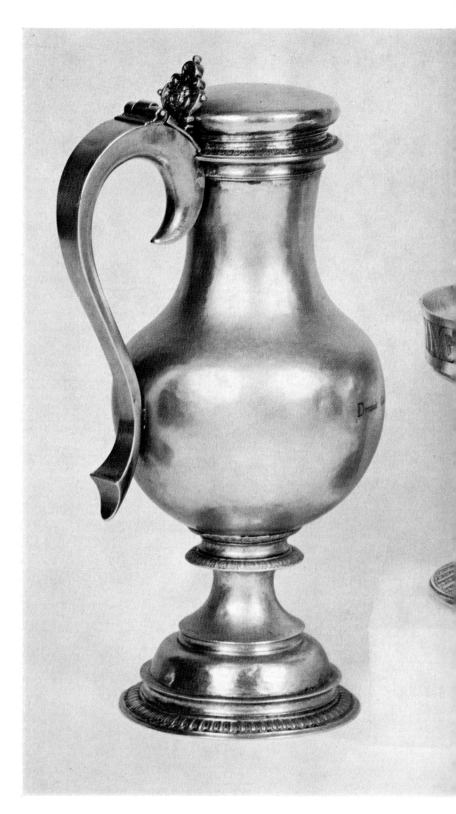

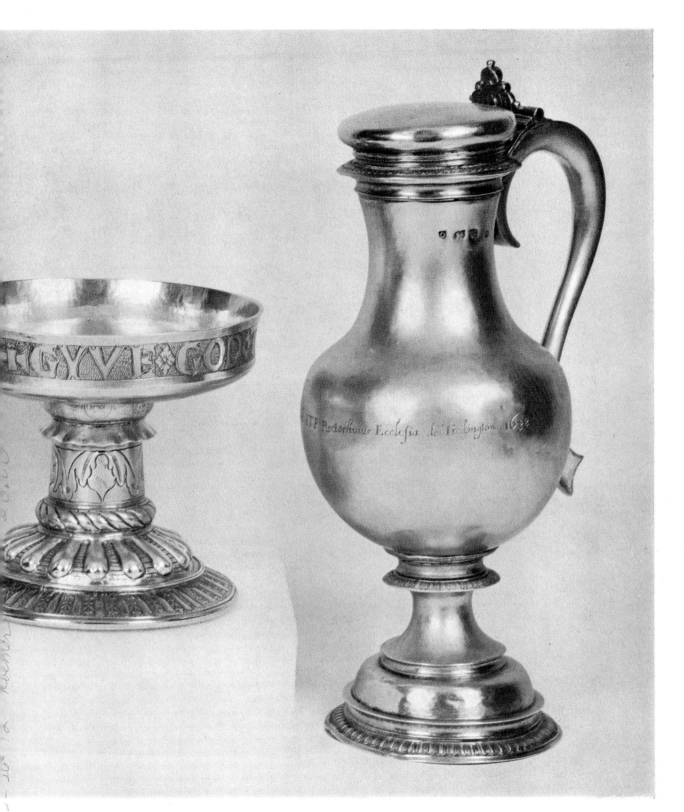

A pair of Elizabeth I parcel-gilt livery pots, inscribed *Donavit Guilielmus Smith STP Rector huius Ecclesiae de Tredington*, 1638, maker's mark H.L., 1591. Height 11¾ in. £30,000 ($72,000).
Sold in London on the instructions of the Rector and Churchwardens of St. Gregory's, Tredington, Warwickshire on 17th June 1971.

An Edward VI parcel-gilt grace cup, inscribed GYVE GOD THAKES [*sic*] FOR ALL THYNGS. Inscribed under the bowl *Ex dono Dorothea Wither de Hall Vidvae* 1698, maker's mark R.D., 1551. Height 5 in. Diameter 6 in. £36,000 ($86,400). Sold in London on the instructions of the Vicar and the Churchwardens of All Saints, Deane, Hampshire on 17th June 1971.

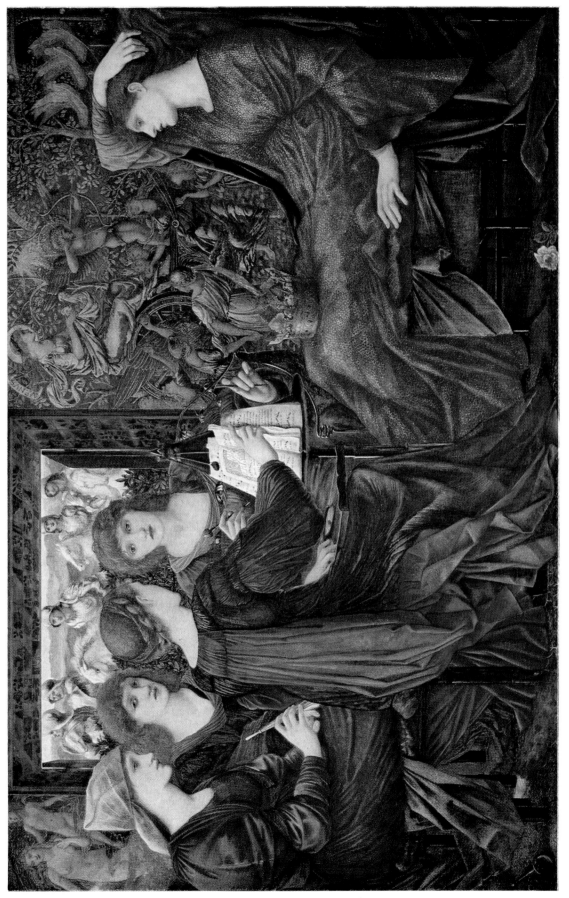

SIR EDWARD BURNE-JONES, BT., A.R.A.
Laus Veneris.
Signed and dated 1873–75. 48 in. by 72 in.
London £33,000 ($79,200). 17.III.71.
From the Huntington-Hartford Collection.

Contents

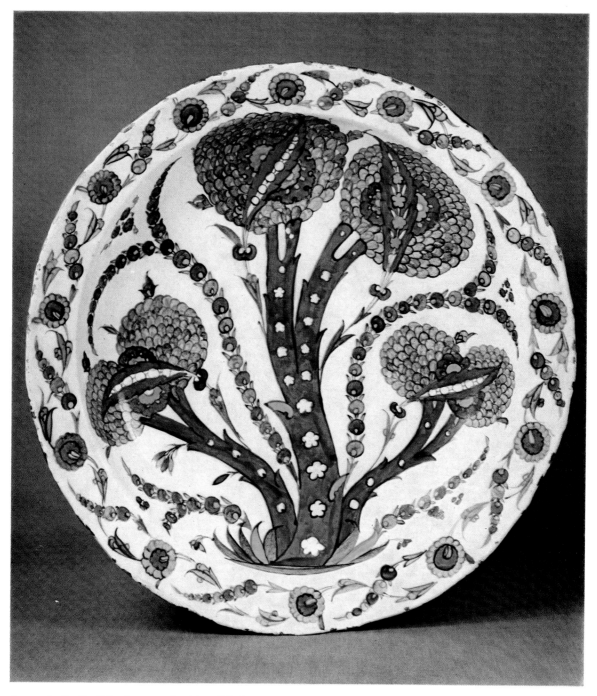

An early Isnik dish, decorated with a fabulous
flowering tree, the slightly everted rim decorated
with scrolling flowers in the same palette, the
reverse with tulip sprays and floral sprigs.
1540–50. 14¼ in.
London £5,200 ($12,480). 29.III.71.

Opposite page:
An Islamic pottery Mihrab. Kashan,
13th/14th century A.D. 40¼ in. by 46½ in.
New York $8,000 (£3,333). 18.XII.70.
From the Kevorkian Collection.

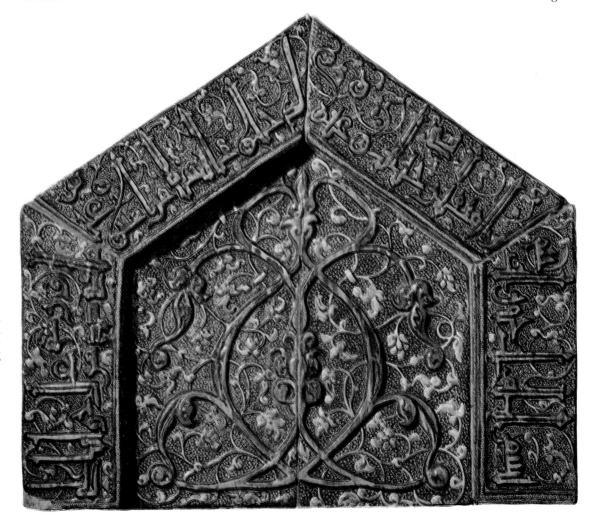

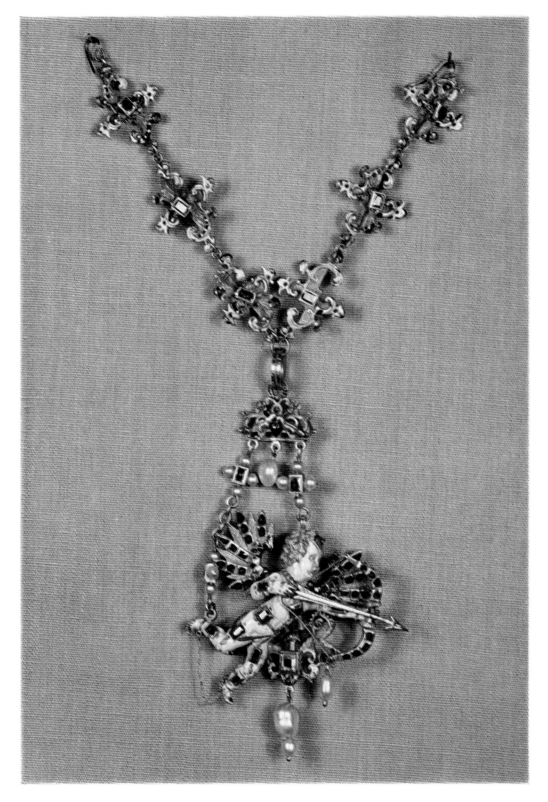

A German or Flemish gold and jewelled pendant, in the form of a cupid
aiming an arrow.
Late 16th century. Jewel 3¾ in. high, chain 7 in. long.
£6,500 ($15,600).

The Lopez-Willshaw Collection

BY J. F. HAYWARD

Arturo Lopez-Willshaw was one of the most discerning collectors of the post first World War generation. His financial resources were such that he could indulge his tastes almost without limitation, and he built up in his château at Neuilly a collection of works of art, silver and furniture that was as carefully chosen as it was superbly displayed. The happy chance that the initial L of the French kings of the eighteenth century coincided with the initial letter of Lopez inspired him to base the decor of his château on that of Versailles and he created there an ambience of splendour that is lacking from the now sparsely furnished rooms of the former royal palace. In order to display appropriately his Renaissance jewels and works of art he installed them in a small cabinet in a tower he especially erected for the purpose. The proportions of the cabinet, which was based on a Renaissance *Kunst und Wunderkammer*, were taken from Bramante's temple of San Pietro in Montorio; the walls were covered with carmine velvet and the objects were set in shell-headed niches sunk in four walls of the octagonal chamber.[1]

[1] Views of the Lopez-Willshaw cabinet were published in Connaissance des Arts, *Un Ecrin Géant*, p. 156, December, 1958.

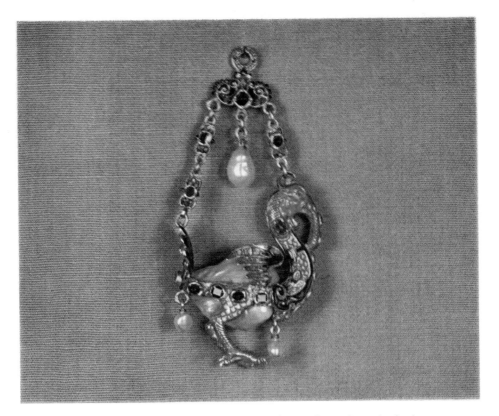

German enamelled gold pendant jewel, in the form of a turkey, the body
a baroque pearl. Late 16th century. Height $3\frac{1}{4}$ in.
£7,500 ($18,000).

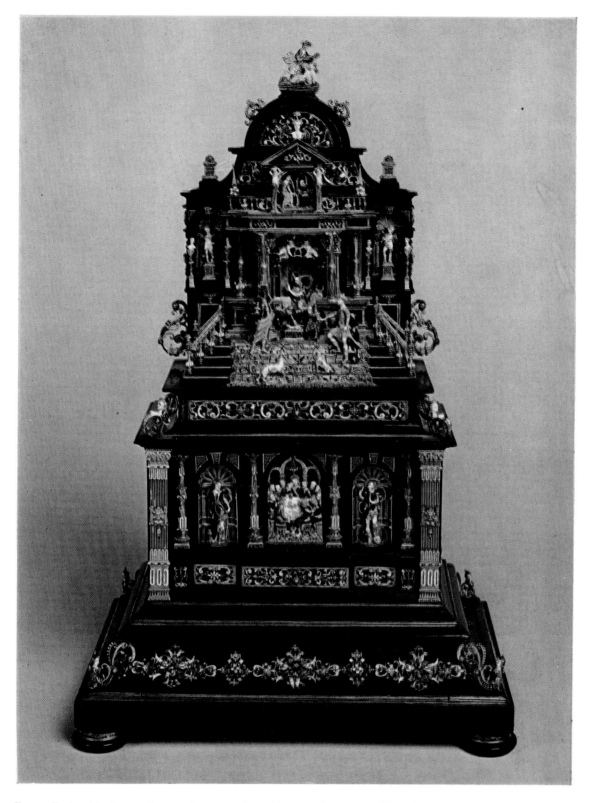

Enamelled gold, silver-gilt and ebony combined house altar and cabinet by a Bavarian court goldsmith. Last quarter of the 16th century. Height 15 in., width 4½ in. £68,000 ($163,200).

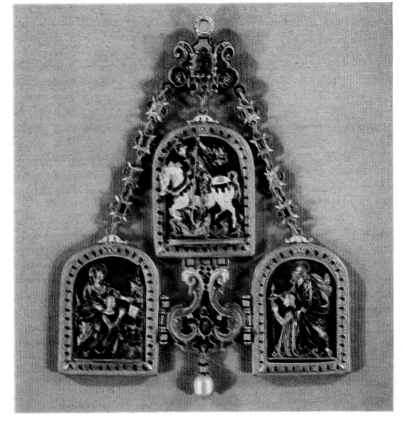

Set of three Flemish gold plaques from a miniature altar, each wrought in high relief, enamelled in translucent colours, but with the faces and hands in natural colour. Relief plaques first half of 16th century, the remainder later.
Height 6 in., width 4¾ in.
£6,200 ($14,880).
The style of the costume and the Renaissance detail of the prie-dieu establish the plaques as dating from the 16th century and they are most likely to be of Flemish origin.

The collection sold at Sotheby's consisted of thirteen jewels, sixteen hard-stone cups with mounts of enamelled gold and one ebony shrine. Now that the ancestral collections of the former ruling houses and great noblemen have been dispersed or become state property, the appearance of so large a number of sixteenth century pieces, of uniformly high quality, was an altogether exceptional occasion. The jewels included some of the finest extant outside the European dynastic collections. The earliest was composed of three gold plaques wrought in low relief and enamelled in brilliant colours, with a mounted figure of Saint George in the centre and with a donor supported by a patron saint on each of the wings. These plaques, which had been mounted together and set on a lapis lazuli ground at a later date to form a large pendant, were apparently the work of a Flemish goldsmith who derived the composition from a contemporary Flemish painting. Hitherto, two workshops producing enamelled gold reliefs, in Burgundy and in South Germany respectively, have been recognized, but these came from another source. The costume fashion and the Renaissance details of the prie-dieu before which the female donor kneels establish the period as the first quarter of the sixteenth century. In their original form the plaques probably belonged to a polyptych house altar. The most imposing single object in the collection was a complete house alter created by Augsburg cabinet-makers and goldsmiths working for the court of Duke Albrecht V of Bavaria (page 12). This splendid piece could almost be regarded as jewellery, for its ebony carcase was adorned with innumerable jewels in the form of figures modelled in the round, in high and low relief,

Detail 1

of scrollwork and bunches of fruit, all in enamelled gold. Recent research[2] on the very similar house altars in the Munich *Reiche Kapelle* has attributed the cabinet and goldsmith's work to two Augsburg masters, Abraham Lotter and Hans Krieger respectively. Considering the magnificence of the altar, it is not surprising that in April 1572 Abraham Lotter should have petitioned the Augsburg City Council for permission to set bars in front of his workshop: he was, he stated, then executing commissions for the Emperor Maximilian II and for Duke Albrecht V of Bavaria. While the upper part of this altar with its scene of the Adoration of the Kings is constructed like a stage set, the lower part is of cabinet form. The three panels set with a relief of the Last Supper, flanked by figures of Saints, are, in fact, movable (detail 1). The central one can be pulled out and is fitted as a drawer, while each side panel slides to left and right respectively to reveal a tier of three drawers. There are other drawers in the base and the upper part. These may have been intended to contain relics, but the general effect of the cabinet is so far from devotional art that their use for trinkets seems more likely.

While religious art such as this house altar became increasingly secular in effect, jewellery in the third quarter of the century still tended to follow medieval tradition in incorporating a religious theme. Two of the finest jewels were of this type: the pendants of the Sacrifice of Abraham and of the Adoration of the Magi (pages 15 and 16). Contemporary portraits often show the female sitters encumbered with jewels of great

[2] Ulla Krempel, *Augsburger und Münchner Emailarbeiten des Manierismus*, Münchner Jahrbuch der bildenden Kunst, 1967, p. 138 ff.

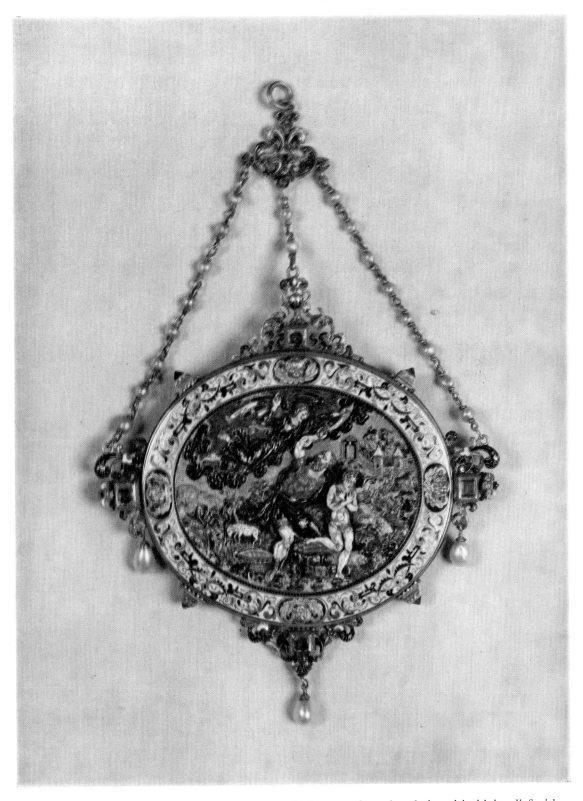

Large French enamelled gold pendant, the central plaque embossed and chased in high relief with a scene depicting the Sacrifice of Abraham.
Second half of sixteenth century. Overall height 7 in.
£17,000 ($40,800).

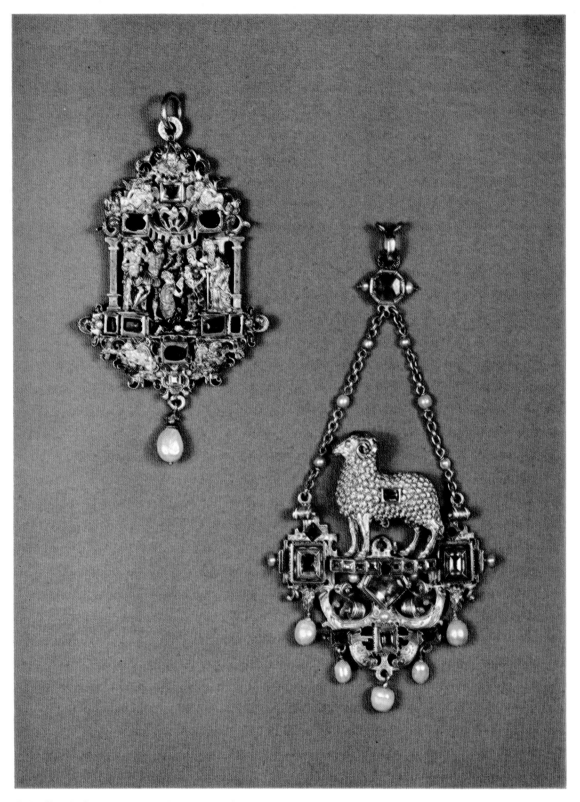

Left: South German enamelled gold Tabernacle jewel. Third quarter of 16th century. Height 4 in.
£10,000 ($24,000).
Right: South German enamelled gold pendant jewel, in the form of a ram.
Second half of 16th century. Height 5¼ in.
£12,000 ($28,800).

size, but the Sacrifice of Abraham jewel was of exceptional proportions. It is conceivable that it was intended as a votive jewel to be hung at a shrine, but, if this were the case, one would expect the subject to be a patron saint rather than an Old Testament incident. In common with many other Renaissance jewels the country of origin of this pendant is uncertain; the central relief recalls so closely the manner of Etienne Delaune that a French origin seems the most likely. Apart from his many engravings for goldsmiths and enamellers, Delaune produced a large number of jewellery designs of which numerous examples, mostly unpublished, are in the Ashmolean Museum, Oxford. The present jewel of the Adoration belongs to a type that was made both in the Low Countries, especially Antwerp, and in South Germany. Printed designs of similar tabernacle jewels by Hans Collaert and Erasmus Hornick,[3] published in Antwerp and Nuremberg respectively, exist, but this fact, although indicating a possible cultural source, does not necessarily establish the nationality or place of work of its maker. Such designs passed rapidly from one city to another.

No human artifact has been so ruthlessly sacrificed to meet the changing demands of fashion through the ages as the creations of the jeweller. The value of the precious stones has nearly always been so great that the jewels in which they were set have been broken up in subsequent periods without regard to their beauty of design or excellence of craftsmanship. The few Renaissance jewels that survive usually owe their preservation to the fact that the stones in them were few and unimportant or that less valuable ones had been substituted for the originals. In later centuries, with the development of more effective methods of cutting, the stones were rated as more important than their settings, but in the sixteenth century the reverse was true. The typical Renaissance jewel was often a miniature work of sculpture, either a relief or modelled in the round: it was the creation essentially of the goldsmiths, the gemstones playing a subservient decorative role. There was less reason to destroy such pieces: this explains the apparently anomalous circumstance that a larger number of fine jewels survives from the sixteenth than from the seventeenth century. The typical jewel of the last quarter of the sixteenth century no longer showed the medieval obsession with death and the after-life, but drew on classical sources for its subjects. The minute nymphs and satyrs of enamelled gold which often form the themes of Renaissance jewels reflect the highly permissive atmosphere of the court of Catherine de Medici and her three sons who were in succession kings of France, so graphically portrayed in Brantome's well named 'Vie des Dames Galantes'.

The most spectacular jewel in the Lopez-Willshaw Collection was the Siren pendant, which shares with the Canning jewel in the Victoria and Albert Museum the romantic tradition that it formed part of the Medici treasure in Florence, was presented by one of the Grand-dukes of Tuscany to a Moghul Emperor and was taken as British war booty after the Indian Mutiny (page 18). It is of exceptional interest, inasmuch as it appears to be the only extant sixteenth century jewelled pendant that bears a maker's signature. The minute monogram of the letters V.D. on the back has, however, yet to be interpreted. The goldsmith who created it had to face the

[3] See J. Evans, *History of Jewellery*, 1953, figs. 12–15.

B

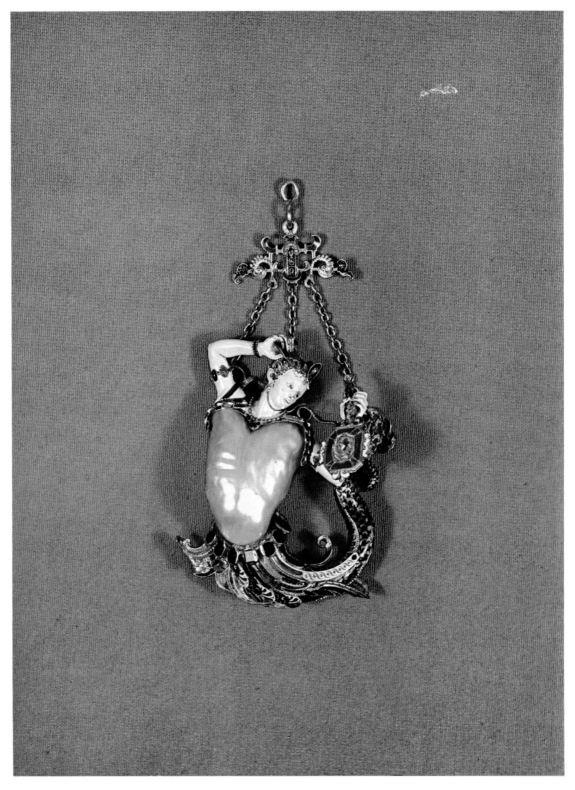

An Italian pendant jewel, possibly Florentine, in the form of a siren.
Third quarter of 16th century. Height 4¼ in.
£40,000 ($96,000).

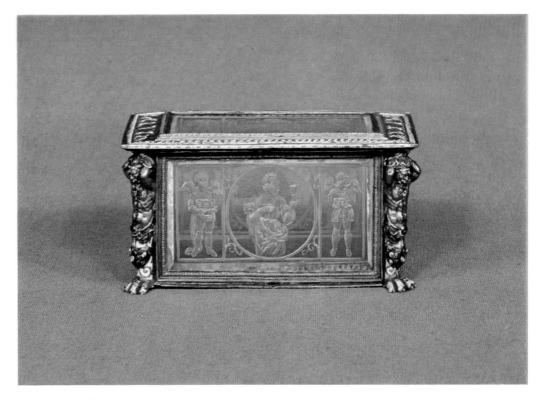

Italian enamelled gold and rock crystal casket, the top mounted with a rectangular crystal plaque engraved with a figure of Charity, accompanied by four infants within a roundel, on each side a putto bearing a dish of fruit; the front with Faith holding a chalice and the Host, with winged cherubs each holding a tablet engraved with the Sacred Monogram; the back with a figure of Hope flanked by winged cherubs, the interior of the base set with a lapis-lazuli panel, the framework of gold champlevé enamelled blue, the angles each with an enamelled gold-bearded male term. Mid-16th century. $4\frac{1}{4}$ in. high by $1\frac{1}{2}$ in. wide by $1\frac{3}{4}$ in. deep. £16,000 ($38,400).

problem that even the quite exceptional Baroque pearl lacked two excrescences corresponding to the form of the female torso and in this case the delicious Siren's head has been set upon a rather hermaphroditic body. In addition to the monogram the back of the jewel has a label inscribed with a Latin verse which can be translated as 'Both the appearance and the song of the Siren deceive'. The letter T appears three times in the inscription written large, possibly to indicate that the name of the lady who originally owned it began with this letter. The wording of the inscription would seem to imply that the relations between the donor of the jewel and his mistress were not entirely happy. It would be difficult to conceive of a more appropriate design for a jewel than that of the Cupid pendant (page 10). It is not surprising that other versions of this exist, including an almost identical one in the Rijksmuseum, Amsterdam. The jewel is set with a large number of rubies for which the white enamelled body of the Cupid provides an effective contrast. At the time the ruby was, carat for carat, more highly valued than the diamond, hence its lavish use in the finer jewellery of the period. This jewel is exceptional in that it retains part of its accompanying necklace. Contemporary portraits show that such jewels might be suspended from a chain around the neck or hung on a hat or from the shoulders or bust.

Detail 2 Detail 3

The Lopez-Willshaw collection included examples of hard-stone cups from the main European centres of the glyptic art, Milan, Florence, Prague and Freiburg im Breisgau. These superb vessels cut from rock-crystal, heliotrope, lapis-lazuli, jasper or agate, enriched with enamelled gold mounts and sometimes jewelled as well, were intended purely for display, to be admired as prodigies both of nature and of the craftsman's virtuosity. A collection of such vessels also threw a flattering light on the taste, wealth and power of the Prince who had commissioned them. So much was this the case that every Renaissance monarch seems to have owned a number of them.

With one exception, the hardstone pieces of the collection date from the second half of the sixteenth century. This is the entrancing little casket (page 19), which forms a pair to another in the Spiritual Treasury (*Geistliche Schatzkammer*) of the former Holy Roman Emperors in Vienna. A *terminus post quem* can be fixed by the design of the interlacing arabesques on the base (detail 2). This type of ornament, which was of oriental derivation, first appears in European art in the 1540's, so the casket can be dated to the last decade of the first half of the century. The rock-crystal panels which fill the top and sides are engraved with figures and angels after Raphael (detail 3), both these and those on the companion casket in Vienna are copied from the Predella scenes on the Raphael Entombment of Christ in the Vatican.[4] The style of the engraving suggests the workshop, though not necessarily the hand, of Valerio Belli, who was working for Popes Clement VII and Paul III in Rome about the time these caskets were made. It is, in fact, likely that the casket in Vienna was a gift from one of the Popes to the Emperor Maximilian II. The Lopez-Willshaw casket may have accompanied the other casket to Vienna and left there subsequently, or it may have been given to some other Renaissance Prince. The purpose of such small caskets is uncertain. In view of the ecclesiastical nature of the engraved scenes, they may have originally contained precious relics.

Taste and fashion in the latter part of the sixteenth century moved away from the impeccable proportions of a style based on classical antiquity and preferred original and quite fantastic designs (*inventiones*). The artist–craftsman was encouraged to devise the most complex forms and took an evident delight in setting himself the most

[4] Illustrated Gutbier & Lübke, *Rafaelwerk*, pl. 82.

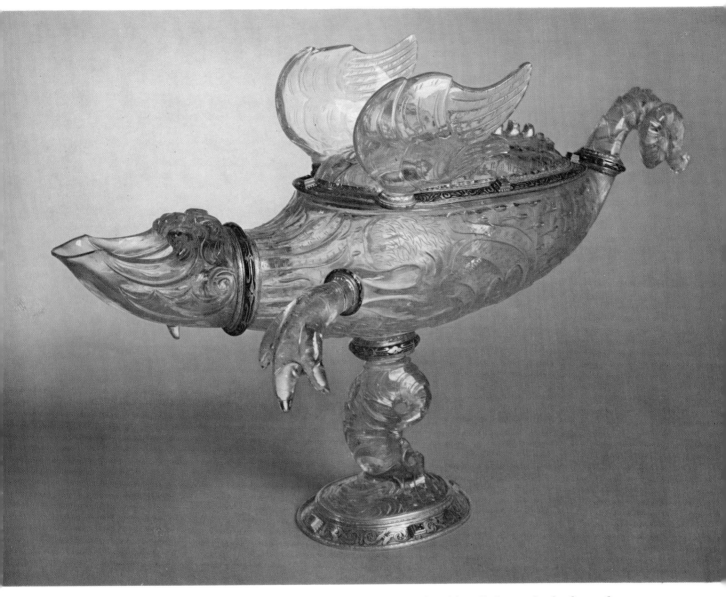

Milanese, Saracchi workshop, rock crystal, enamelled gold and jewelled ewer in the form of a dragon, the body carved in relief with scales and wings; two feet each with three claws; the head with open mouth forming the spout, the tail ending in a curl, each element attached to the body by a gold ring decorated in champlevé enamel with black strapwork; the cover carved with raised crest and two upstanding wings, the gold mounts enamelled black and set with precious stones *en suite. Circa* 1600. 9¾ in. high by 14¾ in. wide. £16,000 ($38,400).

difficult problems. The monarchs of Europe vied with each other in attracting to their courts the most skilled artists from Florence, Milan, Munich, Nürnberg, Augsburg, Utrecht, etc. Under royal patronage workshops grew up staffed with artists drawn from different countries and only rarely did the taste of the patron become manifest in a uniform and recognizable style. Two of the rock-crystal vessels in the collection can be attributed to the workshop of the Milanese family, Saracchi; the galley-shaped ewer (page 22) and the covered ewer shaped like a sea-monster (page 21).

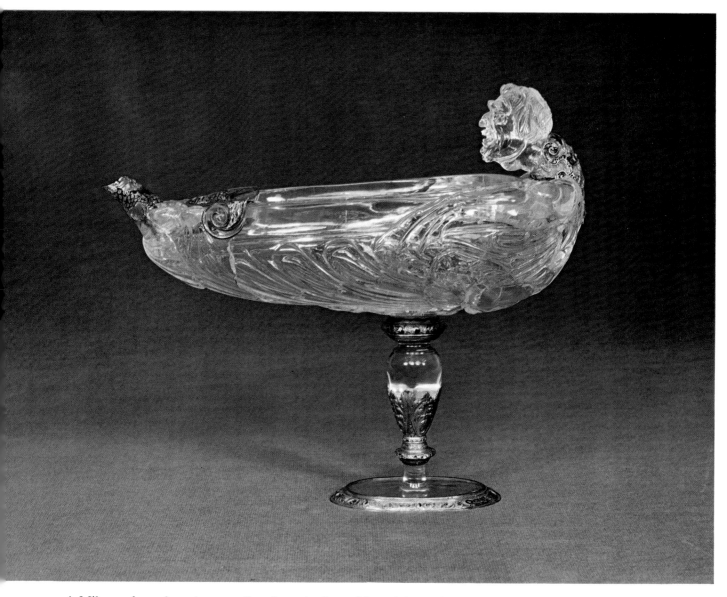

A Milanese boat-shaped ewer galley, from the Saracchi workshop, of rock crystal, enamelled gold and silver-gilt, the oval bowl carved in relief with a winged satyr at one end and carved with a shell and grotesque mask at the other end. Height 8 in., length 9½ in., *circa* 1600.
This piece belongs to a group of boat-shaped rock crystal vessels, produced in the Saracchi workshop. Other examples are in the Rijksmuseum, The Munich Residenz, Grünes Gewölbe, Dresden.

The former came from the collection of the Electors of Saxony in the Grünes Gewölbe, Dresden;[5] and its enamelled gold mounts show close affinities to those of another rock-crystal galley of rather more elaborate construction which is still at Dresden. The most characteristic productions of the Saracchi workshops were fantastic monsters constructed of several pieces of rock-crystal fixed together by enamelled gold collars.

[5] W. Holzhausen, *Bergkristallschale mit Goldemailverzeirungen*, Pantheon, May 1934.

Heliotrope and enamelled gold standing cup, from the Habsburg Imperial Court Workshop, the rim and foot mounts in champlevé enamel with compositions of fruit, draperies, flies and snails, in translucent colours and strapwork in opaque white. *Circa* 1600. Diameter 4½ in.
£5,500 ($13,200).

In devising those monsters the Milanese hard-stone carvers had to be guided by the shape of the rock-crystal in its natural state but such was their ingenuity and versatility that they never failed to achieve the most adventurous forms out of their precious but difficult material.

Of equal importance to the Saracchi was another Milanese family, that of the Miseroni.[6] Not only did this family establish a large workshop in Milan but it supplied from its ranks artists who worked for the courts of the Emperor Rudolph II, for Philip II of Spain and for the Dukes of Bavaria. The Emperor Maximilian II had ordered rock-crystal vessels from both the Saracchi and the Miseroni workshops in Milan, but in 1588 his son Rudolph II succeeded in recruiting Ottavio Miseroni to work for his court in Prague. The style of the Milanese masters did not change greatly whether they were working in their Milan workshop or abroad and in order to determine the origin of a given piece it is often necessary to base one's decision on the style of the mounts. The richness or otherwise of these depended to some extent on the amount of money available. Rock-crystal was as a material so precious that it was usually mounted in enamelled gold, at any rate in Italy. Rock-crystals mounted in

[6] Ernest Kris, *Steinschmiedekunst*, Vienna, 1929, Vol. I, p. 137 ff.

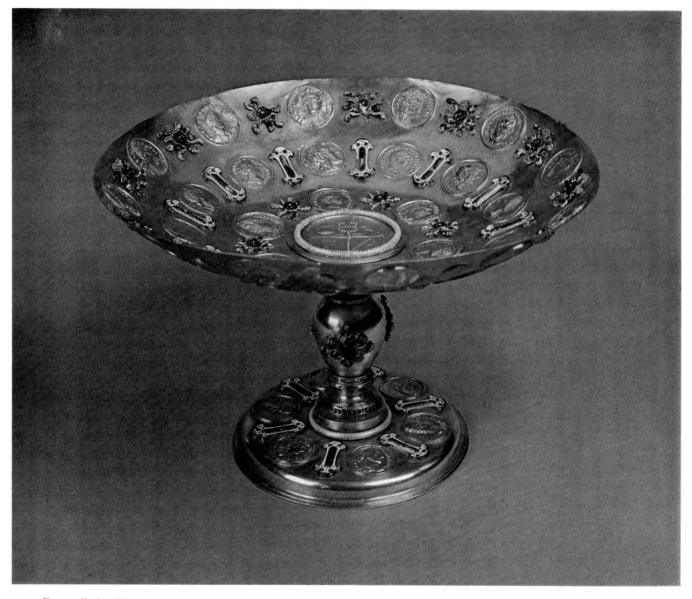

Enamelled gold tazza, the bowl set with concentric rows of gold casts from antique coins, the spaces between the coins being occupied by embossed and polychrome enamelled gold ornaments.

First half of the 16th century. Height 4½ in., diameter 7¼ in.

£11,000 ($26,400).

This tazza is closely related to the Olmützer bowl in the Grünes Gewölbe in Dresden, which is set with twenty-two Roman gold coins or Renaissance copies of them. These two, together with another bowl in Dresden, appear to be the only recorded gold coin cups of the 16th century. The coins are cast as follows: three from Greek staters, eight from Roman denarii, fourteen from aureii and eleven from late Roman and Byzantine solidi. The central medallion is cast from a Roman original of the Imperatorial period.

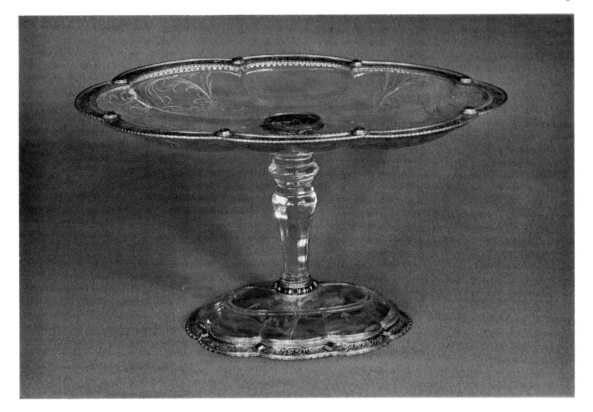

Milanese rock-crystal enamelled gold and jewelled tazza.
Last quarter of 16th century.
Diameter 10 in., height 5½ in.
£5,000 ($12,000).

Germany or in England on the other hand usually have silver-gilt mounts. Milanese mounts were restrained in design, champlevé enamelled with black foliate scrollwork, interrupted at intervals by small coloured stones in gold collets or by miniature ones in red, blue or green enamel. A typical Milanese tazza with mounts of this type is illustrated on this page. At the top of the stem and visible through the rock-crystal bowl are the addorsed arms of two South German families, Krafter of Augsburg and Ott of Ulm, presumably indicating that the vessel commemorated a marriage between members of these two wealthy merchant families. A member of the Ott family was, in fact, the agent in Venice to the Augsburg banking house of Fugger in the late sixteenth century.[7] It is surprising to find so splendid a piece commissioned for a bourgeois family.

Ottavio Miseroni worked in Prague on the production of hard-stone vessels for thirty-five years until he was succeeded as head of the hard-stone cutting workshops by his son Dionysio. Certain changes took place in the design and practice of hard-stone carving about the turn of the century as the sophisticated Mannerist version –

[7] Stockbauer, *Kunstbestrebungen am Bayerischen Hofe unter Albrecht V und Wilhelm V*, Quellenschriften für Kunstgeschichte, 1874, Vienna, Vol. VII.

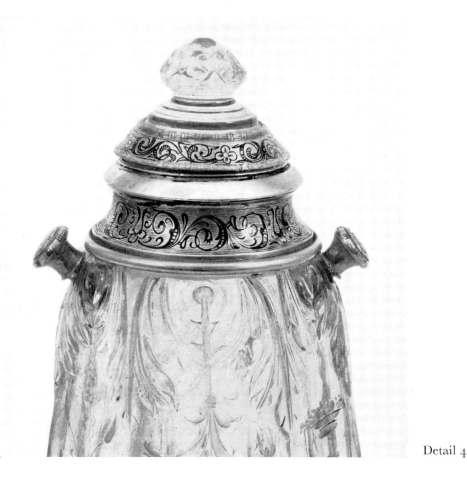

Detail 4

or perversion – of the classic Renaissance style gave way to the more positive and masculine Baroque. Mannerist taste had preferred the transparent rock-crystal to the strongly coloured semi-precious hard-stones and intaglio-cut to relief ornament. Intaglio cutting could hardly be seen and was ineffective when executed on opaque materials. The seventeenth century makers concentrated on achieving their effect by the imaginative shaping of the vessel and by abundant relief ornament. The beginnings of such relief ornament can be seen on the shoulders of the hexagonal bottle (detail 4) on which, however, the sides are still engraved with delicate scrolls and cartouches enclosing figures emblematic of the Planets (page 27). The engraving of this piece conforms to the style practised by Milanese masters both in Milan and in Prague. In this case the sobriety of the gold mounts points to a Milanese workshop rather than to Prague, where a richer effect was achieved by using polychrome translucent enamels. Most likely to be of Prague origin was the smoky quartz cup (page 28). This well illustrates the Baroque taste for more massive effect and relief ornament. A recent study[8] of the hard-stone collections of the Hapsburg Emperors in Vienna has attributed a number of similar vessels of coloured hard-stone (agate, jade, heliotrope) to Ottavio Miseroni. These have bowls of oval shape with a grotesque mask

[8] Umeni, 2, 1970, Prague. Beket Bubovinska, *Anmerkungen zur Persönlichkeit Ottavio Miseronis.*

Continued on page 33

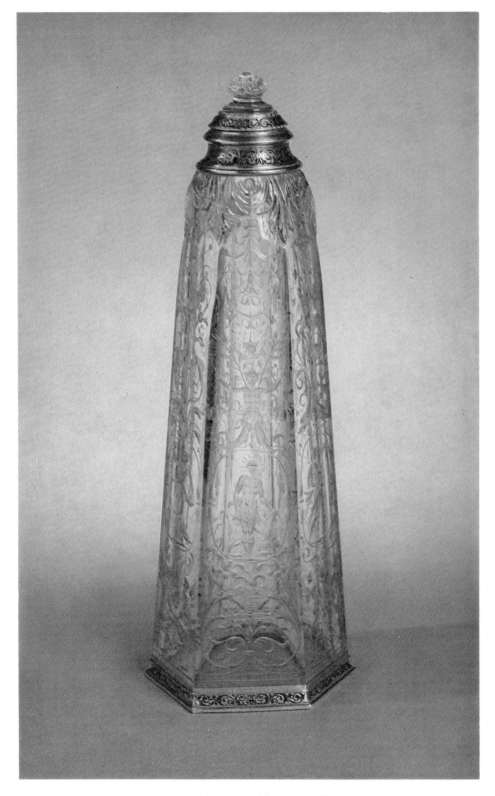

Enamelled gold and rock-crystal hexagonal bottle attributed
to the Habsburg Imperial Court Workshop.
Late 16th century. Height 12¾ in.
£16,000 ($38,400).

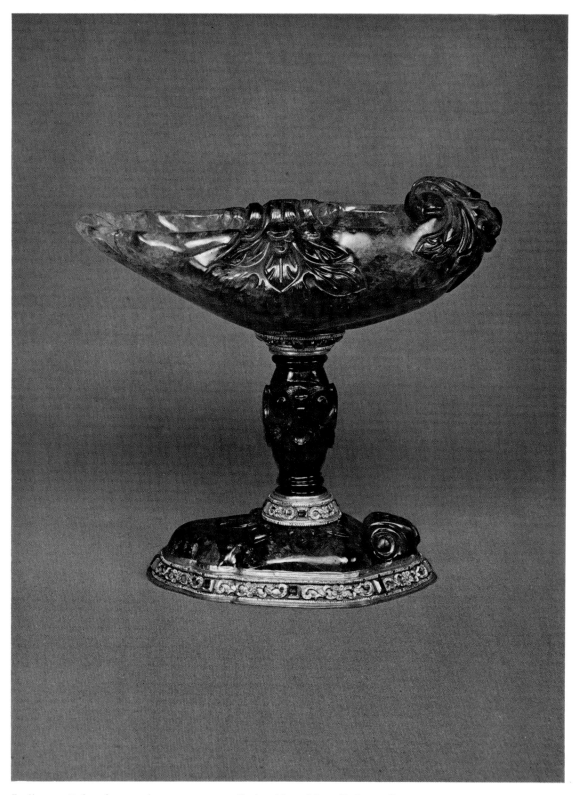

Italian or Bohemian smoky quartz enamelled gold and jewelled standing cup,
the bowl of shaped oval form carved with foliage and a grotesque mask.
Early 17th century. Height 5¾ in.
£7,000 ($16,800).

THE LOPEZ-WILLSHAW COLLECTION 29

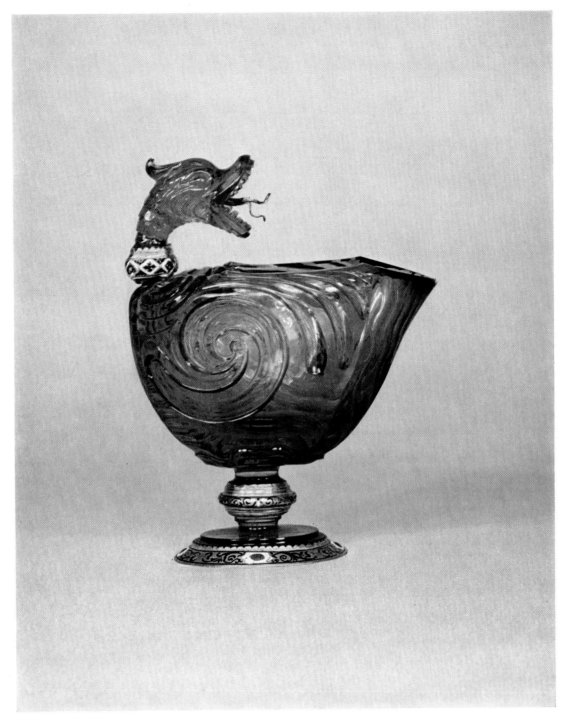

Smoky quartz and enamelled gold ewer from the Habsburg Imperial Court Workshop, the body
resembling a nautilus shell; the handle is carved as a dragon's head.
First half of 17th century. Height 7 in., width 5½ in.
£12,000 ($28,800).
The enamelled decoration of the mounts with running scrollwork in black champlevé is in
the Milanese fashion and was probably executed by one of the Milanese goldsmiths working in
the Prague workshops.

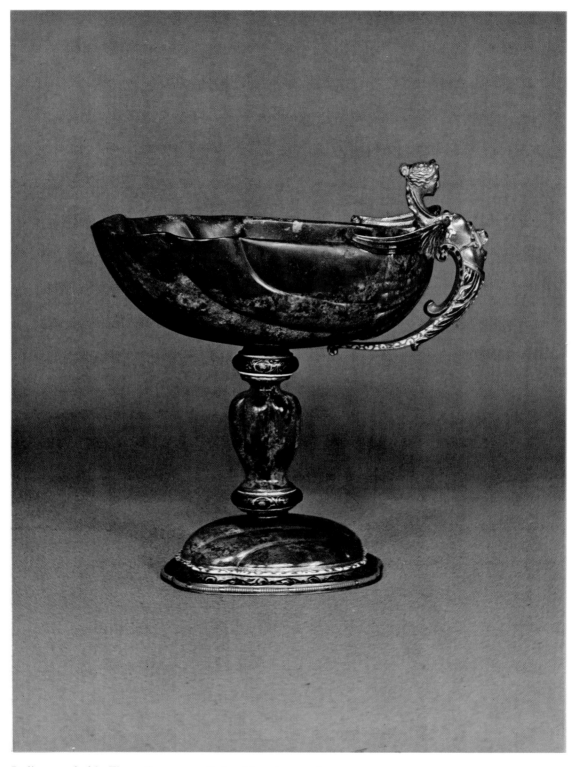

Italian, probably Florentine, enamelled gold and green jasper cup,
with a single gold handle in the form of a winged female term.
Last quarter of 16th century. Height $5\frac{1}{8}$ in., width $6\frac{1}{4}$ in.
£17,000 ($40,800).

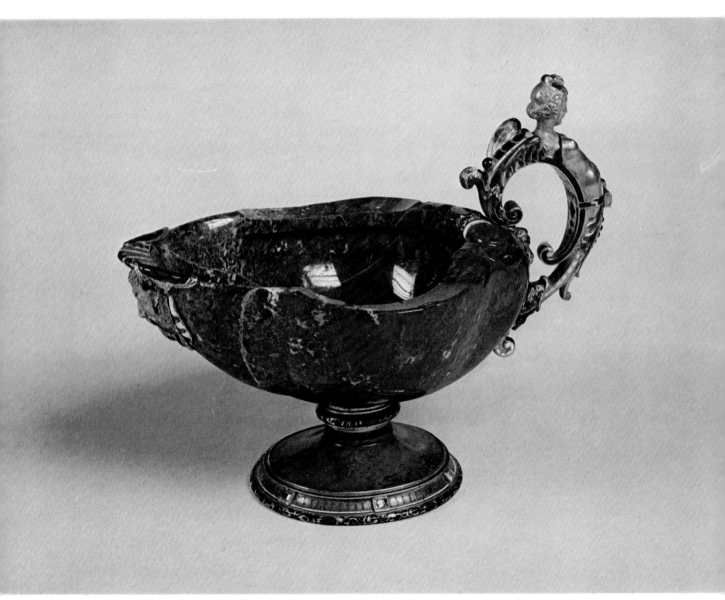

Italian enamelled gold and jewelled heliotrope ewer, quadrilobate bowl standing on short stem with oval spreading foot, enamelled gold knop, the foot rim champlevé enamelled blue and black with red translucent enamel jewels and further set with six table-cut diamonds in gold collets; the handle modelled as a nude female winged term, her tail passing through the jaws of a wolf and ending in a volute, the upper end of the handle attached to the bowl by a red and green translucent enamel strap and terminating below in a bunch of fruit; a table-cut diamond in gold collet set in the harpy's coiffure and her girdle; the spout with enamelled gold mount, the lower part modelled in relief with the head of a faun with translucent green ears and red horns, flanked by pendent drapery. Probably Florentine.
Second half of the 16th century. Height 5 in., width 6 in.
£16,000 ($38,400).

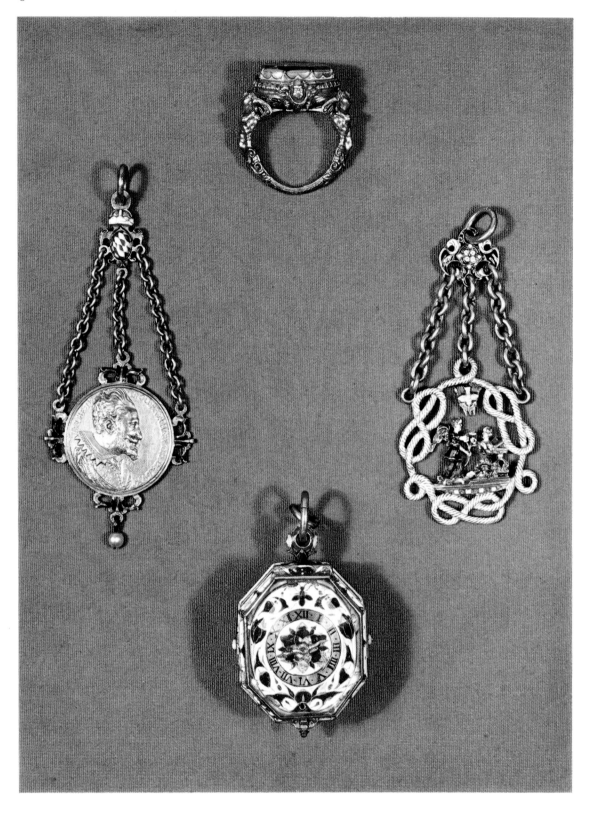

or figure carved in relief at one end and stand on baluster stems. One has mounts composed of white enamelled scrolls interrupted by gemstones in closed collets corresponding closely to those of the Lopez-Willshaw cup. Rudolph II employed seven hard-stone cutters on various occasions. Ottavio Miseroni and his two brothers, Alessandro and Giovanni Ambrogio, Giovanni Castricci and three Germans, Caspar Lehmann, Mathias Kritsch and Hans Schweiger, but of those artists only the Miseroni family can definitely be associated on the basis of archival evidence with hard-stone vases. A speciality of the Prague workshop was the production of vessels carved in smoky topaz: another of the Lopez-Willshaw pieces was the ewer (page 29) carved from this material in the form of a nautilus shell while the handle is a dragon's head. The design corresponds to that favoured by Ottavio Miseroni, though, in view of its slightly later style, it may have been the work of Dionysio, who worked at Prague from 1623 until his death in 1661 – an even longer period than his father. The idea of carving one material – smoky topaz – in the form of another – shell – was a typical conceit of the period, offering to the patron's jaded appetite a pleasure derived from the original conception and the superb craftsmanship.

The most spectacular and most precious of the hard-stones was lapis-lazuli followed by heliotrope (also known as bloodstone or plasma). The former was not represented in the collection but there were two splendid heliotrope ewers of rather similar design, one with a tall and one with a shorter stem, the handle in each case formed as a winged harpy of enamelled gold, her breast set with a diamond (pages 30 and 31). Such pieces with more elaborately wrought mounts are believed to have been produced in the Florentine workshop established by Francesco I, Grand-duke of Tuscany, in the Cosimo di San Marco under the guidance of the Court architect and *arbiter elegantiae*, Bernardo Buontalenti.[9]

Such was the importance of the Lopez-Willshaw collection that the sale brought not only collectors but also Museum curators from Europe and the United States to see its riches. So rare is such material that it can be studied adequately only in the former European dynastic treasuries in Paris, Vienna, Munich, Dresden, Florence and Prague. Many years are likely to pass before such an opportunity to examine the finest examples of the Renaissance goldsmiths' craft, unhindered by Museum glass cases, bolts and bars, is repeated.

[9] L. Berti, *Il Principe dello Studiolo*, Firenze, 1967, p. 51 ff.

Facing page: Top, Italian Renaissance enamelled gold ring. Third quarter of 16th century.
£3,400 ($8,160).
Centre left: Bavarian enamelled gold pendant jewel set with a medal of Duke Albert VI of Wittelsbach (1584–1666). Second quarter of 17th century. Height 4¼ in.
£1,000 ($,400).
Centre right: Italian enamelled gold pendant jewel of the order of Sant' Annunziata.
Late 16th century. Height 3½ in.
£3,600 ($8,640).
Bottom: French enamelled gold and rock-crystal watch by C. de Lespée of Rheims,
First quarter of 17th century. Length overall 2¼ in.
£10,500 ($25,200).

C

Sotheby's of London, New York: the early days
Some egotistical reminiscences

BY JOHN CARTER

What with Sotheby's Parke-Bernet grossing over $38 million in 1969–70 (not to mention those consignments from the United States which contributed to Sotheby's London total of £25 million), with branch auction houses on 84th Street and in Los Angeles, with agencies in Houston and Buenos Aires, it is hard, even for those of us who were involved at the time, to remember that Sotheby's of London was established in New York no longer ago than December 1955. And most of the 677 members of the present staff of the firm's continent-wide ramifications (there were then 84) would probably be as much surprised as the 'general reader' to realize that Sotheby's American agency, the earliest of these many outposts, was operated for the first four or five years of its existence by one man, working out of a mid-town hotel room for a month or six weeks twice a year, based on desk-space and the part-time services of a secretary in a law office in the Wall Street section of lower Broadway.

The Background

Since the traffic in works of art has always, since classical times at least, been international, the fine art markets of London and Paris and (increasingly) New York have long been closely linked. During the earlier years of this century such London auction houses as Christie's and Sotheby's had maintained an intimate contact with the American market as the source of an ever-growing volume of purchasing power; even if it was in those days seldom envisaged as a source of potential consignments to the London sale room. In 1939, however, the British Treasury imposed a strict control on the export of sterling, and this control extended to any object that might be readily converted into foreign currency (especially dollars, as the most critical currency at the time) at the other end of the journey. Similarly no one in the British Isles could purchase anything abroad, whether a bottle of scent or a Botticelli, without getting an import licence to pay for it, such as would not be granted unless its necessity for the conduct of the war could be firmly established; an unlikely occurrence for most private persons trying to mitigate the drabness of war-time life, and equally unlikely for a dealer in any department of the fine art trades. This meant a virtually complete shut-down on any transatlantic movement of pictures, furniture, porcelain, glass, silver, books and manuscripts – everything, in fact, in the field of works of art or antiques. During the war, when such business was at a low ebb, the fact that this wall effectively insulated the London and New York markets from each other was accepted, however reluctantly, as a necessary measure of war-time economy. What could not be foreseen was that a still dollar-hungry Treasury and a nervous Board of Trade would maintain the exchange controls after the war was over. This meant that as the fine art trade revived and important sales again began to be held in London and New York, the dividing wall changed from steel to glass; so that in England anguished professionals and the more internationally observant connoisseurs could see objects on the wrong

side of the exchange control selling for half what they would have been willing to pay for them, while owners in the United States who foresaw a better market in Europe for something they wanted to sell could only make use of it by consigning to London if they were prepared to accept blocked sterling at the end of the deal. Whatever might be the case with a collector or even a dealer, who could perhaps make use of the sterling in Great Britain, it altogether ruled out estates or trustees or any such potential consignor as needed the proceeds of sale in dollars.

Believe it or not, this situation persisted, despite mounting pressure from the English trade, for almost ten years. I remember a memorandum composed about 1950 for the Antiquarian Booksellers' Association (I was at that time the European representative of Scribners of New York) which concluded with the ringing assertion that London, as a unique complex of expertise, had been and could be again if they would only let us, the hub of the international market; but that you couldn't run an *entrepôt* business on a one-way street.

Transition

Things moved slowly, but official obstruction gradually gave way to common sense. In December 1953 Vere Pilkington, an old friend from school days, by then Chairman of Sotheby's, paid us a visit in Washington, where I was then on a temporary assignment at the Embassy. He told me it looked as if antiques and works of art would soon be back to free trade (or as the bureaucrats put it 'on general license') and asked me what I thought of the prospects of securing consignments from the United States for sale in London – a resumption, in short, of two-way traffic. I told him that in the only field I knew anything about, namely rare books, I thought they should be excellent: for example, at least two important libraries had perforce been sold in New York recently which could obviously have done better in the European market (Wilmerding 1947 and the Cortlandt Bishop French collection 1948); and I could only suppose that the same would be true in other departments, where English or Continental taste for certain objects or styles might at any given moment be more active than American. During subsequent visits from other Sotheby partners (then a select band), Jim Kiddell, for whom my wife and I formed a lifelong affection at first sight, Peter Wilson, already a rising star, and Anthony Hobson, whom I knew and warmly respected, it was agreed that I should in due course join the firm and set up an agency in New York for the direct promotion of Sotheby's business in the United States. In December 1954 the exchange control restrictions were removed, and in the following months our arrangements were completed and plans laid.

Accordingly, on 31st October 1955, after a month's overlap with my successor as the Ambassador's Personal Assistant, I said a reluctant goodbye to Sir Roger Makins, the best and most stimulating of masters and one of the most effective Ambassadors we have ever had in Washington, and to my friends in Chancery, as brilliant (and congenial) a crew as perhaps any embassy has enjoyed anywhere. It happened that my last day as a member of Her Majesty's Foreign Service coincided with a performance in Washington, after a triumphant season in New York, of the Sadlers Wells Ballet. We were giving a grand party for the company in the Embassy afterwards, and I remember that as midnight struck it was my final official duty to hand Margot

Fonteyn, long one of my divinities, off the receiving line to supper with (as of that moment) a private citizen. I thought this a good omen for my new assignment, and the pair of her dancing slippers which she subsequently gave me as a memento have stood on my chimney-piece ever since.

Establishment

The next day I left for New York and began putting into effect the still sketchy plans for the first Sotheby outpost. Thanks to the friendship of the late Donald Hyde, a distinguished lawyer, and his wife Mary, both already great book-collectors, and his enthusiastic approval of the project, I had been able to organize the first thing we needed: an address in Manhattan, some minimal desk-space and the part-time services of a secretary. The address was 61 Broadway, a large office block down-town in the Wall Street neighbourhood; the desk-space and some necessary storage for catalogues and stationery were provided by arrangement with Messrs Mackenzie, Hyde and Partners; and Miss Rose McTernon, who handled Donald Hyde's many bibliophilic interests as well as his legal business, proved to be a jewel of a secretary. Moreover, we should have at our back the loyal support and wise counsel of a man who knew as much about the auction business as about such legal matters as any new and inexperienced outfit was bound to get involved in.

Thus armed with a secure base I decided that the first step was the immediate insertion, in bold type, of the firm's name in the telephone book: it was essential to establish Sotheby's physical presence, not two thousand miles away and ten days by mail in London, but within easy reach of a 'phone call from San Francisco, Cincinnati or New Orleans. The name itself, I remember telling my colleagues, was an initial disadvantage vis-a-vis our principal European rivals, in that anybody could pronounce and spell Christie's, while those who had even heard of Sotheby's weren't sure how to pronounce it and more often than not spelled it (some still do) either Sotherby's or Southby's. For the Manhattan telephone directory, however, we had one compensating advantage: it is an unusual name, even in England, and there was no other Sotheby listed in New York (there still isn't). Thanks to some wire-pulling by my friends in the Consulate General, always a valued source of advice and assistance in those early days, the next issue, in time for our official opening for business, duly included SOTHEBY'S OF LONDON, 61 Broadway, Bowling Green 9.0765.

Back in England, I spent an intensive month or so at headquarters, familiarizing myself with Sotheby's existing American connexions, setting up the machinery for New York's liaison with the various departments, and getting acquainted with the partners I did not already know. Cyril Butterwick, then in charge of silver and jewellery, was an old friend from his book-collecting days as an Eton master, but this was my first sight of the other top brass, such as Tim Clarke, Carmen Gronau and Richard Timewell. Equally important, I was starting to learn the rudiments at least of the innumerable categories in the fine arts business of which I knew virtually nothing. In retrospect, it seems to me that Vere Pilkington and his colleagues took a very imaginative risk when they put in charge of the development of Sotheby's American potentialities someone who had, certainly, an established reputation in the

An early letter heading, printed
by the Rampant Lion's Press, Cambridge,
for Sotheby's of London.

A luscious Renoir on view in Charleston,
South Carolina, in the hands of John Carter.

Anglo-American rare book world, who knew, perhaps, more of that large country than most Englishmen (aside from business trips for Scribners in earlier days, I had visited with my Ambassador 44 out of the then 48 States of the Union), but who hadn't the least idea of the going price of a Rubens oil-sketch, a T'ang horse, an Oeben commode, a Kaendler figure or a pair of George II candlesticks. Yet, risk or no risk, it was Sotheby's prescience that counted: we were established in New York as a going concern within a year of the resumption of free trade in works of art and more than two years ahead of any European rivals.*

Reconnaissance and propaganda
Those were two gruelling years; of preparatory exploration and the renewal or establishment of useful connections, of physical reconnaissance, above all of persistent propaganda. While there was plenty to do in ensuring that Sotheby catalogues reached potential bidders in good time and that their requests for special reports or enquiries for estimates were promptly dealt with, the machinery for American *bidding* at our sales, whether handled direct or through a trusted agent in London or New York, was long established and well understood, even in 'the sticks': all it needed was

* That Christie's were aware of the implications of the change in the currency regulations was evident in the communiqués which heralded the state visit to America of their Chairman, Sir Alec Martin, in October 1955. Moreover, that immensely distinguished art critic and historian Professor W. G. Constable, then Curator of Paintings at the Boston Museum of Fine Arts, had been acting as consultant to Christie's since 1950; but this could hardly be classified as a regular agency in the sense that Sotheby's of London now was, and such as Christie's in due course (1958) set up in New York under Robert M. Leylan. 'W.G.' was always the soul of kindness to me when I visited him in Cambridge, Mass.

to be kept well oiled and polished. What was thoroughly rusty from disuse – fifteen years (1939–54) is a habit-forming interval – was the notion that it might be more advantageous for Americans to *sell* in London than locally.

Even the experienced hands, whether dealers or internationally sensitive owners or custodians, had to be convinced that payment of the proceeds of sale in dollars was now routine, reassured that H.M. Treasury was not going to reverse the free trade decision overnight, satisfied that any apprehension about some downward movement in the sterling/dollar exchange between consignment and payment could be forestalled by the purchase of forward dollars on the day of the sale. Europe had been so cocooned with currency regulations during the post-war years that I was not surprised to find the canny professionals on 57th Street as suspicious as the traditionally cautious Trust and Estate officials in Wall Street on whom depend so many decisions about the disposition of an art-rich family property. As for owners, advisers, lawyers or bankers in Oswego or Keokuk or Spokane or San Diego – indeed, even in sophisticated cities like Chicago, Philadelphia or Los Angeles – the furthest destination for the sale of even a resplendent collection that would occur to them in 1955–56 would be New York; which, if they were thinking of public sale, meant for all intents and purposes Parke-Bernet, the principal fine art auction house in the country since its establishment in 1937 and thus, inevitably, the prime target for Sotheby competition.

It had been deemed appropriate, for prestige purposes in the United States, that my name should be added to the Sotheby masthead, and after some debate – none but the august partners had ever appeared there before – the title of 'Associate' was evolved, to which for our New York writing paper and leaflets I added the explanatory suffix 'for American operations'. (For years mine remained the only name 'below the line', but the title proved useful and I now have a number of distinguished companions.) And so, in December 1955, Sotheby's of London, with an 'office', 'staff', stationery, telephone, suitable announcements – and high hopes – was officially in business. Since most of the business was in those days in mid-town Manhattan, with 57th Street as a sort of professional axis – today, of course, the market hub has moved north to upper Madison Avenue – I established myself in a cosy attic in the Waldorf Towers (an annexe to the famous hotel); then as now a very glossy hang-out indeed, which raised some eyebrows among my friends the rare book dealers but usefully impressed some of the professionals in the various fine art trades with whom I now had to establish connexions, as well as prospective clients susceptible to such nuances. I owed this stylish perch entirely to the kindness of the then manager, Mr F. dell'Agnese, an immensely distinguished-looking man – rumour had it that he had been connected in some subtle capacity with the British Embassy during the war – with an air more ambassadorial than most of the visiting diplomats in whom the Towers specialized. On my last stay there during one of my Ambassador's fairly frequent official trips to New York I had bidden him a regretful goodbye, explaining that I was shortly returning to the world of commerce and should not be able to afford such luxurious accommodation. 'Mr Carter', he said, 'there is always room for *un ami de la maison*, even if it is only an attaché's or secretary's room attached to one of our larger suites; just let me know when you are coming, and I shall arrange it'; and so, for several years, he did (diplomatic discount and all).

The Daily Round

I kept in daily touch with Miss McTernon by telephone and normally when in New York went downtown once a week to dictate letters, reports to London and so forth. As any business visitor to New York knows all too well, the first hour or so of the day is spent on the telephone arranging or confirming or shifting appointments. Private clients, friends or allies must be caught before they go out – but how early is it decent to ring them up? Businessmen must be allowed time to reach their offices – but how long should one allow for them to read their mail and yet catch them before they go into a meeting? Moreover an Englishman, accustomed to lunching at one, needs to remember that many American businessmen go to lunch at twelve. My yellow pad for the day's agenda was always in a state of exasperated revision, and one could seldom get started on the round before ten.

To begin with, of course, this consisted mostly of cementing old connexions, whether the firm's or my own, and making new ones; amongst the trade, among museum officials, among private collectors. Everyone who could possibly be of use to Sotheby's must be made aware that the firm's services were now available to them on their own doorstep, and not only to themselves but to others who might seek their advice for the most advantageous disposal of a collection or a single valuable item. To back up what soon became a well-polished spiel I always carried a brief-case full of the most impressive recent Sotheby catalogues (and price lists) to document the thesis that we could get higher prices in every department at a commission rate less than half Parke-Bernet's and even further below those ruling in Paris, which was sometimes in the mind of picture and furniture people. 'Take', I would say, 'a Cézanne or a Chardin which you know (as of course an alert professional would know) will bring the same $100,000 under the hammer whether it is sold at Parke-Bernet or Sotheby's or the Hotel Drouot, because the same half-dozen people, whether in New York or Los Angeles or Chicago or Paris or Basle, will be the high bidders. What does the owner put in his pocket *when the dust dies down?* In London $90,000, in New York perhaps $75,000 or $80,000 (PB's scales were flexible), in Paris, after commissions *and* taxes (none in London), about $65,000.' Sotheby's much lower commission rates, plus the fact that the protection of a reserve figure was available in London but not, in those days, in New York (American *buyers* have always, unlike sellers, been suspicious of reserves), was one of the most powerful arguments in my bag, when added to the demonstrable superiority of the firm's expertise in all departments, the international prestige of its catalogues, and, not least, its easy proximity to the continental market – European dealers, collectors and museum men have always been, as they are today, in and out of Sotheby's every week, whereas in those days it had to be a really tremendous sale to justify the expensive trip to New York. (The fact that some at least of these advantages were shared by another famous London auction house called Christie's was never, of course, mentioned.)

First reactions

What was from the first enormously encouraging was the ready, often enthusiastic, response to the establishment of Sotheby's of London in New York: a response not only of practical interest but also of what an explorer so badly needed, practical

advice. In the rare book sector I had of course, after twenty-odd years in the trans-
atlantic business, a fairly wide circle of friendly acquaintance among the dealers –
John Fleming, the Drakes, Michael Papantonio and John Kohn of Seven Gables,
Lathrop Harper and half a dozen more; librarians like Fred Adams of the Morgan,
John Gordan and Karl Kup of the New York Public; collectors like Arthur Houghton,
Robert Taylor, Waller Barrett to supplement our special relationship with Don and
Mary Hyde; and two invaluable allies in Edward Lazare, the perfectionist editor of
American Book Prices Current, and Sol Malkin, the indefatigable editor of that indispen-
sable weekly, *Antiquarian Bookman*; while the Grolier Club provided (even though I
was not yet a member) a rewarding meeting place for the bibliophile fraternity under
the benign Edwardian aegis of its secretary Miss Ruth Grannis. On the wider, general
front, the Century Club (opposite number to the Garrick), to which I had belonged
for a number of years, included many members from all over the country interested
in or concerned with the world of connoisseurship.

In the fields of pictures, drawings and prints, to which I was a complete novice
professionally, I was exceedingly fortunate in being able to seek advice from such
friends as Kirk Askew and George Dix of Durlachers, Ted Rousseau and Hyatt Mayor
of the Metropolitan Museum, Alfred Barr, Monroe Wheeler and Dorothy Miller of
the Museum of Modern Art, good friends of my wife's, who had been before our
marriage Curator of its Department of Architecture and Industrial Art. Among the
picture dealers on whom I now began calling, Charles Henschel, the Czar of Knoed-
lers, was conspicuously kind, Harry Sperling proved a mine of advice, while Dr.
J. K. Thannhauser, though by now officially retired from the market-place, knew as
much about it (especially the back stairs) as any man living and for years welcomed
me hospitably to the fruits of that knowledge. For porcelain and works of art I learned
to cultivate Edward Pinkus, Freddy Victoria, La Vieille Russie; for furniture Alastair
Stair and Michael Comer (in later years always known in the office as 'Comer
Darling' from his affectionate telephone style with the secretaries); for silver Eric
Shrubsole, like myself an Englishman running the New York end of a London firm,
who soon became a steady and reliable consultant. No one in those prentice days gave
me better and sounder advice on the technical side than Bernard Harmer, head of
the American operations of the famous firm of stamp auctioneers: he had been through
all my hoops before and come out with brilliant success. (Not the least of his kind-
nesses was to produce for me, years later when Peregrine Pollen had set up a proper
Sotheby office in New York, the prettiest secretary anybody ever had, who now
decorates the top echelon of Sotheby-Parke-Bernet Los Angeles.)

If nearly all this work lay between the upper thirties and the upper sixties, mostly
on the east side of Fifth Avenue – clients and private prospects also tended to live in
what is known as 'the silk-stocking district', though some important ones later ap-
peared on the unfashionable west side of Central Park – there was another area that I
early began to cultivate: the trust and estate officers of the big banks with head offices
around Wall Street. Armed with introductions from Sotheby's bankers in London,
the National and Provincial, I must have called on more than twenty of them during
the first year. Not one of them, I found (expectably), had ever even thought of
advising consignment from an art-rich estate to London, and hardly any of them had

heard of Sotheby's. But they very quickly grasped the economic argument, they were impressed by the selection of catalogues, they welcomed my offer to put not only themselves but also their branch managers around the country on the list for our monthly Burlington Calendar, and at least half a dozen of them proved very useful connexions. I also managed, with the bait of some modest advertising, to cultivate the editors of the two national 'house organs' of that line of business, which resulted in due course in a long article in *The Trust Bulletin* for May 1957 and another a year later in *Trusts and Estates*, whose title 'The International Market in Works of Art' did not detain the reader for more than a few paragraphs from the detailed reasons why, for anything fine, the obvious place to sell was Sotheby's.

On the road
But New York, as has been frequently observed though not always fully appreciated by foreigners, is not America. It was and is the unquestioned transatlantic hub of our sort of business (as well as many other sorts), and it was in Manhattan that the foundations needed to be laid. Once our base-camp was established, and at least provisionally accepted, it was time to fan out among the next most obvious centres.

Accordingly, in mid-April 1956, after a week in New York, I took a swing through half a dozen key points: Princeton (staying with Fred Adams, memorable dinner with Erwin and Mrs Panofsky); Philadelphia (Mabel Zahn of Sessler's, Horace Jayne at the Museum of Art, drinks with Henry McIlhenny, dinner with William McCarthy of the Rosenbach Foundation); Washington (Louis B. Wright at the Folger, Frederick Goff and David Mearns at the Library of Congress, the Duncan Phillips Collection, John Pope at the Freer, Jack Thacher of Dumbarton Oaks; dinner with John Walker of the National Gallery and his wife, our next-door neighbours in Georgetown during my Embassy years; Sunday excursion to the Paul Mellons at Upperville); St Louis (under the kind wing of Martha Love; several fine private collections as well as the Art Gallery); Kansas City (with an excursion to Kansas University at Lawrence); Chicago (weekend in that chic suburb Lake Forest with book-collector George A. Poole; two receptive newspaper editors; an evening with Gaylord Donnelly of the Lakeside Press at the bibliophile Caxton Club, and a visit to Leigh and Mary Block's already remarkable collection of pictures); Cleveland (William Milliken at the Art Museum; evening with the bibliophile Rowfant Club); Boston and Cambridge (Perry Rathbone, Museum of Fine Arts, overnight to George Goodspeed of the famous bookshop, Walter Muir Whitehill of the Boston Athenaeum, the Gardner Museum; lunch with the Club of Odd Volumes, the Fogg with John Coolidge and Agnes Mongan, the Houghton Library with William A. Jackson and Philip Hofer); New Haven (Jim Babb and other good friends at the Yale Library, Andrew Ritchie of the Art Gallery; Bob Barry, bookseller); overnight to Wilmarth S. Lewis, alias Horace Walpole, at Farmington; and so back to New York after 21 days on the road – somewhat the worse for wear but much encouraged and with plenty of information to relay to London.

In the course of similar exercises in reconnaissance, propaganda and the showing of the Sotheby flag, with an increasing proportion of visits to potential or actually proposing consignors, I covered in the following couple of years Minneapolis, Cincinnati, Piqua (Ohio), Indianapolis, Tulsa, Dallas, Austin, Houston, San Francisco,

Los Angeles, New Orleans, Memphis, Charlottesville, Baltimore; with Washington, Philadelphia, New Haven, Boston and Chicago becoming such regular stops as to constitute what the RAF used to call the milk-run. Many of the more important cities were represented in the network of British Consulates throughout the United States, and here my Washington experience, during which I had had dealings with most of H.M. Consuls and had got to know some of them pretty well – Berkeley Gage in Chicago being an outstanding case – served Sotheby's in good stead. I kept up to date on changes of post from the annual Embassy list; the British Consul normally enjoys a wide acquaintance among the notables in his area; and my ex-colleagues were invariably helpful – after all Anglo-American trade is an important component of their work – in arranging for me to meet over lunch or a drink people whom either I had marked down or they had suggested as useful connexions for the firm's two-way business.

I had also, from the Ambassador's private office, where his country-wide excursions were planned, got to know the numerous American branches of the English-Speaking Union, and this experience came in useful a few years later when, quite unexpectedly, I received an invitation from the ESU's London headquarters to undertake a short tour of their midwestern branches with a talk on Sotheby's and the international fine art market – it seemed that their audiences were getting worn out with addresses on 'Whither Africa?', 'Britain and the Commonwealth', or, worst of all, 'Anglo-American Relations', and would like something friskier. This, we thought at 34 New Bond Street, was an opportunity too good to miss; expenses paid, all arrangements made, and captive audiences under impeccably non-commercial sponsorship for an itinerary which I stipulated on controlling myself. The first tour was sufficiently successful to lead to two more, and by 1962 I had preached the Sotheby gospel in pulpits flanked by the Union Jack and the Stars and Stripes in Louisville, Indianapolis, St Louis, Memphis, Cleveland, Toledo, Detroit, Chicago, Cincinnati, Richmond, Raleigh (North Carolina), Charleston and Palm Beach. Branches liked to be offered a choice of subjects, and I always offered several: for example, 'Behind the Scenes at Sotheby's', 'Bull market in Bond Street', 'Sold to the Highest Bidder', 'Going, going, gone'; a later set was 'Art in the market place', 'Blue chips and painted canvas', 'A Renoir is a girl's best friend – or is it?'. Whichever title they selected, they actually got the same speech, naturally with suitable local or regional trimmings, and it was always ten minutes shorter than the prescribed length so as to allow plenty of opportunity for questions, for I was there to learn as well as to expound. I learned a great deal, and, with American hospitality what it is, we steadily extended our local connexions. Such tours are always rather exacting, but I enjoyed them. I can only remember two momentary embarrassments: one was finding in the front row at Palm Beach that great collector Chester Dale, who really did know about the art market, with a broad grin on his face; the other was when the chairman of the meeting at Louisville quite unexpectedly announced, *before* I started, that I was being appointed a member of the Honourable Order of Kentucky Colonels (a distinction I still relish). In general, it will have been noticed, I had signed on for other than the more obviously sophisticated cities, partly because Sotheby's objective was mainly exploratory but also because, as very much of a tyro in the auction business, I did not want to expose myself

to too closely expert – or possibly hostile – cross-questioning. I risked Chicago because I knew I should have plenty of friends in the audience: even so somebody did ask – not me but the chairman – whether the ESU was planning to give Christie's equivalent free advertising time. Fortunately this amply justified plaint was received with laughter and applause.

Hard results

But enough of reconnaissance and propaganda, necessary though it was in these early days. The only effective propaganda, as we at the Ministry of Information learned painfully during the war, is victories. The New York agency was lucky to start with one substantial one already in the bag: the capture from Parke-Bernet of the renowned collection of autograph letters and documents formed by the banker André de Coppet, which in ten sales between 1955 and 1959 racked up £196,454 ($552,800), rather more than twice the New York appraisal. This coup we owed to the late owner's confidence in that good and learned man John Taylor, then senior cataloguer in the Book Department; a confidence stoutly maintained against all executorial opposition by his English widow, Eileen de Coppet (now Princess Viktor zu Wied), who remained a loyal ally of the firm's. Another valuable shot in my argumentative locker was Sotheby's sale on 11th December 1955 (£27,400, $66,000) of the very distinguished collection of early Chinese porcelain from the estate of Arnold Schoenlicht of New York (and The Hague), secured, and catalogued with an authority none of our rivals could match, by Jim Kiddell (he still regrets that the widow declined to sell her Renoir).

This was an auspicious start in two fields, but the momentum needed to be increased and expanded. The general routine was that I should follow up on my next trip and report to headquarters on any American prospect not obviously calling for an *ad hoc* flight by one of the partners. In the reverse direction I would explore and report on whatever prospects I could engage, signalling for expert reinforcement from the department concerned if the property was important enough and hot enough to justify it. Often it proved not to be. I recall, for example, spending a full day in a New York warehouse examining a putatively grand collection of Italian old master paintings and a further day checking the relevant reference books. They looked (in terms of the attributions) distinctly fishy to me, and I noticed that many of the authentications attached to the inventory were signed, not by somebody like Venturi, or even by Valentiner (a notorious optimist in his later years), but by a man impressively described as an expert on the staff of the Vatican Gallery. I cabled Carmen Gronau – these were the days before telephoning became daily routine or the installation of the invaluable telex – 'Please advise reliability Dottore A- P-'. The reply next day read succinctly 'The worst'.

Another prospect of mine turned out better, and resulted in the first sale ever held in London devoted entirely to Impressionist and Post-Impressionist pictures; a modest and largely forgotten affair in retrospect but at the time a significant straw in the wind. This was a collection safely brought out of Germany in earlier days by Mr Alfred Schwabacher of New York; one well-known, I soon discovered, to the local dealers, but full, I thought, of desirable things, if only the owner could be persuaded

(and it was a hard sell) to take the risk of a public sale in London with the firm whose early recognition of the auction possibilities in this field was in the event a crucial factor in Sotheby's great upswing during the next ten years. Peter Wilson, making a trip on this and other business, added the requisite authority (and estimates) to my arguments, and in due course the eleven pictures, 'The Property of a New York Collector', including a lovely Berthe Morisot, a Matisse still life and three Renoirs from Ambroise Vollard's collection, brought £29,400 ($83,430) on 4th July 1956.

In the 1956/7 season, during which American consignments were already responsible for more than 20 per cent of Sotheby's record turnover of £3,168,476 ($8,851,732), two picture sales were especially notable. The first, on 28th November 1956, included a group of old master and other paintings from the collection of the late Jakob Goldschmidt of New York, captured by Peter Wilson, which contributed £137,700 ($379,960) to the total of the biggest picture sale held anywhere in the world since 1928. The second (10th July 1957) was the collection of Impressionist and Post-Impressionist pictures, drawings and sculpture from the estate of Wilhelm Weinberg of Scarsdale, N.Y., whose 56 lots realized the then remarkable total of £326,000 ($914,246). I remember vividly the drive out to Scarsdale with Peter Wilson and Carmen Gronau; with us was John Walker of the National Gallery, who had never seen the collection but wanted to and whose reactions we thought would be helpful, and – a last-minute addition of his to the party in the rented Cadillac – Chester Dale, who smoked a foul cigar all the way out and slept all the way back. The house was under dust-sheets, the lighting negligible as in so many suburban residences in America, so that the whole delicate operation had to be conducted mainly by means of hand torches supplied by the caretaker in charge. Despite these handicaps my brilliant colleagues came up with a remarkably prescient estimate for a dazzlingly name-studded but somewhat off-beat collection; the deal was consummated; and the subsequent sale (for which closed-circuit television had been installed for the first time) was graced by the presence at a private preview of the Queen, the Duke of Edinburgh and Princess Margaret, to whom the Weinberg executors were duly presented – thus providing Mollie Panter-Downes of *The New Yorker* with the slogan 'Sell at Sotheby's and get to meet the Royal Family'.

The big one

If the Weinberg sale established Sotheby's in professional circles as the place to sell modern French pictures successfully, it was the second sale from the Goldschmidt estate, on 15th October 1958, which hit every headline in the world and put Sotheby's firmly on the international map as the dominant auction house. In 19 minutes, at the first evening sale ever held at Sotheby's, Peter Wilson sold seven superlative pictures – two Cézannes, three Manets, a Van Gogh and a Renoir – for a total of £781,000 ($2,202,400). I was in Los Angeles at the time of the sale, with one ear on the telephone to London, reporting on the other line to Edward G. Robinson, who had declined my advice to put his shirt on his one favourite lot instead of spreading, and consequently got nothing. The star piece was one of the four versions of Cézanne's *Garçon au Gilet Rouge*, which at the then world record price of £220,000 ($620,400) went to a New York dealer acting for a resolutely undisclosed client. Rumour was of

course immediately rife, with the name of Mr Paul Mellon among those canvassed (as it turned out, quite correctly). A week later, lunching with Mr Mellon at the Metropolitan Club in Washington, I asked if I should be right in congratulating him on buying a certain wonderful picture. 'Did I', he asked by way of reply, 'pay too much?' Before I could say no, he added 'You stand in front of a picture like that, and what is money?' I warmly applauded this admirable sentiment and have often cited it, when people talk about 'inflated' prices for really great works of art, as the ideal attitude for any serious connoisseur.

Sotheby's first Annual Review (32 pages) published in 1958 next to the last edition of *Art at Auction*.

Steady build up

An innovation of mine in 1957 was a slender wrapped small quarto pamphlet entitled simply *Sotheby's 213th Season, 1956/1957* and containing 32 pages of illustrations drawn from the various departments' high-lights. This was aimed primarily though not exclusively at our American mailing-list; the brief preface emphasized consignments from the United States, and in the American issue all the prices were in dollars. Its successor for the season 1957/8 was no bulkier, though two of the plates were now in colour instead of one; but these modest pieces of promotion proved effective and Sotheby's 215th Season ran to 144 pages, Sotheby's 216th Season to 188, until (by now in other hands than mine) we were producing a quite substantial book.

This in due course (via a brief period under the title *The Ivory Hammer*) became Philip Wilson's sumptuous annual, *Art at Auction*, the latest volume of which is now in your hands.

During the acorn period the introductions to these annual reports serve as a reminder to me of Belle da Costa Greene's early Italian pictures consigned by the Pierpont Morgan Library, the Landau collection of Rowlandsons from New York, the Flesh group of Barbizon paintings from Ohio, Gerald Oliven's noble Franz Hals from Beverly Hills, and, most intimately, the famous Irwin Laughlin collection of French eighteenth century drawings, prints, etc., consigned by Mrs Hubert Chanler of Washington, D.C. In this last negotiation, as in most others of importance initiated from the New York agency, I was of course dependent on guidance from reports and photographs sent to London, or personal reinforcement, in this case Peter Wilson's. The exceptions were prospects in the field of books and manuscripts, which I could handle on my own. I had my failures, like the Edward Parsons Library in New Orleans (not really much regretted) or the De Bellis incunabula in San Francisco (three blisteringly hot days in an unventilated room with every book thrice-wrapped in brown paper). But there were successes too – in the early days the Herschel V. Jones Americana from Minneapolis, the Auerbach collection of Mormon literature, the fine Otis T. Bradley library from New York, and, most exciting of all, the famous White-Emerson collection of William Blake, from Brookline, Mass., to which I was introduced by William A. Jackson. After a preview in New York, the seven illuminated books brought £40,800 ($114,000) at Sotheby's on 19th May 1958; not much by 1971 standards, but an eminently satisfactory total at the time. Among later captures were the Eli Moschcowitz medical collection from New York, which I got because the executors found some learned notes of mine inserted in his author-corrected copy of the first edition of Browne's *Urne Buriall* (bread upon the waters), the John F. Neylan library from San Francisco and the substantial Archer M. Huntington collection of autograph letters and documents consigned by the American Academy of Arts and Letters (to outraged protests in the New York press from Parke-Bernet).

Our Rivals

There is an admirable tradition of personal affability among English auction-houses (however strenuously we may be cutting each other's throats professionally) and this I endeavoured to maintain vis-à-vis our New York competitors, Parke-Bernet. I had a great respect for Leslie Hyam, the English-born President, a man of style as well as of wide knowledge and dynamic energy, and although I never knew him at all well, our relations were always cordial whether we met officially or around town at a cocktail party. Arthur Swann, the veteran head of the book department (also an Englishman by birth) I had known for many years, and if, in view of my own speciality and considerable American experience, his attitude to the rival now on his door-step was much warier than that of his departmental colleagues, who had never heard of Carter, nevertheless we always remained on good terms. The same was true of his successor, Charles Retz, who had actually been a colleague of mine at Scribners in earlier days. By the time Dr Robert Metzdorf, also an old acquaintance, took over, Sotheby's had made sufficient inroads into PB's book business to put rather a different

complexion on the relationship; as one bookseller put it, 'The trouble is that Bob sees you under every book-collector's bed'; and in the 1960s he made a good many acrimonious attacks on Sotheby's both from the lecture platform and in print. In the event, to our genuine regret, for he was a good scholar and had run the PB book department most efficiently, he was the only executive who resigned when Sotheby's took over in 1964.

Perhaps I did provoke them a bit. At any important book sale I would execute what Stephen Potter would have called a 'ploy' but my friends in the trade called 'a PB tease'. After a warm greeting from Bill Latimer, an old friend of many years, at the door, I would swan round the booksellers present, all of whom of course I knew well, carrying a couple of Sotheby catalogues much more ostentatiously than that of the sale in progress.

As for our London competitors, I was lucky enough to find a kindred spirit in Robert M. Leylan from the moment he set up Christie's New York office on 57th Street in 1958. His experience in the field of pictures and works of art generally was much in advance of mine: he had worked with César de Hauke and Germain Seligman, and had a wide knowledge of American connoisseurship generally; though he fortunately paid little or no attention to books. We met often over a drink for an exchange of gossip – I remember we christened one particularly obstreperous prospect whom we were both pursuing 'orrible Alfred' – and a comparison of those complaints against the unreasonable or negligent behaviour of our respective headquarters which are endemic to all outpost executives. Although we were deadly rivals vis-à-vis London – Sotheby's in those days were getting substantially more American consignments than Christie's did – we were at one in our competition with PB; and it was our habit at any really glossy evening sale, such as the Lurcy pictures or the Museum of Modern Art benefit sale, to amble round arm-in-arm in our black ties, each sporting a red carnation. Bob Leylan became (and has remained) a good friend and I was sorry when he left Christie's service.

The end of the beginning
As far as Sotheby's of London, New York, was concerned, the second Goldschmidt sale in October 1958 was the watershed. Hitherto we had been, admittedly with increasing success, fighting for business: from then on (I am not thinking, of course, of such Homeric struggles as those for the Erickson pictures, won by PB, or the Fribourg French furniture and works of art, won by Sotheby's against PB, Christie's and Paris), we were as often turning it away. It was thus shortly obvious that a regular office, properly staffed, under a full-time executive, was the minimum necessary to cope with the increasing load. By Sotheby's good judgement, and to Sotheby-Parke-Bernet's lasting good fortune, the man chosen for this assignment was Peregrine Pollen: from the first my friend, always the most loyal and stimulating of colleagues, and sharer, during the hectic years between the establishment of Sotheby's of London Ltd. in 1960 and the assimilation of Parke-Bernet in 1964, of so many trials and tribulations as well as many exhilarating adventures. From the early 1960s onwards the story of Sotheby's in New York is increasingly Peregrine Pollen's rather than mine. And it is now high time I concluded this *recherche du temps perdu*.

Old Master Paintings

The most important painting sold at Sotheby's this season was *Asensio Juliá in his studio* by Goya, which fetched £170,000 ($408,000), an auction record, in March. Paintings by this great Spanish master are now rarely seen in the salerooms, this portrait was a masterpiece of its kind. The sitter was Goya's pupil and friend and it was this intimacy which may have caused the painter to execute so untypical a work, a subtle study of great tranquillity, almost a conversation piece.

The other outstanding picture was Domenichino's *The adoration of the shepherds*, a magnificent painting probably based upon a lost composition by Annibale Carracci, one of the founders of the great Bolognese school of painting of which Domenichino was so distinguished a member. Also sold in March at Sotheby's, the painting was purchased by Messrs Colnaghi, acting on behalf of the National Gallery of Scotland, for £100,000 ($240,000).

In November, a charming and exceedingly rare still-life of fruit by the French painter Louise Moillon fetched a remarkable £30,000 ($72,000), whilst in June, a large and impressive painting of flowers by the Flemish artist Osias Beert, was sold for £19,500 ($46,800). In New York, a fine landscape by Jan Breughel the Elder, a very attractive work, realized $50,000 (£20,833), and a painting in the same sale by his brother Pieter Breughel the Younger, *The battle between Carnival and Lent*, fetched the same sum.

Of the Dutch paintings sold this season, the most distinguished was a sensitive portrait by Frans Hals, *Portrait of a lady holding gloves*, which fetched £62,000 ($148,800) in London. Pieter de Hooch's *Interior with a lady feeding a parrot*, a fine example of the artist's Amsterdam period, was sold for £32,000 ($76,800) in the same sale.

Apart from the Domenichino, there have been several important Italian paintings from the seventeenth and eighteenth centuries, both in London and New York. At Sotheby's in November, a splendid view of the Piazza del Popolo in Rome by Panini, dated 1741, was sold for £25,000 ($60,000) and the following June, two views of Venice by Canaletto were sold for £54,000 ($129,600) and £39,000 ($93,600) respectively. Both these pictures had at one time been in the Duke of Leeds' collection at Hornby Castle, two other pictures by Canaletto from the same series were sold at Sotheby's in June 1969.

In the May sale at Parke-Bernet, a beautiful Venetian view by Guardi, *Isola di S. Giorgio Maggiore*, one of the finest pictures by this artist to have appeared at auction in the last few years, fetched $130,000 (£54,166), whilst Pietro Longhi's *Il Solletico* was sold for the record sum of $125,000 (£52,082).

One of the most interesting paintings in Sotheby's June sale was Bernardo Strozzi's majestic composition, *Saint Sebastian and the holy women*, which was sold for £26,000 ($62,400). This hitherto unknown picture is on the same theme, although with considerable variations, as the large altarpiece in the church of San Benedetto, Venice, which has long been considered one of the artist's greatest works.

Also in June, the finest painting by Nicolas Lancret sold at auction since the war, *Autumn*, fetched £76,000 ($182,400). This is one of a series representing *The four Seasons*, two of which are in the Hermitage Museum, Leningrad. No less remarkable, however, were the two small paintings by the same artist, *The sleeping shepherdess* and *The dance* which were also sold in June and realized £83,000 ($199,200).

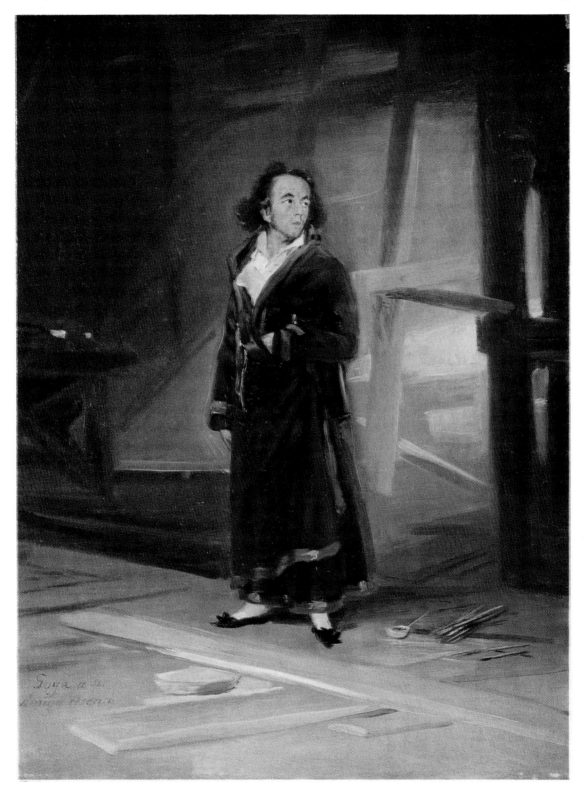

FRANCISCO JOSE DE GOYA Y LUCIENTES
Asensio Juliá in his studio.
Signed: *Goya a su/Amigo Asensi.* 21½ in. by 16¼ in.
London £170,000 ($408,000). 24.III.71.
From the collection of Mr Arthur Sachs of Paris.

D

PIETER DE HOOCH
Interior with a lady feeding a parrot.
$31\frac{1}{2}$ in. by 26 in.
London £32,000 ($76,800). 30.vi.71.

FRANS HALS
Portrait of a lady holding gloves.
Inscribed: ÆTAT SVAE 52/AN° 1643. 31½ in. by 25½ in.
London £62,000 ($148,800). 30.VI.71.
From the collection of the late D. M. Allnatt.

DOMENICO ZAMPIERI, called DOMENICHINO
The adoration of the shepherds.
56¼ in. by 45¼ in.
London £100,000 ($240,000). 24.III.71.
From the collection of the Dulwich College Picture Gallery.

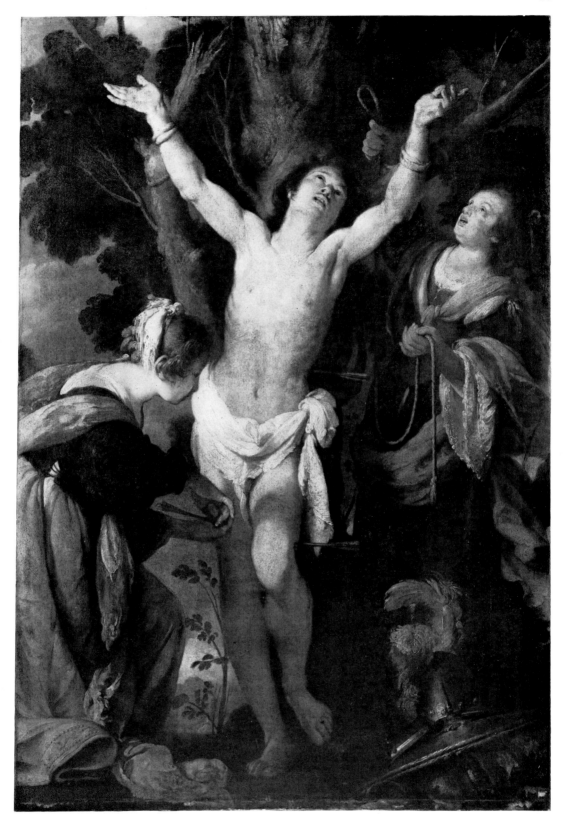

BERNARDO STROZZI
St Sebastian and the holy women.
65 in. by 46 in.
London £26,000 ($62,400). 30.VI.71.

D*

PIETRO LONGHI
Il Solletico.
$23\frac{3}{4}$ in. by 19 in.
New York $125,000 (£52,082). 20.v.71.

FRANCESCO GUARDI
A landscape.
On panel, unframed. $8\frac{7}{8}$ in. by $6\frac{3}{8}$ in.
New York $20,000 (£8,333). 20.V.71.
From the collection of the Topstone Fund (A Charitable
Foundation), New York.

FRANCESCO GUARDI
Isola di S. Giorgio Maggiore.
$13\frac{1}{2}$ in. by $30\frac{3}{4}$ in.
New York $130,000 (£54,166). 22.x.70.
From the collection of the late Irma N. Straus.

GIOVANNI PAOLO PANINI
The Piazza del Popolo, Rome.
Signed and dated: I.PAVL. PANINI/ROMAE 1741. 37 in. by 52 in.
London £25,000 ($60,000). 25.XI.70.
From the collection of Captain Stephen Tempest.

ANTONIO CANALE, called CANALETTO
Venice: the Piazza San Marco seen from the Piazzetta.
29¼ in. by 46 in.
London £54,000 ($129,600). 30.VI.71.
From the collection of Col. Gerard Leigh.
Formerly in the collection of the Duke of Leeds, Hornby Castle.

ANTONIO CANALE, called CANALETTO
Venice: the south side of the Piazza San Marco.
29¼ in. by 46 in.
London £39,000 ($98,600). 30.VI.71.
From the collection of Col. Gerard Leigh.
Formerly in the collection of the Duke of Leeds, Hornby Castle.

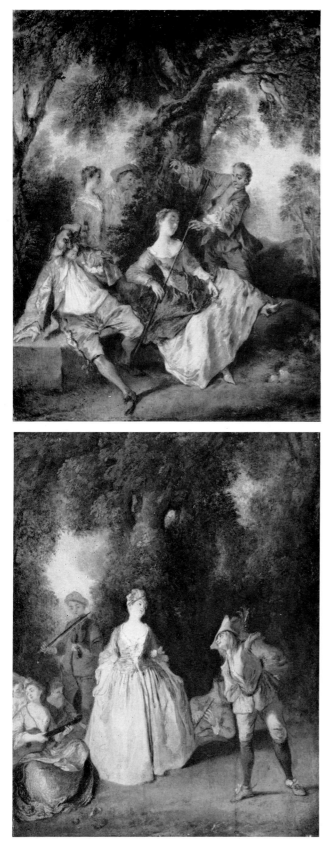

NICOLAS LANCRET
*The sleeping shepherdess
and The dance.*
On panel. 11 in. by $8\frac{7}{8}$ in.
and $11\frac{1}{4}$ in. by 9 in.
London £83,000 ($199,200).
30.VI.71.
From the collection of the
Hon. Mrs A. Plunket.

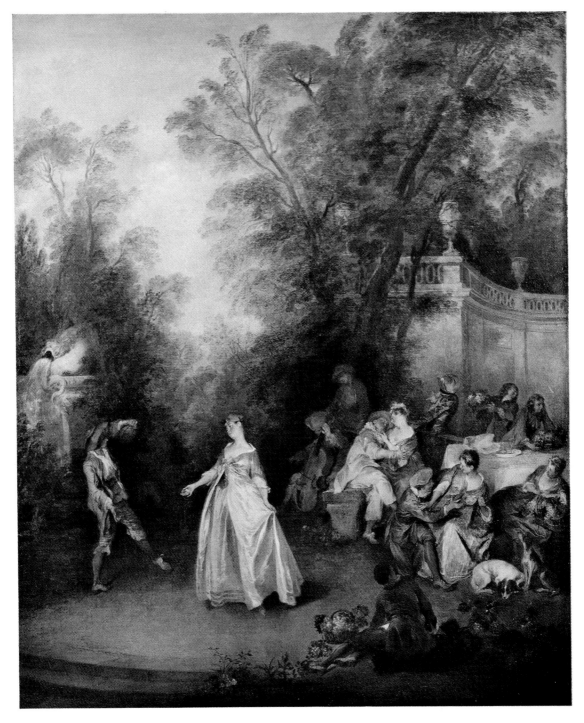

NICOLAS LANCRET
Autumn.
44½ in. by 36½ in.
London £76,000 ($182,400). 30.VI.71.
From the collection of the late Mme Alexandrine de Rothschild.
This is one of the four Seasons painted for Leriget de La Faye and in his inventory of 1731. *Spring* and *Summer* from the same series were later bought by Catherine the Great and are now in the Hermitage Museum, Leningrad.

PIETER BRUEGHEL THE YOUNGER
The battle between Carnival and Lent.
On panel. 46¼ in. by 65¼ in.
New York $50,000 (£20,833). 22.x.70.
From the collection of the Walker Art Center, Minneapolis.

SEBASTIAN VRANCX
The fruit and flower market.
65 in. by 92 in.
New York $18,000 (£7,500). 20.V.71.
From the collection of the late Charles F. and Berenice Slick Urschel, one of a set
of four sold for a total of $51,000 (£21,250).

LOUISE MOILLON
Still life.
Signed and dated 1630. On panel. 12¾ in. by 19¼ in.
London £30,000 ($72,000). 25.XI.70.
From the collection of Owen Grazebrook, Esq.

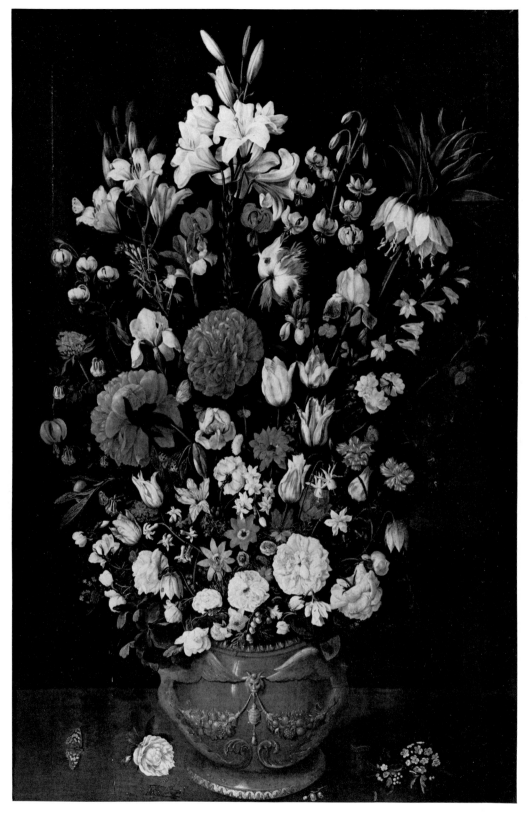

OSIAS BEERT
Flowers in an urn.
On panel. $51\frac{1}{2}$ in. by $34\frac{3}{4}$ in.
London £19,500 ($46,800). 30.VI.71.
From the collection of the late Dirk Bolderheij.

E

JAN BRUEGHEL THE ELDER
A village scene.
On copper. Signed and dated 1609. $8\frac{3}{4}$ in. by $13\frac{3}{4}$ in.
New York $50,000 (£20,833). 20.V.71.
From the collection of the late Robert J. Gellert

FRANS POST
A Brazilian landscape.
On panel. Signed. 11¾ in. by 15½ in.
London £11,000 ($26,400). 25.XI.70.
From the collection of the Viscount Cobham, K.G., G.C.M.G., T.D.

JOHANNES VAN NOORDT
A boy with a falcon.
$28\frac{1}{2}$ in. by 24 in.
London £9,400 ($22,560). 25.XI.70.
From the collection of the Lord Vivian.

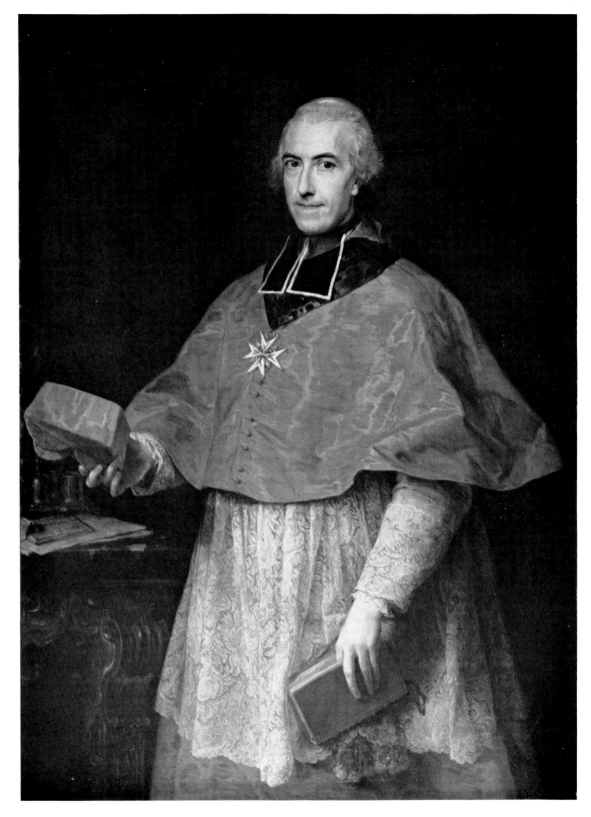

POMPEO BATONI
Portrait of Cardinal Rochechouart.
Signed and dated 1762. 53¼ in. by 38¼ in.
New York $27,000 (£11,249). 20.v.71.
From the collection of The New York Historical
Society, formerly in the Thomas J. Bryan Collection.

Old Master Drawings

The most important sale of old master drawings held anywhere in the world this season was that of the Straus collection which fetched a total of $468,125 (£195,052) for 50 lots at Parke-Bernet on 21st October. See Nicholas Ward-Jackson's article on pages 80–91.

In London, the outstanding event was the sale of Rembrandt's superb red chalk drawing of *A bearded man seated in an armchair*, which was purchased on 26th November by Monsieur Alain Delon, the French actor, for £55,000 ($132,000). One of the most notable of the artist's graphic works sold at auction since the war, this drawing, dated 1631, was used for the figure of Joseph in the painting of *Joseph telling his dream* in the Rijksmuseum, Amsterdam and in reverse for the etching of the same subject which is dated 1638.

Two other fine Rembrandt drawings were also sold in London this season, the brown ink *Study of a seated beggar woman* which fetched £10,000 ($24,000) in November and the ink drawing of a subject thought to represent *The judgement of Solomon*, which was purchased by the Armand Hammer Foundation on 23rd March for £13,000 ($31,200). This last mentioned work was unknown to scholars before it was brought into Sotheby's for sale.

One of the finest Italian drawings offered in London was the beautiful pen and wash *Virgin and Child* by Parmigianino which fetched £2,000 ($4,800) in July. The previous March, an exceptionally rare drawing by Piero di Cosimo, *A standing figure leaning on a staff* was sold for £650 ($1,560), a very reasonable price for so fine a thing.

Amongst eighteenth century Italian drawings, a magnificent view of a Venetian lagoon by Francesco Guardi made £8,600 ($20,640) in November whilst the following July, a rare ink and wash *Capriccio* view by Canaletto realized £5,800 ($13,920). Remarkably high prices were paid for four gouaches by Giacomo Guardi, including £720 ($1,728) for a view of the *Piazza San Marco*, whilst two of Domenico Tiepolo's scenes from the Life of Punchinello, from the famous album of 103 such drawings purchased at Sotheby's in 1920 for £610 by Colnaghi's, were sold in July for £5,200 ($14,480) and £7,500 ($18,000) respectively.

An interesting drawing was the attractive *Study of a young man*, dated 1819, by the Roman artist Bartolommeo Pinelli. Pinelli was mainly known as a draughtsman and illustrator, although it is recorded somewhat ambiguously, that when he arrived in Paris, his extraordinary Roman beauty caused him to have considerable success.

Of the French drawings, the exceptional examples by Watteau, Fragonard, Ingres and Hoin in the Strauss collection were outstanding. At Sotheby's in November, a very fine drawing by Fragonard of the *Holy Family* fetched £5,000 ($12,000) and a superb portrait by Ingres, *Madame de Lavalette*, dated 1817, realized $25,000 (£10,417) in the Norton Simon sale on 7th May. Also from Mr Simon's collection was Boucher's *Venus reclining against a dolphin*, which at $19,000 (£7,916), proved one of the most expensive drawings by this artist ever sold at auction.

HARMENSZ REMBRANDT VAN RIJN
A bearded man seated in an armchair.
Red chalk, on ochre-tinted paper, the chair added in black chalk and heightened with
white on the left hand, signed and dated 1631. 233 mm. by 160 mm.
London £55,000 ($132,000). 26.XI.70.
From the Moriz und Elsa von Kuffner Stiftung.

REMBRANDT VAN RIJN
The judgement of Solomon (?).
Pen and brown ink and brown wash.
172 mm. by 173 mm.
London £13,000 ($31,200). 23.III.71.
From the collection of B. F. Nicholson, Esq

REMBRANDT VAN RIJN
A study of a seated beggar woman.
Pen and brown ink. 80 mm. by 108 mm.
London £10,000 ($24,000). 26.XI.70.
From the Moriz und Elsa von Kuffner
Stiftung.

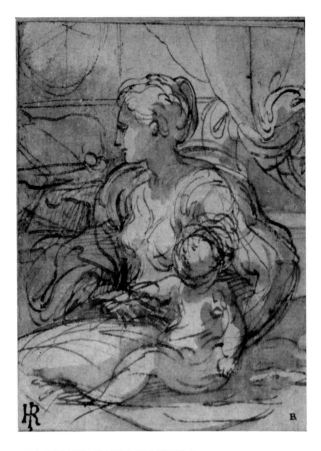

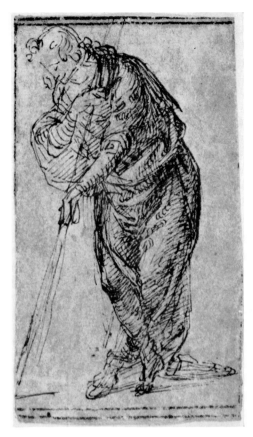

FRANCESCO MARIA MAZZOLA,
called IL PARMIGIANINO
The Virgin with the Child seated in front of her.
Pen and brown ink and wash. 97 mm. by 71 mm.
London £2,000 ($4,800). 1.VII.71.
From the collection of Roy W. Cunio, Esq.

PIERO DI COSIMO
A standing figure leaning on a staff.
Pen and brown ink.
83 mm. by 49 mm.
London £650 ($1,560). 23.III.71.

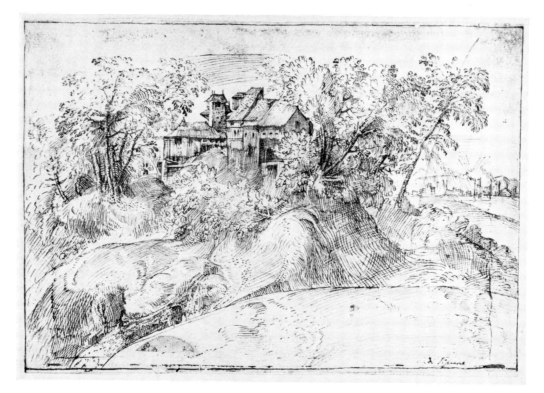

DOMENICO CAMPAGNOLA
Recto: A group of farm buildings on a wooded hill.
Verso: Studies of a tree, a galley and of primitive irrigation.
Pen and brown ink, the verso pen and ink and red chalk. 164 mm. by 242 mm.
London, £1,100 ($2,640). I.VII.71.

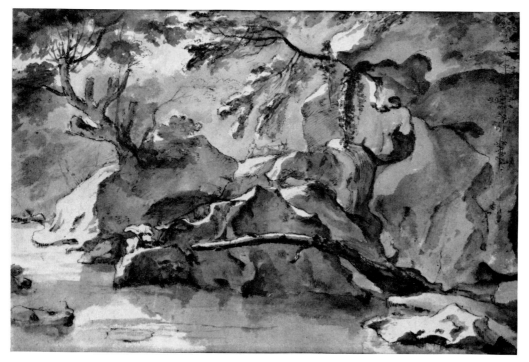

HERMAN VAN SWANEVELT
A view of a stream.
Pen and brown ink and grey wash. 265 mm. by 410 mm.
London £2,000 ($4,800). 26.XI.70.

JEAN-HONORE FRAGONARD
Elegant company resting and walking near a flight of steps.
Brown washes over black chalk. 250 mm. by 375 mm.
London £4,200 ($10,080). 26.XI.70.
From the collection of Baroness von Wrangell,
formerly the property of the late George Blumenthal.

JACOB ESSELENS
Figures on a seashore near some beached boats.
Black chalk and grey wash. 182 mm. by 308 mm.
London £1,000 ($2,400). 26.XI.70.

GIOVANNI ANTONIO CANALE, called CANALETTO
Capriccio: a pavilion and a ruined arcade by the lagoon.
Pen and brown ink and grey wash. Inscribed outside
the framing line: *Antonio Canal del.* 305 mm. by 438 mm.
London £5,800 ($13,920). 1.VII.71.

FRANCESCO GUARDI
Sailing boats and gondolas on the lagoon.
Pen and brown ink and brown wash, some grey wash, over black chalk. 345 mm. by 273 mm.
London £8,600 ($20,640). 26.XI.70.
From the collection of Baroness von Wrangell, formerly the property of the late George Blumenthal.

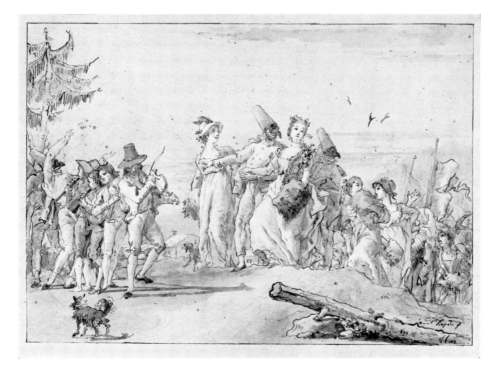

GIOVANNI DOMENICO TIEPOLO
The bridal procession of Punchinello's parents.
Pen and brown ink and wash, over black chalk. Signed. 290 mm. by 410 mm.
London £5,200 ($12,480). 1.VII.71.
From the collection of the late Celia Tobin Clark, San Francisco.

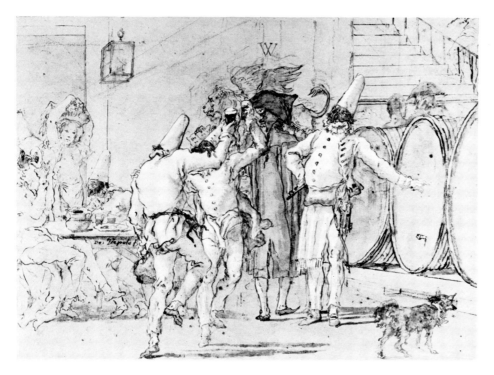

GIOVANNI DOMENICO TIEPOLO
Punchinello and his companions at a winetasting.
Pen and brown ink and pale brown wash, over black chalk. Signed. 290 mm. by 410 mm.
London £7,500 ($18,000). 23.III.71.
From the collection of Madame Guy Schwob, Paris.

1. *Piazza S. Marco looking east along the central line* by Giacomo Guardi. Signed. 155 mm. by 247 mm. £720 ($1,728). 1.VII.71. **2.** *A capriccio* by Isaac de Moucheron. Signed and dated 1736. 238 mm. by 330 mm. £550 ($1,320). 23.III.71. **3.** *Entrance to the Grand Canal* by Giacomo Guardi. 155 mm. by 247 mm. £760 ($1,824). 1.VII.71. **4.** *Danae visited by Jupiter* by J.-H. Fragonard. 270 mm. by 393 mm. $22,000 (£9,166). 7.V.71. **5.** *La Sultane lisant* by Jean-Baptiste le Prince. 212 mm. by 287 mm. £1,000 ($2,400). 1.VII.71. **6.** *Venus reclining against a dolphin* by François Boucher. 228 mm. by 342 mm. $19,000 (£7,916). 7.V.71. **7.** *A study of a woman carrying a bundle* by Simon Vouet. 270 mm. by 200 mm. £1,650 ($3,960). 23.III.71. **8.** *The Holy Family* by J.-H. Fragonard. 422 mm. by 340 mm. £5,000 ($12,000). 26.XI.70. **9.** *A study of a young man* by Jan-Anton Garemyn. Dated 1759. 310 mm. by 225 mm. £1,000 ($2,400). 23.III.71. **10.** *Eer boven golt* by Hendrik Goltzius. Signed and dated 1612. 165 mm. by 120 mm. $7,000 (£2,916). 22.X.70. **11.** *A portrait of a bearded gentleman* by Leandro Bassano. 260 mm. by 193 mm. £1,050 ($2,520). 23.III.71. **12.** *The head of a young man looking upwards* by G. B. Tiepolo. 242 mm. by 168 mm. £4,600 ($11,040). 1.VII.71. **13.** *Portrait of Madame de Lavalette* by Jean-Auguste Dominique Ingres. Signed and dated 1817. $25,000 (£10,416). 159 mm. by 108 mm. 7.V.71. **14.** *A study of a young man seated* by Bartolomeo Pinelli. Signed and dated 1819. 555 mm. by 440 mm. £900 ($2,160). 23.III.71.

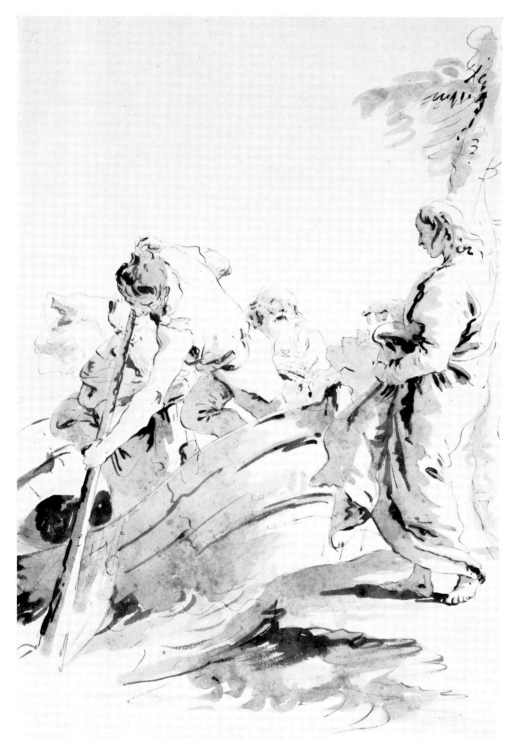

GIOVANNI BATTISTA TIEPOLO
Christ calling the fishermen.
Pen and brown ink and brown wash, over black chalk.
$16\frac{1}{2}$ in. by $11\frac{1}{2}$ in. $45,000 (£18,750).

The Irma N. Straus Collection of Old Master Drawings

BY NICHOLAS WARD-JACKSON

Although the collection of fifty old master drawings formed by the late Mrs Irma Nathan Straus, widow of Ambassador Jesse Isidor Straus, ranked among the best known in America, it had never benefited from a public exhibition – and this in a country where the slightest collection is honoured with a scholarly catalogue. As a result, the exhibition at Parke-Bernet Galleries, prior to the sale, was very well attended, not only by members of the public but also by collectors and museum curators seeking to familiarise themselves with the collection. The sale, which was held on 21st October, 1970, realized a total of $468,225 (£195,000) and accounted for world records for drawings by Fragonard, Ingres, Tiepolo and Watteau.

The major part of the collection had been formed while Jesse Isidor Straus was American Ambassador to France before the Second World War. Many of the drawings were purchased from well known *marchands amateurs* like Albert Meyer and Richard Owen, but always with the advice and encouragement of a family friend, Paul Sachs, the curator of the Fogg Art Museum and the most influential connoisseur of drawings of his day in America. The result was a select collection of consistent quality, displaying a marked preference for the presentation drawing rather than the preparatory sketch.

Such a drawing was *Christ calling the fishermen* by Giovanni Battista Tiepolo. The drawing came from the legendary Orloff album containing ninety-six magnificent Tiepolo drawings, which evidence indicates was preserved by the Tiepolo family themselves. The album appears to have been part of the collection of Gregory Vladimovitch Orloff who published a general history of Italian painting in 1825. The ninety-six drawings were distributed at the Paris sale of Prince Alexis Orloff in 1920. The Orloff drawings are characteristic for their sparkling freshness and finished quality. They are rarely related to oil paintings and from an early date in the eighteenth century were appreciated as independent works of art.

Many of Tiepolo's drawings of the forties possess a nervous quality expressed with a restless use of light and a delight in crumbling textures. If they are twilight creations of Tiepolo's mind, then the Straus sheet was conceived at dawn and constitutes one of his most important baroque compositions. The thrust of the fisherman's oar and of the approaching boat is arrested by the calm movement of Christ's body, just as the fluidity of wash is controlled by an exquisite use of line.

It is only recently that Tiepolo's drawings have been appreciated, due largely to the interest of American scholars and collectors. This interest culminated in the two recent and magnificent exhibitions at the Fogg and Metropolitan museums. At the end of the nineteenth century, it was possible for an art historian to write of Tiepolo; '. . . aur reste, aucun Grand Venetien n'a beaucoup dessiné' and for nine volumes, containing over a thousand Tiepolo drawings, to sell at the Cheney sale at Sotheby's in 1885 for as little as £15 (or $75 at that time). The $45,000 (£18,750), which a New

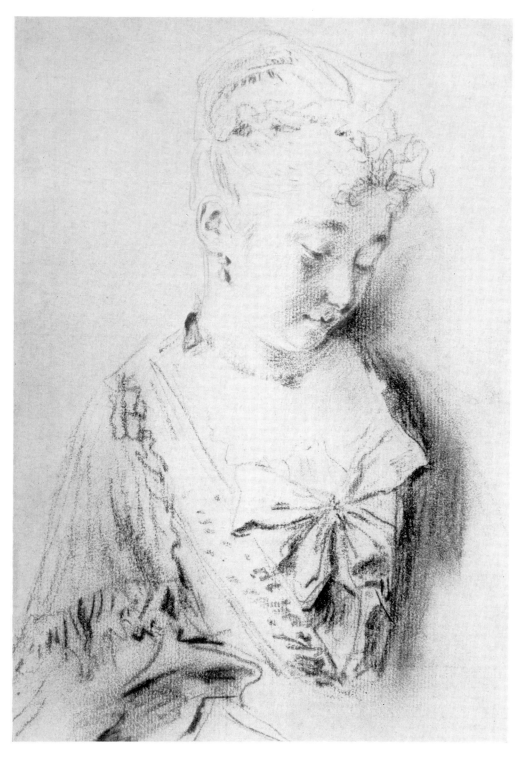

JEAN ANTOINE WATTEAU
A young girl looking down, head and shoulders.
Red and black chalks. $8\frac{1}{4}$ in. by $5\frac{3}{4}$ in.
$50,000 (£20,083).

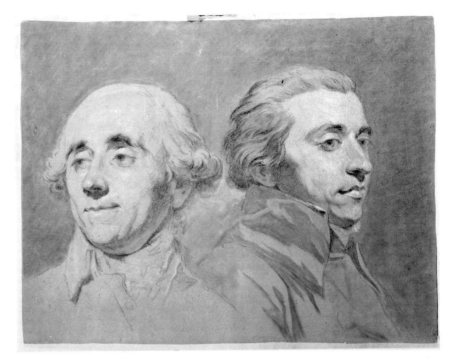

CLAUDE HOIN
The heads of two men.
Black and white chalks, on blue paper. 14⅞ in. by 20 in.
$11,500 (£4,790).
The head on the left is thought to portray Jean-Honoré Fragonard.

York private collector paid for the Straus Tiepolo, makes the Cheney price seem incredible. Indeed, it was more than three times the previous world record for a drawing by this artist.

The Tiepolo was one of very few Italian drawings in the collection, as Mrs Straus' passionate interest lay in the French eighteenth century. Although the figure of the man in *Studies of a girl seated on a bank* by Jean Antoine Watteau was introduced into two well known paintings by the artist, the drawing has none of the qualities of a sketch and, like the Tiepolo, can be enjoyed as a finished work of art. Technical accomplishment apart, the haunting magic of the drawing lies in the contrast between the desperate, almost violent, pose of the man and the detached repose of the young girl. A document of 1777 makes it possible to identify the sitters as coming from the family of St Leboucq-Santussan.

As the most celebrated drawing in the Straus collection and an increasingly rare example of the artist's use of three colours in chalk drawing, the Watteau commanded the very respectable sum of $65,000 (£27,083).

There was some danger that the presence of such an important Watteau drawing in the sale might overshadow a slighter, but arguably more sensitive, drawing by the artist. This proved not to be the case, as the same collector paid $50,000 (£20,833) for *A young girl looking down*. The freshly observed pose and the withdrawn expression of the young girl evinced an intimacy that constantly surprises one in the seemingly brittle and sophisticated world of Watteau.

JEAN-HONORÉ FRAGONARD
Le Petit Prédicateur.
Brown wash, over black chalk. 13¾ in. by 18⅞ in.
$29,000 (£12,083).

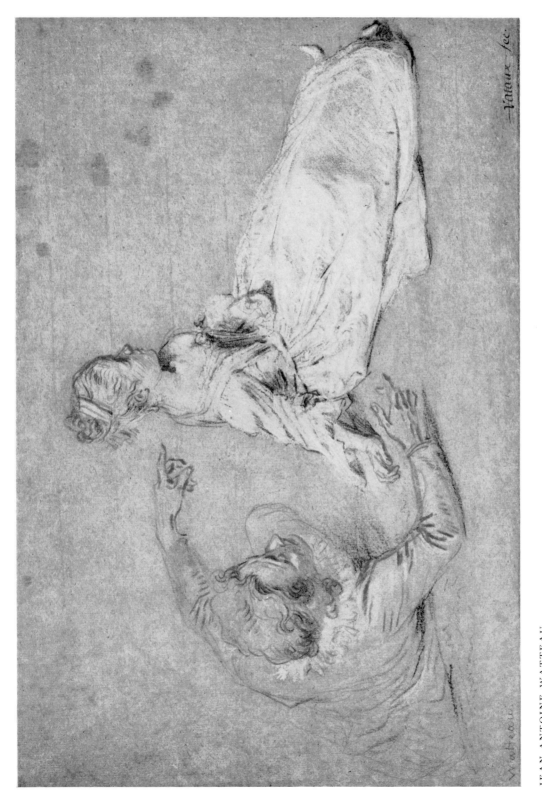

JEAN ANTOINE WATTEAU
Studies of a girl seated on a bank.
Red, black and white chalks, with an old attribution: *Vataux fec*, on buff paper. $9\frac{1}{2}$ in. by $13\frac{3}{4}$ in.
$65,000 (£27,083).

JEAN-HONORÉ FRAGONARD
La Lecture.
Brown wash, the corners rounded out.
11 in. by 8¼ in.
$13,000 (£5,416).
The subjects of this drawing are thought to
be Madame Fragonard reading a letter
to her sister, Marguerite Gérard.

NICOLAS LAVREINCE
L'Amour frivole.
Gouache. 11⅜ in. by 8½ in.
$6,250 (£2,604).

LOUIS CARROGIS DE
CARMONTELLE
The Craymoyel Family.
Watercolour, over red chalk.
13 in. by 9 in.
$10,000 (£4,166).

The conscientious collector of today, having obtained two of the finest Watteaus on the market, might feel compelled to seek out a Lancret and a Pater of similar quality. Although Mrs Straus was not hampered by the modern obsession for historical representation, she was not blinded in her search for quality by the fame and reputation of a particular artist. One of the delightful characteristics of her collection was the choice examples of *petits maîtres* like Lavreince, Portail, Huet, Moreau and Robert. By far the most impressive drawing in this category was the *Heads of two men* by Claude Hoin. Drawn with black and white chalk over a duck egg blue wash, it combined the devastating panache of a Latour with a sensitivity rarely associated with Hoin. Drawings by this artist seldom fetch over £200 in the sale room, but no one was surprised when a discerning dealer chose to pay $11,500 (£4,790) for this exceptional example.

JEAN-HONORÉ FRAGONARD
A young couple seated at a writing table.
Brown wash, over black chalk. 7⅛ in. by 9⅛ in.
$8,000 (£3,333).

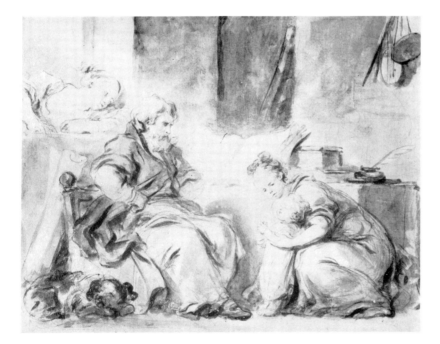

JEAN-HONORÉ FRAGONARD
La Reprimande du Grand Papa.
Grey-brown wash, over black chalk. 13½ in. by 17¾ in.
$17,000 (£7,083).

JEAN-HONORÉ FRAGONARD
Visite à la Nourrice.
Grey wash over black chalk. 12 in. by 15 in.
$26,000 (£10,832).

Undoubtedly, Mrs Straus was aware of the traditional identification of the sitter to the left of the Hoin as Jean-Honoré Fragonard. The six drawings by this artist in her collection were given pride of place in her apartment and included three elaborate narrative scenes executed in wash over black chalk, *Visite à la Nourrice*, *Le Petit Predicateur* and *La Reprimande du Grand Papa*, and a view of the Villa Aldobrandini in red chalk. Fragonard can be one of the most difficult draughtsmen to present convincingly at auction. Not only can doubts as to authenticity arise, due to the existence of other versions, but the sentimental content of his more formal compositions is unfashionable. None of the Straus Fragonards had been exhibited since the war and nearly all bore a distinguished provenance. The enthusiastic bidding which greeted the six drawings exemplified the confidence which Mrs Straus had inspired. The most handsome of the drawings, *Le Petit Predicateur*, of which there is a pendant in the Edmund de Rothschild collection, fetched a world record price of $29,000 (£12,083), while a prettier, more humorous drawing, of a young couple seated at a writing table, being visited by their children, fetched $8,000 (£3,333) – one of the very few drawings in the sale knocked down to a European buyer.

JEAN AUGUSTE DOMINIQUE INGRES
Portrait of Mrs Charles Badham, neé Margaret Campbell.
Graphite, signed and dated Rome 1816. $10\frac{1}{4}$ in. by $8\frac{1}{4}$ in.
$65,000 (£27,083).

While visitors to the pre-sale exhibition may have succumbed to the charm of the Fragonards, Mrs Charles Badham had the same dampening effect as she must have had on the hot blooded Roman visitors to her house in the via Gregoriana, who sought to amuse her during her husband's absence on his scholarly travels. Her close neighbour, Jean Auguste Dominique Ingres, has recorded her plump complacency with the accuracy of a Jane Austen or a Thackeray. No doubt it was she who insisted on the backdrop of the Villa Medici and the obelisk in front of Trinità dei Monti, as a record of the cosmopolitan life, of which she never ceased to remind her friends back among the comforts of England.

How Ingres must have complained of the economic necessity, which compelled him to produce these exquisite masterpieces of portraiture and how he must have longed for a major religious commission. In a letter of 1818, two years after he had drawn Mrs Badham, he described his feelings. ' . . . La chûte de la famille Murat, à Naples, m'a ruiné par des tableaux perdus ou vendus sans être payes; ce qui a causé un derangement si grand dans mon petit menage que je ne l'ai pas encore reparé, à cause de dettes que j'ai du contracter pour vivre dans un malheureux moment ou je ne pouvais pas vendre un seul tableau. Je fus obligé alors d'adopter un genre de dessin, (portraits au crayon), metier que j'ai fait à Rome pres de deaux ans.'

It is a sobering thought that if Ingres' French patrons had not been obliged to return to France in 1815 due to political conditions, we would be without this *genre de dessin* which has contributed so much to his reputation.

Ingres' portrait of Mrs Badham is one of the most magisterial of this period. Despite his disdain for such a bread and butter commission, he cannot hide the delight of a virtuoso in mapping the angular pose of the sitter, in contrasting the rippling flow of the rich cashmere shawl with the simplicity of the dress and conveying her winsome features with a silverpoint delicacy. This drawing had been lent to two major exhibitions during the last decade and the new owner paid $65,000 (£27,083) for it, only to be confronted by a request for yet a third appearance.

Mrs Jesse Straus formed collections in many different fields. Her collection of early Italian paintings she bequeathed to the Metropolitan. The Fogg Museum received an early Gothic tapestry because it extended a series the museum already owned and another went to the Louvre. As Professor John Coolidge reminds us in his introduction to the handsome sale catalogue, no one who visited Mrs Straus in her apartment could fail to realize her particular involvement with her drawings – an involvement which she expressed not only in the masterpieces we have discussed but in an anonymous Flemish School miniature of the *Education of the Virgin* or a restrained pastel portrait by Edgar Degas.

The Straus sale was the most important sale of Old Master drawings held in America since the Second World War. No doubt Mrs Straus would have been pleased at the international attention which the sale received just as she would have been bemused by the very high prices paid. Her greatest source of satisfaction would have been the stimulus which the sale gave to seasoned collectors in other fields to acquire their first Old Master drawings. The cream of her collection was bought by one such collector and promises to become the nucleus of an important national collection.

REMBRANDT VAN RIJN
Christ presented to the People: Oblong plate.
Drypoint, fifth state of eight, with extra shading in the window-space behind the spectator
to the right, but before the figures in front of the tribune were removed. 357 mm. by 454 mm.
London £19,000 ($45,600). 26.XI.70.

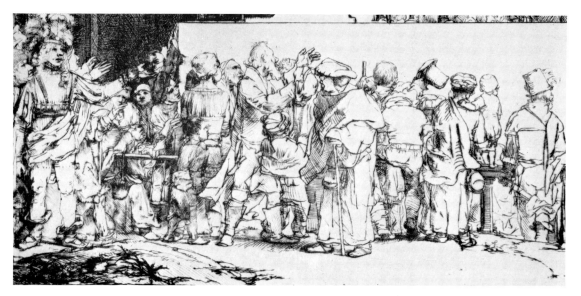

Detail

Detail

Detail

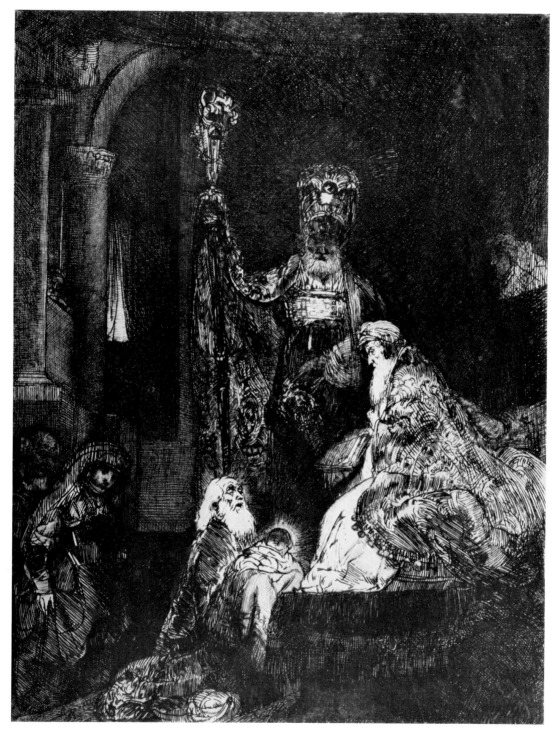

REMBRANDT VAN RIJN
The Presentation in the Temple in the dark manner.
Etching and drypoint, only state. 210 mm. by 160 mm.
London £17,000 ($40,800). 26.XI.70.

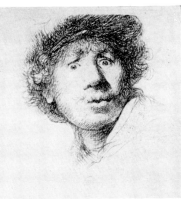

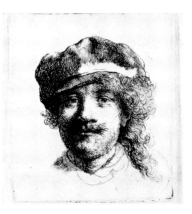

REMBRANDT VAN RIJN
Self-Portrait in a Heavy
Fur Cap: Bust.
Etching, only state. 62 mm.
by 56 mm. London £720
($1,728). 26.XI.70.

REMBRANDT VAN RIJN
Self-Portrait in a Cap,
Open-mouthed.
Etching, only state.
50 mm. by 44 mm.
London £700 ($1,680).
26.XI.70.

REMBRANDT VAN RIJN
Rembrandt with Three
Moustaches.
Etching, only state.
50 mm. by 44 mm.
London £950 ($2,280)
26.XI.70.

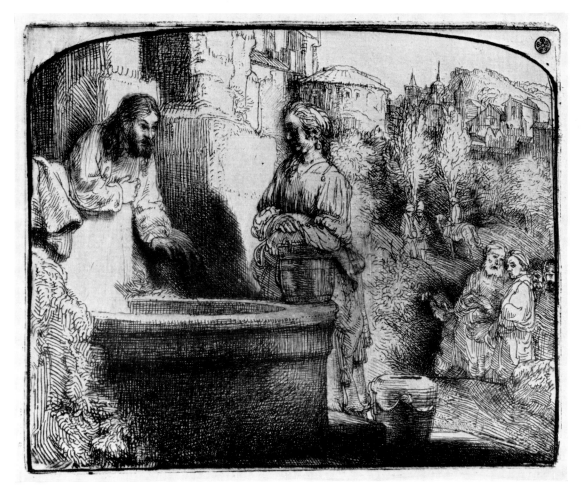

REMBRANDT VAN RIJN
Christ and the Woman of Samaria: Arched.
Etching and drypoint, second state of three. 126 mm. by 159 mm.
London £3,800 ($9,120). 26.XI.70.

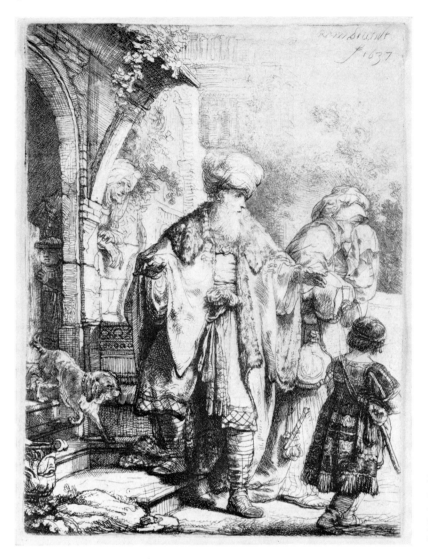

REMBRANDT VAN RIJN
Abraham Casting out Hagar and Ishmael.
Etching with touches of drypoint'
only state. 126 mm. by 94 mm.
London £500 ($1,200). 26.XI.70.

Detail

REMBRANDT VAN RIJN
The Entombment.
Etching and drypoint, fourth (final) state. 209 mm. by 159 mm.
London £3,100 ($7,440). 26.XI.70.

F

Prints

This season has been particularly distinguished by the sale on 26th November of the first part of Viscount Downe's collection of Rembrandt etchings for a total of £197,920 ($475,008). This was one of the few great collections of its kind remaining in private hands and amongst the most important prints were a fine fourth state impression of *Christ Presented to the People: Oblong plate* at £19,000 ($45,600), a strong impression of *The Presentation in the Temple in the dark manner* at £17,000 ($40,800), a third state of *The Three Crosses* at £9,500 ($22,800) and an outstanding impression of *The Descent from the Cross by Torchlight* which was sold for £8,000 ($19,200).

Apart from the high prices paid for these prints which were of exceptional importance, one of the most interesting features of the sale was the obvious demand for fine impressions of less significant etchings. A very good example of *Abraham casting out Hagar and Ishmael*, which had cost £16 ($78) in 1935, made £500 ($1,200), a fifth state of *The Image seen by Nebuchadnezzar*, rose from £4 ($19) in 1935 to £1,300 ($3,120) and *The Holy Family*, bought at Sotheby's in 1943 for £10 ($40), obtained £450 ($1,008).

One of the rarest prints sold this season was the engraving by the Flemish artist Jan Cornelisz. Vermeyen of *Extreme Unction (A Deathbed scene)*, which fetched £3,500 ($8,400); only one other impression of this superb print, in Amsterdam, is known to exist. *Raccolta di varie stampe a chiaroscuro tratte dai disegni originali di Francesco Mazzuola*, a volume containing 101 prints, including the set of 72 chiaroscuro woodcuts by Antonio Maria Zanetti and Giovanni Battista Tiepolo's 10 *Capriccii* etchings in very early impressions, was sold for £6,000 ($14,400), a price which demonstrates the infrequency with which this book is found in an unbroken state.

The long overdue revival of interest in Mannerist prints continued during this season. A good impression of *The Virgin Spinning* by Jacques Bellange, perhaps the greatest of all Mannerist printmakers, was sold for £1,400 ($3,360), Giorgio Ghisi's mysterious engraving after Luca Penni, *Raphael's Dream or the Melencolia of Michelangelo*, fetched the unprecedented sum of £1,200 ($2,880), whilst a very good impression of Federico Barocci's etching *The Virgin appearing to Saint Francis in the Chapel* realized £550 ($1,320).

In the last important old master sale of the season, an extremely fine set of Goya's *Los Caprichos* in the first edition, containing a rare and important proof impression of plate 35, fetched £12,000 ($28,800), an auction record, whilst nine beautiful etchings of men's heads by Giovanni Domenico Tiepolo, all trial proofs, fetched prices ranging between £70 ($168) and £170 ($408).

The most important modern print sold this season was the rare lithograph by Manet, *Les Courses*, which realized £6,500 ($15,600) in London in December. Outstanding also were the two groups of Whistler etchings, sold in London and New York respectively, which established a new level of prices for prints by this artist. A fourth state of *Nocturne* sold for $3,250 (£1,354) and a unique trial proof of the third state of *Maude*, elaborately worked in sepia and grey wash, fetched $6,000 (£2,500). Also of great importance was the fine impression of Winslow Homer's etching *Eight Bells*, generally considered one of the masterpieces of American printmaking, which fetched $9,000 (£3,750) in New York.

FRANCISCO JOSE DE GOYA Y LUCIENTES
Le descañona, etching with aquatint, a proof before letters of pl. 35 of *Los Caprichos*,
inserted in a 1st edition set of the eighty plates.
London £12,000 ($28,800) the set. 29.VI.71.

GIORGIO GHISI
Raphael's Dream or The Melancolia of Michelangelo, after Luca Penni.
Engraving. 381 mm. by 538 mm.
London £1,200 ($2,880). 25.III.71.

JAN CORNELISZ. VERMEYEN
Extreme Unction (A Deathbed Scene).
Engraving. 355 mm. by 498 mm.
London £3,500 ($8,400). 8.x.70.

GIOVANNI BATTISTA TIEPOLO
Four Capriccii from a set of ten etchings published in A. M. Zanetti's
Raccolta di varie stampe . . . , Venice, 1749. The book included 72 of
Zanetti's chiaroscuro woodcuts after Parmigianino and the ten G. B. Tiepolo
etchings.
London £6,000 ($14,400). 25.III.71.

Opposite page:
GIOVANNI DOMENICO TIEPOLO
*Idée Pittoresche sopra La Fugga in Egitto
di Gesu, Maria e Gioseppe . . . Anno 1753.*
Etchings, two plates from the set of 27.
London £2,800 ($6,720) the set. 25.III.71.

JACQUES BELLANGE
The Virgin Spinning.
Etching. 257 mm. by 191 mm.
London £1,400 ($3,360). 8.x.70.

1. *Apollo and Diana* by Albrecht Dürer. Engraving, 116 mm. by 74 mm. £1,900 ($4,560). 25.III.71. **2.** *The Entombment* by Martin Schongauer. Engraving, 163 mm. by 116 mm. $5,200 (£2,166). 5.XI.70. **3.** *St Eustace* by Albrecht Dürer. Engraving. 359 mm. by 262 mm. £5,500 ($13,200). 29.VI.71. **4.** *The Peasant settling his Debt* by Adriaen van Ostade. Etching, twelfth state of fourteen. 107 mm. by 89 mm. £110 ($264). 8.X.70. **5.** *A Man holding a Compass* by G. D. Tiepolo. Etching, trial proof, 160 mm. by 123 mm. £150 ($360). 29.VI.71. **6.** *An Old Man with Medallion pinned to his Bonnet* by G. D. Tiepolo. Etching, trial proof. 173 mm. by 124 mm. £170 ($480). 29.VI.71. **7.** *A bare-headed Man with long Beard* by G. D.

Tiepolo. Etching, trial proof. 138 mm. by 110 mm. £160 ($384). 29.VI.71. **8.** *A Man wearing a Cloak with jewelled Clasp*, by G. D. Tiepolo. Etching, trial proof. 144 mm. by 117 mm. £120. ($288). 29.VI.71. **9.** One of the seventy-two Zanetti's chiaroscuro woodcuts included in *Raccolta di varie stampe* £6,000 ($14,400). 25.III.71. **10.** *Invenzioni Capric di Carceri* by Giovanni Battista Piranesi. Etching. 540 mm. by 410 mm. £480 ($1,152). 29.VI.71. **11.** *The Philosopher* from *Scherzi di Fantasia* by G. B. Tiepolo. Etching, first state of three. 231 mm. by 170 mm. £820 ($1,968). 29.VI.71. **12.** *The Virgin appearing to St Francis in the Chapel* by Federico Barocci. Etching. 544 mm. by 327 mm. £550 ($1,320). 25.III.71.

EDOUARD MANET
Les Courses.
Lithograph, first state before letters. 1864. 420 mm. by 535 mm.
London £6,500 ($15,600). 17.XII.70.
From the collection of the Rt Hon. the Lord Butler of Saffron Walden, P.C.

J. A. MCNEILL WHISTLER
Nocturne.
Etching, fourth state of five. Signed with butterfly. 204 mm. by 295 mm.
New York $3,250 (£1,353). 11.V.71.

J. A. MCNEILL WHISTLER
Maude, Standing.
Etching, unique trial proof of the third state of twelve. 228 by 152 mm.
New York $6,000 (£2,500). 11.v.71. Formerly in the collection of H. H. Benedict.

WINSLOW HOMER
Saved.
Etching. Signed in pencil. 1889. 416 mm. by 700 mm.
New York $2,000 (£833). 13.v.71.

WINSLOW HOMER
Eight Bells.
Etching, impression from the first edition, printed on heavy Japan paper.
Signed in pencil. 1887. 490 mm. by 630 mm.
New York $9,000 (£3,750). 4.II.71.

JACQUES VILLON
Les Cartes.
Aquatint, printed in colours. Signed in pencil. 1903. 348 mm. by 448 mm.
London £2,200 ($5,280). 17.XII.70.

HENRI DE TOULOUSE-LAUTREC
Femme au Tub, from *Elles.*
Lithograph, printed in colours, on paper watermarked 'G. Pellet/T. Lautrec'.
Inscribed by Pellet in ink *Série no.* 21 and signed with his stamp.
400 mm. by 520 mm. London £1,800 ($4,320). 17.XII.70.

1. *Vieux Chevalier* by Odilon Redon. Lithograph. Signed. 298 mm. by 239 mm. £700 ($1,680). 17.XII.70. **2.** *The Garden* by J. A. McNeill Whistler. Etching. Butterfly signature. 306 mm. by 238 mm. £500 ($1,200). 25.III.71. **3.** *The Dyer* by J. A. McNeill Whistler. Etching. Butterfly signature. 306 mm. by 240 mm. £620 ($1,488). 25.III.71. **4.** *Le Petit Pont* by Charles Meryon. Etching. Signed. 1850. 263 mm. by 192 mm. £600 ($1,440). 17.XII.70. **5.** *L'Artisan Moderne* by H. de Toulouse-Lautrec. Lithograph poster, printed in colour. 910 mm. by 640 mm. £600 ($1,440). 27.IV.71. **6.** *Femme en corset*, from *Elles* by Toulouse-Lautrec. Lithograph. Stamped monogram. 516 mm. by 400 mm. £1,500 ($3,600). 27.IV.71. **7.** *Le Repas Frugal* by Pablo Picasso. Etching 463 mm. by 377 mm. £4,200 ($10,080). 17.XII.70. **8.** *La Robe Relevée (Portrait of Madame Helleu)* by Paul-César Helleu. Drypoint. 590 mm. by 340 mm. £70 ($168). 17.XII.70. **9.** *Baudelaire avec Socle* by Jacques Villon. Etching. Signed. 1920. 418 mm. by 281 mm. £500 ($1,200). 27.IV.71. **10.** *Feuilles, Couleur, Lumière* by Georges Braque. Lithograph printed in colour. Signed. 1954. 965 mm. by 598 mm. $5,000 (£2,083). 14.XI.70. **11.** *Colour Numerals: Figure 7* by Jasper Johns. Lithograph printed in colour. Signed. 1969. 705 mm. by 545 mm. $4,250 (£1,770). 12.V.71. **12.** *Red Bathrobe* by Jim Dine. Lithograph. Signed and dated 1969. 350 mm. by 968 mm. $2,100 (£874). 12.V.71.

CANADIAN SCHOOL 19TH (CENTURY)
A View of Niagara with the Suspension Bridge in the Middle Distance.
Oil on canvas. *Circa* 1840. 63·5 cm. by 76·5 cm.
London £880 ($2,112). 28.I.71.

THOMAS BAINES
The Victoria Falls, Zambesi River, sketched on the spot
during the Journey of J. Chapman and T. Baines.
Chromolithographs, title-page with vignette, text and ten plates, folio. 1865.
London £680 ($1,632). 24.VI.71.
From the collection of Sir Richard Acland, Bt.

DOMINIC SERRES, R.A.
A Perspective View of His Majesty's Land Forces going in Flat Boats to take possession
of the North Gate of the City and Punto Castle on the 14th August 1762. Also Two
Sloops of War assisting to open the Booms.
Oil on canvas. Signed in brushpoint. 1764. 39·4 cm. by 62 cm.
London £1,350 ($3,240). 28.I.71.

SOUTH AMERICAN SCHOOL (19TH CENTURY)
Rio de Janeiro. William Bragge being presented by Don Pedro II with the Order
of the Rose, awarded to him for building the first railway in Brazil.
Oil on canvas. 40 cm. by 59·5 cm. London £550 ($1,320). 24.VI.71.
William Bragge (1823–84) helped to build the Chester to Holyhead Railway, which was
opened in 1848, and in Brazil constructed the railway from Rio to Petropolis.

G

GEORGE ROMNEY
Portrait of Captain John Stables.
50 in. by 40 in.
New York $35,000 (£14,583). 22.X.70.
John Stables (1744–96) was a director of the East India
Company and a member of the Supreme Council at
Calcutta.
From the collection of the late Mrs A. Hamilton Rice.

18th, 19th and 20th Century English and Foreign Paintings and Drawings

Some exceptionally fine paintings from all periods of British art have been sold this season. In November, the splendid *Portrait of John Eardley Wilmot Esq.*, by Benjamin West, P.R.A., the most English of American expatriates, was sold for an auction record £36,000 ($86,400), a price which demonstrates further the tremendous rise in value of paintings by Americans, or with American associations, most clearly shown by the works sold in New York this season. Among other eighteenth century portraits, Romney's painting of *Captain John Stables* realized $35,000 (£14,583) in New York in October.

Although there have been fewer sporting pictures in the salerooms this season, their outstanding quality created great interest. An attractive painting of a racehorse by Stubbs, *Lustre*, of about 1760, realized £68,000 ($163,200) in London in November; the previous month in New York, an important work by Ben Marshall, *Mameluke*, dated 1827, was sold for $65,000 (£27,083).

The year has been remarkable for a number of superb English drawings and watercolours, including a group of excellent works by Turner: of these *Sallenches, Savoy* of about 1810, made £16,500 ($39,600) at Sotheby's in March, *Off Yarmouth* of about 1830 fetched £9,800 ($23,520) and a small but most attractive French view made £3,700 ($8,880) in the part of the Duke collection sold on 29th April.

Other important drawings were a tiny visionary landscape in ink and sepia wash by Samuel Palmer, *A cornfield by moonlight*, of about 1826 that fetched the expected high price of £6,200 ($14,880); a fine landscape by de Wint, *Haymaking*, was sold for £2,400 ($5,760) and a drawing of great historical importance, Landseer's pen and wash study of Paganini playing the violin, made £1,060 ($2,544).

Few important works by Sickert have appeared on the open market in recent years but Sotheby's and Parke-Bernet have sold three outstanding examples this season. In the Norton Simon sale in New York on 5th May, a *View of the Basilica of Saint Mark's and the Torre dell'Orologio, Venice*, executed about 1903, fetched a record $10,000 (£4,167), the *Reclining Nude* of about 1907 was sold for $8,500 (£3,542), and in London the following July, *Nude at a Mirror*, of similar style and period to the *Reclining Nude*, fetched £4,000 ($9,600).

Francis Bacon's forceful *Study for a Portrait of Pope Innocent X* fetched £26,000 ($62,400), the auction record for a painting by a living British artist, and Ben Nicholson's *Wicca* of 1953 also fetched the very high sum of £16,500 ($39,600).

Among other high prices paid this year for works by nineteenth-century Continental artists, *A group of rustic children* by Waldmüller, the most important Austrian painter of the period, fetched £15,000 ($36,000), and a typical pastoral scene by Filippo Palizzi, dated 1867, fetched £12,000 ($28,000). The most outstanding painting however, was Signorini's view of *The Ponte Vecchio, Florence*, which fetched £32,000 ($76,800); this painting was a masterpiece by one of the most important members of the group of Italian painters known as the *Macchiaioli*.

SIR THOMAS LAWRENCE, P.R.A.
*Charles Chetwynd-Talbot, Viscount Ingestre, and his brother,
the Hon. John Chetwynd-Talbot.*
Painted before 1795. 89 in. by $83\frac{1}{2}$ in.
London £8,000 ($19,200). 17.III.71.
From the collection of the Earl of Shrewsbury and
Waterford, who inherited it from the Earls of Talbot.

BENJAMIN WEST, P.R.A.
Portrait of John Eardley Wilmot, Esq.
Signed and dated 1812. 40½ in. by 57¼ in.
London £36,000 ($86,400). 18.XI.70.
From the collection of the late Sir John Eardley-Wilmot, Bt.
The sitter was the Commissioner appointed to adjust the claims of the American Loyalists and is seen here with an allegorical composition of Peace between America and Great Britain by the artist.

FRANCIS SWAINE
British Men-of-War.
Signed. 28 in. by 50 in.
London £4,000 ($9,600). 18.XI.70.
From the collection of P. H. Clarke, Esq.

THOMAS BAKER OF LEAMINGTON
A view of Chatsworth.
Signed and dated 1843. 13 in. by 18¾ in.
London £2,300 ($5,520). 21.X.70.
From the collection of P. N. Meats, Esq.

GEORGE MORLAND
Morning, or the Benevolent Sportsman.
Signed with initials. Engraved by J. Grozer,
1795. 42½ in. by 56¼ in.
London £4,500 ($10,800). 17.III.71.
From the collection of Mrs J. H. Dent-
Brocklehurst, removed from Sudeley Castle.

SAMUEL PALMER, R.W.S.
The Rest on the Flight into Egypt.
On panel. 8 in. by 10½ in.
London £5,200 ($12,480). 17.III.71.
From the collection of A. H. Palmer, Esq., of Vancouver.

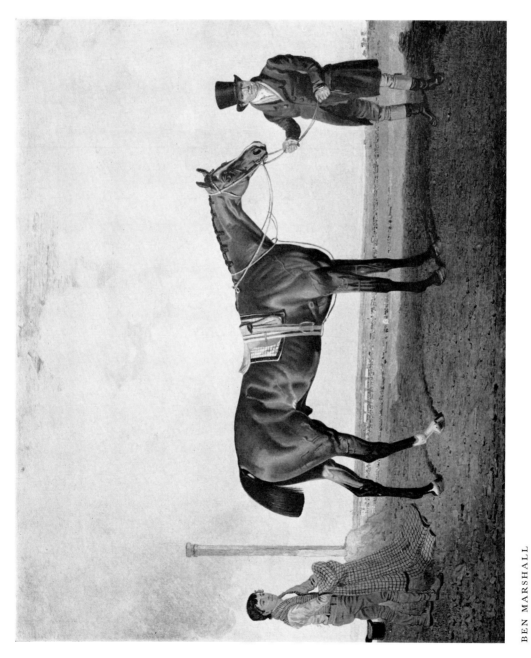

BEN MARSHALL
Mameluke.
Inscribed, signed and dated 1827.
$28\frac{3}{4}$ in. by $35\frac{1}{2}$ in.
New York $65,000 (£27,083). 22.x.70.
From the collection of Mr and Mrs Charles Robson.

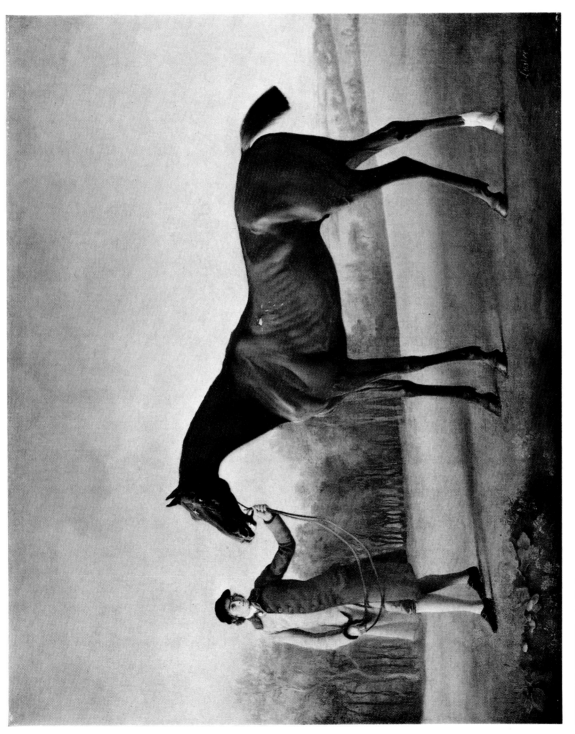

GEORGE STUBBS, A.R.A.
Lustre.
Signed and inscribed. *Circa* 1760. 38½ in. by 48¾ in.
London £68,000 ($163,200). 18.XI.70.
From the collection of the Edward James Foundation of West Dean, Sussex.

CORNELIUS SPRINGER
A Dutch street scene.
On panel. Signed with monogram and dated '52. 13¾ in. by 16½ in.
London £5,400 ($12,960). 19.v.71.
From the collection of Lieutenant Commander
C. B. Cathie, R.N. (Retd.).

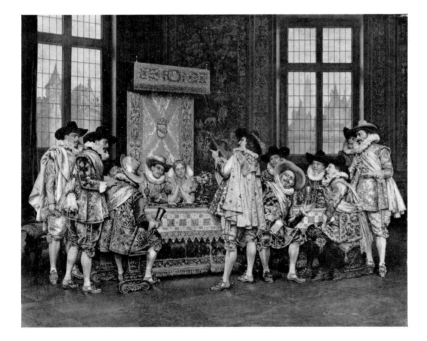

ADOLPHE ALEXANDRE LESREL
The Banquet.
On panel. Signed and dated 1903. 27½ in. by 35½ in.
London £5,200 ($12,480). 19.v.71.

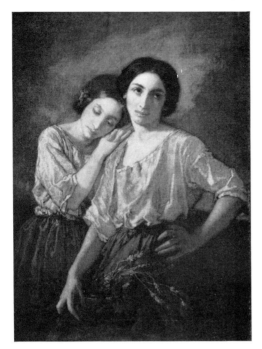

THOMAS COUTURE
The Two Sisters.
48⅛ in. by 32⅛ in.
New York $13,000 (£5,416). 12.XI.70.
From the collection of the Walker Art
Center.

GEORGES ANTOINE ROCHEGROSSE
Femme assise sur un Trone.
Signed and dated 1886.
67 in. by 45 in.
New York $4,000 (£1,666).
12.XI.70.

WILLIAM ADOLPHE BOUGUEREAU
La Baigneuse.
Signed and dated 1870. 47½ in. by 36 in.
New York $7,000 (£2,916). 12.XI.70.

ANTOINE AUGUSTE THIVET
La Cigarette.
Signed. 79 in. by 55½ in.
New York $4,500 (£1,874).
12.XI.70.

TELEMACO SIGNORINI
The Ponte Vecchio, Florence.
Signed. Painted *circa* 1880. 60 in. by 51 in.
London £32,000 ($76,800). 17.11.71.
From the collection of the L. Atsoparthis family.

FERDINAND GEORG WALDMÜLLER
A group of rustic children playing outside a cottage.
On panel. Signed and dated 1888.
18½ in. by 23¾ in.
London £15,000 ($36,000). 21.x.70.
From the collection of Mrs M. D. Edgington.

FILIPPO PALIZZI
Returning from the pastures.
Signed and dated '67. 19¾ in. by 39¼ in.
London £12,000 ($28,800). 17.II.71.
From the collection of L. T. Stevenson, Esq.

JOSEPH MALLORD WILLIAM TURNER, R.A.
Sallenches, Savoy.
Watercolour, executed *circa* 1810. Signed. 11 in. by 15½ in.
London £16,500 ($39,600). 18.III.71.
Formerly in the collections of Walter Fawkes of Farnley Hall
and of Humphrey Roberts.

JOSEPH MALLORD WILLIAM TURNER, R.A.
Off Yarmouth.
Watercolour on blue paper. Executed *circa* 1830. 5¼ in. by 7¼ in.
London £9,800 ($23,520). 18.III.71.

SAMUEL PALMER, R.W.S.
A cornfield by moonlight.
Pen and ink and sepia wash. Drawn *circa* 1826. 2⅝ in. by 4⅛ in.
London £6,200 ($14,880). 18.III.71.
From the collection of A. H. Palmer, Esq., of Vancouver.

SAMUEL PALMER, R.W.S.
A mountain landscape at sunset.
Watercolour, heightened with bodycolour. 10 in. by 17 in.
London £2,500 ($6,000). 24.VI.71.
From the collection of Charles Kearley, Esq.

JOHANN HEINRICH FUSELI
Portrait study of a lady (recto)
and *A study of a lady (verso)*.
Watercolours. 8½ in. by 7¼ in.
London £3,500 ($8,400). 19.XI.70.

PETER DE WINT, R.W.S.
Haymaking.
Watercolour. 7 in. by 19¼ in.
London £2,400 ($5,760). 19.XI.70.
From the collection of Dr F. R. Parrington, F.R.S.

H

RICHARD PARKES BONINGTON
Venice – the Rio dei Greci and the Greek Church.
Watercolour. $7\frac{1}{4}$ in. by $5\frac{5}{8}$ in.
London £5,500 ($13,200). 18.III.71.
Formerly in the Palser collection.

SIR EDWIN LANDSEER, R.A.
Paganini playing.
Pen and ink and sepia wash. 12¾ in. by 7¾ in.
London £1,060 ($2,544). 24.VI.71.
From the collection of Russell Ellice, Esq.,
of Glengarry.

THOMAS GAINSBOROUGH, R.A.
A Water Party.
Pen and ink and grey wash drawing, heightened with white.
$9\frac{1}{2}$ in. by $15\frac{3}{4}$ in.
London £1,800 ($4,320). 29.IV.71.
From the collection of L. G. Duke, Esq., C.B.E.

SAMUEL DANIELL
Landscape, Ceylon.
Watercolour. $12\frac{3}{4}$ in. by $17\frac{3}{4}$ in.
London £1,000 ($2,400). 29.IV.71.
From the collection of L. G. Duke, Esq., C.B.E.

JOSEPH MALLORD WILLIAM TURNER, R.A.
A View in France.
Watercolour, heightened with white on grey paper.
$5\frac{3}{8}$ in. by $7\frac{1}{4}$ in.
London £3,700 ($8,880). 29.IV.71.
From the collection of L. G. Duke, Esq., C.B.E.

SAMUEL PALMER, R.W.S.
Hailsham, Sussex.
Watercolour. Signed with monogram twice and dated 1821.
$8\frac{1}{4}$ in. by $12\frac{1}{4}$ in.
London £4,000 ($9,600). 29.IV.71.
From the collection of L. G. Duke, Esq., C.B.E.

HENRY LAMB, R.A.
Lytton Strachey and Clive Bell criticising works of art.
Pen and indian ink drawing. $7\frac{3}{4}$ in. by $6\frac{1}{2}$ in.
London £310 ($744). 12.V.71.
From the collection of the late Roger Senhouse,
Esq.

DUNCAN GRANT
Venus Reclining.
$24\frac{1}{2}$ in. by $36\frac{1}{2}$ in.
London £920 ($2,208). 12.V.71.
From the collection of the late Roger Senhouse, Esq.
Formerly in the collections of Lytton Strachey and
Sir Michael Sadler.

WALTER RICHARD SICKERT, A.R.A.
Nude at a Mirror.
Painted *circa* 1907. Signed.
$23\frac{3}{4}$ in. by $19\frac{1}{4}$ in.
London £4,000 ($9,600). 14.VII.71.
From the collection of Herbert H. Marks, Esq.

JACK B. YEATS
Amulets, Amiens Street – Loop Line – South Quays.
Signed. Painted in 1947. 17¾ in. by 23½ in.
London £3,100 ($7,440). 9.XII.70.
From the collection of Mrs C. Lawson-Tancred.

VICTOR PASMORE
The Thames at Chiswick.
Painted *circa* 1943. 9 in. by 11 in.
London £2,100 ($5,040). 9.XII.70.
This is a small study for the large painting in the Tate Gallery,
The Quiet River: The Thames at Chiswick (1943–4).
From the collection of Martin Bluff, Esq.

FRANCIS BACON
Study for a portrait VIII. 1953.
$59\frac{1}{4}$ in. by $49\frac{1}{2}$ in.
London £26,000 ($62,400). 9.XII.70.

PAUL NASH
Landscape of the Vernal Equinox II. 1944.
Pencil, watercolour and oil on paper. Signed.
$21\frac{1}{4}$ in. by $28\frac{3}{4}$ in.
London £4,400 ($10,560). 7.IV.71.
From the collection of Lady Lane.

BEN NICHOLSON
Wicca. March 1953.
Pencil and oil on board. Signed, inscribed and dated.
$44\frac{3}{4}$ in. by $62\frac{3}{4}$ in.
London £16,500 ($39,600). 7.IV.71.

American Paintings and Sculpture

This has been a remarkable season for American paintings and sculptures, both from the nineteenth and twentieth centuries, although there have been an exceptional number of works of great importance on the open market. In December, the Wilson and Garvan collections of nineteenth century paintings were sold at Parke-Bernet which included the fine *Portrait of George Washington* by Gilbert Stuart at $205,000 (£86,135), Eakin's *Cowboys in the Badlands* at $210,000 (£87,500), the world auction record for an American painting and *Coming to the Call*, an extraordinary oil by Frederic Remington, which made $105,000 (£44,469).

The following April, Mr Huntington Hartford's collection was sold and included Thomas Moran's *The Mountain of the Holy Cross, Colorado*, which realized $110,000 (£45,832). In the same sale, *The Courtship*, by Thomas Eakins fetched $120,000 (£50,000), a cast of Remington's most important bronze, *The Wounded Bunkie*, made $60,000 (£25,000) and four fine sketches by Sargent for his famous painting *The Oyster Gatherers of Cancale* in the Corcoran Gallery, Washington, were sold for a total of $52,500 (£21,875).

Three important works by the leader of the Philadelphia school of still-life painters, William Harnett, have been discovered during the last year, two of which were sold by Parke-Bernet. The charming *Attention, Company!* (*Front Face*), hitherto known only from an inscribed photograph, fetched $67,500 (£28,125) in December and the typical *Still Life, with Three Castles Tobacco, No 2* $32,000 (£13,333) in April.

In London in June, a delightful and very rare watercolour by Audubon, *A Robin perched on a mossy stone*, was sold for £6,800 ($16,320). The artist had given this drawing to Mrs Hannah Rathbone, a member of the well-known family of Liverpool merchants who befriended him when he came to England from Cincinnatti in 1826. It had remained in the recipient's family until the Sotheby sale.

The pre-war twentieth century school of American painting was best represented by two outstanding works by Reginald Marsh from the Huntington Hartford collection which were sold in April. *Wonderland Circus, Sideshow, Coney Island* executed in 1930, fetched $45,000 (£18,779) and *Pip and Flip, twins from Peru* of 1932, $42,500 (£17,708). Marsh evolved his art at the same time as Thomas Benton and Grant Wood, during the era of the Depression. His crowded paintings of New York and Coney Island, with their violent movement and prevalent air of false gaiety, are powerful and harsh evocations of the period.

The most important post-war paintings and sculptures, unquestionably the finest group hitherto offered at auction, were sold in a remarkable record-breaking auction at Parke-Bernet on 18th November, a sale which included works from the Cohen, Scull, Factor and Benenson collections. Lichtenstein's *Big Painting No 6* of 1965 fetched $75,000 (£31,250), the highest price ever paid on the open market for a twentieth century American painting, and a superb work by Clyfford Still, one of the leading members of the Abstract Expressionist group, entitled *Indian Red and Black 1946-H*, made $60,000 (£25,000).

JOHN JAMES LAFOREST AUDUBON
A Robin perched on a mossy stone.
Pencil, black chalk, watercolour, touches of gum arabic and pastel on the bird's feathers.
Signed by the artist with an inscription addressed to Hannah Rathbone on the reverse.
London £6,800 ($16,320). 24.VI.71.
From the collection of Miss Joyce Rathbone.

A magnificent work by Morris Louis executed in 1959, *Faces*, fetched the remarkable sum of $47,500 (£19,788), whilst one of the most famous of Pop paintings, Robert Indiana's *Love*, was sold for $19,000 (£7,916). *Silver Skies* by another leading Pop artist, James Rosenquist, fetched $27,500 (£11,458). Ellsworth Kelly's impressive *Gate* in orange painted steel made $18,000 (£7,500) and Claes Oldenburg's extraordinary construction called *Stove* sold for $45,000 (£18,750); Oldenburg has recently been the subject of major retrospective exhibitions in America and Europe and is certainly one of the most respected of the younger generation of artists.

THOMAS MORAN, N.A.
The Mountain of the Holy Cross, Colorado.
Signed and dated 1875. 80 in. by 63 in.
New York $110,000 (£45,832). 7.IV.71.
From the Huntington Hartford collection, New York.

GILBERT STUART
Portrait of George Washington.
44½ in. by 34½ in.
New York $205,000 (£86,135). 10.XII.70.
From the collection of the late Matilda R. Wilson, Rochester, Michigan.

JOHN GEORGE BROWN
A Shooting Party at rest, a Canoe on a river at the left.
Signed and dated 1865 and inscribed NY. $31\frac{1}{2}$ in. by $49\frac{5}{8}$ in.
London £4,600 ($11,040). 28.1.71.

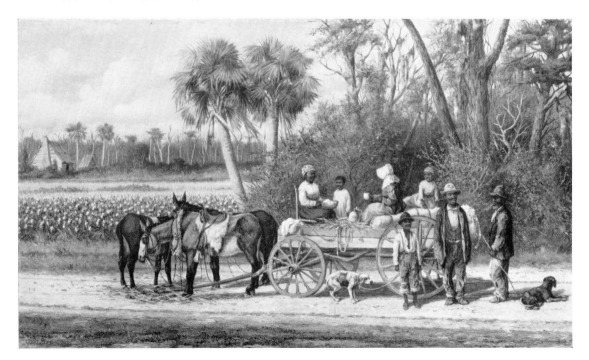

WILLIAM AIKEN WALKER
A Cart drawn by three Mules with Negroes resting.
Signed. $13\frac{1}{2}$ in. by $23\frac{3}{4}$ in.
London £4,300 ($10,320). 28.1.71.

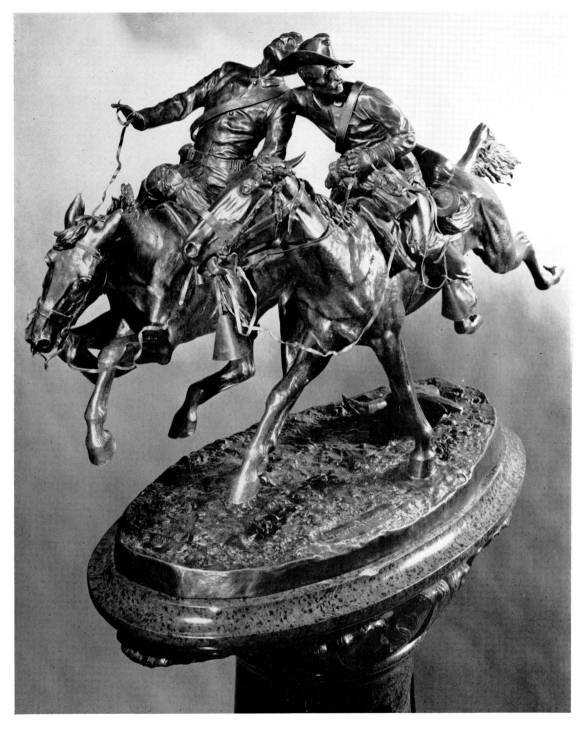

FREDERIC REMINGTON, A.N.A.
The Wounded Bunkie.
Bronze, brown patina.
Signed; inscribed *Copyright by Frederic Remington–1896–F*
and marked *cast by the Henry Bonnard Bronze Co., N.Y., 1896.*
Height 20¾ in., length 31 in.
New York $60,000 (£25,000). 7.IV.71.

K

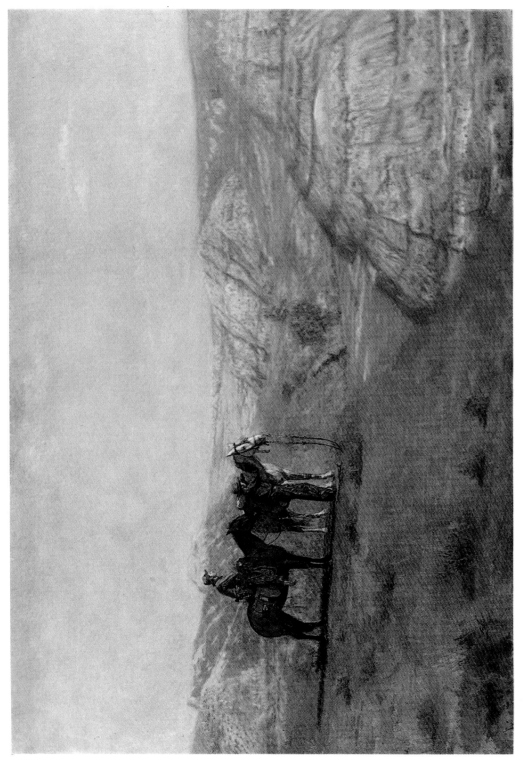

THOMAS EAKINS, N.A.
Cowboys in the Badlands.
Signed and dated '88. 32½ in. by 45½ in.
New York $210,000 (£87,500). 10.XII.70.
From the collection of Mrs Francis P. Garvan.

FREDERIC REMINGTON, A.N.A.
Coming to the Call.
Signed, painted *circa* 1904. 27¼ in. by 40¼ in.
New York $105,000 (£44,469). 10.xii.70.
From the collection of the late Matilda R. Wilson, Rochester, Michigan.

ROBERT HENRI, N.A.
The Young Sport.
Signed. 24 in. by 20 in.
New York $13,500 (£5,624). 10.XII.70.
From the collection of
Mrs Francis P. Garvan.

THOMAS EAKINS, N.A.
Courtship.
Painted *circa* 1878. 20 in. by 24 in.
New York $120,000 (£50,000). 7.IV.71.
From the collection of Mrs John Richard Hacke, Decatur, Georgia.

Breton woman with basket,
18½ in. by 11½ in. $16,000 (£6,667).

Young boy on the beach,
17½ in. by 10 in. $10,500 (£4,374).

Breton woman on the beach,
18¾ in. by 10¾ in. $12,500 (£5,208).

Breton girl with basket,
19 in. by 11½ in. $13,500 (£5,624).

JOHN SINGER SARGENT, N.A., R.A.
Four signed sketches for the *Oyster Gatherers of Cancale,* his first Salon painting, executed in 1878, now in the Corcoran Gallery Washington, D.C., a smaller version is in the Museum of Fine Arts, Boston.
The drawings illustrated above were sold in New York on 7th April, 1971

WILLIAM HARNETT
'*Attention, Company!*' ('*Front Face*')
Signed and dated 1878; inscribed *Attention Company on the reverse.* 36 in. by 28 in.
New York $67,500 (£28,125). 10.XII.70.

REGINALD MARSH, N.A.
Wonderland Circus, Sideshow, Coney Island.
Tempera on masonite. Signed and dated 1930. 47½ in. by 47½ in.
New York $45,000 (£18,779). 7.IV.71.
From the Huntington Hartford collection.

ARTHUR F. TAIT, N.A.
Deer in a Forest Landscape.
Signed and dated *N.H.* 1878. 29 in. by 22 in.
New York $12,000 (£5,000). 10.XII.70.
From the collection of Mrs Francis P. Garvan.

JASPER F. CROPSEY, N.A.
Autumn Landscape.
Signed and dated 1871. 12 in. by 20 in.
New York $14,000 (£5,833). 7.IV.71.
From the collection of the late Margaret Cameron Waters, Grand Rapids, Michigan.

ANDREW WYETH, N.A.
Kuerner's.
Watercolour. Signed. 20 in. by 28 in.
New York $21,000 (£8,749). 7.IV.71.

FRANZ KLINE
Andrus.
Signed and dated 1961 on the reverse. 78 in. by 133 in.
New York $52,500 (£21,875). 18.XI.70.

CLAES OLDENBURG
Stove.
Muslin and burlap soaked in plaster, painted with enamel; utensils
and stove. Executed in 1962. 58 in. by 28 in. by $27\frac{1}{2}$ in.
New York $45,000 (£18,749). 18.XI.71.

MORRIS LOUIS
Faces.
Painted in 1959. 91 in. by 136 in.
New York $47,500 (£19,789). 18.XI.70.
From the collection of Mr and Mrs Thomas H. Benenson, Ibiza.

MILTON AVERY
Reclining Nude.
On board. Signed and dated 1950. 32 in. by 47 in.
New York $9,500 (£3,958). 7.IV.71.
From the Meyer Pearlman collection.

CLYFFORD STILL
Indian Red and Black 1946–H.
Signed and titled twice on the reverse. 78 in. by 68½ in.
New York $60,000 (£25,000). 18.XI.70.

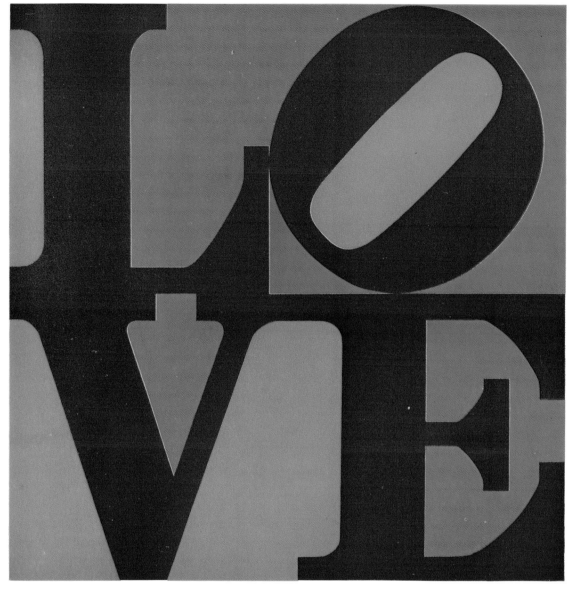

ROBERT INDIANA
Love.
Signed, dated *New York, Spring 1966.* 60 in. by 60 in.
New York $19,000 (£7,916). 18.XI.70.

Opposite page:
Above:
JAMES ROSENQUIST
Silver Skies.
Signed, titled and dated 1962 on the reverse. 78 in. by 198 in.
$27,500 (£11,458).

Below:
ROY LICHTENSTEIN
Big Painting No. 6
Oil and magna on canvas. Signed and dated 1965 on the reverse. 92½ in. by 129 in.
$75,000 (£31,250).
The paintings illustrated on the opposite page are from the collection of Mr and Mrs Robert
C. Scull, New York, sold at Parke-Bernet on 18th November, 1970.

Impressionist and Modern Paintings, Drawings and Sculpture

Sotheby's have been fortunate this season in holding two of the most important sales of modern art to have taken place in the last ten years, that of the late William Goetz's collection on 14th October in London and part of Mr Norton Simon's collection in New York on 5th May. Both these sales offered some magnificent works and several new record prices were achieved.

One of the outstanding features of the Goetz sale was the exceptional group of Fauve pictures. Matisse's painting of 1905/6, *Interieur à la Fillette (La Lecture)* fetched £105,000 ($252,000); it is interesting to note that only works by three other twentieth century painters, Picasso, Braque and Modigliani, have fetched over £100,000 ($240,000) at auction. Apart from this, Derain's *The Pool of London* fetched £80,000 ($192,000) and Vlaminck's smaller *Le Pont de Chatou* made £85,000 ($204,000). A short time later in the season Derain's *Port de Pêche, Collioure*, realized $225,000 (£93,748) in New York and Braque's *La Ciotat* of 1907 was sold at Sotheby's in July for £61,500 ($147,600); this had been sold at Sotheby's in 1960 for £12,000 ($56,000).

Also in the Goetz sale, Odilon Redon's flower picture of *circa* 1905, *Vase de Fleurs avec Branches de Pommier en Fleur*, realized £72,000 ($172,800) and an early work by Cézanne, a vibrant, light-filled composition painted near Pontoise *circa* 1873/4 entitled *La Maison et l'Arbre*, made £180,000 ($432,000). *La Poudreuse*, a small painting by Toulouse-Lautrec, one of the very few finished oils by this artist to have appeared in the salerooms in the last decade, was sold for a record £140,000 ($336,000).

Seven months later, the Norton Simon sale proved even more spectacular. Superb paintings by Boudin, van Gogh, Gauguin, Degas, Monet and Signac all fetched exceptional prices, whilst Degas' magnificent bronze, *Petite Danseuse de Quatorze Ans*, unquestionably one of the greatest sculptures of the nineteenth century, realized $380,000 (£158,334), the highest sum ever paid at auction for a sculpture of any period. It is worth recalling that the last cast of this piece sold at auction fetched $30,000 (£10,714) at Parke-Bernet in 1955.

In the last five or ten years there has been increasing demand for really fine drawings and small paintings. A rare and beautiful pastel by Millet, *Le Briquet*, rose in price from £650 ($1,820) in 1958 to $36,000 (£15,000). Cézanne's *Les Baigneurs*, a picture measuring only 13¾ inches by 8¾ inches, realized $120,000 (£50,000) as opposed to the $44,000 (£15,714) it had cost at auction in 1961, whilst Degas' important pastel of 1879, *Danseuse Basculant*, increased from the £105,000 ($294,060) it had fetched in the famous Cargill sale in London in 1963 to $530,000 (£220,833).

Two unusual collections sold in London in July caused considerable interest. The collection of twentieth century paintings and drawings formed by the great dancer and choreographer Léonide Massine produced two outstanding works, a cubist Braque of 1918, *La Table*, which fetched £66,000 ($158,400) and the extraordinarily beautiful pencil drawing by Picasso, *Portrait de Léonide Massine* which realized £12,300 ($29,520). The other sale was of a collection of cubist and futurist works formed by a Californian private collector which did not, however, include any by the big four, Picasso, Braque, Leger and Gris. The most important work here was Severini's impressive *Danseuse No 5* of *circa* 1916, which fetched £12,500 ($30,000).

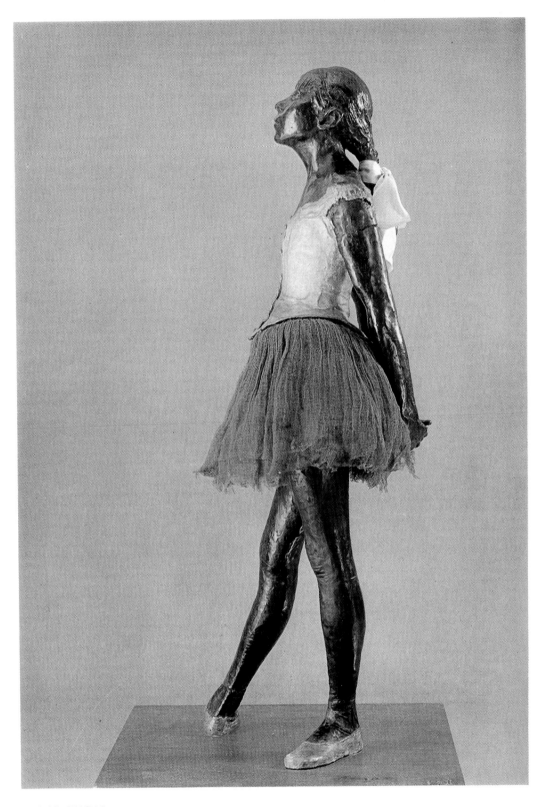

EDGAR DEGAS
Petite Danseuse de Quatorze Ans.
Bronze. Signed, stamped
A. A. Hébrard cire perdue and
inscribed *HER*. Executed in 1880. Height 37½ in.
New York $380,000 (£158,334). 5.v.71.
From the Norton Simon collection.

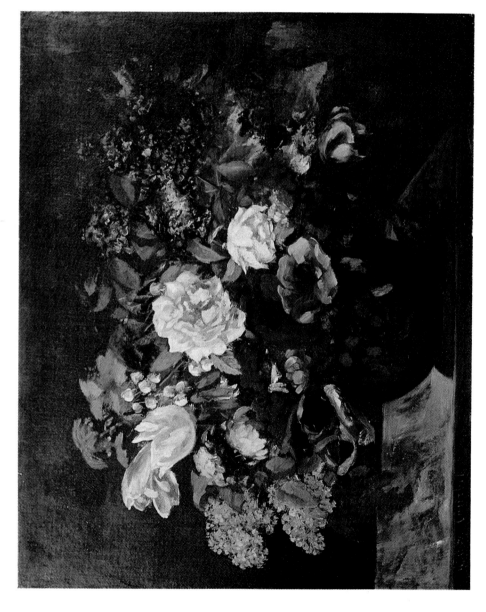

GUSTAVE COURBET
Nature morte aux Fleurs.
Signed. 20 in. by 24 in.
New York $125,000 (£52,082). 28.x.70.
Painted in 1863, in the Saintonge where Courbet was staying with
Etienne Baudry and where he met Corot.
From the collection of the late Alfred E. Goldschmidt.

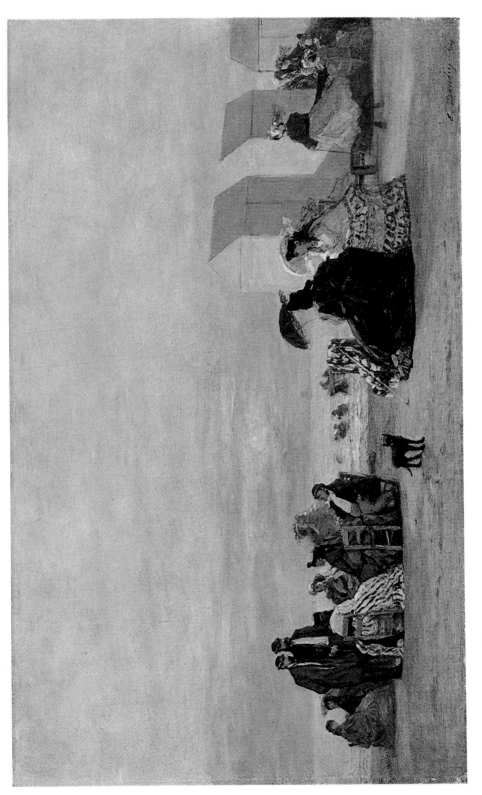

EUGENE LOUIS BOUDIN
Crinolines sur la Plage.
On panel. Signed and dated '64. 14 in. by 22¾ in.
New York $160,000 (£66,666). 5.V.71.
From the Norton Simon collection.

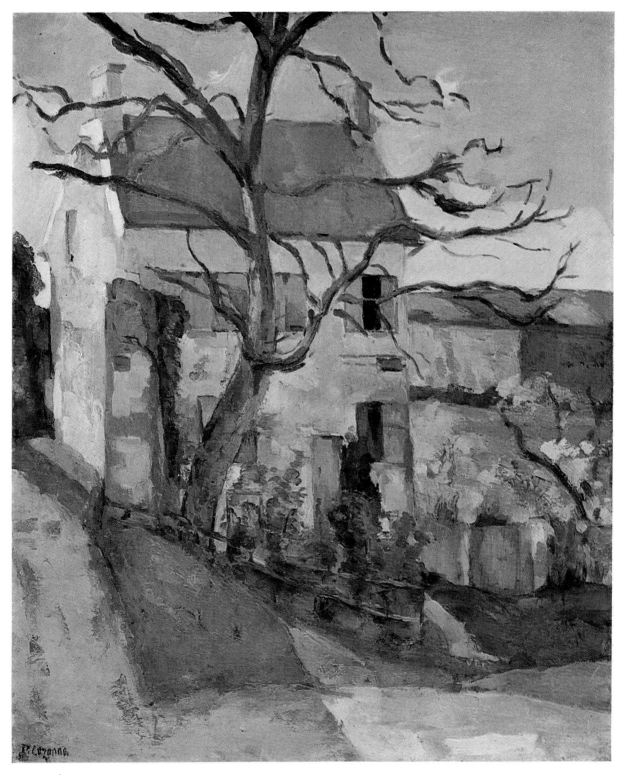

PAUL CÉZANNE
La Maison et l'Arbre.
Signed. Painted *circa* 1873–74 probably at the *Chemin de l'Ermitage, Pontoise.* 26 in. by 21¾ in.
London £180,000 ($432,000). 14.X.70.
From the collection of Mr and Mrs William Goetz.

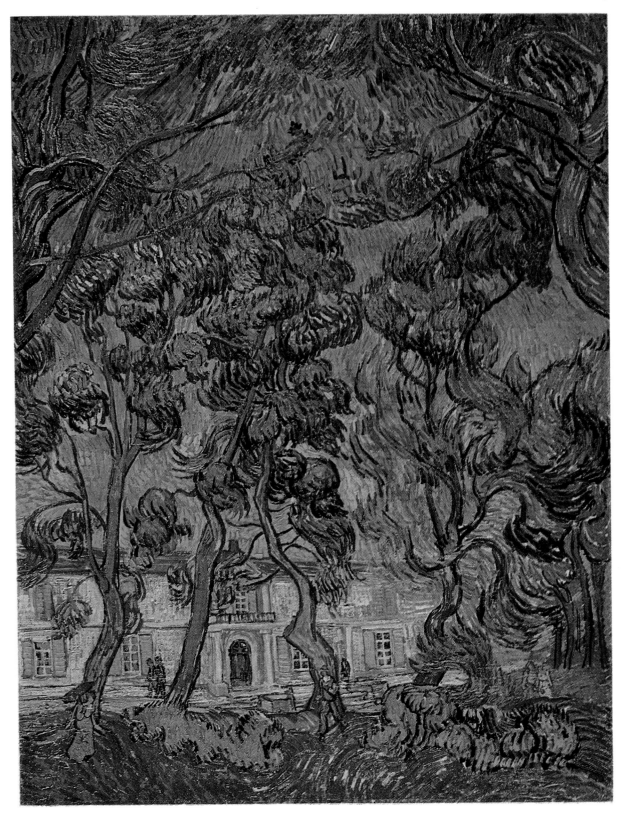

VINCENT VAN GOGH
L'Hôpital de Saint Paul à Saint-Remy.
Painted in 1889. 36 in. by 28½ in.
New York $1,200,000 (£500,000). 5.v.71.
From the Norton Simon collection.

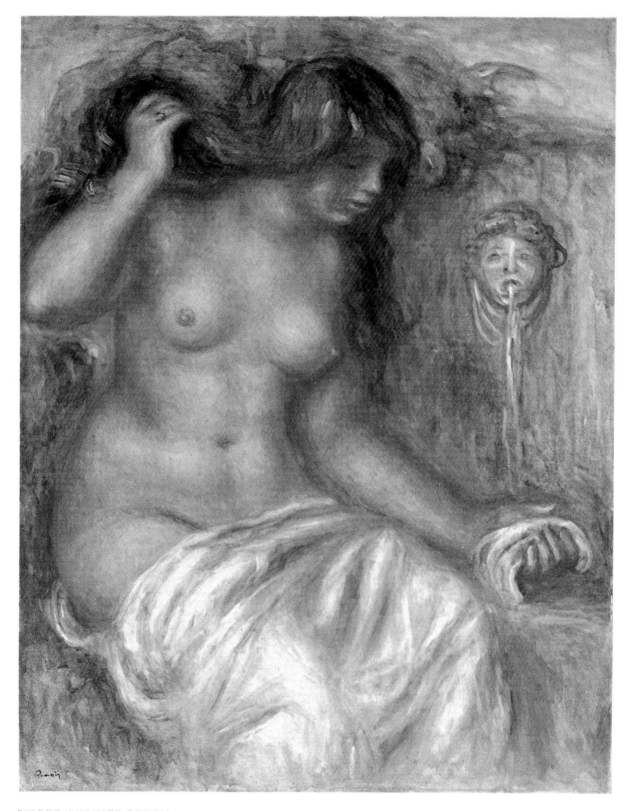

PIERRE AUGUSTE RENOIR
La Source.
Stamped with the signature. Painted *circa* 1910. 36 in. by 29 in.
New York $230,000 (£95,832). 5.v.71.
From the Norton Simon collection.

PAUL GAUGUIN
Portrait de l'Artiste avec sa Palette.
Painted in 1891, signed and inscribed *A Ch. Morice de son ami P. Go.* 22 in. by 18 in.
New York $420,000 (£175,000). 5.v.71.
From the Norton Simon collection.

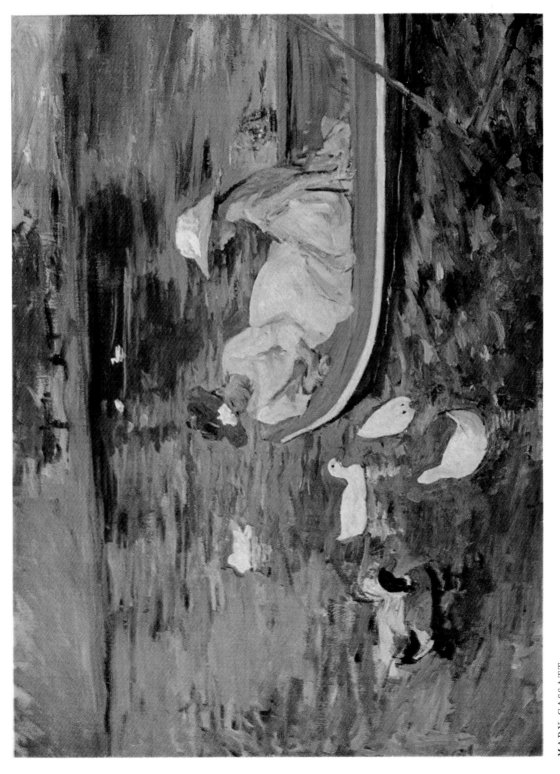

MARY CASSATT
Summertime.
Signed. Painted in 1894. 29 in. by 39½ in.
New York $150,000 (£62,499). 10.III.71.
From the Huntington Hartford collection.

CLAUDE MONET
Le Bassin de Nymphéas, Giverny.
Signed and dated 1919. 38½ in. by 78¼ in.
New York $320,000 (£133,334). 5.v.71.
From the Norton Simon collection.

L*

PAUL CÉZANNE
Etude pour 'Les Joueurs de Cartes'.
Painted *circa* 1890–92. 19¾ in. by 18 in.
New York $370,000 (£154,600). 28.x.70.
From the collection of the late
Alfred E. Goldschmidt.

HENRI DE TOULOUSE-LAUTREC
La Poudreuse (Femme à sa Toilette).
Peinture à l'essence on board, signed. Painted in 1889. 18 in. by 21¾ in.
London £140,000 ($336,000). 14.x.70.
From the collection of Mr and Mrs William Goetz.

PAUL SIGNAC
Le Port de Collioure.
Signed, dated '87 and numbered *Op.* 166. 23½ in. by 36¼ in.
New York $250,000 (£104,166). 5.v.71.
From the Norton Simon collection.

CAMILLE PISSARO
Boulevard Montmartre, Mardi-Gras.
Signed and dated '97. 25 in. by 31½ in. New York $230,000 (£95,832). 5.v.71.
From the Norton Simon collection.

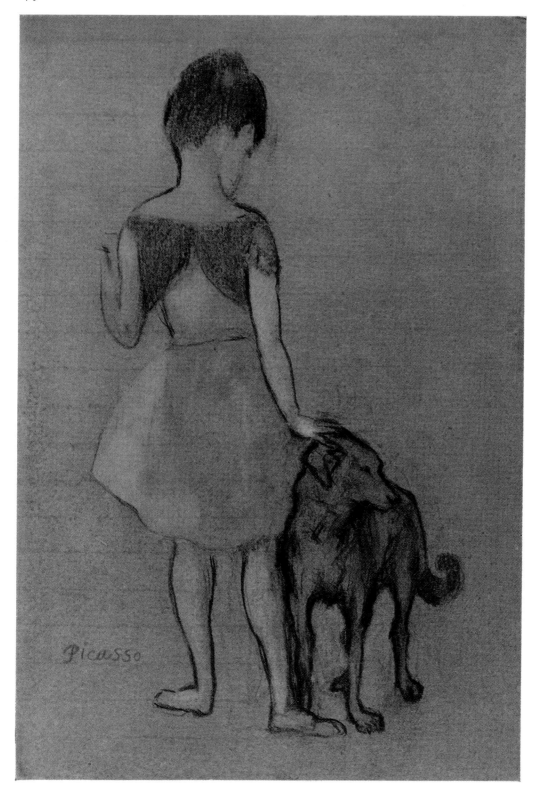

PABLO PICASSO
Fillette au Chien.
Pastel and gouache on paper, signed. Executed in 1905. 27¾ in. by 18½ in.
London £62,000 ($148,800). 14.x.70.
From the collection of Mr and Mrs William Goetz.

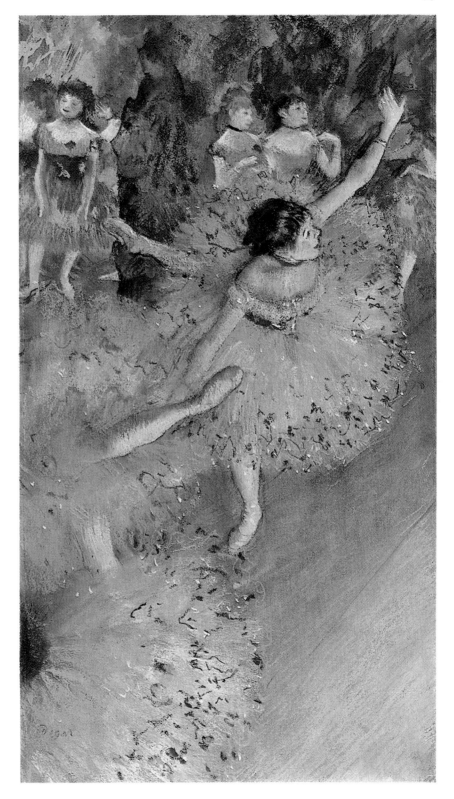

EDGAR DEGAS
Danseuse Basculant (Danseuse Verte).
Pastel. Executed *circa* 1879. Signed. 26 in. by 14¼ in.
New York $530,000 (£220,834). 5.v.71.
From the Norton Simon collection.
Formerly in the William A. Cargill collection, sold at
Sotheby's in June 1963 for £105,000 ($294,000).

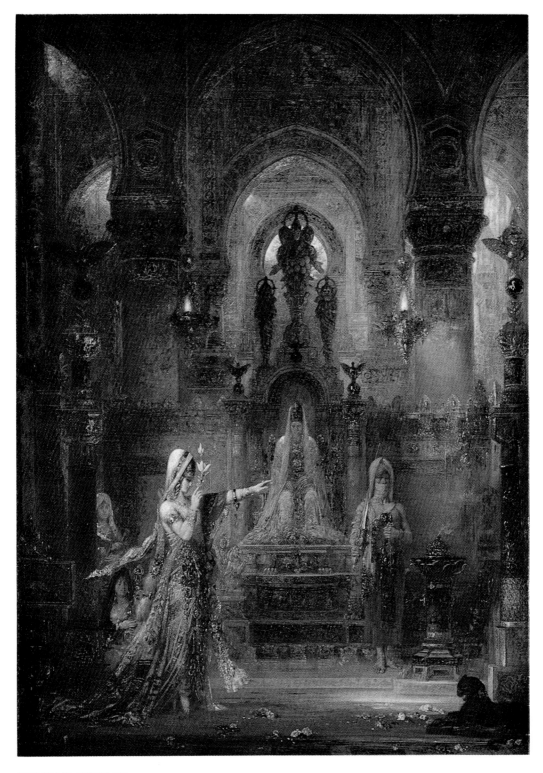

GUSTAVE MOREAU
Salomé dansant devant Herode.
Signed, painted in 1876. 56¾ in. by 40¾ in.
New York $95,000 (£39,583). 10.III.71.
From the Huntington Hartford collection.

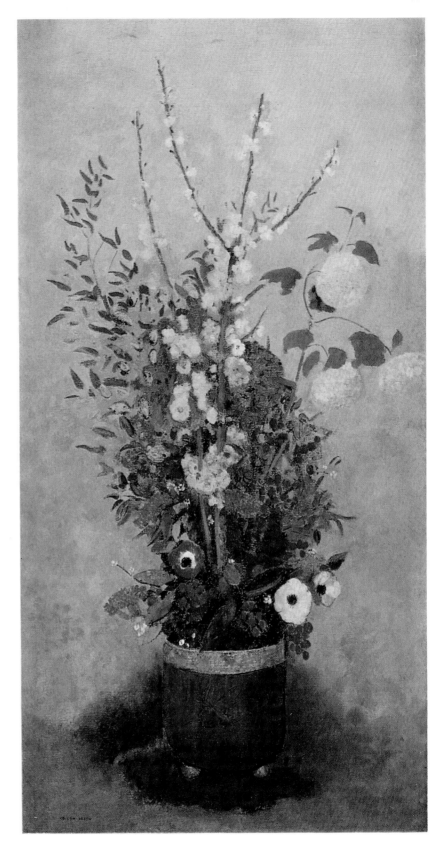

ODILON REDON
Vase de Fleurs avec Branches de Pommier en Fleur.
Signed, painted *circa* 1905–06. 51 in. by 26¾ in.
London £72,000 ($172,800). 14.X.70.
From the collection of Mr and Mrs William Goetz.

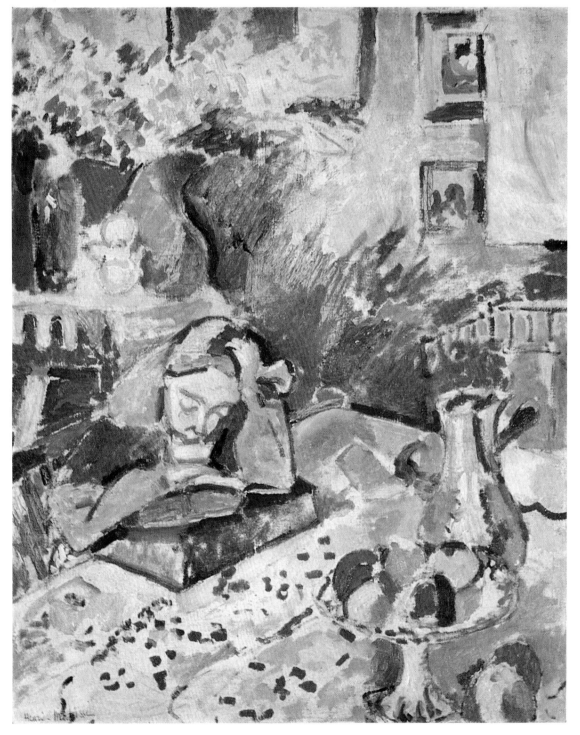

HENRI MATISSE
Intérieur à la Fillette (*La Lecture*).
Painted in 1905–06. Signed. 29½ in. by 24½ in.
London £105,000 ($252,000). 14.X.70.
From the collection of Mr and Mrs William Goetz.

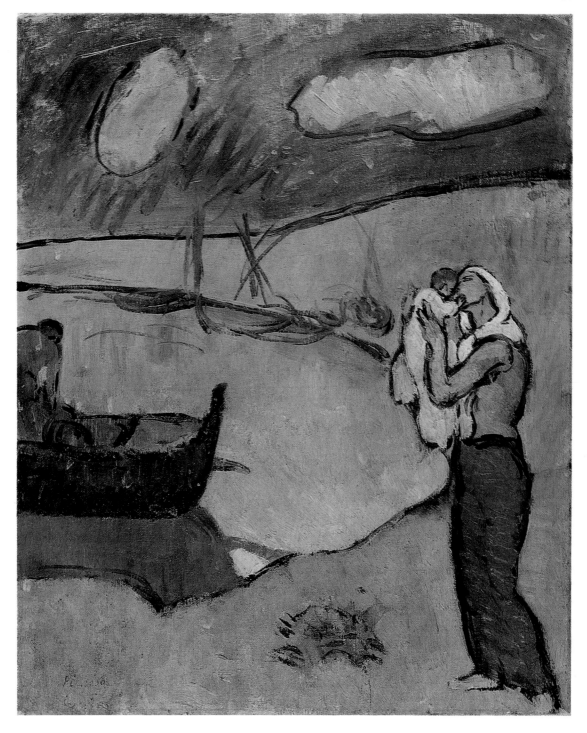

PABLO PICASSO
Les Adieux du Pêcheur.
Signed. Painted in 1902. 18¼in. by 15in.
London £52,000 ($124,800). 21.IV.71.
From the collections of Richard Doetsch-Benzinger
and Eric Adam of Zürich.

MAURICE DE VLAMINCK
Le Pont de Chatou.
Signed, painted in 1905. 25¾ in. by 32 in.
London £85,000 ($204,000). 14.X.70.
From the collection of Mr and Mrs William Goetz.

ANDRE DERAIN
Port de Pêche, Collioure.
Signed, painted in 1905. 32 in. by 39½ in.
New York $225,000 (£93,748). 28.x.70.
Another view of the same scene is in the Hermitage Museum, Leningrad.

EGON SCHIELE
Die Freunde ('*Tafelrunde*').
Painted in 1918. 39¼ in. by 47 in. London £39,500 ($94,800). 2.XII.70.
Schiele's famous poster for his first one-man show at the *Secession* in
Vienna in 1918 is based on this composition.

GEORGES BRAQUE
La Table.
Signed; signed and dated '18 on the reverse. $25\frac{1}{4}$ in. by $31\frac{3}{4}$ in.
London £66,000 ($158,400). 7.VII.71.
From the collection of Monsieur Léonide Massine.

FERNAND LEGER
Nature Morte - Coquillage.
Signed and dated '27. 25½ in. by 18 in.
London £14,600 ($35,040). 7.VII.71.

LEOPOLD SURVAGE
L'Entrée de la Ville.
Signed. Painted *circa* 1918. 39½ in. by 32 in.
London £3,200 ($7,680). 7.VII.71.

WASSILY KANDINSKY
Kirche in Froschhausen.
On board. Signed and dated 1908. 17¾ in. by 13 in.
New York $46,000 (£19,166). 28.x.70.

LYONEL FEININGER
Ost-See.
Signed and dated 1924. 17 in. by 28 in.
London £22,500 ($54,000). 21.IV.71.
From the collections of Richard Doetsch-Benzinger and
Eric Adam, his grandson.

MARIA ELENA VIEIRA DA SILVA
Perspectives urbaines.
Signed and dated 1952. 38 in. by 51 in.
London £14,000 ($33,600). 2.XII.70.
From the collection of Colonel Aubrey Gibson.

PAUL KLEE
Neue Harmonie.
Signed. Painted in 1936. 36¾ in. by 26 in.
New York $110,000 (£45,832). 10.iii.71.
From the collection of Benjamin Baldwin.

Opposite page:
RENE MAGRITTE
La Durée Poignardée.
Signed and dated 1938. 57½ in. by 38¼ in.
New York $70,000 (£29,166). 28.x.70.
From the collection of The Edward James
Foundation.

HENRI MATISSE
La Serpentine.
Bronze, signed, stamped *Bronze, cire perdue, C. Valsuani* and
numbered 9. Executed in 1909. Height 22 in.
New York $94,000 (£39,166). 5.v.71.
From the Norton Simon collection.

HENRY MOORE
Seated Woman.
Bronze. Executed in 1952.
Numbered 5/5. Height 42¾ in.
New York $68,000 (£28,333).
29.x.70.
From the collection of
Mr and Mrs Arthur J. Kobacker.

HENRY MOORE
Reclining Figure.
Bronze. Executed in 1945. Length 14½ in.
New York $29,000 (£12,082). 29.x.70.

GINO SEVERINI
Danseuse No. 5.
Signed. Painted *circa* 1916. 36½ in. by 28¾ in.
London £12,500 ($30,000). 7.VII.71.
Formerly in the John Quinn collection.

1. Albert Gleizes: *Tableau Familier*. Signed, 1923. 25½ in. by 36½ in. £4,400 ($10,560). 7.VII.71.

2. Fortunato Depero: *Futurista 1916 – Movimento d'Uccello*. Signed. 39 in. by 51 in. £2,800 ($6,720). 7.VII.71. **3.** Serge Férat: *Nature Morte, Fruits et Journal*. Signed. *Circa* 1916. 18 in. by 21¼ in. £1,600 ($3,840). 8.VII.71.

4. Georges Valmier: *Collage*. Signed, 1922. 3¼ in. by 9 in. £450 ($1,080). 7.VII.71. **5.** André Masson: *Nature Morte à l'Oiseau*. Signed, 1924. 14½ in. by 17¾ in. £1,650 ($3,960). 8.VII.71.

6. Louis Marcoussis: *Nature Morte à la Guitare*. Signed, 1927. 7½ in. by 10¾ in. £1,900 ($4,560). 7.VII.71. **7.** Henri Laurens: *Tête de Femme*. Polychromed terracotta relief, signed, 1919. 13¾ in. by 9¾ in. £3,100 ($7,440). 8.VII.71.

8. Auguste Herbin: *Homme-Femme*. Signed, 1944. 57½ in. by 34¾ in. £5,400 ($12,960). 7.VII.71.

9. Jean Metzinger: *Paysage – Village*. Signed, 1917. 36¼ in. by 23½ in. £3,200 ($7,680). 7.VII.71. **10.** Angel Zarraga: *Le Dieu vert*. Signed, *circa* 1918–20. 31¾ in. by 25¼ in. £1,600 ($3,840). 7.VII.71. **11.** Victor Servranckx: *Opus I*. Gouache. Signed, 1919. 17¼ in. by 14¼ in. £2,300 ($5,520). 12.XI.70. **12.** Jean-Michel Atlan: *Composition aux Lignes noires*. Signed. 38½ in. by 25 in. £1,700 ($4,080). 11.XI.70.

13. Willi Baumeister: *Bild mit gelben Kreis*. Oil and sand, 1921. 31½ in. by 25¼ in. £3,200 ($7,680). 7.VII.71. **14.** Victor Vasarely: *Menhoor*. Signed, dated 1952. 15¾ in. by 12¼ in. £1,900 ($4,560). 21.IV.71.

1. Maximilien Luce *L'Eglise Saint-Médard, Paris*. Signed, *circa* 1888. 25½ in. by 32 in. $37,000 (£15,416). 28.X.70. **2.** James Ensor *Le Général Léman et Ensor discutant peinture*. Signed, 1890. 4¾ in. by 6¼ in. £3,800 ($9,120). 12.XI.70. **3.** Willy Finch *Route de Campagne près de la Mer du Nord*. Signed, *circa* 1890. 25¾ in. by 30¼ in. £4,000 ($9,600). 12.XI.70. **4.** José Gutierrez Solana *El Carnaval en la Aldea*. Signed. 38½ in. by 48¼ in. £15,000 ($36,000). 7.VII.71. **5.** Léonore Fini *Le Chat Manoul*. Signed, 1943. 14½ in. by 17¾ in. £2,100 ($5,040). 21.IV.71. **6.** Camille Bombois *Les Bords de l'Yonne*. Signed. 10¼ in. by 15¾ in. £3,100 ($7,440). 8.VII.71. **7.** Henri le Sidaner *Les Roses sur la Maison*. Signed. 42½ in. by 35½ in. £5,500 ($13,200).

7.VII.71. **8.** Tsuguharu Foujita *Deux Fillettes dans la Cuisine*. Signed. 18 in. by 15 in. £4,800 ($11,520). 8.VII.71. **9.** Lovis Corinth *Sofie mit Puppe*. Signed, 1906. 36½ in. by 28¾ in. £4,500 ($10,800). 21.IV.71. **10.** Maurice Utrillo *Nôtre Dame de Paris*. Signed, 1927. 63¾ in. by 51⅛ in. £22,000 ($52,800). 7.VII.71. **11.** Alberto Giacometti *Grand Nu*. Signed, 1962. 68¾ in. by 27½ in. $60,000 (£25,000). 28.X.70. **12.** Salvador Dali *Discovery of America by Christopher Columbus*. Signed, 1959. 168 in. by 144 in. $100,000 (£41,666). 10.III.71. **13.** Matta *Composition*. Signed, *circa* 1959. 50¾ in. by 50¾ in. £4,000 ($9,600). 7.VII.71. **14.** Joaquin Sorolla y Bastida *Moro Vendedor de Naranjas*. Signed, 1901. 38¼ in. by 25¼ in. £5,200 ($12,480). 21.IV.71.

1. Henri-Joseph Harpignies *Le Pont des Arts, Paris*. Signed, 1892. 9 in. by 15¼ in. £720 ($1,728). 22.IV.71. **2.** Adolf Menzel *Dame mit einem Fächer*. Signed, 1888. 5 in. by 8¼ in. £1,100 ($2,640). 3.XII.70. **3.** Pierre-Auguste Renoir *La Ferme à Roche Guyon*. Signed, 1887. 8½ in. by 11½ in. £4,300 ($10,320). 8.VII.71. **4.** Fernand Léger *Le Remorqueur*. Signed, 1922. 9¼ in. by 12 in. £5,000 ($12,000). 3.XII.70. **5.** Suzanne Duchamp *French Girl Acrobate*. Signed, 1920. 17¾ in. by 21¼ in. £420 ($1,008). 3.XII.70. **6.** Léon Bakst *Daphnis et Chloë*, design for the decor. Signed. 28¾ in. by 40¼ in. £1,700 ($4,080). 3.VI.71. **7.** Jacques Lipchitz *Personnage assis*. Signed, 1918. 15¾ in. by 12½ in.

£2,600 ($6,240). 22.IV.71. **8.** Pablo Picasso *Nature morte à la table*. Signed, 1922. 6½ in. by 4⅛ in. $21,000 (£8,749). 5.V.71. **9.** Juan Gris *Nature Morte*. Signed, *circa* 1919–20. 12½ in. by 10 in. £3,100 ($7,440). 22.IV.71. **10.** Jean Cocteau *Le Spectre de la Rose*. Poster, signed. 56¼ in. by 48 in. £620 ($1,488). 3.VI.71. **11.** Constant Permeke *Standing Nude*. Circa 1945. 59¾ in. by 32¼ in. £1,700 ($4,080). 12.XI.70. **12.** Pablo Picasso *Femme assise*. Signed, 1920. 10½ in. by 8 in. £8,500 ($20,400). 8.VII.71. **13.** Sam Francis *Untitled*. Circa 1964–66. 29½ in. by 22 in. £1,450 ($3,480). 22.IV.71. **14.** Fernand Léger *L'Acrobate et le Cheval*. Signed, *circa* 1953. 18 in. by 14 in. £4,200 ($10,080). 3.XII.70.

PAUL CEZANNE
Nature morte.
Watercolour. Executed in October 1906. $18\frac{1}{2}$ in. by $24\frac{1}{2}$ in.
New York $210,000 (£87,498). 10.III.71.
This is the last work that Cézanne completed before his
death.
From the collection of the late Mary S. Higgins.

Opposite page:
GEORGES SEURAT
La Poseuse de face.
Pen and ink. Signed. Drawn in 1887. $10\frac{1}{6}$ in. by $6\frac{3}{8}$ in.
New York $33,000 (£13,750). 5.V.71.
From the Norton Simon collection.

EDGAR DEGAS
Jockeys.
Pencil. Stamped with the mark of the Vente Degas.
Drawn *circa* 1881–85. 11¼ in. by 17¾ in.
London £18,000 ($43,200). 22.IV.71.
Formerly in the collection of the late Lord Howard de
Walden.

EUGENE LAMI
Courses à Chantilly.
Watercolour, pen and indian ink and gouache. Signed and
dated 1835. 13½ in. by 22½ in.
London £5,200 ($12,480). 3.XII.70.

JEAN-FRANÇOIS MILLET
Le Briquet.
Pastel. Signed. 16¾ in. by 20¼ in.
New York $36,000 (£15,000). 5.v.71.
From the Norton Simon collection.
Formerly in the collection of the late L. M. Flesh,
sold at Sotheby's on 9th July, 1958 for £650 ($1,560).

HONORE DAUMIER
Avant l'Audience.
Pen and ink and watercolour. Signed. Executed *circa* 1860–65.
$8\frac{1}{4}$ in. by $8\frac{3}{4}$ in.
New York $85,000 (£32,416). 5.v.71.
From the Norton Simon collection.

M*

PABLO PICASSO
Portrait de Léonide Massine.
Pencil. Signed and dated *Londres* 1919. 15 in. by 11¾ in.
London £12,300 ($29,520). 7.VII.71.
From the collection of Monsieur Léonide Massine.

HENRI MATISSE
Femme au Collier.
Pen and indian ink. Signed and dated 1932.
21¾ in. by 17½ in.
London £6,900 ($16,560). 8.VII.71.

EGON SCHIELE
Bartiger Mann.
Tempera and pencil. Signed and dated 1913. 19 in. by
12½ in.
London £6,600 ($15,840). 3.XII.70.

PABLO PICASSO
Buste de Femme, la main gauche levée.
Charcoal, indian ink and watercolour.
Signed. Executed in the summer of 1906. 24½ in. by 18½ in.
New York $105,000 (£43,749). 10.III.71.
From the collection of the late Mary S. Higgins.

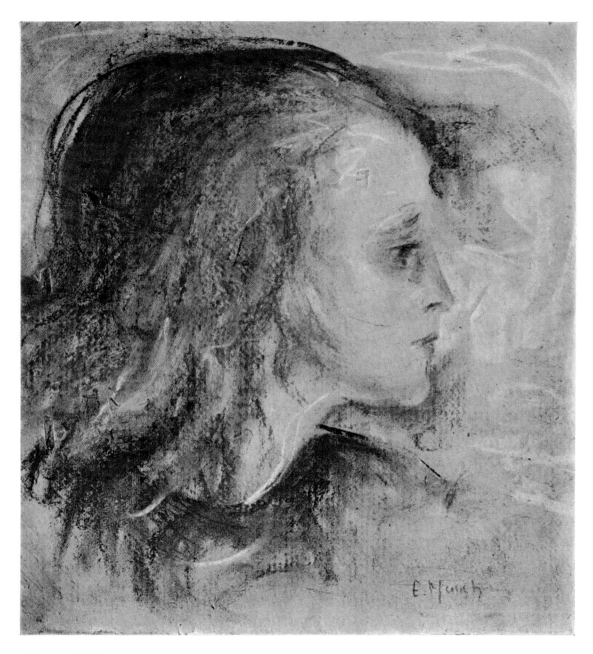

EDVARD MUNCH
The Sick Child.
Coloured crayons. Signed. Probably executed in 1896.
16½ in. by 16 in.
London £13,200 ($31,680). 3.XII.70.
From the collection of Mrs Gunilla Af Petersens.

Opposite above:
EGON SCHIELE
Knieender Akt.
Tempera, pencil and black crayon, signed and dated 1917.
11 in. by 16¾ in.
London £8,700 ($20,880). 3.XII.70.

Opposite below:
RENE MAGRITTE
Le Repos de l'Esprit.
Gouache. Signed. Executed *circa* 1942–43. 15¼ in. by 22¼ in.
London £7,500 ($18,000). 3.XII.70.
From the collection of Mr and Mrs A. Cuvelier.

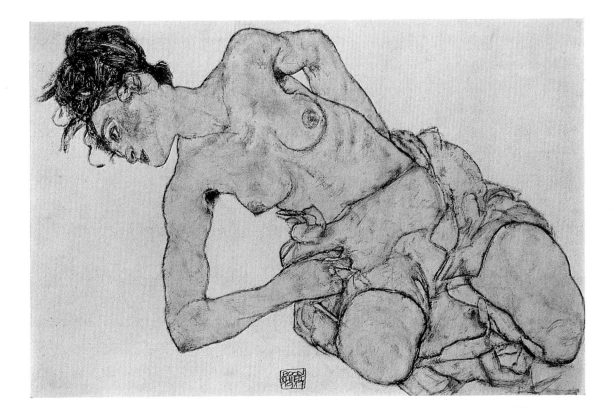

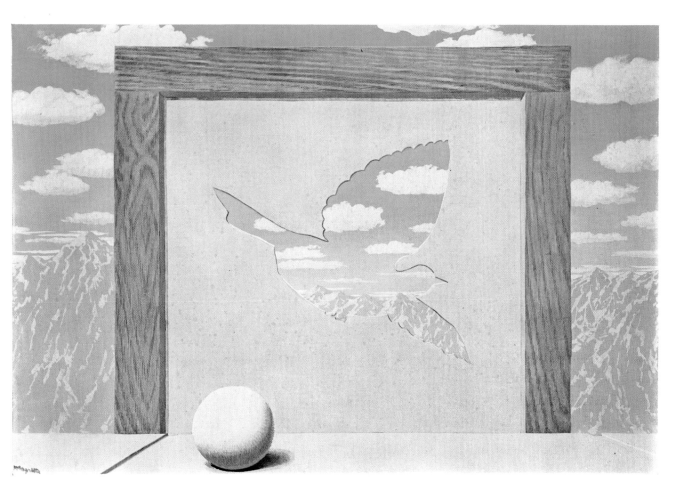

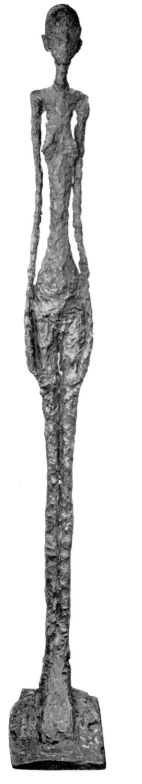

ALBERTO GIACOMETTI
Femme Debout 1.
Bronze. Signed numbered 4/6,
stamped *Susse Frères, Paris, cire perdue*.
Executed in 1960. Height 106½ in.
New York $135,000 (£56,249).
29.x.70.

GIACOMO MANZU
Pattinatrice.
Bronze. Stamped *Manzu, Fonderia
MAF, Milano*. Executed in 1960.
Height 65 in.
New York $36,000 (£15,000). 29.x.70.

ALEXANDER ARCHIPENKO
Queen of Sheba.
Bronze. Signed, numbered 2/8 and dated
1961. Height 65 in.
New York $23,000 (£9,583). 11.III.71.

MAX ERNST
Jeune Homme au Coeur battant.
Bronze. Executed in 1944. Height 25½ in.
London £6,400 ($15,360). 21.IV.71.

JACQUES LIPCHITZ
Arlequin.
Limestone. Signed and dated 1920.
Height 28¾ in.
New York $36,000 (£15,000). 29.X.70.
From the collection of the late Alan Polkes.

REG BUTLER
Figure in Space.
Bronze. Signed with initials, numbered 5/8
stamped *Susse Fondeur, Paris.*
Height 53½ in.
New York $10,000 (£4,166). 11.III.71.

The Fable of the Girl and her Milk Pail.
Watercolour. London £500 ($1,200). 20.IV.71.

Opposite page:
Left: Watercolour to illustrate
The Language of Flowers.
London £190 ($456). 5.II.68.

Right: Pen and ink drawing to illustrate
The English Spelling Book (a group of six).
London £190 ($456). 5.II.68.

Kate Greenaway, her Books and Drawings

BY MICHAEL HESELTINE

Kate Greenaway was born in Hoxton on 17th March 1846, the second daughter of John Greenaway the wood engraver. She went to her first art class in Clerkenwell at the age of twelve, and soon after joined the chief school of the Science and Art Department (later to become the Board of Education) where she won a number of prizes for her work. She also studied life drawing at Heatherley's, and was later one of the first students to attend the recently opened Slade. Her first work to be exhibited was a watercolour and a series of drawings, shown at the Dudley Gallery in 1868.

These drawings were purchased at the exhibition by the Rev. W. J. Loftie, who reproduced them in *The People's Magazine* which he edited. They were soon followed by designs for Christmas and Valentine cards published by Marcus Ward. Some of the first books to contain her illustrations were separately published fairy tales. The earliest one to appear is listed as *Diamonds and Toads*, 1871, but published under the title *The Fairy at the Fountain*. There were earlier works, however, like W. H. G. Kingston's *Infant Amusements*, published in 1867. In these books the artist was not named and the drawings are cruder than Kate's later work. They are uncommon, but it is probable that there are copies still to be found and recognised. The first work in which her name appears on the title page is *Fairy Gifts, or a Wallet of Wonders* by Kathleen Knox, published in 1874.

Kate Greenaway's first major work was *Under the Window*, printed in 1878. The book, in which both illustrations and verses were by the artist, marks a turning point in her career. It was enthusiastically reviewed, and established her as one of the leading illustrators of the period. Frederick Locker Lampson, Austin Dobson, and John Ruskin were among the early admirers of her work, and became her life-long friends. The success of the book enabled her to choose her own subjects from now on. She was particularly fond of old and familiar nursery rhymes, the poems of Jane and Ann

Taylor, *The Language of Flowers*, *The English Spelling Book*, and similar works, to which her drawings were so well suited.

The credit for this first book of verses and pictures is largely due to Edmund Evans who reproduced the drawings. He perfected the art of printing from coloured wood engravings, and was already producing the books illustrated by Walter Crane and Randolph Caldecott. These wood engravings are remarkably faithful to the water-colours to illustrate *Under the Window* and her many other books and almanacks printed by Evans during the following twenty years.

The books themselves now indicate the popularity of Kate Greenaway. The majority, whether the early issues of Routledge or the re-issues by Warne, show considerable signs of use by their young owners. However, copies occasionally turn up in excellent condition, indicating that the books were bought and carefully kept by adults for their own enjoyment. The extent of adult interest is also reflected in Spielmann and Layard's biography, published in 1905, four years after her death. This work is still of great importance: much of the information gathered from John

Watercolour to illustrate *Diamonds and Toads*.
London £400 ($960). 20.IV.71.

Greenaway the artist's brother, and her friends and contemporaries, preserved in this book would otherwise have been lost.

Kate Greenaway deserved the success that she enjoyed. She was conscientious in her work and persevered to improve it. Her technique during the period between her art-school days and the late 1870's developed considerably, particularly in her use of colour. The watercolour for *Diamonds and Toads* may be a bad example of her early work, but a very important drawing, as it is probably the earliest to appear on the market. John Greenaway dated it as being about 1868 or 1869 and identified the model as his younger sister. The amount of practice and determination applied to her watercolours is evident when this drawing is compared with 'The Fable of the Girl and her Milk Pail' or 'Lucy Locket lost her Pocket', both exhibited in January 1894. Her line drawing of the same period as the early painting was far more competent, as can be seen from those reproduced in Spielmann and Layard. Here the development was stylistic rather than technical. Her earliest drawings are fairly typical of the period, then comes the influence of the 'illustrators of the sixties' and

Lucy Locket lost her Pocket watercolour.
London £700 ($1,680). 20.IV.71.

Pre-Raphaelites, and finally the settling into her own unique style for which she is remembered and admired today.

She restricted herself to drawings of children, and would have had difficulty producing illustrations of other subjects, hence her concentration on children's books. Her own childhood affected her drawing more than any other factor. Although born in London, she spent a lot of time in Rolleston, a village near Newark. The countryside made a deep impression on her as did the local farming people in the simple old-fashioned clothes of the area. Paintings and drawings of the villagers and the friends she stayed with portray them in smocks, shawls, and loosely fitting dresses far removed from the current fashions in town.

Her pictures of children suggest that she developed a few standard faces and figures. This is to a point true, but most of her illustrations were made from life drawings. She had a succession of models, some of whom were professional, some the children of friends or relations. Most of them appear in a number of illustrations and paintings, hence the repeated faces. However, a close inspection of these faces would suggest that she selected her models carefully to ensure that their features conformed with the type of face she preferred. The clothes they wear were equally real, usually designed and made by Kate to combine the freedom of those remembered from her days at Rolleston with the stylishness of those popular towards the end of the eighteenth century. As the popularity of her books increased, so did the garments she designed for them. More and more children were dressed in hats, bonnets, dresses, coats, capes, breeches and jackets based on her simple styles. A sash, bow, or ribbon was often the only decoration on an otherwise plain garment. She maintained this fashion for the whole of her career, and it is significant that there is only one book that she illustrated set in a period other than her own. This is Robert Browning's *Pied Piper of Hamelin*. Dresses are cut down to make tunics for the men, otherwise the costumes are her usual designs. The children of this medieval town would look equally at home sitting at tea in a Victorian garden.

As Kate Greenaway's work was so popular and her books and paintings were selling very well she soon had a number of imitators who hoped to profit from her reputation. The first edition of *Under the Window* was entirely sold out; 20,000 copies having been printed, an incredibly large edition for this time. The artist herself was a quiet unassuming person, and there are several anecdotes in Spielmann and Layard which tell of other people claiming to be the artist, or of books by inferior illustrators ascribed to her. Although she does not seem to have said much on this matter the drawings speak for her. H. H. Emmerson, Constance Haslewood, George Lambert and T. Pym are some of the artists who imitated her drawings during the 1880's. The similarity between the layout of their books and those of Kate Greenaway, the children depicted, and the clothes that they are wearing is obvious, but none of these other artists approached the charm or delicacy of the originator. It is to be regretted that these artists were content to imitate rather than develop the style and the fashions which she introduced.

Direct copies of her drawings were also made, and the initials K G were usually incorporated. Some were probably done by older children in all innocence, as it was still common practice for people of varying talents to copy book illustrations that

they liked, but others were deliberate fakes, produced and sold to the unwary collector. Most of these fakes were done early this century. There is a story which came to me from a highly reputable source that a man died some years ago and a large number of fakes were burnt during the clearing up of his effects. Unfortunately many must have been fed onto the market before this happened, and now that the genuine drawings are so valuable this is particularly disturbing. The number of drawings brought in to Sotheby's for sale increases as the prices rise. About one fifth of those brought in during the last few years have been fakes, and it is a particularly unenviable task to tell an owner that the Kate Greenaway drawing that has been in the family for years is not in fact genuine. However, the opportunity to inspect these fakes as well as the genuine drawings has been invaluable. Some are based on a published drawing with minor variations. At first sight they will often seem to be genuine, and when checked against the books will appear to be a study for the illustration on which it has been based. Others will be drawn with figures in characteristic poses and signed with Kate Greenaway's initials, otherwise being entirely original. These are usually more easy to recognize than the copies with minor revisions. Most of these fakes have a number of re-occurring features and I am convinced that they are the work of one person or two working together. Although there is no proof I think it probable that they were part of the hoard mentioned earlier.

The watercolour by Kate Greenaway to illustrate *The Language of Flowers* and the pen and ink drawing for *The English Spelling Book* are two of her better drawings, and good examples to compare with the fake illustrated here, which was based on the

Illustration in *A Day in a Child's Life*.

A fake based on the same illustration.

Child with a Toy.
Pencil drawing.
London £200 ($480). 20.IV.71.

illustration in *A Day in a Child's Life* reproduced beside it. The characteristics repeatedly seen in these fakes are represented in this one and are as follows: the ink used in drawing the outline is brown instead of the more usual black used by Kate Greenaway; the curls of the girl's hair (and in other examples lace frills) are tight and fussy; the arms and hands of the baby, although copied from the illustration are very badly drawn; the cupid's-bow mouth is over-exaggerated; the bows on the dresses (an addition to the original) are quite unrealistic; and lastly the pleats and folds of the baby's dress do not relate to the hem.

If the person or persons producing these fakes had known or paid more attention to Kate Greenaway's method of working their detection could have been far more difficult. As most of the drawings she did for illustrations were drawn at some stage from life, the unnatural bows and pleats do not occur in her books, nor do children with malformed bodies and unshapely hands. The fakes would have been based on the illustrations in the books rather than the original drawings, and lack much of the delicacy found in the outline and colouring of the originals.

We have fortunately had in for inspection enough examples to make these comparisons, and it should be pointed out that the guide given above should be applied with care, particularly if done without some knowledge of the genuine drawings. The comparison of these with one another has been equally revealing. A number have been found to link up with book illustrations, paintings reproduced in Spielmann and Layard, or others already sold here, some of which are described below.

Girl with a Tambourine.
Pencil and watercolour.
London £60 ($144). 20.IV.71.

Three girls with instruments.
Watercolour.
London £600 ($1,440). 16.III.70.

Not all Kate's drawings were done for illustrations: Spielmann and Layard illustrate many examples of the sketches drawn by her in her letters to Ruskin, which appear to have been drawn quickly and are more free than usual. It was he who encouraged her to work on her exhibition drawings, of which 'The Fable of the Girl and her Milk Pail' and 'Lucy Locket' are fine examples. In 1891 she had her first 'one-man' exhibition, and from then on concentrated on these paintings. She was no longer concerned with a drawing that could be reproduced by Evans's wood engravings. Although the familiar faces, dresses, and attitudes remain, the fine ink outline and simple colour wash are gone, replaced by intricate brushwork producing a variety of textures and far more depth.

The studies for these paintings show a different technique too. The pencil drawings have a soft quality produced by a light outline and a considerable amount of shading as in the 'Child with a Toy'. The same model appears in an exhibition painting in similar pose and costume titled 'Winter 1892', reproduced opposite page 20 of Spielmann and Layard. Another study, the 'Girl with a Tambourine' has similar pencil work and added water-colouring. This study was probably one of a series for the

Four pencil drawings to illustrate *Who'l go a jump*. London £50 ($120). 20.IV.71.

Pencil and (opposite page) finished ink and watercolour drawings for *Who'l go a jump*.
London £320 ($768). 20.IV.71.

painting of three girls playing instruments in which the same model appears with a
tambourine in the same but simplified dress, wearing the same necklace.

Few people are lucky enough to own one of these fine exhibition drawings, but
most of the books are still reasonably common and inexpensive, and there are suf-
ficient titles to make a worth-while collection. The care put into them can be seen in a
series of drawings sold here this year. They were to illustrate a poem by the artist
titled 'Who'l go a Jump', and included four studies of the same model standing in

different poses; followed by a rough sketch of the four combined in one picture, with the position of the legs and feet revised to suit the text which was written below; and finally the finished ink and watercolour drawing. The words of the verses were rewritten before the drawing was published in *Marigold Garden* as 'The Little Jumping Girls'. Neither version is of much interest as a poem, and Kate Greenaway's verses could never have been taken very seriously, but words are not really necessary to accompany pictures by an artist who has been constantly popular for a hundred years.

N

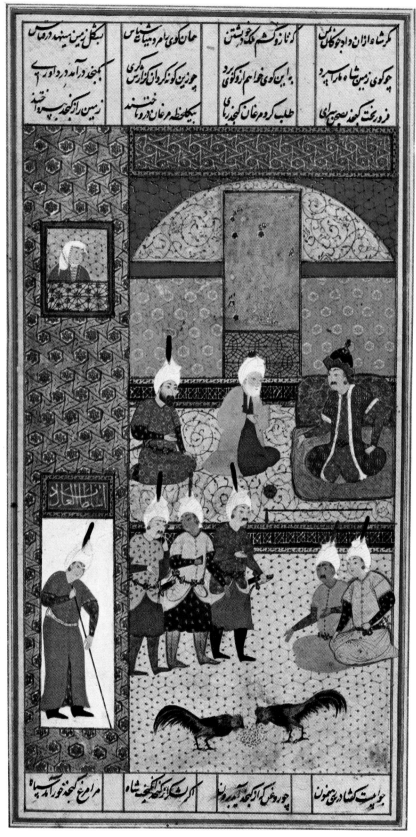

NIZAMI
Khamsa.
Persian manuscript written by
the scribe Muhammad Kātib,
with 30 miniatures, Shiraz,
dated 1516 and 1521.
London £5,000 ($12,000). 7.XII.70.
From the Kevorkian Collection.

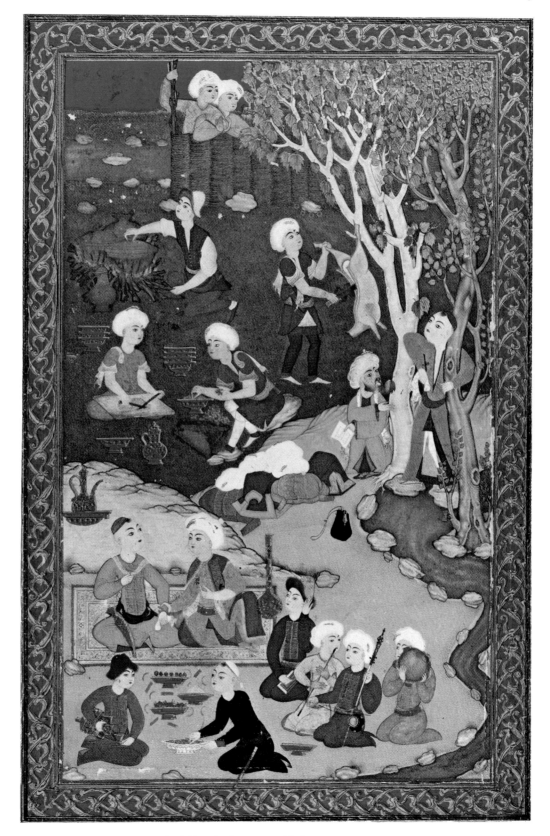

A prince and his companion picnicking in the countryside by a stream.
A fine Turkish miniature of the last quarter of the 16th century.
London £5,000 ($12,000). 7.XII.70.
From the Kevorkian Collection.

Portrait of a European gentleman in Indian dress.
Indian miniature, Company school, Lucknow, early 19th century.
London £850 ($2,040). 14.VII.71.
From the collection of Dr W. B. Manley.

Oriental Manuscripts and Miniatures

BY TOBY FALK

On 14th July the sale took place of a collection of oriental miniatures formed by Dr W. B. Manley whose interest in oriental art originates from the period 1905–24 when he served in the Indian Police in the Bombay Presidency. The fact that the major portion of the material was purchased since his return to England gives the collection a particular flavour, a high proportion of the miniatures being typical of the type of object brought back to this country by those who served in India in the eighteenth and nineteenth century. Many of these miniatures were done by Indian artists for a European patron; the finest was undoubtedly the portrait of a European gentleman wearing Indian dress, sitting before an open window smoking a hookah while his servant waves a fly-whisk over him: this brought £850 ($2,040), a record price for this type of Indian miniature. Another unusual item in the sale was the group of twenty-one paintings on ivory known as the 'Auckland Miniatures'; these were copied in the late 1830's from drawings of Indian life made by Emily Eden, sister of the governor-general Lord Auckland. Charming little pictures in their own right these miniatures are also representative of the interest shown by Indian artists in the work of English painters who were so thoroughly recording everything they saw.

Illustrations on the other different four pages are of miniatures from collections sold this season. The record price of £5,000 ($12,000) was paid for a Turkish example of the late sixteenth century showing a prince enjoying himself in the countryside while his servants entertain him and prepare a picnic; this price reflects the current interest in Turkish painting which was a less prolific art than its Persian counterpart. In the field of Persian manuscripts a copy of Nizāmī's *Khamsa* with thirty illustrations in the Shiraz style of *circa* 1520 was sold for £5,000 ($12,000). The poems of Nizāmī are amongst the most popular of all Persian poetical romances, and the illustrations of this particular copy were fine examples of the miniature painting of the period. The prices of £5,800 ($13,920) and £6,500 ($15,600) were paid for two exceptional Mughal miniatures from the time of the emperor Akbar. One was an illustration from a large copy of the emperor's own memoirs, the *Akbarnāma*, and it displays magnificently the vigour and energy with which early Mughal painting was charged. The other shows a quieter and more fanciful aspect of the art in a scene of King Solomon with his court of angels and animals. This picture was probably once incorporated in Akbar's own copy of poems by the Persian author Hāfiz.

The forces of Humāyūn pursuing the forces of Mirzā Kāmrān during the battle of Kabul in A.D. 1553.
A fine Mughal miniature painted by Mahesh, with some faces by Padarath, from the large copy of the *Akbarnāma* by Abul Fazl produced for the emperor Akbar, *c.* 1595–1600.
London £5,800 ($13,920). 13.VII.71.

King Solomon enthroned with his court of angels, demons, animals and birds.
A fine Mughal miniature from a poetical manuscript, *circa* 1600.
London £6,500 ($15,600). 13.VII.71.

Western Manuscripts

On 1st December, Sotheby's sold 43 manuscripts ranging in date from the ninth to the twentieth century, part of the very important collection formed by the late Major J. R. Abbey; the total for the sale was £197,850 ($474,840).

Unquestionably the most beautiful volume in the sale, and one with an exceptionally distinguished provenance, was the famous *Ruskin Hours*, named after John Ruskin, who is known to have purchased it sometime before 1853; after his death, it passed to another great collector, Sir Sydney Cockerell and then to a third equally famous collector, Sir A. Chester Beatty, in whose sale at Sotheby's in 1932 it fetched £2,900 ($11,600). The manuscript was illuminated in north-eastern France around 1312; it contains 12 calendar miniatures, 11 large and 96 small historiated initials, 5 small miniatures in the Litany and numerous illuminated borders. It is interesting to note that Ruskin illustrated some of the volume's illuminations in *Stones of Venice* and *Modern Painters*. This magnificent manuscript was sold for £28,000 ($67,200).

An important English manuscript was the Psalter illuminated by William de Brailes and others in the mid-thirteenth century; in the history of English art, de Brailes holds an important place as one of the earliest documented English artists. This is one of only 6 known manuscripts containing work by him and although only one page bears illumination from his hand, this and the other exceptionally fine miniatures and historiated initials make this one of the most significant surviving English mid-thirteenth century illuminated manuscripts; it was sold for £10,000 ($24,000). Later in the season, another fine English manuscript, dating from the mid-fourteenth century and known as the *Zouche Hours*, fetched £3,800 ($9,120).

The Abbey sale also contained some examples of Dutch illumination of a quality rarely seen on the market today. A splendid *Horae* containing 17 miniatures of the early fifteenth century Utrecht school fetched £18,000 ($43,200), whilst another Book of Hours from the same period and place fetched £13,000 ($31,200). This second volume is of great art historical importance as it contains 30 miniatures in two distinct and famous styles, that of the illuminators who worked with the Master of Zweder van Culemborg on the Lochorst Bible, now in the Fitzwilliam Museum, and that of the artist known as the Master of Mary of Guelder; this is the only manuscript in which these two styles co-exist. Later in the season, a third fine Dutch manuscript, illuminated in the southern Netherlands about 1440, realized £10,000 ($24,000).

With regard to manuscripts, Major Abbey was perhaps best known for his concentration on Italian illumination and calligraphy, some fine examples of which appeared in the December sale. A remarkable copy of Giovanni Pontano's *De Amore Conjugali*, written in Naples in the late fifteenth century by Pietro Hippolyto da Luna, with a richly illuminated title page and an important binding by Baldassare Scariglia, the head of the Royal Neopolitan bindery and reputedly the first European craftsman to do gold-tooling, fetched £11,000 ($26,400); the Prayer Book of Pope Sixtus IV written and illuminated in 1481 by Joachinus de Gigantibus, sold for £9,000 ($21,600) and a copy of Cicero's *Orationes Philippicae*, written in Padua in 1476 by Johannes Nydenna and incidentally the first manuscript purchased by Major Abbey, fetched £8,500 ($20,400).

SAINT AUGUSTINE
Retractationes. Manuscript on vellum [?north-eastern France, second half of the 9th century].
London £5,200 ($12,480). 1.XII.70. From the collection of the late Major J. R. Abbey.

Caption for page 226.

Hours of the Virgin, use of Amiens. Manuscript on vellum decorated with occupation miniatures, large and small historiated initials, and panels incorporating miniatures of the saints [north-eastern France, *c.* 1312].
London £28,000 ($76,200). 1.XII.70.
From the collection of the late Major J. R. Abbey.
The manuscript was formerly in the collection of John Ruskin, and is now known as the *Ruskin Hours.* He reproduced decorations in it to illustrate *Stones of Venice* and *Modern Painters.*

Caption for page 227.

Hours of the Virgin, etc., in Dutch. Manuscript on vellum with seventeen inserted miniatures depicting the life of Christ, Diocese of Utrecht, *c.* 1420.
London £18,000 ($43,200). 1.XII.70.
From the collection of the late Major J. R. Abbey.

Incipiunt hore de beata uirgine.

Domine labia mea aperies: et os meum an-
nunciabit laudem tuam.

Deus in adiutorium meum
intende domine ad adiu-
uandum me festina.

Gloria patri et filio et spiritui sancto.

Sicut erat in principio et nunc
et semper et in secula seculorum amen.

Hours of the Virgin, etc., in Dutch.
Manuscript on vellum, decorated with 30 miniatures and 2 historiated initials
[Diocese of Utrecht, *circa* 1415].
London £13,000 ($31,200). I.XII.70.
From the collection of the late Major J. R. Abbey.

Hours of the Virgin, use of
Sarum, 'The Zouche Hours'.
Manuscript on vellum,
decorated with 6 miniatures
and 7 large historiated initials
[England, *circa* 1340–50].
London £3,800 ($9,120).
16.XII.70.
From the collection of
C. Shelton-Agar, Esq.

Hours of the Virgin, use of Rome, in Latin.
Manuscript on vellum, decorated with 19 large miniatures, and
illuminated borders and initials [southern Netherlands, *circa* 1440].
London £10,000 ($24,000). 12.VII.71.

Psalter.

Manuscript on vellum, decorated with historiated initials and miniatures by William de Brailes and others [England, middle of the 13th century].

London £10,000 ($24,000). 1.XII.70.

From the collection of the late Major J. R. Abbey.

William de Brailes is one of the few named English artists of the 13th century with a well-defined artistic personality. The illustration here is of the only page in the manuscript by him.

Printed Books

This season, a remarkable number of exceptionally important libraries have been sold at Sotheby's. Amongst the famous collections represented were the Sassoon collection of Hebraica, a selection from the Britwell library, a small but extremely important selection of early printed books from the Pierpont Library, New York, the gastronomical library formed by Harry Schraemli, a further selection of books and bindings from the library of the late Major J. R. Abbey, the first part of the famous geographical library formed by Boies Penrose, f.s.a., f.r.g.s., and the largest collection of Victorian fiction to appear on the market for some years.

The Britwell Library was described by Seymour de Ricci in 1930 as 'a collection of old English books, the greatest ever brought together by a private individual'. A series of sales between 1916 and 1927 at Sotheby's removed some of the finest books although the sale on 29th March, 1971, revealed that a great many items of outstanding importance had remained in the collection; the two-day sale made a total of £174,866 ($419,678).

The outstanding item in the collection was the magnificent hand-coloured copy of the *Cosmographia* of Claudius Ptolemaeus, printed on vellum in Ulm in 1482; this fetched £34,000 ($81,600), a price which reflects the tremendous importance and rarity of this, the first edition of Ptolemy printed in Germany and the added rarity of it being a copy on vellum.

Amongst English books, a hand-coloured copy of Blake's *The First Book of Urizen*, printed by the poet-artist in 1794, was sold for £24,000 ($57,600). This price was no surprise as unbroken copies of Blake's works, which he himself had illuminated, are also of exceptional rarity on the market today.

Other outstanding lots included Charles I's travelling library, an item of considerable historical interest consisting of 58 works of the classics, which was sold for £6,500 ($15,000) and a unique advance copy of the first edition of Keats' *Endymion*, with an unrecorded state of the title-page and four textual corrections in the author's hand, which realized £6,200 ($14,880).

On 8th June, 29 important printed books, duplicates from the Pierpont Morgan Library, New York, were sold at Sotheby's for a total of £115,240 ($276,576). There were three English incunables in the sale: a copy of Chaucer's translation of Boethius' *De Consolatione Philosophiae*, printed by Caxton *circa* 1478, fetched £25,000 ($60,000), being the only copy offered at auction this century; Caxton's own translation of de Cessolis' *The Game and Playe of the Chesse*, printed by the translator at Bruges after 31st March, 1474/5, and one of only 11 surviving copies, realized £44,000 ($105,600), this is the second book printed in the English language; the third fifteenth century English book, a copy of Wynkyn de Worde's third printing of *The Golden Legend*, managed to make £1,200 ($2,880), even though it lacked 35 leaves.

Of the Continental books, the most important was the extremely rare first Aldine edition of Vergilius Maro's *Opera*, printed in 1501 and important in the history of typography as the first book from this press to use italic type; it fetched £8,500 ($20,400).

WILLIAM BLAKE
The First Book of Urizen.
25 plates printed in colours and finished with watercolour washes,
Lambeth, printed by Will. Blake, 1794.
London £24,000 ($57,600). 29.III.71.
From the collection of the late S. R. Christie-Miller, Esq.

O

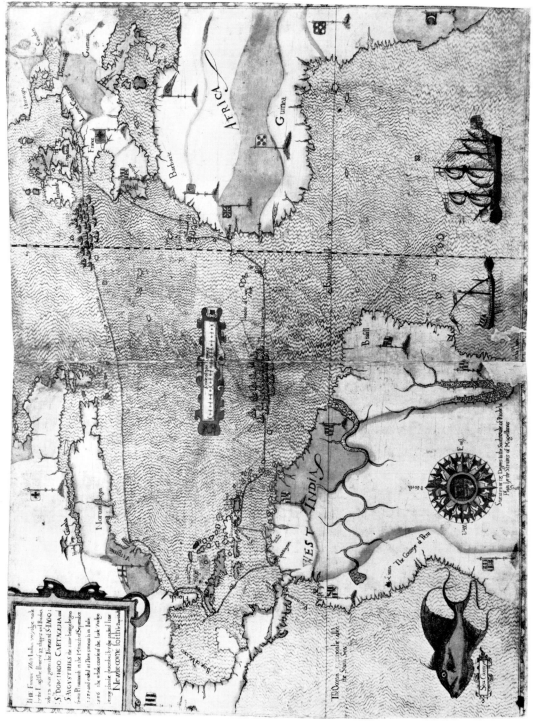

BATISTO BOAZIO
The set of five maps to accompany Walter Bigges's *A Summarie and True
Discourse of Sir Francis Drakes West Indian Voyage*, 1589.
London £6,000 ($14,400). 7.VI.71.
From the collection of Boies Penrose, Esq., F.S.A., F.R.G.S.

JOHN DEE
*General and Rare Memorials pertayning to the Perfecte
Arte of Navigation.*
First edition, of which only 100 copies were printed,
1577.
London £3,800 ($9,120). 7.VI.71.
From the collection of Boies Penrose, Esq., F.S.A.,
F.R.G.S.

PIETRO MARTIRE D'ANGHIERA and others.
The Decades of the Newe Worlde or West India, 1555.
London £6,500 ($15,600). 7.VI.71.
From the collection of Boies Penrose, Esq., F.S.A.,
F.R.G.S.
This copy belonged at one time to Captain Roger
North, who accompanied Raleigh to Guiana in 1617.

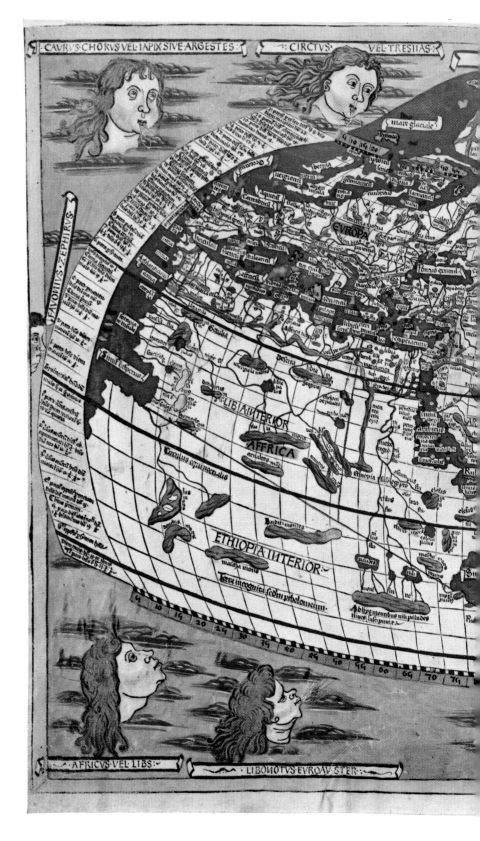

CLAUDIUS PTOLEMAEUS
Cosmographia.
Printed on vellum with 32
woodcut maps, very finely
coloured by a contemporary
hand, bound in 18th century
French red morocco gilt by
N.-D. Derome le Jeune, Ulm,
1482.
London £34,000 ($81,600).
30.III.71.
From the collection of the late
S. R. Christie-Miller, Esq.

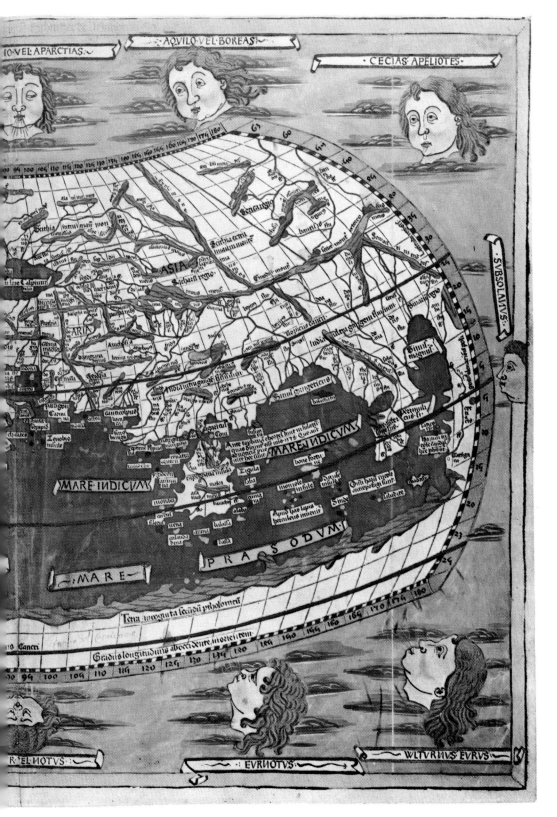

Hereafter ensue the True Encountre or Bataple lately
don betweene Englade and Scotlande.
An extremely rare work printed by Richard Faques in 1513
or later.
London £3,800 ($9,120). 29.iii.71.
From the collection of the late S. R. Christie-Miller, Esq.

VINCENTIUS BELLOVACENSIS, OR VINCENT DE BEAUVAIS
The Mirror of the World, translated into English by William Caxton.
First edition in English, with woodcut illustrations and diagrams,
William Caxton, 1481.
London £22,000 ($52,800). 30.xi.70.
The first illustrated book printed in England.

ROBERT FABYAN
Chronicles of England and France.
Woodcut illustrations, Richard Pynson, 1516.
London £3,400 ($8,160). 29.III.71.
From the collection of the late S. R. Christie-Miller, Esq.

STEPHAN FRIDOLIN
*Schatzbehalter oder Schrein der Wahren Reichtümer
des Heiles und Ewiger Seligkeit.*
96 full-page woodcuts by Michael Wolgemut,
Nuremberg, 1491.
London £4,800 ($11,520). 8.VI.71.
From the collection of The Pierpont Morgan Library.

ALFRED, LORD TENNYSON
The Princess.
Finely bound by T. J. Cobden-Sanderson, green morocco gilt, 1883.
London £1,500 ($3,600). 19.X.70.
From the collection of the late Major J. R. Abbey.

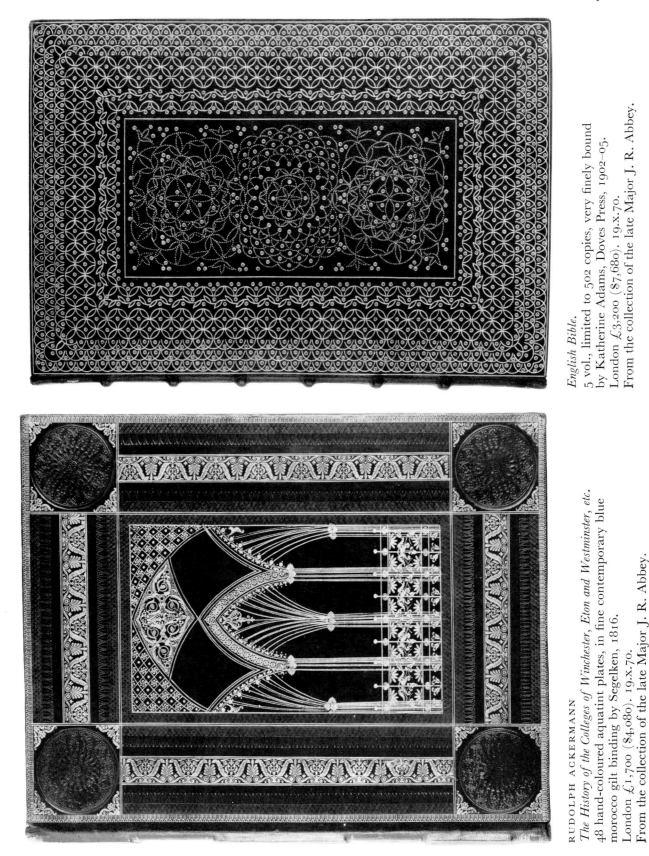

English Bible.
5 vol., limited to 502 copies, very finely bound
by Katherine Adams, Doves Press, 1902–05.
London £3,200 ($7,680). 19.X.70.
From the collection of the late Major J. R. Abbey.

RUDOLPH ACKERMANN
The History of the Colleges of Winchester, Eton and Westminster, etc.
48 hand-coloured aquatint plates, in fine contemporary blue
morocco gilt binding by Segelken, 1816.
London £1,700 ($4,080). 19.X.70.
From the collection of the late Major J. R. Abbey.

P

ANICIUS MANILIUS BOETHIUS
De Consolatione Philosophiae.
First edition in English [Westminster], William
Caxton, [*circa* 1478].
London £25,000 ($60,000). 8.vi.71.
From the collection of the Pierpont Morgan Library.

JACOBUS DE CESSOLIS
The Game and Playe of the Chesse.
First English edition [Bruges, William Caxton,
after 31 March 1474/5].
London £44,000 ($105,600). 8.vi.71.
From the collection of the Pierpont Morgan Library.
This work, translated by Caxton from the French of
Jehan de Vignay, is the second book to be printed in
the English language.

Bible, Pentateuch, Torah, Haftorot, Megillot.
Printed on vellum, Hijar, Eliezer Ben Alantansi
[*circa* 1487–95].
London £4,800 ($11,520). 1.III.71.
From the collection of Hebrew printed books formed
by the late David Solomon Sassoon.

Mischna (Traditional Laws), with the commentary of
Maimonides.
Bound in 2 vol., Naples, Joshua Solomon Sonico, 8 May 1492.
London £2,400 ($5,760). 1.III.71.
From the collection of Hebrew printed books formed
by the late David Solomon Sassoon.
The first complete edition of this work.

POEMS:
WRITTEN
BY
WIL. SHAKE-SPEARE, Gent.

Printed at *London* by *Tho. Cotes,* and are to be fold by *Iohn Benfon,* dwelling in St. *Dunftans* Church-yard.

Left:
WILLIAM BLAKE
Poetical Sketches.
First edition, 1783.
London £3,800 ($9,120). 29.III.71.
From the collection of the late
S. R. Christie-Miller, Esq.
This rare book is the earliest
of Blake's poetical works.

Right:
WILLIAM SHAKESPEARE
Poems.
First edition, 1640.
London £4,500 ($10,800). 8.VI.71.
From the collection of the
Pierpont Morgan Library.

POETICAL
SKETCHES.

By W. B.

LONDON:
Printed in the Year MDCCLXXXIII.

BOOK IV. ENDYMION. 195

Favour from thee, and so I ~~promised~~ gave
To the void air, bidding them find out love:
But when I came to feel how far above
All fancy, pride, and fickle maidenhood,
All earthly pleasure, all imagin'd good,
Was the warm tremble of a devout kiss,—
Even then, that moment, at the thought of this, 750
Fainting I fell into a bed of flowers,
And languish'd there three days. Ye milder powers,
Am I not cruelly wrong'd? Believe, believe
Me, dear Endymion, were I to weave
With my own fancies garlands of sweet life,
Thou shouldst be one of all. Ah, bitter strife!
I may not be thy love: I am forbidden—
Indeed I am—thwarted, affrighted, chidden,
By things I trembled at, and gorgon wrath.
Twice hast thou ask'd whither I went: henceforth 760
Ask me no more! I may not utter it,
Nor may I be thy love. We might commit
Ourselves at once to vengeance; we might die;
We might embrace and die: voluptuous thought!

OEDIPUS TYRANNUS;

OR,

SWELLFOOT the TYRANT.

A Tragedy.

IN TWO ACTS.

TRANSLATED FROM THE ORIGINAL DORIC.

—— Choose Reform or civil-war,
When thro' thy streets, instead of hare with dogs,
A Consort-Queen shall hunt a King with hogs,
Riding on the IONIAN MINOTAUR.

LONDON:

PUBLISHED FOR THE AUTHOR,
BY J. JOHNSTON, 98, CHEAPSIDE, AND SOLD BY ALL BOOKSELLERS.
1820.

Left:
PERCY BYSSHE SHELLEY
Oedipus Tyrannus.
First edition, 1820.
London £4,800 ($11,520). 30.III.71.
From the collection of the late
S. R. Christie-Miller, Esq.
This extremely rare work was suppressed immediately on publication on account of the 'highly libellous' nature of its contents.

Right:
JOHN KEATS
Endymion: a Romance, 1818.
London £6,200 ($14,880). 29.III.71.
From the collection of the late
S. R. Christie-Miller, Esq.
A unique advance copy of the first edition, with a hitherto unrecorded state of the title-page and four corrections in the author's hand.

The Gigantick History of the Two Famous Giants and other Curiosities in the Guildhall, London.
2 vol., woodcut frontispieces and one illustration,
T. Boreman, 1741.
London £300 ($720). 20.IV.71.

ANTHONY BENEZIT
A First Book for Children, Philadelphia, 1788.
London £320 ($768). 20.IV.71.
A presentation copy of this rare early American
children's book, inscribed by the author to William
Foster.

JACQUES VONTET
L'Art de Trancher la Viande de Toute Sorte de Fruicts.
Manuscript with 38 engraved plates illustrating
methods of carving game, fish, fruit, etc. [?Lyons, 1647.]
London £1,000 ($2,400). 23.II.71.
From the collection of books and manuscripts on
food and wine formed by Harry Schraemli.

ARNOLDUS DE VILLANOVA
Ein löblicher Tractat von Beraytung und Brauchung der Wein zu Gesunthayt der Menschen
Ulm, Johann Zauiner, 1499.
London £3,200 ($7,680). 22.II.71.
From the collection of books and manuscripts on
food and wine formed by Harry Schraemli.

Three undivided court cards printed from one woodblock
in the Upper Rhineland, *circa* 1460.
These are the earliest examples in the De La Rue collection
of playing cards, sold as one lot.
London £12,000 ($28,800). 30.XI.70.

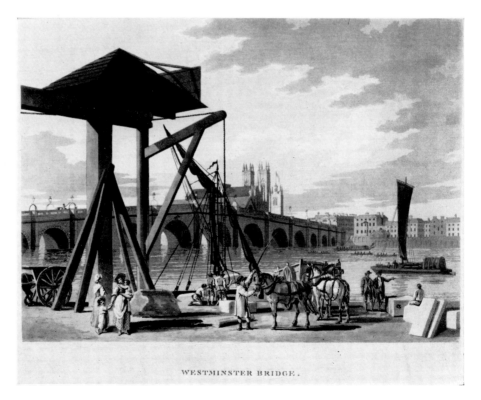

WESTMINSTER BRIDGE.

THOMAS MALTON
A Picturesque Tour through the Cities of London and Westminster; Oxford.
3 vol. in 1 with 124 aquatint plates, those of the first work
printed in colour and finished by hand, 1792–1803.
London £2,000 ($4,800). 30.XI.70.
From the collection of P. H. Godsal.

MARY LAWRENCE
A Collection of Roses from Nature.
91 hand-coloured plates, 1799.
London £2,800 ($6,720). 30.XI.70.

JACOB DE GHEYN, the elder.
Maniement d'Armes d'Arquebuses, Mousquetz, et Piques.
117 engraved plates, Amsterdam, Robert de Baudous, 1608.
London £580 ($1,392). 30.XI.70.

HENRI MATISSE
Jazz.
20 illustrations by the author, Paris, 1947.
London £4,200 ($10,080). 22.VI.71.

EDGAR ALLAN POE
Le Corbeau.
Six lithographed illustrations by
Edouard Manet, Paris, 1875.
London £1,000 ($2,400). 22.VI.71.

P*

PETER IDLEY
Instructions to his Son.
Manuscript, early 16th century.
London £5,000 ($12,000). 14.VI.71.
From the collection of the late Sir Thomas Phillipps, Bt. (1792–1872).
This manuscript is the most complete version of the work known, containing 261
stanzas which were hitherto unrecorded.

[Handwritten letter in an Elizabethan secretary hand, largely illegible. It concludes:]

Yowre not in name but trew
Frend in deede Philip Sidnei

SIR PHILIP SIDNEY
A near-contemporary copy of a long and important letter outlining a course of
self-education for his friend Edward Denny.
London £4,800 ($11,520). 15.vi.71.
From the collection of the late Sir Thomas Phillipps, Bt. (1792–1872).
In this hitherto unrecorded letter there appears the only known reference by
Sidney in his correspondence to his own poetry.

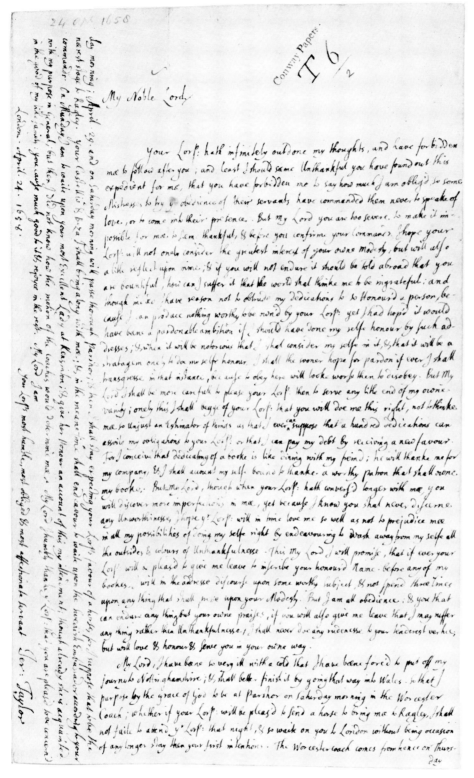

JEREMY TAYLOR
An important series of autograph letters to his patron Edward,
Viscount Conway, 1658–66.
London £2,400 ($5,760). 27.x.70.
From the collection of the Most Noble the Marquess of Hertford.

CHARLES BAUDELAIRE
Autograph manuscript of his poem *Les Sept Viellards*.
London £4,000 ($9,600). 27.IV.71.
From the collection of Louis Le Jeune, Esq.

Antiquities

The antiquities sales this season have been distinguished by the appearance of two outstanding pieces of classical sculpture, which were both sold on 12th July in London, one was an extremely fine Attic marble grave stele depicting the farewell scene between a deceased lady seated on a high-backed chair and one of her relatives. Probably sculpted in about 350 B.C., it was sold for the very high price of £9,500 ($22,800).

The other piece was a remarkable and very powerful Roman marble bust of a priest dating from the third century A.D., which fetched £7,000 ($16,800). Roman marbles of this quality are very rarely seen on the market today. Around his head, the priest wears a diadem with a central medallion of a seven-pointed star; this would indicate a devotion to the sun, worshipped in Egypt under the guise of Serapis and in the rest of the Roman world under the name of Helios; a head wearing a similar diadem is in the Berlin Museum.

On 8th December, Sotheby's sold part of the Kevorkian Foundation collection of antiquities from the Mediterranean and the Near East for a total of £71,677 ($172,024). This was a very wide ranging assemblage with Egyptian bronzes, ancient Greek silver, Greek and Roman marbles, Achaemenid and Sassanian silver, Roman glass and extremely fine Islamic metalwork and glass. Amongst the most outstanding pieces, a beautiful incised Eastern Greek silver cup of the early sixth century B.C. fetched £4,200 ($10,080), an exceptionally rare Fatimid rock-crystal jar, made in Egypt in the tenth to the eleventh century A.D., realized £4,000 ($9,600), whilst an extensive group of Islamic glass included a heavy early ninth century A.D. bottle at £820 ($1,968).

Amongst other important Islamic pieces, an Iranian mosaic faience Mihrab or prayer niche, the outer calligraphic border dating from the seventeenth century, the rest of a later date, realized £5,800 ($13,920), whilst some magnificent metalwork included a beautiful brass thirteenth century writing box, inlaid with gold and silver, which fetched £1,500 ($3,600) and an impressive engraved bowl, made in Afghanistan in the eleventh century, at £1,700 ($4,080).

The finest of the Roman pieces was an attractive marble fragment of an hermaphrodite depicted in 'restless sleep' dating from around the first century A.D. which realized £4,000 ($9,600).

At Parke-Bernet, on 18th December, also from the Kevorkian Foundation collection, an Islamic pottery mihrab of the thirteenth–fourteenth century A.D. fetched $8,000 (£3,333), and an Egyptian bronze female figure from the 23rd/25th Dynasty $8,250 (£3,437).

A number of fine ethnographical pieces have been sold this season, including a magnificently carved Maori wooden head, elaborately tattooed, which realized £9,000 ($21,600) in London on 13th July. This same sale also included a massive late Benin bronze head of an Oba at £5,200 ($12,480), two small Benin plaques depicting single figures at £3,000 ($7,200) and £4,000 ($9,600) and an extremely fine Dan wooden mask from the Ivory Coast at £2,300 ($5,520). At Parke-Bernet a fine Tlingit wood food bowl brought $4,100 (£1,709) and a Tlingit wool blanket was sold for $4,000 (£1,666).

A Roman marble relief depicting the upper
half of a hermaphrodite in 'restless sleep'.
Circa 1st century A.D. 26¾ in. by 34½ in.
London £4,000 ($9,600). 8.XII.70.
From the collection of the Kervorkian
Foundation.

A Benin bronze head of an Oba (king)
from Nigeria. $18\frac{1}{4}$ in.
London £5,200 ($12,480). 13.VII.71.
From the collection of Dr Ernst
Augustin.

A Maori carved wood head, the entire
face and mouth elaborately tattooed. 9¼ in.
London £9,000 ($21,600). 13.VII.71.

An Attic marble grave stele decorated
with a farewell scene. *Circa* 350 B.C.
44¾ in. by 39 in.
London £9,500 ($22,800). 12.VII.71.

A Roman marble bust of a priest of Serapis or
Helios. 3rd century A.D. 29⅞ in.
London £7,000 ($16,800). 12.VII.71.

1. Rhodian gold pectoral ornament. Late 7th C. B.C. Each plaquette 1 in. by $\frac{7}{8}$ in. £1,950 ($4,680). 29.III.71. **2.** Greek gold bracelet with ribbed hoop. 4th C. B.C. £600 ($1,440). 12.VII.71. **3.** An Etruscan silver applique on bronze base. 6th C. B.C. $2\frac{1}{2}$ in. by $2\frac{7}{8}$ in. £600 ($1,440). 12.VII.71. **4.** Greek pottery black-figure Skyphos, Boeotia. *Circa* 4th C. B.C. 12 in. $2,400 (£1,000). 25.II.71. **5.** East Greek silver cup. Early 6th C. B.C. $8\frac{3}{4}$ in. Probably Lydia. £4,200 ($10,080). 8.XII.70. **6.** Greek bronze helmet. 7th/early 6th C. B.C. $11\frac{1}{2}$ in. $3,000 (£1,250). 25.II.71. **7.** Egyptian bronze female figure. 23rd/25th Dynasty (*circa* 817–656 B.C.). $27\frac{1}{2}$ in. $8,250 (£3,437). 18.XII.70. **8.** Late

Hellenistic marble torso of Hygeia. *Circa* 1st C. B.C. 17 in. £1,800 ($4,320). 12.VII.71. **9.** Roman marble male torso from Rhodes. 1st/2nd C. A.D. $13\frac{1}{2}$ in. £1,250 ($3,000). 12.VII.71. **10.** Lower half of a late Hellenistic marble figure of Aphrodite. 2nd/1st C. B.C. 15 in. £1,400 ($3,360). 12.VII.71. **11.** Egyptian stone figure of Djed-Ptah-Iuf-Ankh. Late 25th Dynasty (700–656 B.C.). $10\frac{1}{2}$ in. $4,500 (£1,875). 18.XII.70. **12.** Hellenistic stone head of Aphrodite. *Circa* 1st C. B.C. $11\frac{1}{2}$ in. $5,000 (£2,083). 25.II.71. **13.** Attic black-figure Hydria. *Circa* 530–525 B.C. $15\frac{1}{4}$ in. £1,300 ($3,120). 12.VII.71. **14.** Parthian gold necklace. 1st/3rd C. A.D. £2,400 ($5,760). 12.VII.71.

1. Islamic stucco relief. 10th/11th C. A.D. 18½ in. by 51 in. $6,000 (£2,500). 18.XII.70. **2.** Islamic stucco relief. *Circa* 13th C. A.D. 21 in. by 17¼ in. $2,750 (£1,146). 18.XII.71. **3.** Islamic brass writing box inlaid with silver and gold, Iran or Mesopotamia. Late 13th C. A.D. 7⅞ in. £1,500 ($3,600). 8.XII.70. **4.** Fatimid glazed pottery bowl. *Circa* 11th C. A.D. 7¾ in. £650 ($1,560). 8.XII.70. **5.** Islamic bowl in spun-brass from Afghanistan, probably Ghaznah. 11th C. A.D. 15¾ in. £1,700 ($4,080). 8.XII.70. **6.** Iranian pottery bowl. Late 12th/early 13th C. A.D. 7⅞ in. £450 ($1,080). 13.VII.71. **7.** Fatimid rock-crystal jar. 10th/11th C. A.D. 4 in. £4,000 ($9,600). 8.XII.70. **8.** Islamic brass box, Syria. Mid-13th C. A.D. 4⅛ in. £1,050 ($2,520). 8.XII.70. **9.** Islamic glass bottle. 8th/9th C. A.D. 8¼ in. £820 ($1,968). 8.XII.70. **10.** Persian pottery vessel. 8th/9th C. A.D. 22¾ in. $3,250 (£1,354). 18.XII.70. **11.** Tibetan tanka. 18th C. A.D. 22¾ in. by 31 in. £680 ($1,632). 13.VII.71. **12.** Tibetan silver Mahasiddha. 17th C. A.D. 7½ in. £540 ($1,296). 13.VII.71. **13.** Gandhara stone Bodhisattva. *Circa* 200–400 A.D. 63 in. $6,000 (£2,500). 3.IV.71. **14.** Gandhara stone frieze. 100–300 A.D. 23½ in. by 14½ in. $4,000 (£1,666). 18.XII.70.

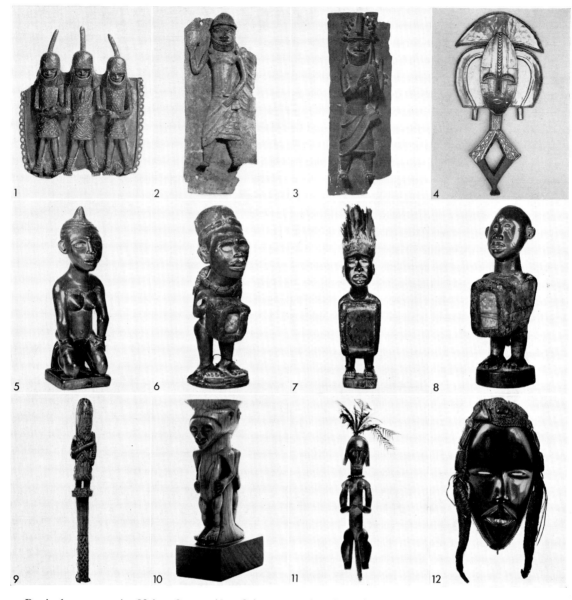

1. Benin bronze aegis. 6⅝ in. £1,900 ($4,560).
13.VII.71. **2.** Benin bronze plaque. 17 in. by
7¼ in. £4,000 ($9,600). 13.VII.71. **3.** Benin
bronze plaque. 17¾ in. by 6½ in. £3,000
($7,200). 13.VII.71. **4.** Bakota wood reliquary
figure, Gabon. 22 in. £1,400 ($3,360). 13.VII.71.
5. Bakongo wood female figure, Congo. 7¼ in.
£540 ($1,296). 13.VII.71. **6.** Bakongo wood
fetish figure, Congo. 8¾ in. £700 ($1,680).
13.VII.71. **7.** Bakongo wood fetish figure, Congo.

14 in. £720 ($1,728). 13.VII.71. **8.** Bakongo
wood male figure, Congo. 9 in. £650 ($1,560).
13.VII.71. **9.** One of two Benin ivory sceptres.
11¾ in. £5,000 ($12,000). 30.XI.70. **10.** Basonge
ivory Janus finial. 4¼ in. £620 ($1,488).
13.VII.71. **11.** Wood Fang reliquary female
figure (*bieri*). Figure 24¼ in. £2,000 ($4,800).
30.XI.70. **12.** Dan wood mask. Ivory Coast.
10 in. £2,300 ($5,520). 13.VII.71.

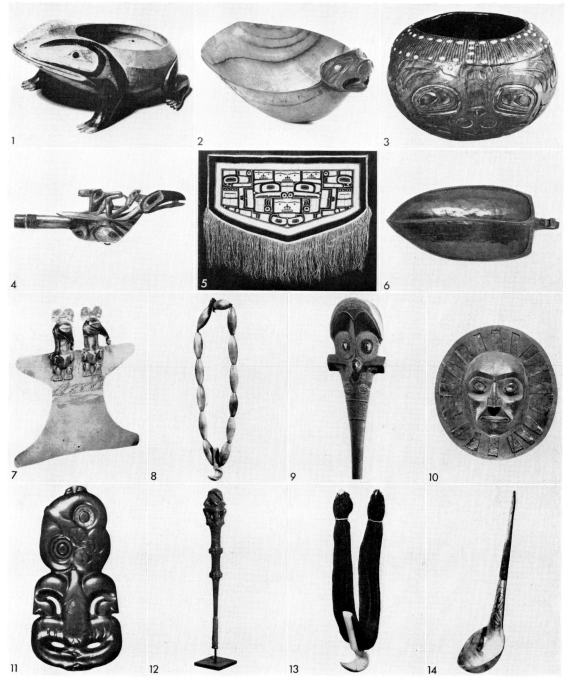

1. Haida wood vessel, 9¼ in. $2,100 (£875). 8.v.71. **2.** Pacific North-West Coast horn ladle. 8½ in. £1,500 ($3,600). 13.VII.71. **3.** Pacific North-West Coast wooden bowl, Tlingit. 11½ in. $4,100 (£1,709). 8.v.71. **4.** Pacific North-West Coast wood rattle, Tlingit. 12¾ in. £1,300 ($3,120). 13.VII.71. **5.** Pacific North-West Coast woollen blanket, Tlingit. 50 in. by 63 in. $4,000 (£1,666). 8.v.71. **6.** Fiji Islands wood dish. 35¼ in. by 15⅛ in. £720 ($1,728). 30.XI.70. **7.** Colombian gold pectoral ornament, Angostura. 1100–1500 A.D. 4½ in. $2,300 (£958). 6.III.71. **8.** Hawaiian Islands ivory necklace, Wailuku. 18¼ in. $2,100 (£875). 7.XI.70. **9.** Marquesas Islands Casuarina wood club, Polynesia. 57¾ in. £560 ($1,344). 30.XI.70. **10.** Pacific North-West Coast wood mask. 15¾ in. £900 ($2,160). 30.XI.70. **11.** Maori jade tiki. 6 in. £920 ($2,208). 13.VII.71. **12.** Tahitian wood fan or fly-whisk handle. 12½ in. £620 ($1,488). 13.VII.71. **13.** Hawaiian Islands hair and ivory necklace, Oahu Island. 15 in. $2,600 (£1,083). 7.XI.70. **14.** Pacific North-West Coast horn ladle, Haida. 23½ in. $1,100 (£458). 8.v.71.

Chinese Ceramics and Works of Art

Important Chinese ceramics and works of art of all types and periods have been sold this season, ranging from the magnificent bronze *fang yi*, which fetched £16,000 ($38,400) in November, to the superb group of Chinese taste porcelain of the Ch'ing dynasty which achieved a totally new level of prices in July.

Apart from the bronze mentioned above, three other fine examples were sold this season. In the sale on 17th November, a wine vessel (*chih*) of the eleventh or early tenth century B.C. was sold for £3,600 ($8,640), and in March a late sixth/early fifth century B.C. *ting* and an eleventh/tenth century wine vessel (*yu*) were sold for £5,000 ($12,000) and £7,000 ($16,800) respectively.

One of the most important works of art was the large and impressive Eastern Wei grey limestone stele showing the Buddha Sakyamuni flanked by Bodhisattvas, made in Honan province in the mid-sixth century A.D., which was bought on 2nd March for the Victoria and Albert Museum for £10,000 ($24,000), a price which reflects the exceptional rarity of large scale Chinese sculpture of this type and quality on the market today. The following July, a marble figure of a Buddhist priest, missing the head, from the Sui dynasty also sold well for £3,200 ($7,680).

In the last two years, there has been a marked shift of taste towards early Chinese ceramics, particularly of the T'ang dynasty and the finest examples of Sung wares, and this season Sotheby's have sold some outstanding examples. In March, a large T'ang glazed pottery jar was sold for the remarkable sum of £28,000 ($67,200), the highest price ever achieved at auction for a piece of this period; in the same sale, a superb T'ang blue-glazed jar realized £8,500 ($20,400) and a glazed pottery figure of a camel fetched £7,500 ($18,000). The following July, an unsaddled Fereghan horse with a pale chestnut glaze, probably the most popular type of T'ang pottery animal, was sold for £12,000 ($28,800).

Of the Sung pieces, unquestionably the most important was the Ting-yao basin, the interior beautifully carved with a tree peony, which was sold in March for £49,000 ($117,600), the second highest price ever paid at auction for any ceramic object. The exceptional demand for this rare and classically simple pottery was perhaps more clearly demonstrated the following July when a Ting-yao bottle, with a sizable chip out of the rim, still managed to fetch £7,000 ($16,800).

The finest piece of Ming porcelain sold during the season was a fifteenth century blue and white stem cup which fetched £44,000 ($104,600), the auction record for a piece from this dynasty. This is the subject of an article by John Tallents on pages 480–487. Amongst other pieces, a Chêng Tê blue and yellow dish, which had previously been sold at Sotheby's in 1960 for £1,050 ($2,940), fetched £6,500 ($15,600).

The sale in July was remarkable for the outstanding group of Chinese taste pieces of the Ch'ing dynasty, a type of porcelain rarely seen on the market in such quantity. Although the quality of these objects was superb, the prices paid were surprising and may well have served to re-focus attention on this area of collecting. A pair of imperial 'famille-rose' bowls of the Yung Chêng period fetched £13,000 ($31,200), a magnificent pair of peach dishes realized £9,500 ($22,800) and a pair of small dishes with quail made £11,000 ($26,400).

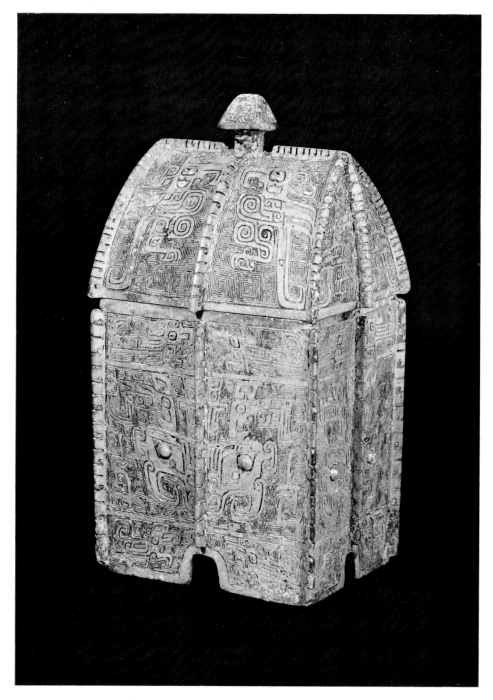

An archaic ritual bronze vessel (*fang yi*), with rare decoration of
confronted birds on the sloping sides of the cover.
Shang Dynasty. 8⅝ in. high by 4⅞ in. wide by 3¾ in. deep.
London £16,000 ($38,400). 17.XI.70.

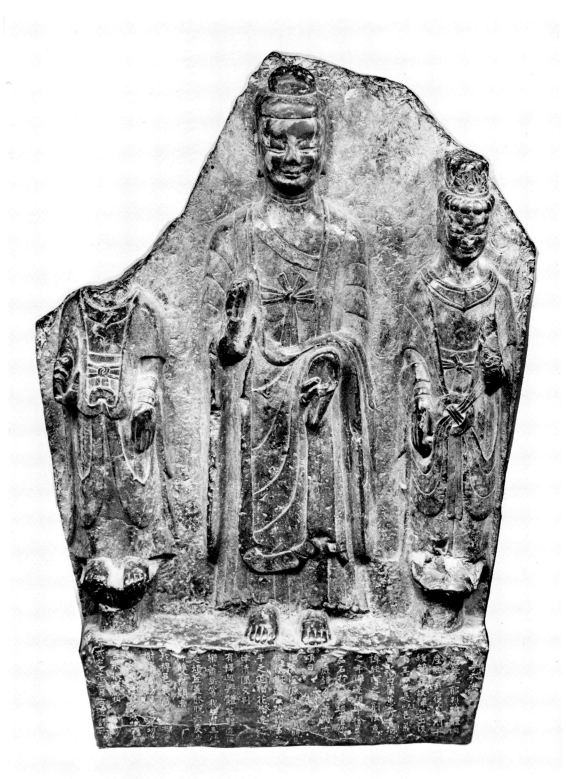

An Eastern Wei grey limestone stele, the central figure of the Buddha
Sakyamuni standing with right hand raised in *abhaya mudra* and the left hand
lowered, flanked by two smiling figures of standing Bodhisattvas on pedestals.
Honan. Mid-6th century A.D. 36½ in. high by 27 in. wide.
London £10,000 ($24,000). 2.III.71. Now in the Victoria and Albert Museum.

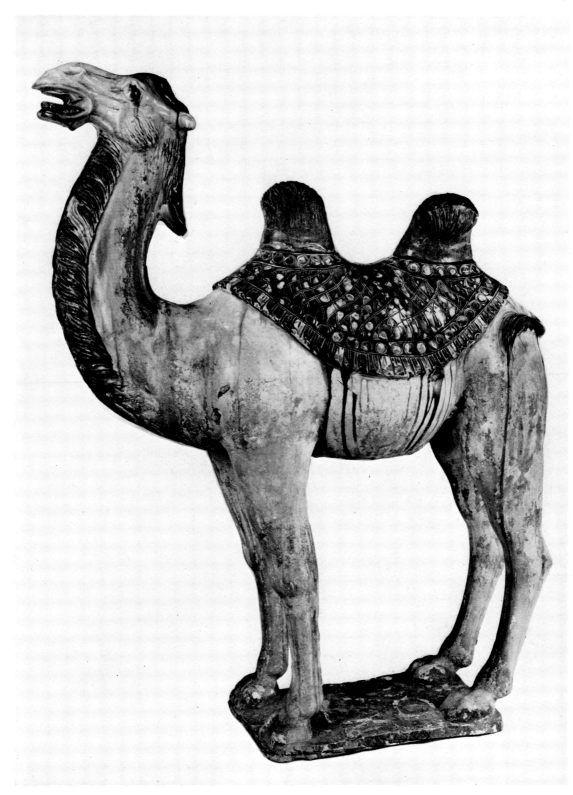

A glazed pottery Bactrian camel.
T'ang Dynasty. 30½ in.
London £7,500 ($18,000). 2.III.71.
From the collection of
K. L. Essayan, Esq.

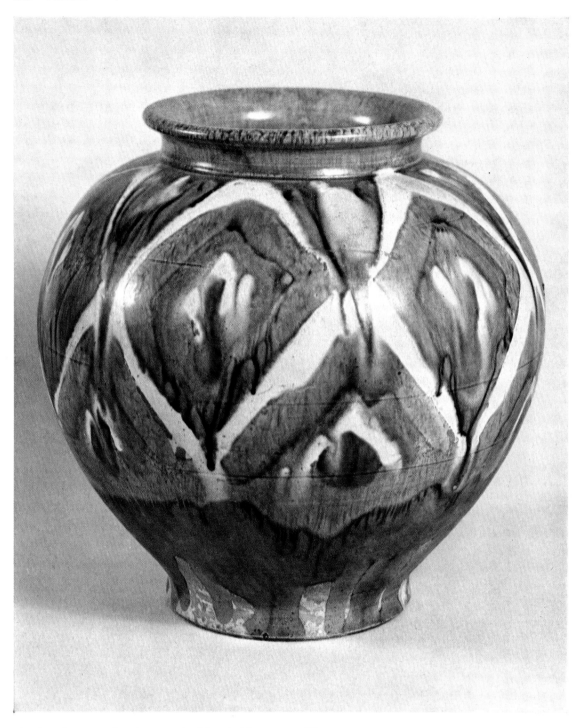

A glazed pottery jar decorated with a bold pattern of lozenges
outlined in green and orange, with white centres splashed in blue.
T'ang Dynasty. 10 in. high by 10¼ in. wide.
London £28,000 ($67,200). 2.III.71.

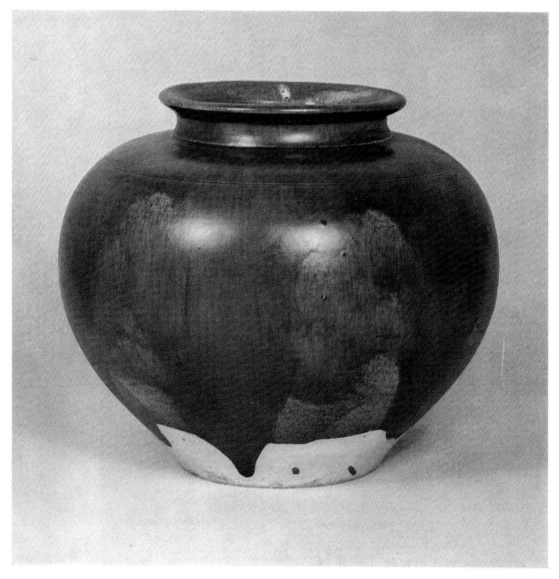

A plain blue-glazed jar.
T'ang Dynasty.
7 in. high by 8 in. wide.
London £8,500 ($20,400). 2.III.71.

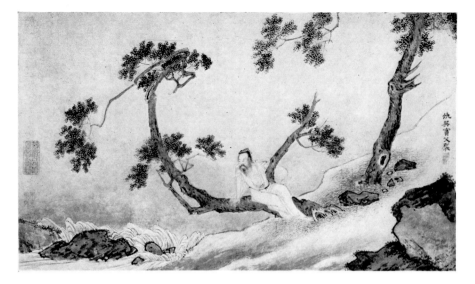

CH'IU YING (active first half of 16th century)
A scholar contemplating a rushing stream.
Ink and colour on paper. Signed by the artist with one seal. Five collectors'
seals, including two from the Ming Dynasty. Calligraphy in *li* style by Wên
Chêng-ming, dated 1558, with his two seals. First half of 16th century.
Handscroll. 11¼ in. by 19⅝ in. New York $10,000 (£4,166). 5.III.71.
The Sung historian–statesman Ssu-ma Kuang (1019–86) is here portrayed in
his Garden for Solitary Enjoyment (*Tu-lo yüan*), resting and looking at the
rushing stream, no doubt reflecting on the lament of Confucius, who likened
the irretrievable passage of time to the incessant flow of water.
From the Chiang Er-Shih collection.

LANG SHIH-NING (Giuseppe Castiglione) (1688–1766)
An imperial archery contest.
Colour on silk. Signed by the artist with his two seals. Eight imperial seals
and eight seals of officials who wrote the colophons. Handscroll.
20¾ in. by 104 in.
New York $12,000 (£5,000). 13.XI.70.
The artist, a Jesuit missionary from Milan, arrived in the capital of the
Manchu Empire in 1715 and enjoyed imperial patronage as an artist and
architect from 1723, under two emperors, Yung-chêng and Ch'ien-lung. The
painting commemorates an archery contest in an imperial park not far from
the ill-fated Old Summer Palace (*Yüan-ming Yüan*) designed, by Lang among
others, as a Chinese Versailles and destroyed by joint British–French forces
in 1860. According to Ch'ien-lung's colophon, the contest took place some
time between 1743 and 1751.
From the collection of S. C. Wong of San Francisco.

WU PIN (active 1568–1617)
Sixteen Lohans and Kuan-yin.
Ink and colour on paper. Signed by the artist with his one seal under signature and two seals at
the beginning of the painting. Title in four large characters by Mi Wan-chung (1570–1628) with
his three seals. Ten seals of Emperor Ch'ien-lung, one each of Emperor Chia-ch'ing and Emperor
Hsüan-t'ung, plus four more Ch'ien-lung seals on the mounting. Dated 1591. 20th century
colophon with three seals by T'ang Pin-yin. Handscroll. 12⅝ in. by 13 ft. 6¾ in.
New York $40,000 (£16,666). 5.III.71.
Lohans, or Arhats, are Buddhist figures who have attained enlightenment for themselves but are
not concerned about others attaining it. Kuan-yin or Avalokitésvara, on the other hand, is the
Bodhisattva of Infinite Compassion, who extends divine power to deliver his (or her) believers from
every kind of peril. The combination of Lohans and Kuan-yin has long been popular with Chinese
figure painters.
From the Chiang Er-Shih collection.

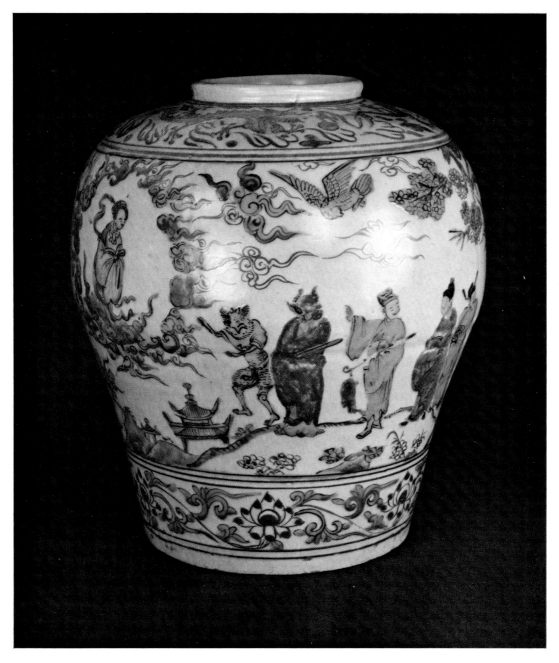

An enamelled Swatow jar of shouldered form, with an
unusual Buddhist subject depicting a female deity
surrounded by a *mandorla* of green and turquoise
clouds, accompanied by a group of civil officials and
two demons.
Late Ming Dynasty. 11¾ in.
London £6,500 ($15,600). 2.III.71.

A fluted Ting-yao basin with a tree peony spray carved in the
centre and sprays of lotus round the sides, the rim metal mounted.
Sung Dynasty. $3\frac{5}{8}$ in. high by $8\frac{3}{4}$ in. wide.
London £49,000 ($117,600). 2.III.71.
From the collection of Mrs Alfred Clark.

A vase in Ku Yüeh-hsüan style, the sides painted in 'famille-rose' enamels, with repairs on the neck and base. Four character mark of Ch'ien Lung in blue enamel, and of the period. $7\frac{1}{4}$ in.
London £6,500 ($15,600). 6.VII.71.
Formerly in the Charles Russell Collection.

One of a pair of peach dishes painted in 'famille-rose' enamels, the design continuous over the rim. Six character marks and period of Yung Chêng. $8\frac{1}{8}$ in.
London £9,500 ($22,800). 6.VII.71.

An imperial 'famille-rose' bowl decorated in Ku Yüeh-hsüan style. Four character mark of Ch'ien Lung in blue enamel, and of the period. $4\frac{1}{2}$ in.
London £7,000 ($16,800). 6.VII.71.
Formerly in the Charles Russell Collection.

One of a pair of imperial 'famille-rose' bowls, each decorated in Ku Yüeh-hsüan style with a group of peonies. Four character marks of Yung Chêng in blue enamel and of the period. 5 in.
London £13,000 ($31,200). 6.VII.71.

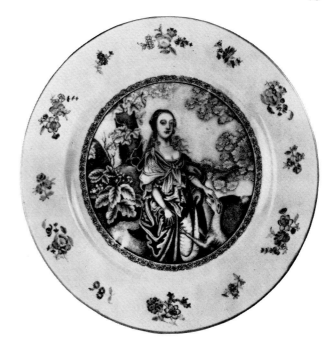

A grisaille plate with a portrait of Elizabeth Gunning as the Duchess of Hamilton and Argyll, after Gavin Hamilton. Ch'ien Lung. 9⅛ in. London £660 ($1,584). 20.IV.71. Elizabeth Gunning was one of three sisters who were all famous beauties. The portrait is engraved in mezzotint by James Faber junior. From the collection of Mrs M. Ayress.

A 'famille-rose' satirical punch bowl, one side enamelled with a kilted Scotsman seated with his legs in the two compartments of a twin-seated privy, festoons of coloured flowers and a minute inscription 'O Sawnoy, Why leav'st thou thy Nelly to moan' and the Jacobite motto *Nemo Me Impune Lacessit*; the reverse inscribed with a rhyme entitled 'Sauney's Mistake'. Inscribed from the caption of the print: *R. Dighton delin. London*. Late Ch'ien Lung. 11¼ in.
London £2,000 ($4,800). 27.X.70.
The anti-Jacobite engraving was first published in 1745 under the title 'Sawney in the Bog-house'. The subject has been attributed to Hogarth.

One of a pair of 'famille-rose' butterfly bowls, each painted with four medallions of different naturalistic butterflies among various flowers. Six character marks of Yung Chêng in underglaze-blue and of the period. 5¼ in. London £7,000 ($16,800). 6.VII.71.

One of a pair of 'famille-rose' Chinese taste saucer dishes, enamelled with quail among rocks and flowers. Six character marks of Yung Chêng, in underglaze-blue and of the period. 5⅜ in. London £11,000 ($26,400). 6.VII.71.

A Chinese taste 'famille verte' bowl painted with a detached branch with red berries, the reverse with two butterflies hovering over a leaf and blossom. K'ang Hsi. 3⅞ in. London £1,700 ($4,080). 6.VII.71.

One of a pair of Chinese taste 'famille verte' shallow bowls with domed bases. Six character marks of K'ang Hsi in underglaze-blue and of the period. 5¼ in. London £2,800 ($6,720). 6.VII.71.

A Chinese taste 'famille verte' bowl with flared sides, the exterior enamelled with a bird perched on a forked branch. Six character mark of K'ang Hsi in underglaze-blue and of the period. London £8,500 ($20,400). 6.VII.71.

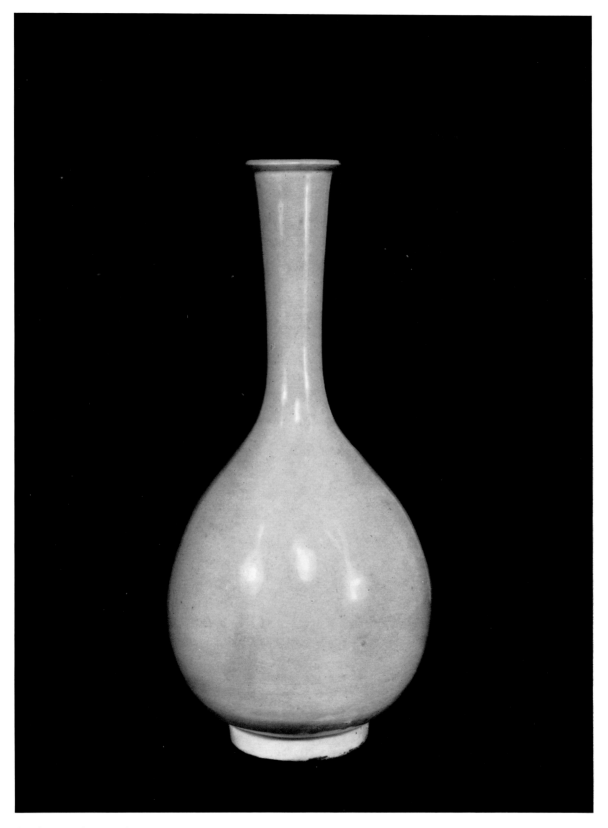

A Ting-yao bottle of a size and form that appears to be previously unrecorded, the flanged rim of the neck with a small repair. 11th century. 11¾ in. London £7,000 ($16,800). 6.VII.71.

1. Northern celadon bowl. Sung Dynasty. 8 in. £2,900 ($6,960). 18.v.71. **2.** Kuan-yao cup. 13th C. 3¼ in. £6,000 ($14,400). 2.iii.71. **3.** Ming green dragon dish. Six character mark and period of Chêng Tê. 6⅞ in. £3,400 ($8,160). 6.vii.71. **4.** Ming blue and yellow dish, six character mark and period of Chêng Tê. 11½ in. £6,500 ($15,600). 2.iii.71. **5.** Tou Ts'ai chicken cup, six character mark and period of Ch'êng Hua. 3¼ in. wide. £14,000 ($33,600). 2.iii.71. **6.** Ming sacrificial red saucer dish. 15th C. 7⅝ in. £5,000 ($12,000). 2.iii.71. **7.** Tureen with arms of Sir Nathaniel Curzon. Ch'ien Lung.

16½ in. £4,500 ($10,800). 20.iv.71. **8.** One of pair of ruby-back 'famille rose' dishes. Yung Chêng. 6⅛ in. £5,500 ($13,200). 6.vii.71. **9.** 'Famille rose' tureen and stand, *circa* 1775. 7 in. and 9¾ in. $5,500 (£2,292). 18.ix.70. **10.** 'Famille rose' plate enamelled with *Earth* scene after Francesco Albani. Ch'ien Lung. 9 in. £1,200 ($2,880). 27.x.70. **11.** Fitzhugh hot-water dish with U.S. arms. $5,250 (£2,187). 11/12.xii.70. **12.** *Saint Peter*: 'famille rose' plate painted with Saint Peter. Ch'ien Lung. 9 in. £1,500 ($3,600). 6.vii.71.

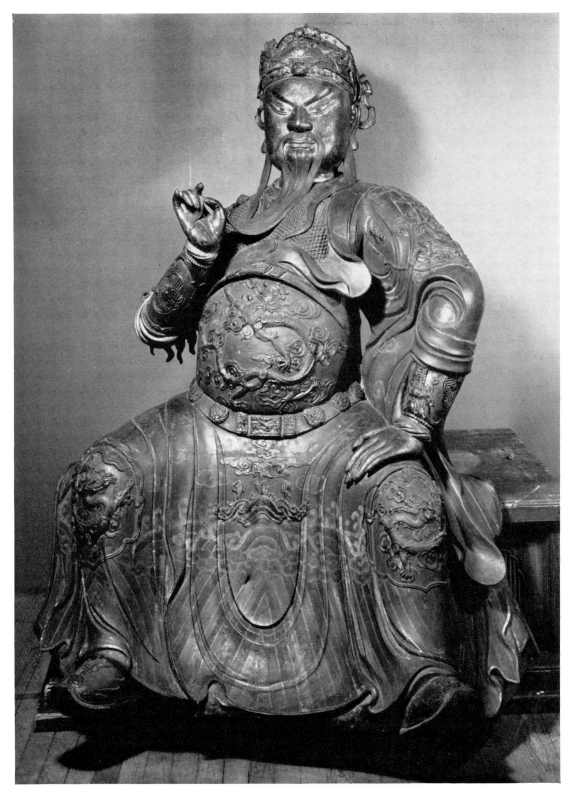

A painted bronze statue of Kuan Ti, the Chinese God of War, with a Japanese
lacquered base. Ch'ien Lung period. 5 ft. 11½ in.
New York $9,000 (£3,750). 16.IV.71.
From the collection of the Isabella Stewart Gardner Museum, Boston.

1. Korean celadon ewer and cover. 11th/12th C. 6½ in. £1,600 ($3,840). 6.VII.71. **2.** White-glazed bottle. T'ang Dynasty. 5¼ in. high by 6 in. wide. £1,500 ($3,600). 2.III.71. **3.** Archaic bronze covered vessel (*ting*). Late 6th/early 5th C. B.C. 8 in. wide by 6⅝ in. high. £5,000 ($12,000). 2.III.71. **4.** Carved hornbill casque. 9½ in. £460 ($1,164). 18.V.71. **5.** Pair of cloisonné enamel standing pigeons. Ch'ien Lung. 7 in. by 7½ in. £1,600 ($3,840). 2.III.71. **6.** Fei-Ts'ui jade quatrefoil bowl with stand. 10 in. $3,250 (£1,354). 13.XI.70. **7.** Imperial spinach green jade brush pot. Ch'ien Lung. 6¼ in. $5,300 (£2,208). 24.XI.70. **8.** Carved stone Bodhisattva. Sui Dynasty. 43½ in. $8,000 (£3,333). 13.XI.70.

9. Headless marble Buddhist priest, from the Ssû Men-t'a, Shantung province. Sui Dynasty. 41 in. £3,200 ($7,680). 6.VII.71. **10.** Jade covered vase. 8½ in. $3,200 (£1,333). 13.XI.70. **11.** Archaic bronze wine vessel and cover (*chih*). 11th/10th C. B.C. 6¾ in. by 4¼ in. £3,600 ($8,640). 17.XI.70. **12.** Unglazed pottery pedlar and rug merchant from Kashgar. T'ang Dynasty. 10¾ in. and 12¼ in. £2,800 ($6,720). and £2,600 ($6,240). 2.III.71. **13.** Glazed unsaddled Fereghan horse. T'ang Dynasty. 23½ in. £12,000 ($28,800). 6.VII.71. **14.** Archaic bronze covered wine vessel (*yu*). 11th/10th C. B.C. 13¼ in. £7,000 ($16,800). 2.III.71.

Japanese Works of Art

The highlights of the London season were the two sales containing extremely important lacquer and porcelain in November and the following May. In the November sale, an outstanding domed lacquer coffer, dating from the late seventeenth century, decorated with grapes, squirrels, pheasants and wisteria in mother-o'-pearl, gold and blue-grey lacquer on a black lacquer ground, fetched £2,800 ($6,720). This piece, made for the European market, is of a type which has only become popular in the West in the last two or three years and this was the highest price paid outside Japan.

The best porcelain was sold in May. Two very fine Nabeshima dishes realized £1,700 ($4,080) and £1,600 ($3,840) respectively. Made in Arita in the eighteenth century, such pieces can be recognized easily by their exquisite drawing in underglaze blue and their pale overglaze enamels. They are rarely seen on the Western market, although they have always been highly prized in their own country and, again, these were the highest prices achieved outside Japan.

The three-day sale of Japanese works of art held in New York in April was particularly outstanding for its magnificent group of colour prints, all of which were splendid impressions and in good condition, probably the finest offered at auction since the Mellor sale at Sotheby's in 1963. Several record prices were achieved including $8,000 (£3,333) for a *Kakemono-e* print by the early eighteenth century artist Okumura Masanobu, depicting a young girl reading a letter; this is the highest price ever paid in the West and it is worth noting that this particular impression has been sold at Parke-Bernet in 1952 for $200 (£41).

Amongst other fine examples were Hokusai's *Ri Haku* (*Li Po*) at $7,500 (£3,125), Chobunsai Eishi's superb depiction of a young woman, which fetched $6,300 (£2,625), a print of a similar subject by Utamaro at $4,000 (£1,667) and a *Kacho-e* (Bird and Flower) print by Hiroshige which fetched $4,500 (£1,874).

The Parke-Bernet sale also contained a large and important collection of sword fittings. A pair of nineteenth century Soten school *shakudo nanako* tsuba for a daisho, signed *Soheishi Soten sei*, realized $800 (£333), another pair for a daisho attributed to Ishiguro Masayoshi were sold for $1,300 (£542), whilst a magnificent pair of iron tsuba for a daisho by the nineteenth century master Araki Tomei (1817–70) fetched $3,500 (£1,458). In London, an important early *Goto Mitokoromono* attributed to Joshin (1512–62), was sold for £500 ($1,200) and an extremely fine iron tsuba by Kano Natsuo made £860 ($2,064), one of the highest auction prices achieved in the West for a piece of this kind.

One of the most noticeable features of the sales, both in London and New York, was the number of Japanese dealers and collectors bidding. They are now obviously keen to buy back some of the fine pieces which appear in the salerooms of the West to supply their rapidly expanding domestic market and some of the best examples sold this season have returned to Japan.

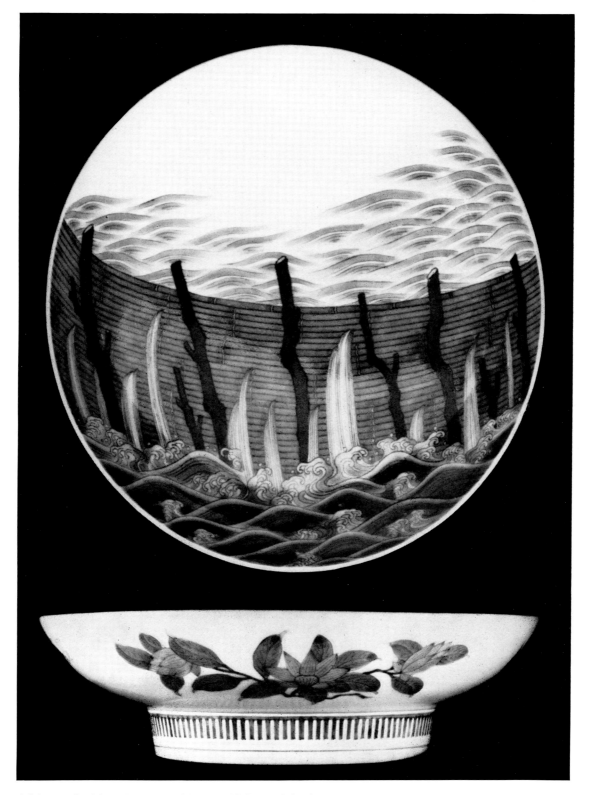

A blue and white *Nabeshima* dish on a high, straight foot.
Second half of 18th century. 19·7 cm.
London £1,600 ($3,840). 19.v.71.

HOKUSAI
Ri Haku (Li Po).
Kakemono-e.
New York $7,500 (£3,125). 28.IV.71.
This print depicts the Chinese T'ang dynasty poet
gazing at a waterfall while his attendants are
doing their best to prevent their master, who was
habitually in a state of intoxication, from falling
into the abyss. It is generally acknowledged to be
one of Hokusai's finest designs.
From the collection of Signor Paolino Gerli.

OKUMURA MASANOBU
A young *kamuro* kneeling and reading a
love letter, with an *oiran* standing
behind and looking down at her. Signed
*Hogetsudo Shomei Kongen Okumura Bunkaku
Masanobu shohitsu*, seal Tanchosai.
27 in. by 10 in.
New York $8,000 (£3,333). 28.IV.71.
The verse above reads: 'being negligent
in blossoming, the flower meets face to
face with green leaves'.
From the collection of Signor Paolino Gerli.

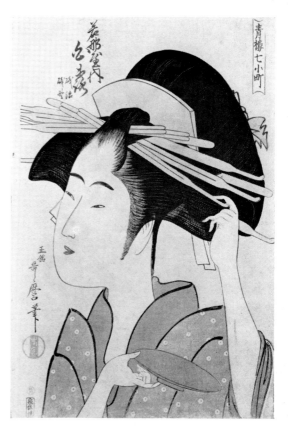

Above left: YUSHIDO SHUNCHO
Oban: A portrait of Okita of Naniwa-ya, a
waitress famed for her beauty.
$3,500 (£1,458).

Above right: UTAMARO.
Oban: Bust portrait of Shiratsuru, a
courtesan of Wakanaya. One of the series
Seiro Nana Komachi. Signed *Shomei Utamaro
hitsu.*
$4,000 (£1,666).

Below left: CHOBUNSAI EISHI.
Oban: young woman in cherry-blossom-
patterned *kimono*, representing Ono no
Komachi in the series *Furyu Ryaku Rokkasen.*
Signed *Eishi zu.*
$6,300 (£2,625).

The coloured prints illustrated on this page
are from the collection of Signor Paolino
Gerli, sold in New York on the 28th April
1971.

A *suzuribako* decorated on side and cover with a scene of a villa overlooking a forest and rice fields, with ladies dressed in Heian style. Late 17th century. 9 in. by 8¾ in. by 2 in. London £320 ($760). 24.XI.70. From the collection of John Lowe, Esq.

A *togidashi* lacquered *suzuribako*, decorated on the *roiro* ground with customers at a fan stall, in the style of the Shunsho family, who worked in the 18th and 19th centuries. 19th century. 19·7 cm. by 17·4 cm. by 2 cm. London £300 ($720). 24.II.71.

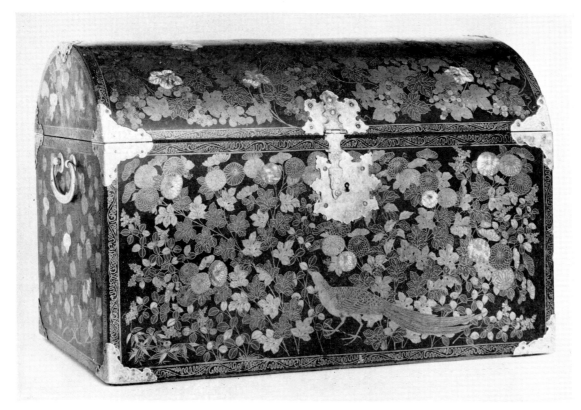

A domed lacquer coffer set with scrolling brass mounts. Late 17th century. 18½ in. by 27½ in. by 14¾ in. London £2,800 ($6,720). 24.XI.70. The brass latch was added in Germany in the first quarter of the 18th century, in Louis XIV style.

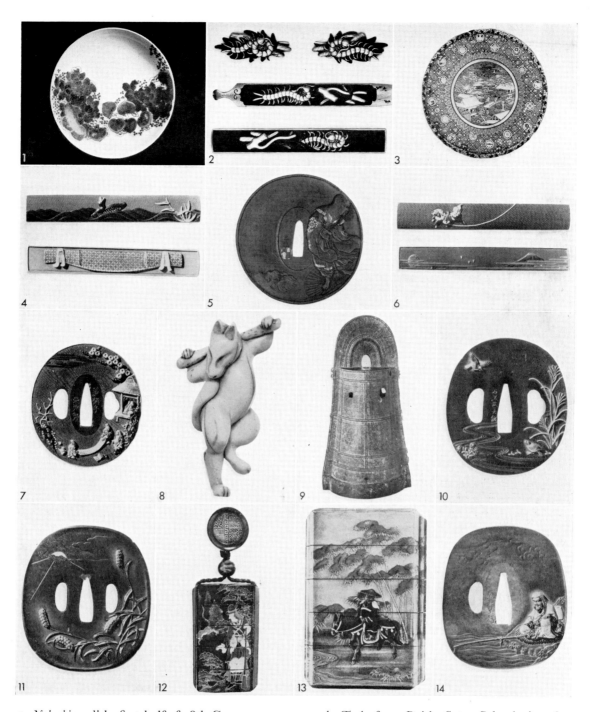

1. *Nabeshima* dish, first half of 18th C., 20·4 cm. £1,700 ($4,080). 19.v.71. 2. Early *Goto Mitokoromono* attributed to Joshin, £500 ($1,200). 7.xii.70. 3. *Komai*-style dish, signed *Nihon Kuni Tokyo (no) ju Komai sei*, 54·6 cm. £800 ($1,920). 19.v.71. 4. Copper *nanako Kozuka*, signed Yanagawa Naotoki, with *kakihan*, early 19th C. $250 (£104). 29.iv.71, and copper *nanako Kozuka* signed Hogen Haruaki (Shummei), with *kakihan*, dated May 1834. $600 (£250). 29.iv.71. 5. Iron *Tsuba*, signed Kano Natsuo, inlaid gold seal. £860 ($2,064). 5.iv.71. 6. *Shakudo nanako Kozuka*, signed Tsu Jimpo. $475 (£197). 29.iv.71, and *Shakudo nanako* and gold *Kozuka*, signed Funada Ikkin, with *kakihan*. $350 (£141). 29.iv.71. 7. One of a pair of *shakudo nanako Tsuba* for a *Daisho*, Soten School, signed prob. 19th C. $800 (£333). 29.iv.71. 8. Model of a dancing fox, unsigned, early 19th C. £800 ($1,920). 24.xi.70. 9. *Dotaku* of regular cast form, archaic period, 40·3 cm. £1,600 ($3,840). 19.v.71. 10. One of a pair of *shakudo Tsuba* for a *Daisho*, attributed to Ishiguro Masayoshi, signed with *kakihan*. $1,300 (£541). 29.iv.71. 11. One of a pair of iron *Tsuba* for a *diasho*, signed Araki Tomei with *kakihan*. $3,500 (£1,458). 29.iv.71. 12. European subject multicoloured lacquer *Inro*, unsigned, Meiji period. £700 ($1,680). 19.v.71. 13. Gold lacquer *Inro*, signed Riounsai. £400 ($960). 24.xi.70. 14. *Shibuichi Tsuba*, signed Katsunaga with *kakihan*, late 19th C. $700 (£291). 29.iv.71.

Works of Art

The outstanding feature of this season's sales has been the number of fine German bronzes. The splendid pair of South German bronze rampant lions, sold for £13,000 ($31,200) on 23rd March, were certainly the best semi-monumental sculptures of their type seen at auction for many years. They are closely attributable to Hans Krumper, who worked in Munich from 1584 until his death in 1634; they bear a strong resemblance to the pair of heraldic lions cast from models by Hubert Gerhardt which now stand at the two entrances of the Munich Residenz of the former Electors of Bavaria. Krumper was apprenticed to Gerhardt and worked on the production of the Residenz lions in the latter's workshop.

Amongst other outstanding German pieces were the magnificent aquamanile in the form of a standing lion, *circa* 1400, an unusually large example, which was sold in New York on 19th March for $23,000 (£9,583) and the beautiful gilt bronze figure of Eve from the workshop of Konrad Meit, *circa* 1500–50, which realized £1,800 ($4,320) in London in November.

Some distinguished Limoges enamels have been sold both in London and New York. The finest champlevé example was the thirteenth century chasse which fetched £6,800 ($16,320) in London in November. The most important of the later pieces was the superb oval medallion of *Gramatique*, which was sold in the Norton Simon sale in New York on 7th May for $21,000 (£8,749), an auction record for an item of sixteenth century Limoges enamel. Dating from the second half of the sixteenth century, this medallion was by Jean de Court, one of the greatest makers of the period.

The previous November, an early sixteenth century painted enamel plaque depicting *Christ on the Road to Calvary*, in the manner of Leonard Limousin, made £800 ($1,920) and in March, an unusual pair of candlesticks attributed to Jean de Court was sold for £980 ($3,352).

The most important of the English works of art sold this season was the ivory portrait bust of George II, attributed to van de Haagen, after Rysbrack, which realized £6,000 ($14,400) on 23rd March. This piece was of exceptional historical interest as it had been given by the King to his physician Doctor John Ranby (1703–73) and had remained in the possession of the recipient's family until it was offered for sale at Sotheby's.

Other English pieces included the impressive set of four sixteenth century wood heraldic lions which was sold in June for £2,000 ($4,800) and the marble portrait bust of Charles James Fox by Nollekens which made £1,500 ($3,600) in November 1970. This bust was extremely popular in its own day and there are many replicas of it in existence. The earliest known example, dated 1791, was apparently made for the Empress Catherine of Russia, whilst two others, of which the present example is one, are dated 1792.

One very interesting piece was the beautiful white marble figure of an Italian greyhound by Joseph Gott, executed in Rome in 1827; this was sold in June for £1,080 ($2,592). Gott was born near Leeds in 1796, was apprenticed for several years to the great neo-classicist John Stuart Flaxman and in 1807 was awarded a gold medal at the Royal Academy. In 1824, he went to Rome where he remained until his death.

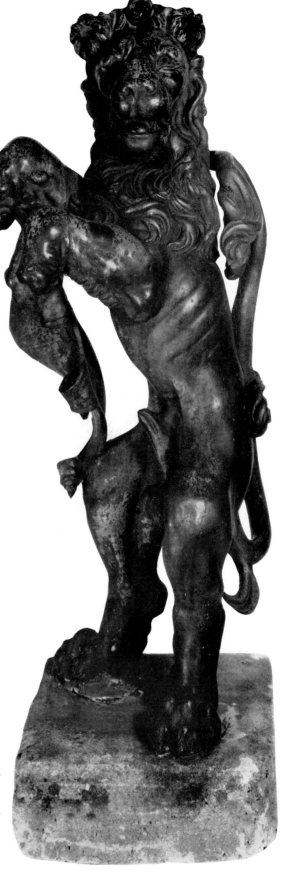

One of a pair of South German rampant bronze
lions, attributed to Hans Krumper.
Late 16th/early 17th century. 31 in. and 32 in.
London £13,000 ($31,200). 23.III.71.
This lion and its companion closely resemble
two pairs of heraldic lions cast from models
by Hubert Gerhardt, both of which now stand on
plinths in front of the entrances to the
Residenz of the former Electors of Bavaria in
Munich. Krumper did much work on the interior
and exterior decoration of the Residenz, so
these lions may have been intended for some
project that was later abandoned.

R*

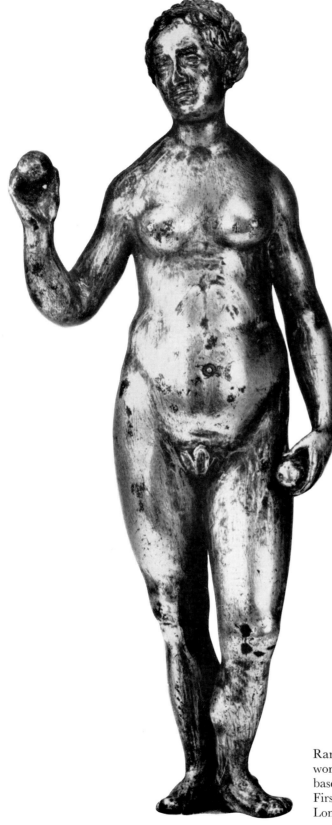

Rare gilt bronze figure of Eve, from the
workshops of Konrad Meit, on ebonized
base.
First half of 16th century. 6 in. high.
London £1,800 ($4,320). 17.XI.70.

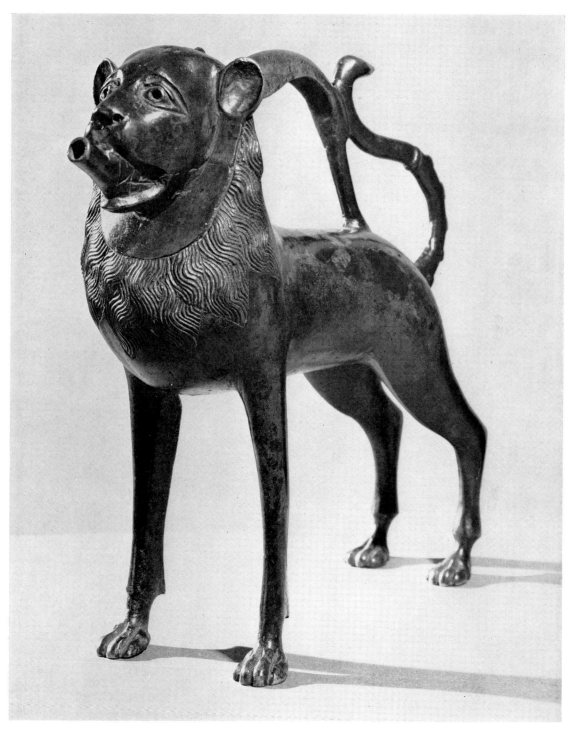

German aquamanile in the form of a standing lion.
Circa 1400. 12¼ in. high.
New York $23,000 (£9,583). 19.III.71.
From the collection of the late Irma N. Straus.

Above left: Limoges champlevé enamel pyx.
13th century. 4¼ in. high.
London £500 ($1,200). 17.XI.70.
From the collection of Baron de Bonstetten.

Above right: Limoges polychrome painted enamel
plaque in the manner of Leonard Limousin.
First half of 16th century. 6½ in.
London £800 ($1,920). 17.XI.70.
From the collection of the Bodmer
family of Zürich.

Left: One of a pair of Limoges enamel
candlesticks, attributed to Jean de Court
(Master I.C.), decorated *en grisaille* with
classical scenes, one after an engraving by
Jacques Androuet du Cerceau.
Late 16th century. 12½ in. high.
London £980 ($2,352). 23.III.71.
From the collection of Miss A. L. Lascelles

JEAN DE COURT
Limoges enamel oval medallion depicting Gramatique. Late 16th century. 20½ in. Signed: I.C.
New York $21,000 (£8,749). 7.V.71.
The border is adapted from a portrait of Henry II by Luca Penni which was engraved by
Nicolas Beatrizet in 1556. A similar shield, signed IDC this time, can be seen in the Galerie
d'Apollon in the Louvre.
From the collection of the Norton Simon Foundation.

Historic English ivory portrait bust of George II, attributed to van de Haagen, after Rysbrack. *Circa* 1740. 6¼ in.
London £6,000 ($14,400). 23.III.71.
This bust was formerly the property of Dr Ranby, physician to George II, to whom it was given by the King, and it remained in the possession of his descendants until this sale.

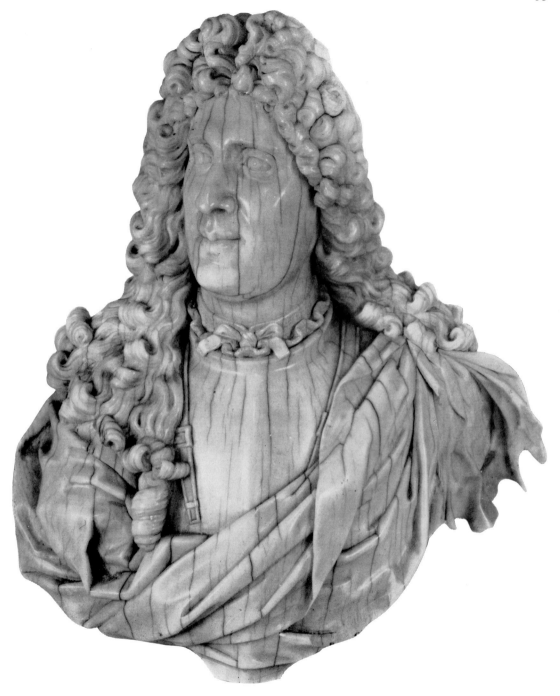

German ivory portrait bust, possibly of Duke Anton Ulrich of Brunswick.
Late 17th century. 6¾ in.
London £3,400 ($8,160). 17.XI.70.
From the collection of H. S. Worthington-Edridge, Esq.

Left:

F. BOSSUIT

Carved ivory relief of Hermes,
Argus and Io in the form
of a heifer.
Signed. Second half of 17th
century. 8⅜ in. by 4½ in.
New York $5,250 (£2,187).
19.III.71.
From the collection of the
late John G. Johnson, Esq.

Right:

F. BOSSUIT

Carved ivory relief of Marsyas
being flayed by Apollo.
Signed. Second half of
17th century. 8⅜ in. by 4½ in.
New York $6,000 (£2,500).
19.III.71.
From the collection of the
late John G. Johnson, Esq.

JEAN-BAPTISTE CARPEAUX
Early plaster study of *Bacchante aux Vignes*.
Signed. *Circa* 1872. 17¼ in. high.
New York $1,900 (£791). 16.x.70.
This is probably a unique cast.
From the collection of the late Fernand Belanger.

JEAN-BAPTISTE CARPEAUX
Early bronze cast of *Ugolin et Ses Enfants*, *modèle* completed 1861.
19 in. high. New York $5,200 (£2,166). 16.x.70.
Although its reception in Paris was less enthusiastic than in
Rome, the French State was nevertheless persuaded into paying for
a bronze cast by Victor Thiébaut. Originally placed in the
Tuileries and now in the Carpeaux galleries in the Louvre, this
bronze won a First Class medal for the sculptor when it was first
shown at the Salon of 1863.
From the collection of the late Fernand Belanger.

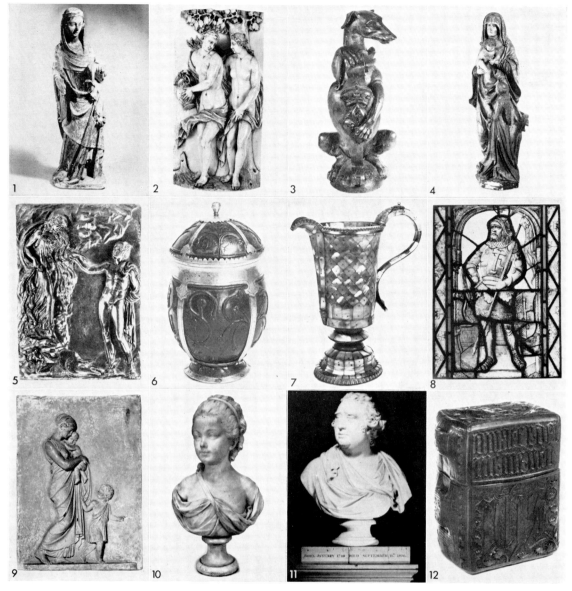

1. Polychrome stone figure of the Virgin and Child, Ile de France, 2nd half of 14th C., $31\frac{1}{4}$ in. $3,000 (£1,250). 19.III.71.

2. Netherlandish ivory plaque by a follower of François van Bossuit, early 17th C., $7\frac{1}{2}$ in. high. £900 ($2,160). 8.VI.71. **3.** One of a set of four English rampant heraldic beasts representing the royal arms, 16th C., 24 in. high. £2,000 ($4,800). 8.VI.71. **4.** South German limewood group of St Anne, the Christ Child and the young Virgin, *circa* 1540, 42 in. high. £2,100 ($5,040). 17.XI.70. **5.** Italian bronze relief of Perseus and Andromeda by Giacomo Zoffoli, signed G.Z.F., *circa* 1770, $9\frac{1}{2}$ in. by 7 in. £820 ($1,968). 23.III.71. **6.** North German or Baltic coconut cup in low relief, dated 1510 but overlaid in early 16th C. with silver-gilt mounts with flared foot, $5\frac{1}{4}$ in. £500 ($1,200). 8.VI.71.

7. Eastern Mediterranean mother-o'-pearl helmet ewer, 17th C., mounts 18th C., $10\frac{1}{2}$ in. £560 ($1,344). 8.VI.71. **8.** English stained-glass panel of Prester John, late 15th C., 22 in. by $16\frac{1}{4}$ in. $2,000 (£833). 19.III.71. **9.** Danish terracotta relief by Bertel Thorvaldsen, *circa* 1805–10, $26\frac{1}{2}$ in. £1,000 ($2,400). 23.III.71.

10. White marble bust of a girl by Louis Claude Vassé, dated 1770, 15 in. high. £3,400 ($8,160). 11.XII.70. **11.** English marble portrait bust of Charles James Fox by Nollekens, dated 1792, 28 in. high. £1,500 ($3,600). 20.XI.70.

12. German cuir ciselé book satchel, *circa* 1500. 6 in. £1,250 ($3,000). 17.XI.70.

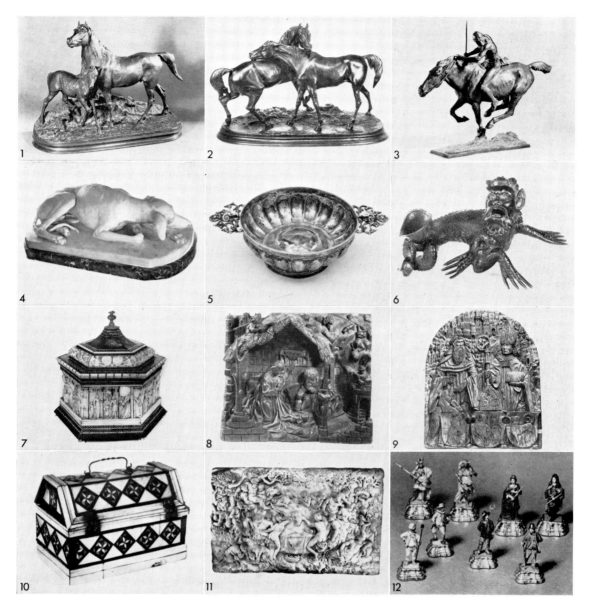

1. *Group of a Mare and a Colt* by Pierre-Jules Mêne, signed, dated 1868, length 23¾ in. $1,900 (£790). 16.x.70. 2. *L'Accolade* by Pierre-Jules Mêne, signed, length 20 in. £700 ($1,680). 30.iv.71. 3. *Bronze equestrian group of an American Indian* by Phimister Proctor, signed, dated 1914, length 24 in. $2,800 (£1,166). 28.v.71.
4. *White marble Italian Greyhound* by Joseph Gott, signed, dated 1827, length 20 in. £1,080 ($2,592). 8.vi.71. 5. South German silver parcel-gilt porringer, *circa* 1600, diameter excluding handles 4⅝ in. £1,100 ($2,640). 17.xi.70.
6. Italian bronze inkstand, from the workshop of Severo da Ravenna, first half of 16th C., 10½ in. £2,700 ($6,480). 23.iii.71. 7. Milanese ivory hexagonal casket from the Embriacchi workshops, 15th C., height 13 in., diameter 13 in. £800 ($1,920). 8.vi.71. 8. Flemish late Gothic oak relief of the Nativity, *circa* 1510, 18 in. wide. £1,600 ($3,840). 8.vi.71. 9. Swiss late Gothic limewood relief, dated 1535, 42 in. high. £2,500 ($6,000). 17.xi.70. 10. North Italian bone overlaid casket 15th C., 5 in. £620 ($1,488). 8.vi.71. 11. Italo-Flemish white marble relief of a Bacchic feast, late 16th C. or early 17th C., 30½ in. wide. £720 ($1,728). 8.vi.71. 12. Carved wood chess set on silver bases, with Augsburg mark of 1737–39, heights 2¾ in. to 3¼ in. (thirty-three pieces), size of chest 17½ in. square. $8,000 (£3,333). 19.iii.71.

Silver

On 15th October, Sotheby's sold the second part of the very fine collection of English silver formed by Mrs Fay Plohn of New York. 90 lots fetched £204,692 ($491,260) which, with the sum made by the first part sold in July 1970, brought the total for the whole collection to £451,050 ($1,082,520). The second part was particularly rich in the work of Paul Storr and two pairs of matching George III soup tureens, covers and stands, London 1806–7, the first pair slightly larger than the second, were sold for £9,500 ($22,800) and £8,000 ($19,200) respectively. These magnificent pieces were made for Ernest Augustus, Duke of Cumberland, the fifth son of George III, and were in the Egyptian taste, a style popularized in Europe after Napoleon's campaign in Egypt. The handles were in the form of cornucopiae from which issued the multi-breasted figure of the Ephesian Artemis; each bowl was applied with winged sphinxes and the bases with four winged lions.

The outstanding lot this season, however, was the pair of superb and unique wall sconces by Adam van Vianen, probably the greatest silversmith of the seventeenth century, which fetched £62,000 ($148,800) in June. Adam van Vianen was born in Utrecht about 1565 and was admitted a master silversmith in 1596; he died in 1627. With his brother Paul, he originated the Dutch Baroque auricular style and was the father of another great silversmith, Christian van Vianen. These are the only wall-lights known to have been made by Adam and the only pieces to be marked twice with his signature. Both Adam and Paul considered themselves artists rather than craftsmen and signed their most important pieces with their full names; other smiths used only initials or more anonymous marks.

Each sconce is embossed with two plaques of classical scenes, which can be found on other pieces from the same workshops but hitherto only pieces signed by Paul. It is interesting to note that a scene depicted on one of the upper plaques, *Mercury holding the head of the decapitated Argus*, appeared in reverse on the body of an ewer and basin signed VIAF which was sold at Sotheby's on 26th June, 1969 as from the workshop of Adam van Vianen and which is now in the Rijksmuseum, Amsterdam.

Another important item of Dutch silver sold this season was the silver plaque of *The Entombment* by Arent van Bolten of Zwolle, signed with the monogram AVB which fetched £2,000 ($4,800) in February. Coming from the distinguished collection of works of art formed by Hans and Peter Bodmer of Zürich, it is now in the Victoria and Albert Museum. Little is known about van Bolten; he was born in Zwolle, Holland, about 1573 and died before 1633. About 16 pieces from his hand are recorded.

Apart from the van Vianen sconces, the sale on 17th June was distinguished by three extremely important pieces of Tudor silver. A pair of Elizabethan parcel-gilt livery pots, maker's mark HL conjoined, London 1591, fetched £30,000 ($72,000) and a beautiful Edward VI parcel-gilt grace cup, maker's mark R.D. in monogram, London 1551, was sold for £36,000 ($86,400) illustrated on pages 4 and 5. Edward VI was on the throne for only five years and silver from his reign is therefore exceedingly scarce; indeed, apart from a very small number of spoons, this piece would appear to be one of only two from the period sold at auction this century.

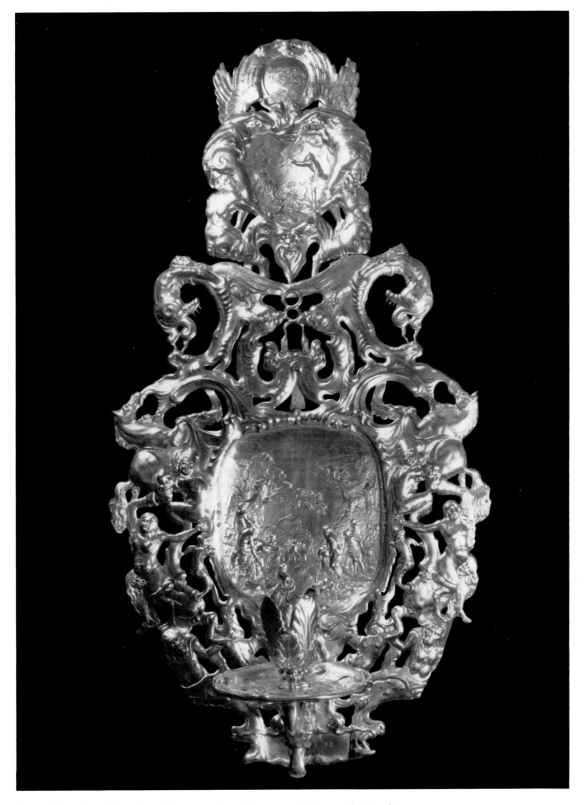

One of a pair of Dutch wall sconces by Adam van Vianen of Utrecht,
each plaque signed A.D. VIANE.FE.ANNO 1622. Height 23½ in. width 12½ in.
London £62,000 ($148,800). 17.VI.71.
From the collection of Sir Arundell Neave, Bt.

A Henry VIII travelling communion set, comprising a parcel gilt chalice and paten and a glass anointing bottle, contained in a contemporary leather-covered wood case. Maker's mark on the chalice a hanap, London 1534. Height 2½ in. London £5,200 ($12,480). 17.VI.71.

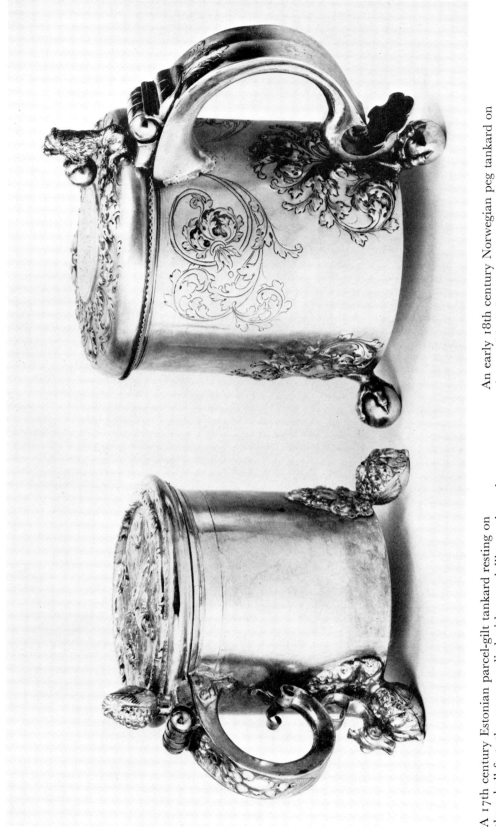

An early 18th century Norwegian peg tankard on claw-and-ball feet, engraved with baroque foliate sprays, the cover bearing an inscription and dated 1709, by Johannes Johannesen Reimers, Bergen, 1703, 7½ in. high. London £1,850 ($4,440). 17.VI.71. From the collection of Lt.-Col. H. C. J. Rome.

A 17th century Estonian parcel-gilt tankard resting on three ball feet, the cover applied with a medallion embossed and chased with warriors, probably by Joachim Thomson, Reval, *circa* 1690, 6¼ in. high. London £1,200 ($2,880). 17.VI.71.

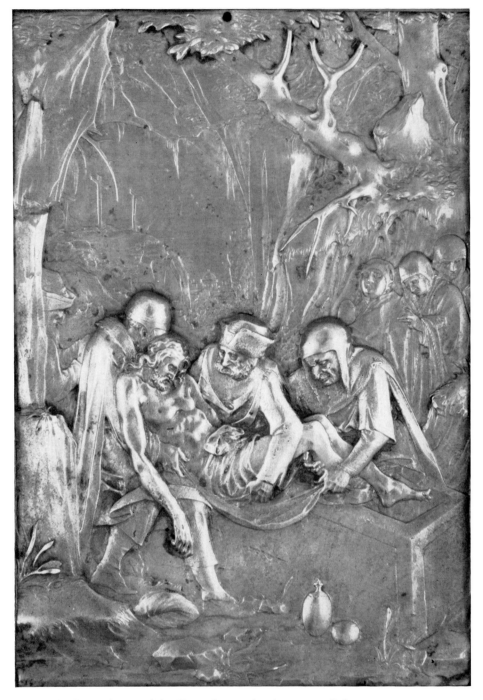

A Dutch silver plaque of the Entombment by Arent van Bolten
of Zwolle, signed with the monogram AVB, early 17th century,
7 in. high.
London £2,000 ($4,800). 11.II.71.
From the collection of Hans and Peter Bodmer.

A Queen Anne Irish circular porringer, the pierced flat handle engraved with a contemporary crest, possibly by Alexander Sinclair, Dublin, 1708–09. Diameter 5½ in.
London £2,100 ($5,040). 17.VI.71.

A Commonwealth cylindrical skillet, engraved with initials and a later coat-of-arms in a rococo cartouche and with a turned wood handle. Maker's mark R.S. between mullets, London 1650. 4¾ in. diameter.
London £1,400 ($3,360). 17.VI.71.
From the collection of H. P. Kitcat, Esq.

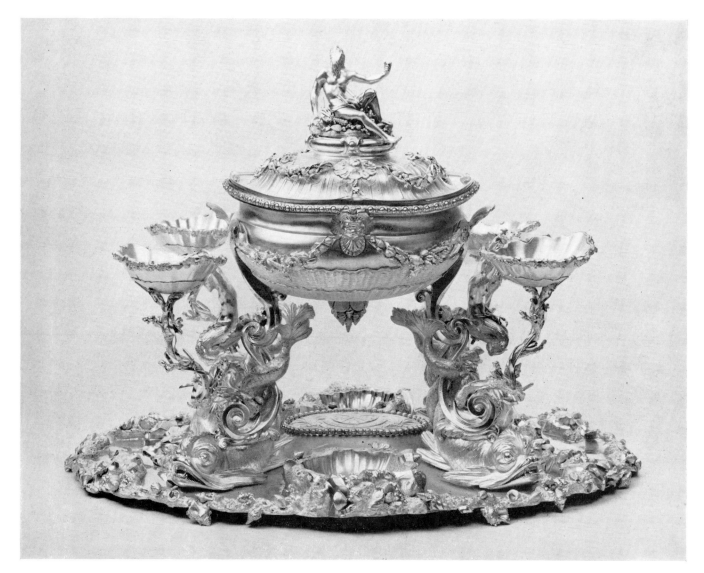

A George III centrepiece, by James Young, the oval base cast, chased and applied with shell-shaped salt cellars, the centre bearing the arms of Fitzgibbon, probably for John Fitzgibbon (1748–1802), who was Attorney General of Ireland, 1784, promoted to Lord Chancellor in June 1789, and created Viscount Fitzgibbon and Earl of Clare in 1795. The central tureen supported by four dolphins and with four detachable epergne dishes, 1786, $25\frac{3}{4}$ in. wide, $19\frac{1}{2}$ in. high. London £8,500 ($20,400). 22.x.70.

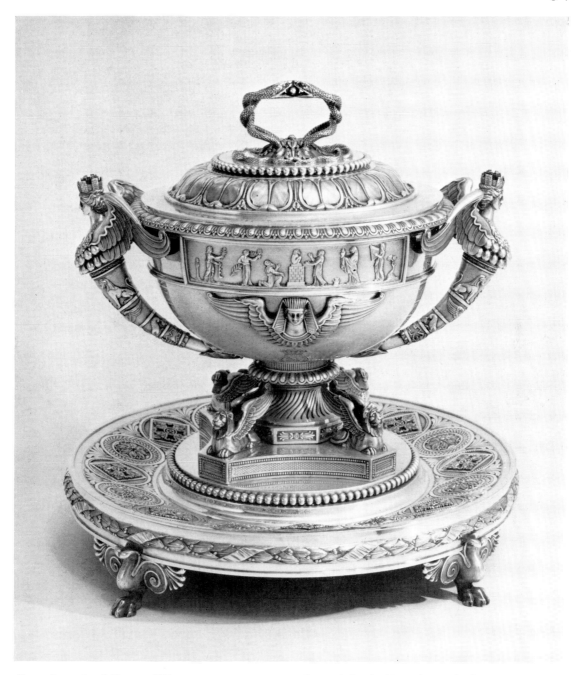

One of a pair of George III soup tureens, covers and stands in the Egyptian style, by Paul Storr, engraved with the Royal Badge and ducal coronet, the initials EDC for Ernest Duke of Cumberland and EA.F's for (Ernst Augustus Fideikommis) the entailed estate of Ernest Augustus. Bearing the Latin signature of Rundell, Bridge & Rundell, one tureen and cover, London 1806, the remainder 1807, $17\frac{1}{2}$ in. high, $17\frac{1}{2}$ in. diameter.
London £9,500 ($22,800). 15.x.70.
From the collection of Mrs Fay Plohn, New York.
Formerly in the collection of the Duke of Cumberland.

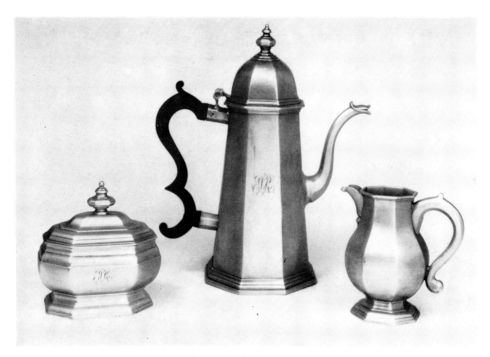

A George I Scottish coffee set of octagonal outline, by William Aytoun, Assay Master Edward Penman, Edinburgh, comprising a coffee pot, a sugar box and a cream jug, 1718–20, heights 10½ in. and 4¾ in.
London £9,800 ($23,520). 22.X.71.

A George I, II and III composite rat-tailed and three-pronged table service, comprising 113 pieces of various makers and dates.
London £5,800 ($12,192). 17.VI.71.
From the collection of Sir Hugh Dawson, Bt., C.B.E.

A George III teapot, by Paul Storr, London, 1811, $5\frac{1}{4}$ in. high. London £420 ($1,008). 17.VI.71. From the collection of M. A. Harvey.

One of a pair of George III four-light candelabra, by Paul Storr, 1808, 27 in. high. London £5,200 ($12,480). 11.II.71.

A George III silver-gilt oval cake basket, by Paul Storr, London, 1797, $20\frac{1}{2}$ in. wide. London £7,000 ($16,800). 15.X.70. From the collection of Mrs Fay Plohn, New York.

1. American silver teapot by Thomas Hammersley, New York, *circa* 1760. Length 9 in. $5,750 (£2,395). 16.iii.71. **2.** One of pair of George II escallop-shaped butter dishes by Paul de Lamerie, London, 1742. Width 5¼ in. £3,200 ($7,680). 17.vi.71. **3.** George III cow creamer by John Schuppe, London, 1763. Length 5¾ in. $2,600 (£1,084). 18.v.71. **4.** American silver waiter by Joseph and Nathaniel Richardson, Philadelphia, *circa* 1785. 8¾ in. $7,200 (£3,000). 10.xi.70. **5.** George III vinaigrette engraved with portrait of Lord Nelson, the interior with stamped and pierced view of the *Victory*, by Matthew Linwood, Birmingham, 1805. Width 1½ in. £350 ($840). 19.xi.70. **6.** One of set of twelve George I dinner plates bearing arms of Queen Anne, by David Willaume, Jr., London, 1725. 9¾ in. £13,500 ($32,400). 15.x.70. **7.** One of pair of early Charles I sweetmeat dishes by W. Maunday, London, 1631. 7 in. £3,500 ($8.400). 22.x.70. **8.** French silver-gilt toilet casket by Jean-Baptiste Claude Odiot, Paris, *circa* 1825. Length 10½ in. $5,200 (£2,167). 9.ii.71. **9.** William III ecuelle by Seth Lofthouse, London, 1697. 11 in. £2,300 ($5,520). 22.x.70. **10.** William III bowl by Jonathan Porter, London, 1701. 7 in. £800 ($1,920). 17.vi.71. **11.** One of pair of George III tea-trays by Paul Storr, London, 1814. Length 28½ in. $8,250 (£3,438). 13.x.70. **12.** One of pair of George III silver-gilt dessert baskets by Paul Storr, London, 1814. Diameter 10 in. £3,200 ($7,680). 22.x.70.

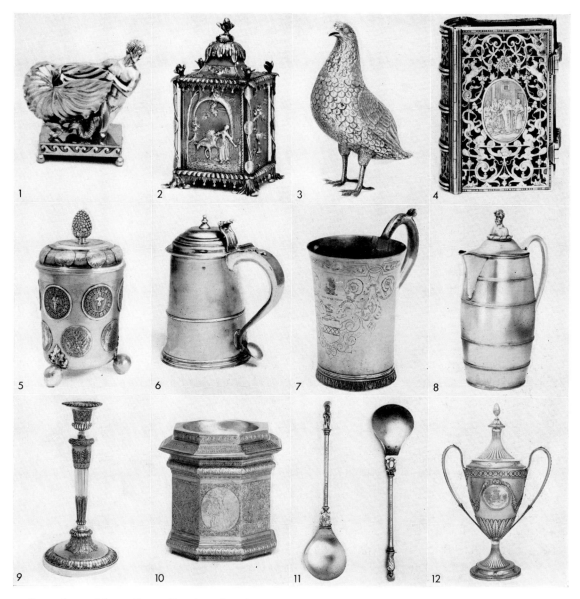

1. One of set of four silver-gilt salt cellars by Paul Storr, London, 1810. Width 4¾ in. £5,500 ($13,400). 15.x.70. **2.** George III tea caddy. Maker's mark *C.M.*, London, 1764. Height 6¼ in. £480 ($1,152). 3.xii.70. **3.** Partridge-shaped Dutch sugar box by Hubert van den Berg, Dordrecht. 1659. Height 8½ in. £1,800 ($4,320). 11.ii.71. **4.** Dutch book cover fitted with book of psalms. Second quarter of 17th C. Height 3½ in. £650 ($1,560). 11.ii.71. **5.** One of pair of German silver-gilt beakers and covers. Maker's mark *B.P.* Circa 1730. 9¼ in. high. £4,200 ($10,080). 29.iv.71. **6.** American silver tankard by Edward Winslow, Boston, *circa* 1730. Height 8 in. $8,250 (£3,437). 16.iii.71. **7.** American beaker by Hull and Sanderson,

Boston. *Circa* 1670. Later handle. Height 6¼ in. $4,750 (£1,979). 10.xi.70. **8.** One of pair of George III silver-gilt beer jugs by Paul Storr, London, 1795. Height 14½ in. £3,600 ($8,640). 11.ii.71. **9.** One of set of eight George III silver-gilt table candlesticks by Paul Storr, London, 1807-08. £8,800 ($9,600). 15.x.70. **10.** Dutch or German octagonal silver-gilt salt. Maker's mark a squirrel. Early 17th C. Height 4 in. £1,500 ($3,600). 11.ii.71. **11.** One of set of twelve German parcel-gilt apostle spoons by Christoph Stimmel, Breslau. *Circa* 1600. Length 9 in. $8,500 (£3,542). 9.ii.71. **12.** George III silver-gilt cup and cover by Hester Bateman, London, 1790. Height 24 in. £3,200 ($7,680). 11.ii.71.

Carpets and Tapestries

On 11th December, in London, the second half of the Kevorkian Foundation carpet collection, 19 pieces, was sold for £66,820 ($160,368), which, together with the 21 examples sold in December 1969 brought the total for the collection to £157,720 ($378,518). Unquestionably the finest piece in the second part was the splendid seventeenth-century Mughal carpet woven during the reign of Shah Jahan (1628–58), which was in an exceptionally fine state of preservation. The field was of a rich crimson red of an extraordinary freshness, woven all over with floral patterns, whilst in the borders, the presence of the famous *herati* design was testimony to the Persian influence on Mughal carpets of this period. This piece was purchased by the Metropolitan Museum for £14,000 ($33,600).

Amongst other fine carpets in the sale, a rare and beautiful Cairo rug, dating from the sixteenth century, fetched £10,500 ($25,200), whilst a pair of seventeenth-century Persian rugs, probably woven at Herat, were sold separately for £6,000 ($14,400) and £5,000 ($12,000) respectively.

In New York on 8th May, the sale of furniture, tapestries and works of art from the Norton Simon Foundation contained some important tapestries, including the magnificent set of four eighteenth-century Gobelins tapestries, which were purchased by the Paul Getty Museum for $190,000 (£79,166). These were woven between 1775 and 1778, under the directorship of Jacques Neilson after cartoons by Boucher and Maurice Jacques, by command of Louis XVI, and were presented by him to the Grand Duke Paul Petrovitch, later Tzar Paul I, and his wife Maria Feodorovna, who installed them in the Imperial palace of Pavlovsk, St Petersburg. They were part of the superb eighteenth-century works of art from this palace purchased by Lord Duveen from the Soviet Government in the early 1930s.

Amongst the Gothic tapestries in the same sale, a splendid late fifteenth-century Tournai piece, depicting *The Lord of the Manor*, one of the finest examples of its kind sold at auction for many years, realized $45,000 (£18,749), and an early fifteenth-century Brussels tapestry of *King Solomon and the Queen of Sheba at Ezion-Geber on the Red Sea*, realized $20,000 (£8,333). A few days later, on 14th May, property from the estate of the late Mary S. Higgins included an attractive fragment of a Gothic millefleurs tapestry, *circa* 1500, measuring only 3 feet 8 inches by 3 feet 10 inches, which was sold for $6,000 (£2,500).

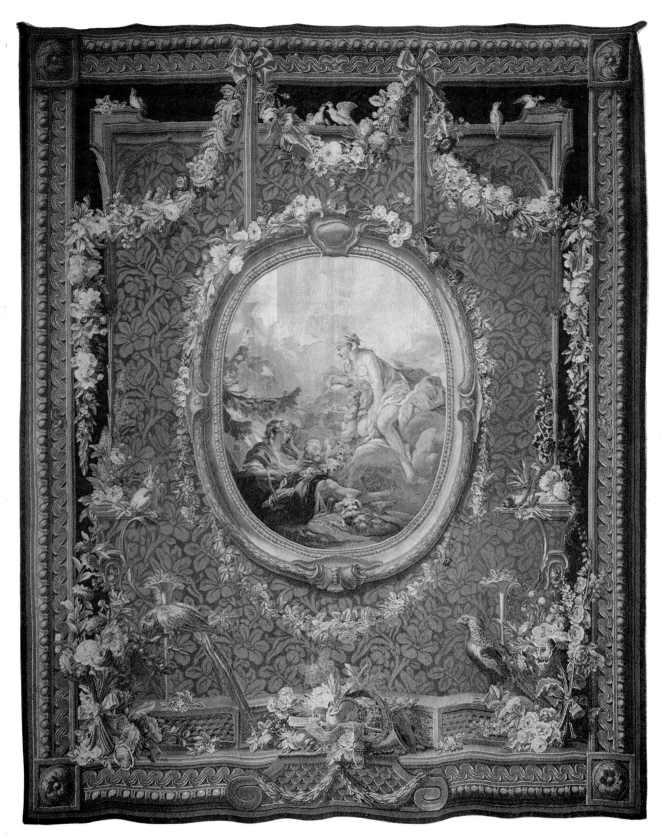

One of a set of four 18th century Gobelins tapestries, woven under the directorship of Jacques Neilson,
after cartoons by François Boucher and Maurice Jacques.
Woven between 1775 and 1778. 12 ft. 6 in. long by 10 ft. 7 in. wide. New York $190,000 (£79,166). 8.v.71.
These tapestries were woven by command of Louis XVI and presented by him in 1782 to the Grand Duke Paul
Petrovitch, later Emperor of Russia, and his wife, the Grand Duchess Maria Feodorovna. Two similar sets can
be seen in the Metropolitan Museum of Art and at Osterley Park.
From the collection of the Norton Simon Foundation.

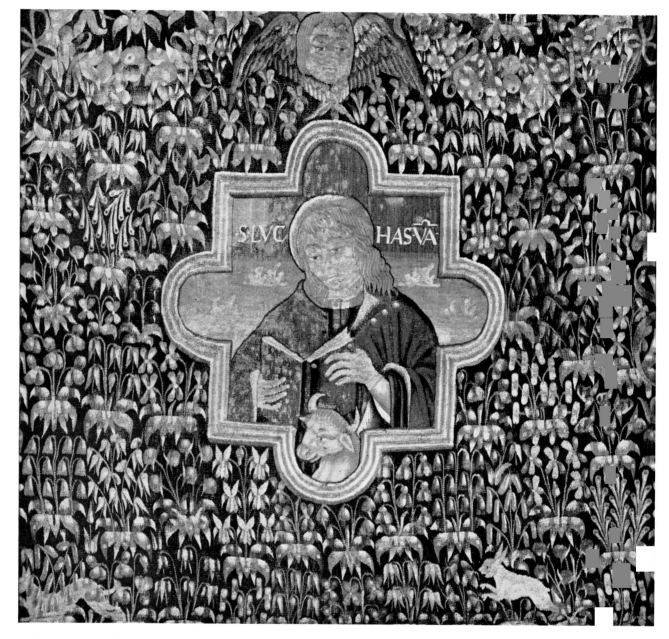

A fragment of a Gothic millefleurs tapestry with a panel in the centre simulating a wood moulding and containing a half-length figure of St Luke, accompanied by his attribute of an ox. Panel inscribed: *SLVC/HAS/VA*. *Circa* 1500. 3 ft. 8 in. high by 3 ft. 10½ in. wide.
New York $6,000 (£2,500). 14.v.71.
From the collection of the late Mary S. Higgins, Worcester, Mass.

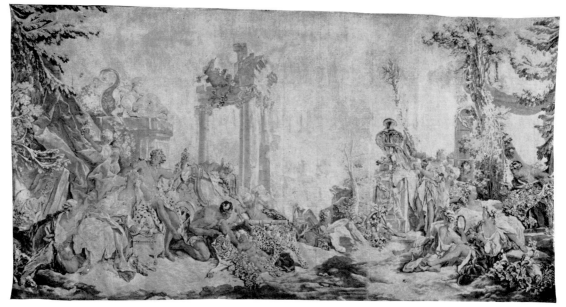

A Louis XV Beauvais tapestry comprising a double panel
from the series *Les Amours des Dieux* after François Boucher.
Designed 1749. 11 ft. high by 21 ft. 4 in. wide.
London £6,000 ($14,400). 4.VI.71.

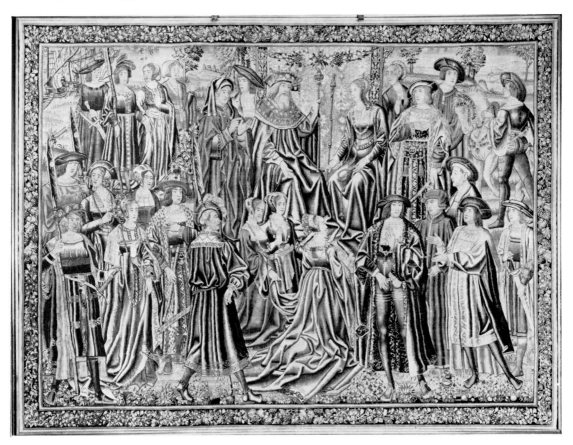

A Brussels tapestry depicting King Solomon and the Queen of Sheba at Ezion-Geber on the Red Sea.
First quarter of 16th century. 11 ft. 4 in. high by 15 ft. 8 in. wide.
New York $20,000 (£8,333). 8.V.71.
From the collection of the Norton Simon Foundation.

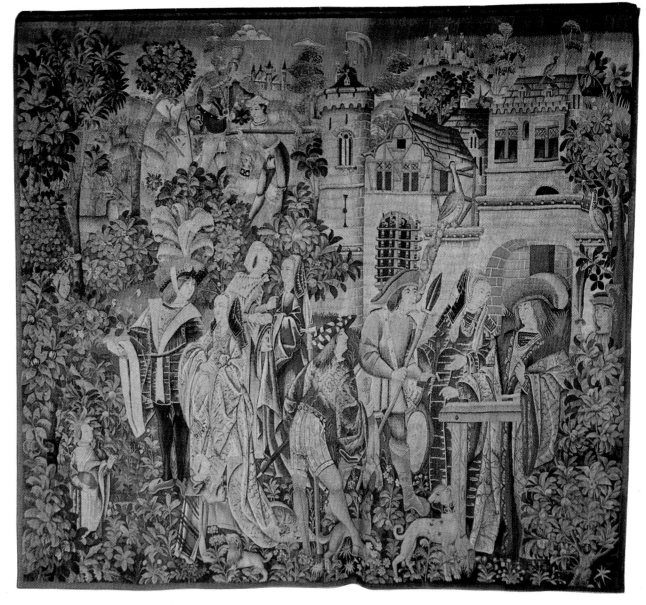

'The Lord of the Manor', a Tournai tapestry.
Circa 1475–1500. 11 ft. 4 in. high by 13 ft. wide.
New York $45,000 (£18,749). 7.v.71.
This tapestry is a reduction of a larger work.
From the collection of the Norton Simon Foundation.

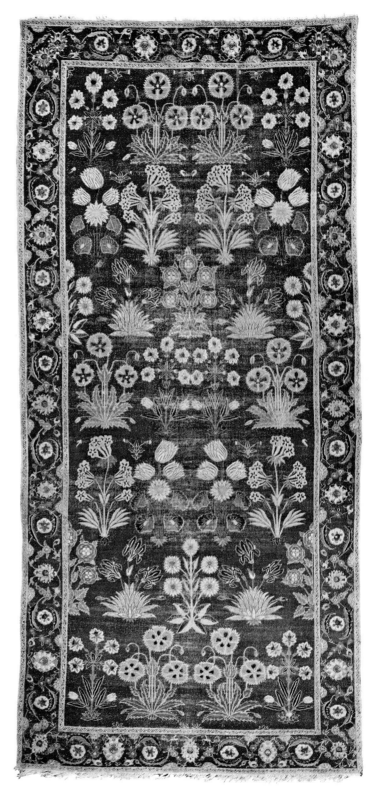

A 17th century Mughal carpet, the crimson field woven with unusually large sprays of flowers, the main border with the *herati* design on crimson. 14 ft. by 6 ft. 7 in.
London £14,000 ($33,600). 11.XII.70. From the collection of the Kevorkian Foundation.

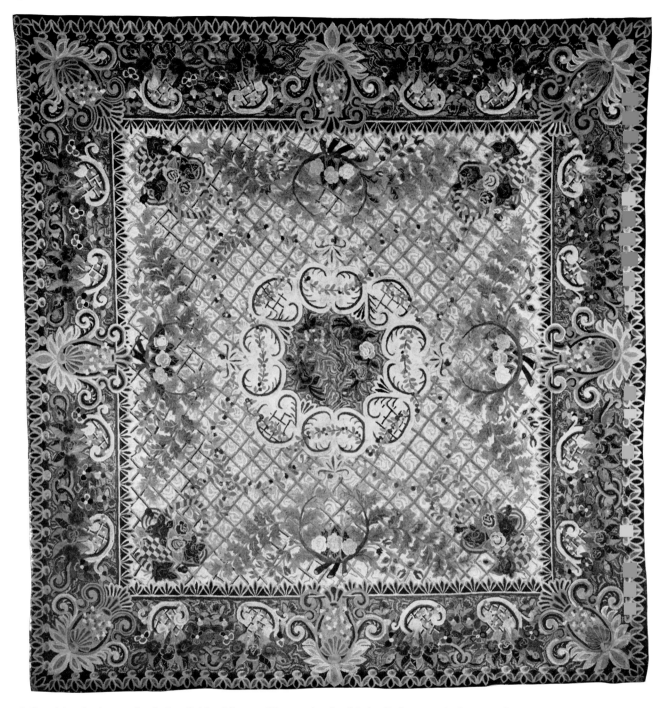

A floral hooked rug, the beige field with a trellis entwined with leafy ferns and clusters of roses.
10 ft. 11 in. by 10 ft. 5 in.
New York $7,000 (£2,917). 12.XII.70.
From the collection of Channing Hare.

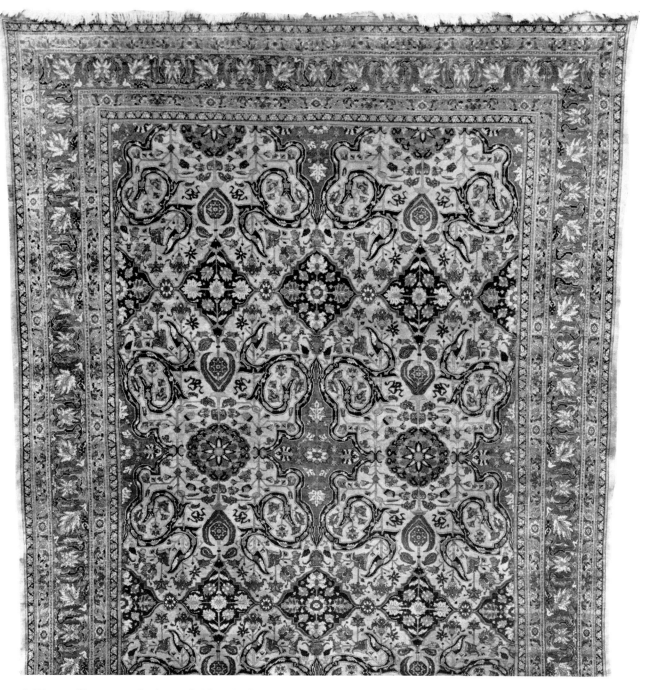

A Herez silk carpet, the ivory field with shaped diamond medallions in
rust and dark royal blue surrounded by blue strapwork and stylized plants.
13 ft. 3 in. by 10 ft. 5 in.
London £4,200 ($10,080). 4.XII.70.
From the collection of Dr A. Ofenheim.

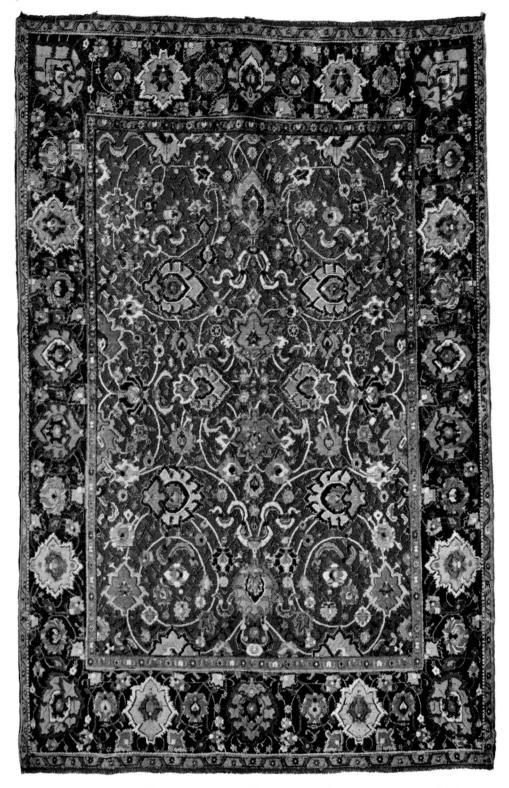

An early 17th century Persian rug, probably woven at Herat, the wine-red field
woven with the Shah Abbas design in white, yellow, blue and green.
7 ft. by 4 ft. 7 in.
London £6,000 ($14,400). 11.XII.70.
From the collection of the Kevorkian Foundation.

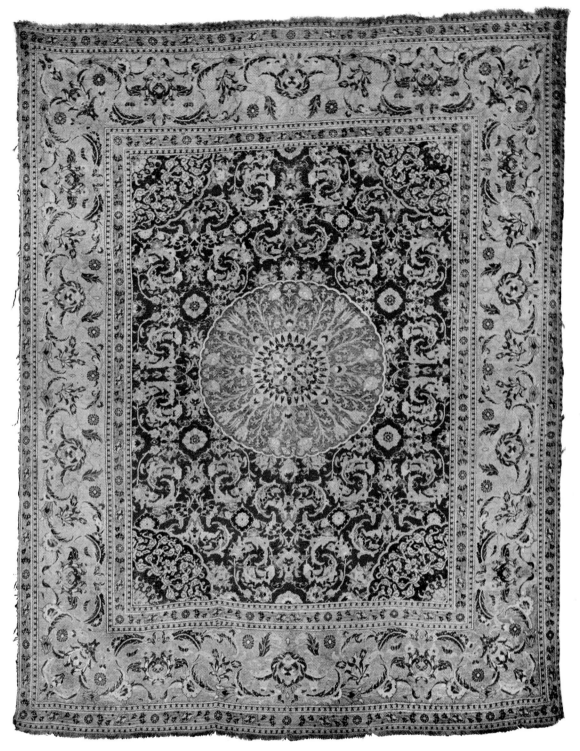

A 16th century Cairo rug.
8 ft. 3 in. by 6 ft. 7 in.
London £10,500 ($25,200). 11.XII.70.
From the collection of the Kevorkian Foundation.

Fig. 1 Commode by Carlin in oak veneered in ebony and inlaid with *pietra dura* plaques. Reproduced by gracious permission of Her Majesty the Queen.

Martin Carlin

BY DEREK SHRUB

The growing influence of women both in Paris and London was a noticeable factor in eighteenth century society. They might be unkindly described as 'blue stockings' but many of the men who so described them were eager to attend their salons.

With this development came the fashion for small intimate rooms and a relatively more informal way of life. Sophisticated comfort which demanded convenience without total loss of grandeur was the result. Louis XV in describing his great-grandfather's Palace at Versailles as 'extrèmement froid' was rationalizing upon a fashionable mood which caused him to remodel rooms at Versailles into 'Petits Appartements' and build the charming Petit Trianon for informal entertainments. In such settings the monumental, sombre coloured furniture of the seventeenth century was unsuitable and small colourful pieces supplanted them. The usefulness of such pieces was increased by the introduction of mechanical devices which allowed a piece of furniture to be transformed from its usual function of say an occasional table, into something more accommodating should the need arise (fig. 5).

A further development of the new informality was the introduction of small supper parties which although said to be respectable, dispensed with attendant servants. Louis XV is said to have designed a mobile dining table for such occasions which arose from the kitchens through the floor of the supper room. This presumably would be laid for a meal with food, dishes, etc. At the end of each course, the table would descend and re-appear re-laid. This was an ingenius and grand exception and the majority of hosts would use a *servante* which was a small table-cum-shelf unit to act as a sort of dumb waiter (fig. 4).

The ébéniste who most successfully catered for this environment was Martin Carlin. His work besides being practicably suited to the requirements of the time employed decoration of a similar type to the walls of fashionable Parisian interiors. The white panels of such rooms were painted with glamourized views of rural-life in subtle shades of pink, blue and green such as one sees in the paintings by Boucher and Fragonard – who actually undertook such work. The decorative scheme would be completed by carved and gilded wooden frames; in fact, very much the effect of the porcelain plaques with their ormolu surrounds used by Carlin on much of his furniture. On occasions the situation was reversed so that a particular piece of porcelain decorated furniture influenced the decor of a room; for instance, a small table with porcelain plaques was included in a list of items bought by Horace Walpole from the shop of Simon Poirier, decorative art dealer of Paris. This table was housed at Walpole's villa, Strawberry Hill and a Moorfields carpet was subsequently designed and made to match the plaques.

Although Carlin is perhaps the cabinet maker most often associated with the use of porcelain, he was by no means the only one to use it, nor the first. Bernard van Risenburgh, a Dutch ébéniste working in Paris, is thought to have been the originator

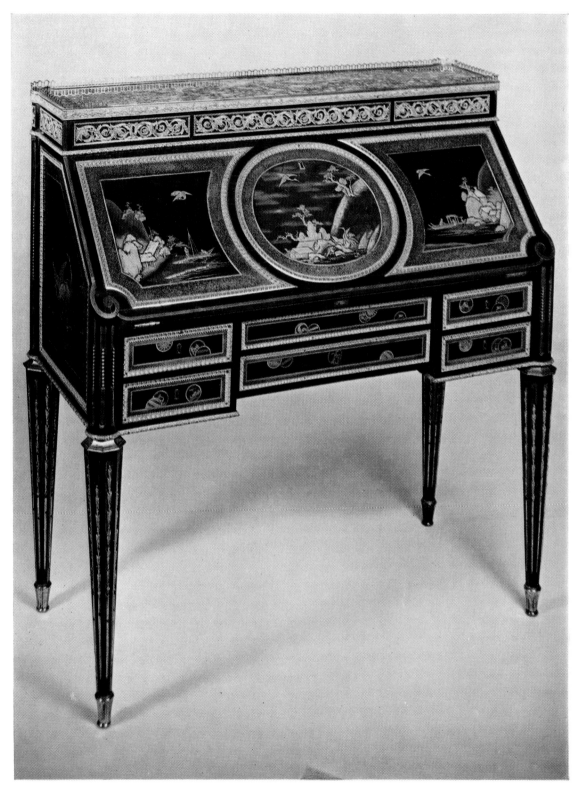

Fig. 2 A Louis XVI secrétaire en pente in Japanese black lacquer and ebony.
Stamped: *M. Carlin, J.M.E.* 3 ft. 4 in. high by 3 ft. 3 in. wide by 1 ft. 6 in. deep.
London £45,000 ($108,000). 11.XII.70.
From the collection of the Most Hon. The Marquess of Lansdowne, P.C., D.L.

of the decoration of furniture with Sèvres. Certainly the earlier (*circa* 1748-50) items of furniture embellished in this way are by him and these take the form of small work – coffee tables. The tops of these are formed by either a Sèvres soup plate or breakfast tray (the rims or handles of which were cut off and framed with ormolu). Whether this practice was an invention of Risenburgh's or that of the dealer Poirier for whom he worked, is not known. Whatever the case, Poirier soon gained a near monopoly of the porcelain plaque market and is thought to have dictated the design of many pieces of furniture decorated in this fashion. Besides employing Bernard van Risenburgh, Poirier also controlled the sale of Carlin's output. Carlin, like Risenburgh,

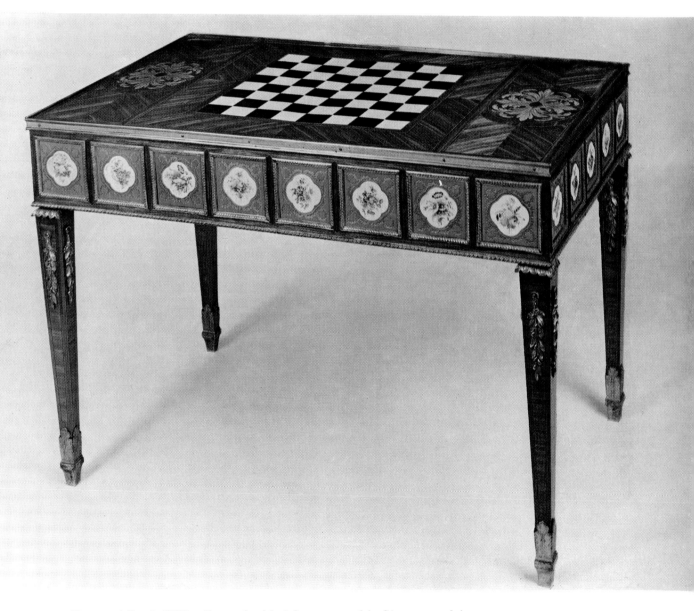

Fig. 3 A Louis XVI tulipwood table à jeu mounted in Sèvres porcelain.
Stamped: *M. Carlin*, *J.M.E.* 2 ft. 6 in. high by 3 ft. 6 in. wide by 2 ft. 2½ in. deep.
London £54,000 ($129,600). 11.XII.70.
From the collection of the Most Hon. The Marquess of Lansdowne, P.C., D.L.

was not a Frenchman by birth but was born at Freiburg im Breisgau, Germany in 1730. It is known that he trained with J. F. Oeben, one of the most important mid-century cabinet makers and himself German, and later married Oeben's sister. This inter-marrying within the furniture-making trade was quite common and served to preserve a workshop's success or to further an individual ébéniste on the outset of his career. Carlin became a master ébéniste in 1766 and some of the earliest porcelain used by him dates from this period; most of his work, however, is usually assigned to 1775–85 on stylistic grounds. A games table by Carlin which encompasses all the foregoing facts was sold at Sotheby's on the 11th December 1970 (fig. 3). This table of tulipwood is decorated with porcelain some of which is inscribed with Poirier's name and ranging in date from 1763 to 1775 (illustrating how one cannot safely date a piece of furniture from the porcelain decoration). Also, Carlin's mark is unusually clear on this piece.

The stamping of furniture by the ébéniste was obligatory in France from 1741 until the Revolution. With the appearance of the Marchand-Merciers – who were the dealer-decorators who acted as middlemen – certain pieces of furniture had their stamps obliterated in order, it is thought, to avoid clients contracting a direct sale with the craftsmen. Carlin's work is often treated this way and has to be attributed as a consequence. Such pieces as the games table mentioned above have an extra value, therefore, as a means of identifying pieces which are either unmarked or have had their marks obliterated. Considering this, it is perhaps less surprising that the table realized £54,000 ($129,600) although most of us would be staggered at this sum. Although the table was made in a period of French cabinet making renowned for quality its finish is dazzling. It is also a near miracle that its fittings are still intact, these are – removable gilt-metal candelabra, tooled leather dice shakers complete with six dice, a rare ormolu flag marker and thirty-two ivory backgammon counters in white and green which originally matched the colour of the porcelain plaques of the table.

The other piece (fig. 2) in the same sale gained £45,000 ($108,000) which although high seems less so in such company. This second piece was typical of Carlin's ability to handle with lightness what is basically a sombre material, black lacquer. This material had been particularly favoured for furniture making in the reign of Louis XIV and had been superseded by lighter and brighter coloured lacquers during the succeeding reigns; but the nostalgic spirit arising in the later years of Louis XV's Court revived interest in certain features of the Old Versailles style. While not wishing to obtain the large out-dated pieces of that period, Parisians preferred to employ cabinet-makers such as Carlin to remodel old pieces into the current taste. Perhaps the lacquer used on the charming *secrétaire en pente* originally decorated a cabinet-on-silvered-stand during the glorious reign of *Le Roi Soleil* – certainly such a concept would please the sympathetically decadent society for which Carlin worked. Of further interest is the sloping-front in a secrétaire of this date. This form with cabriole legs was more typical of the mid-eighteenth century, in fact just such an example by Jacques Dubois was included in the same sale (Lot 54). This would imply that certain clients did not want bang-up-to-date pieces, in fact it is recorded that Queen Marie Antoinette expressed a dislike for the extremes of the classical style which gained

favour in the late eighteenth century and commissioned her cabinet-maker, J. A. Riesener, to decorate cabinets etc. in a particularly rich manner, sometimes using mother of pearl. Riesener actually made a desk similar to Lot 45 for Mme Elizabeth as late as 1779, so it would seem that even the Court had a degree of conservative taste. Another instance of Carlin's treatment of these 'evocative' pieces is the superb commode recently on view in the Queen's Gallery, Buckingham Palace (fig. 1).

This is in the grand manner in that it makes use of *pietra dura* plaques set in ebony and yet is essentially of its period with mounts of great delicacy and proportions of a distinctly Louis XVI elegance. This was obviously part of the furnishings for re-modelled rooms at Windsor designed by Sir Jeffry Wyatville for George IV. These designs, which show such pieces, were sold at Sotheby's in April, 1970.

The present day success of Carlin's furniture, however, depends upon the smaller and more typically Louis XVI pieces, such as the games table. The high prices they command is surely due to the fact that our affluent Society is in spirit with the world of Carlin's day which in fact saw the rise of our middle-class (in the best sense) way of life and that these items of furniture are still eminently usable; letter writing is a chore for most of us and I find backgammon a bore, but an excuse to use as well as admire such objects as these, overcomes all inadequacy.

Fig. 4 *Le Souper Fin*, engraving after Moreau le Jeune.

Fig. 5 Combined work-writing- and reading-table (*table à ouvrage*) by Carlin. Reproduced by permission of the Trustees of the Wallace collection.

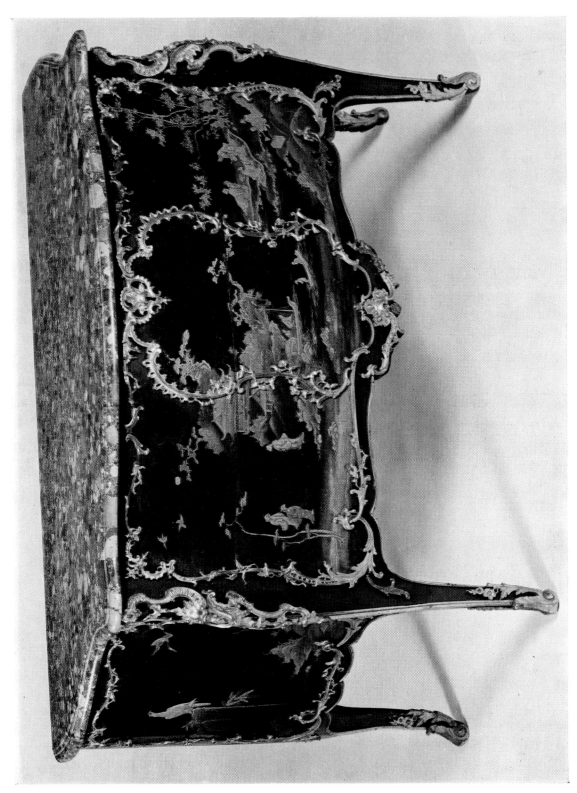

A Louis XV ormolu-mounted Japanese lacquer commode with a moulded
breccia marble top.
Stamped: *B.V.R.B.* 2 ft. 8½ in. high by 4 ft. 7 in. wide by 1 ft. 11 in. deep.
London £41,000 ($98,400). 11.XII.70.
From the collection of the Most Hon. The Marquess of Lansdowne, P.C., D.L.

Furniture

Outstanding French furniture is rarely seen on the market today but this season, there have been several examples in the London salerooms and four of the most important of these were sold at Sotheby's on 11th December. Three of the pieces came from Lord Lansdowne's collection at Meikleour House, Perthshire and had been inherited by descent from Auguste Charles Joseph, Count de Flahaut, a natural son of Talleyrand; two of these, a Louis XVI black lacquer and ebony *secrétaire en pente* and a Louis XVI tulipwood *table à jeu* inset with Sèvres porcelain plaques, were by the great late eighteenth century *ébéniste* Martin Carlin and fetched £45,000 ($108,000) and £54,000 ($129,600) respectively; they are discussed in an article about Carlin's furniture on pages 322–327. The third Lansdowne piece was a superb Louis XV ormolu-mounted black lacquer commode by Bernard van Risenburgh, one of the greatest mid-eighteenth century *ébénistes*, and one of the first to use Japanese lacquer to decorate commodes; it was sold for £41,000 ($98,400).

This same sale also contained the magnificent large bureau plat by Jean Mathieu Chevallier sent for sale by The Hon. Mrs. A. Plunket. Mounted with fines crolling ormolu, this table fetched £42,000 ($100,800), the highest price ever achieved for a piece by a native French *ébéniste*.

One of the most interesting features of the 1969–70 season was the large number of English Tudor pieces on the market. Although there have not been so many examples sold in the past year, a particularly beautiful Henry VIII carved oak 'joyned chair' from the collection of Mrs S. H. Barnett fetched £5,200 ($12,480) on 27th November. This was one of the finest pieces of its kind to have survived and was of unusual art historical interest since it showed the Italian Renaissance influence introduced into England in the first quarter of the sixteenth century. In the same sale, and from the same collection, a Henry VIII carved oak and painted four post bed realized £3,600 ($8,640).

Amongst later English furniture, a very attractive pair of late 18th century Chinese Chippendale armchairs, covered in Soho tapestry, made $11,000 (£4,583) in New York; a splendid George II mahogany armchair in the manner of Thomas Chippendale fetched the remarkable price of £4,400 ($10,560) in London. A very impressive pair of Chippendale Director armchairs also sold well for £6,400 ($15,360), in the same sale.

Although French furniture is still the most expensive of all European furniture, there has been increasing interest in the past two years in the hitherto undervalued pieces from other European countries, especially Holland and Italy. This season a beautiful mid-eighteenth century Dutch bureau cabinet was sold for £4,000 ($9,600), whilst two rare Italian pieces, a mid-seventeenth century red tortoiseshell cabinet and stand and a seventeenth century ivory inlaid writing table fetched £2,000 ($4,800) and £2,400 ($5,760) respectively; a writing table similar to the one mentioned here fetched only £800 ($2,240) at Sotheby's in 1965.

American furniture sold this season is discussed in the article by Ronald DeSilva on pages 348–369.

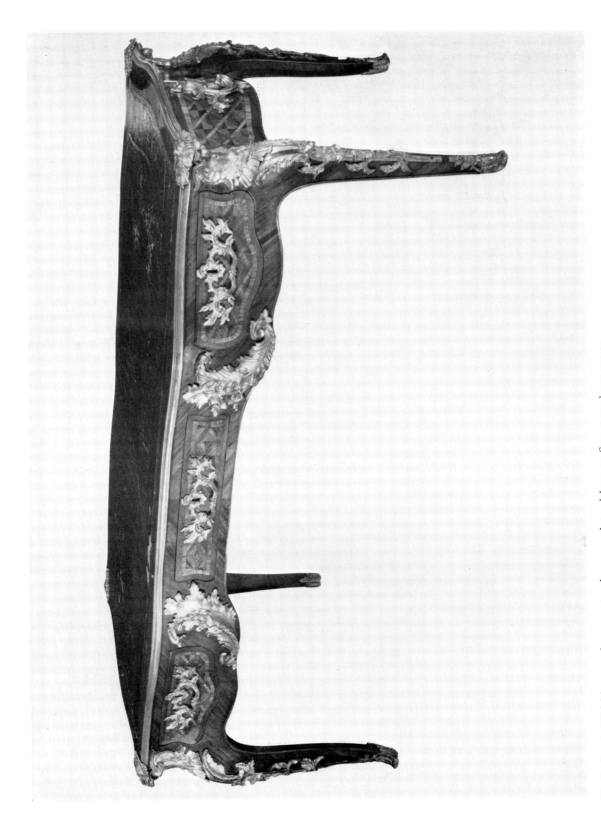

Early Louis XV kingwood parquetry bureau plat with very fine ormolu mounts.
Stamped: *J. M. Chevallier.* 2 ft. 7½ in. high by 3 ft. 6 in. wide by 6 ft. 6 in. long.
London £42,000 ($100,800). 11.XII.70.
From the collection of the Hon. Mrs A. Plunket.

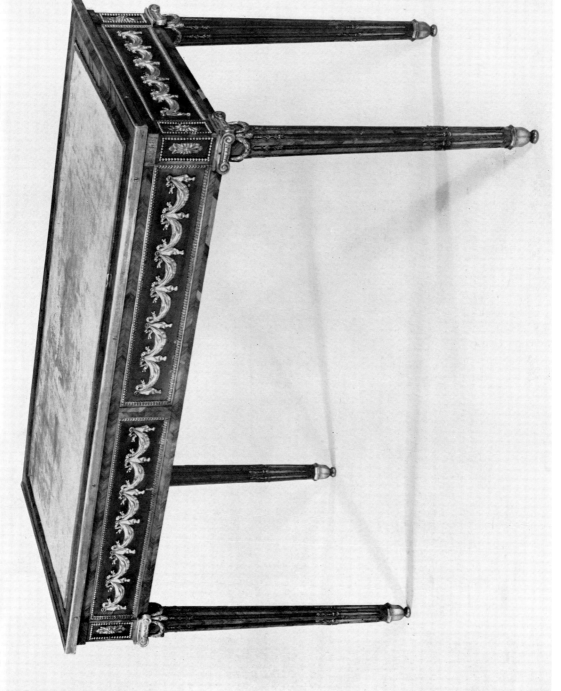

A small Louis XVI ormolu-mounted tulipwood bureau plat.
Stamped: *Montigny, J.M.E.* 3 ft. 8½ in. wide by 1 ft. 10½ in. deep.
London £14,000 ($33,600). 11.XII.70.
From the collection of the Baroness von Wrangell.

A late 14th century oak chest, the front elaborately carved with Gothic tracery, the rectangular stiles with panels of fabulous beasts. 2 ft. 9 in. high by 5 ft. 6¼ in. long by 2 ft. deep.
London £5,400 ($12,960). 27.XI.70.
From the collection of Mrs S. H. Barnett, Claverdon Hall, Warwickshire.

A Florentine carved walnut cassone.
Signed and dated: *Bandinelli Ao 1536*. 27 in. high by 6 ft. 4 in. long.
New York $12,000 (£5,000). 7.V.71.
From the collection of the Norton Simon Foundation.

A mid-18th century Dutch bureau cabinet, decorated with marquetry of flowers, birds and grotesque masks in ivory and fruitwood on a walnut ground.
8 ft. 2 in. high by 4 ft. 4 in. wide.
London £4,000 ($9,600). 18.VI.71.

A mid-17th century Italian red tortoiseshell cabinet on stand. 5 ft. high by 3 ft. 6 in. wide.
London £2,000 ($4,800). 30.IV.71.
From the Trustees of the Pepper Arden Estate, Yorkshire.

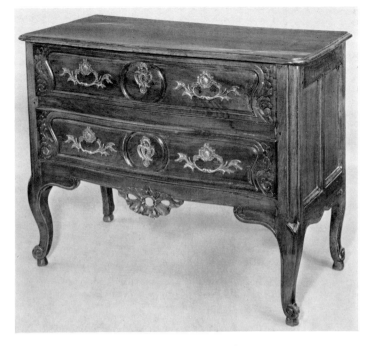

A Louis XV provincial walnut commode.
Liège. Mid-18th century. 33 in. high by 44 in. wide.
New York $2,400 (£1,000). 14.V.71.

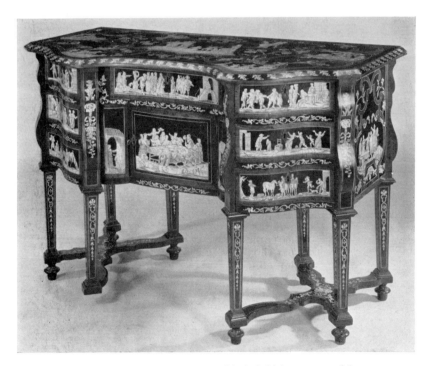

A late 17th century Italian writing table inlaid in engraved ivory
within kingwood bandings and strapwork on an ebony ground.
2 ft. 1 in. high by 4 ft. 4 in. wide by 2 ft. 1½ in. deep.
London £2,400 ($5,760). 12.III.71.

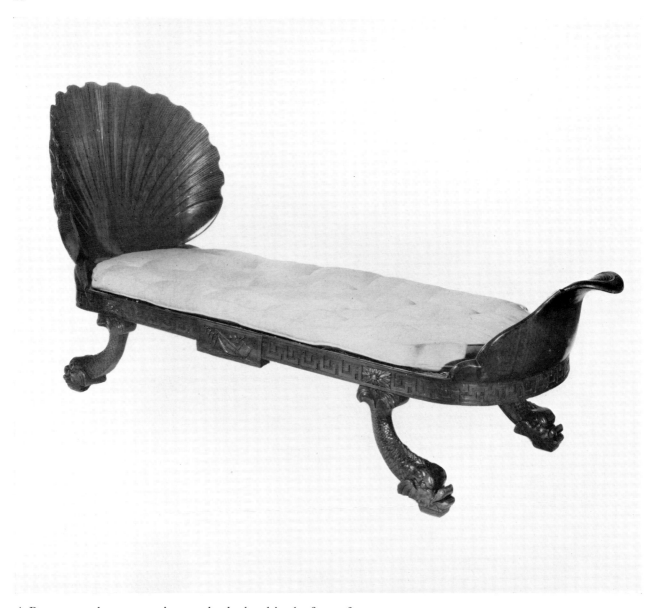

A Regency mahogany marine couch, the head in the form of a
scallopshell and the overscrolled foot with a panel of scales.
Stamped: *C. Munro. Circa* 1805. 6 ft. 6 in. long.
London £2,200 ($5,280). 28.v.71.
From the collection of Lady Birley.

A Henry VIII carved oak and painted four post bed.
6 ft. 4½ in. high by 6 ft. 4 in. long by 4 ft. 8 in. wide, with restorations.
London £3,600 ($8,640). 27.XI.70.
From the collection of Mrs S. H. Barnett, Claverdon Hall, Warwickshire.
Formerly in the collection of J. Seymour Lucas, R.A.

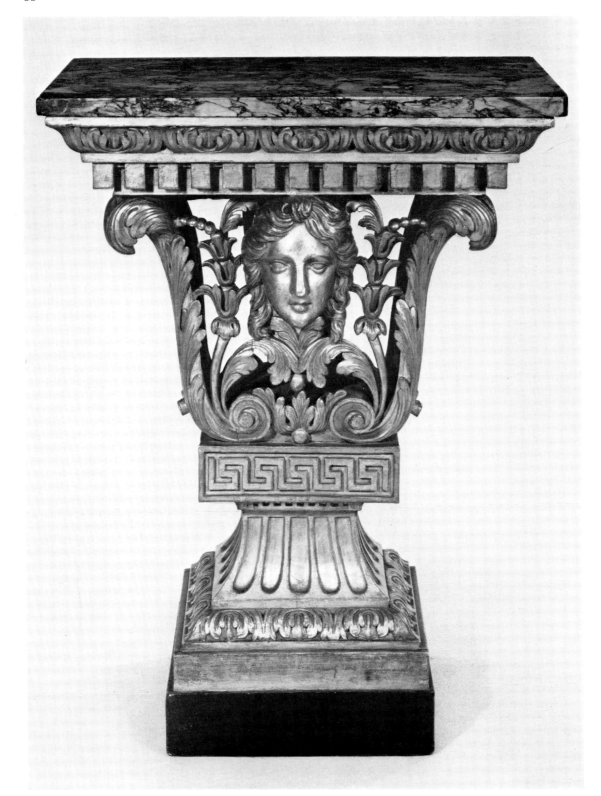

A small giltwood console table by William Kent, with a Siena marble top.
Made for Lord Burlington's Villa, Chiswick House.
2 ft. 11 in. high by 2 ft. 3½ in. wide.
London £4,000 ($9,600). 30.IV.71.
From the house of Ralph Andrew Harari, O.B.E. and the late Mrs Manya Harari.
Formerly in the collections of the Earl of Burlington and Cork and the Dukes
of Devonshire, now in the Victoria and Albert Museum.

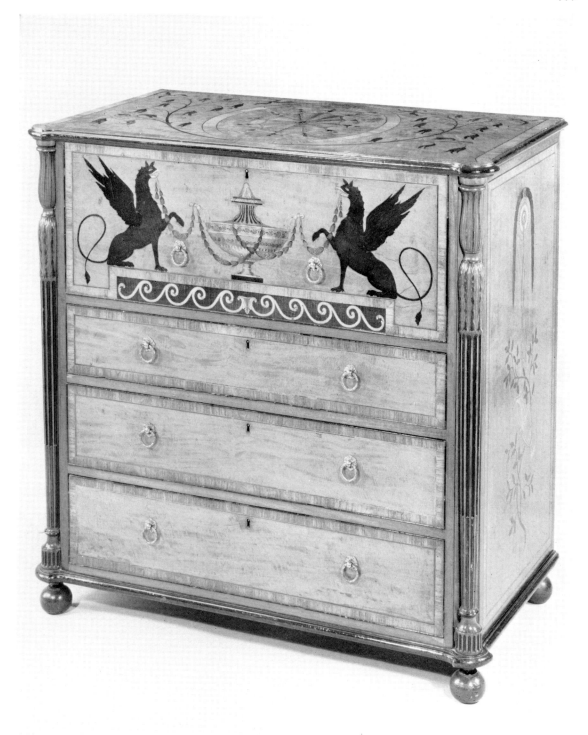

An early George III mahogany marquetry secretaire, the fall
front inlaid, partly in blue stained woods.
2 ft. 10½ in. high by 3 ft. wide by 1 ft. 7 in. deep.
London £4,200 ($10,080). 20.XI.70.
From the collection of the late E. C. P. Lascelles, Woolbeding House,
Sussex.

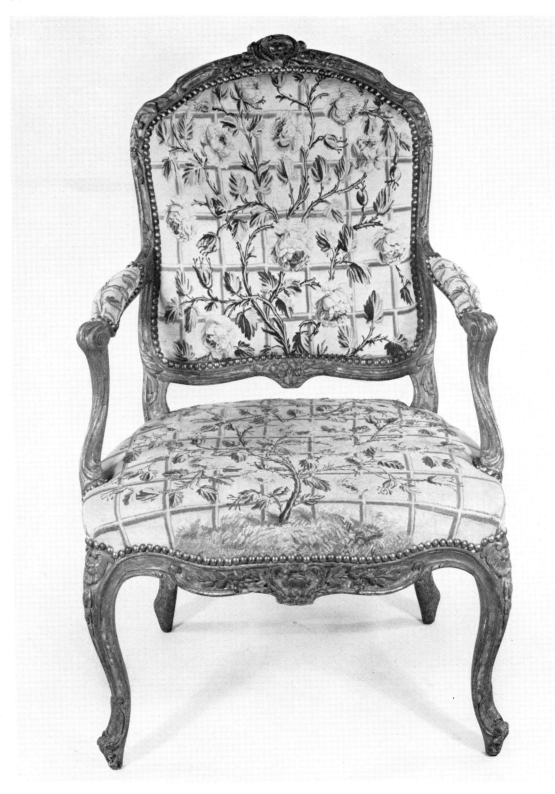

A Louis XV carved and painted beechwood fauteuil, covered in a Beauvais tapestry of white and dark red roses against a white ground.
Stamped: *Tilliard*.
London £3,000 ($7,200). 11.XII.70.
From the collection of the Baroness von Wrangell.

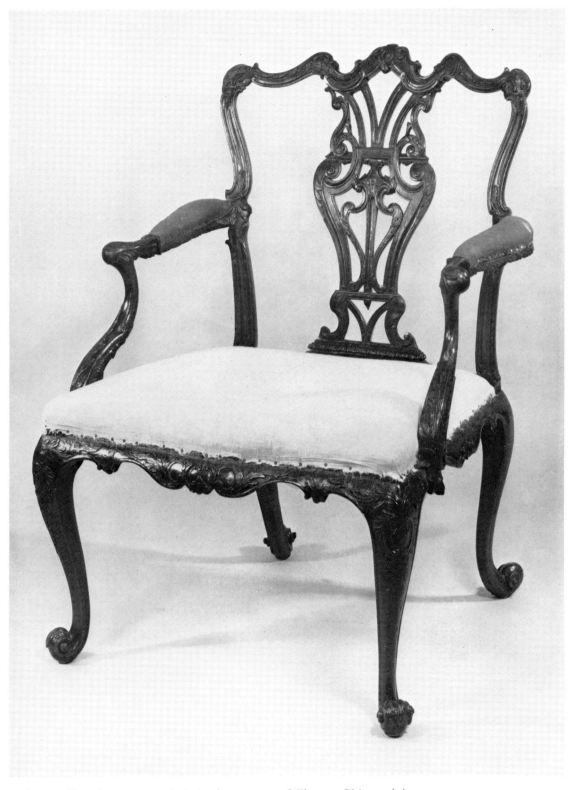

A George II mahogany armchair in the manner of Thomas Chippendale.
London £4,400 ($10,560). 2.IV.71.
From the collection of J. Ivan Yates, Esq.
Formerly in the Percival Griffiths collection.

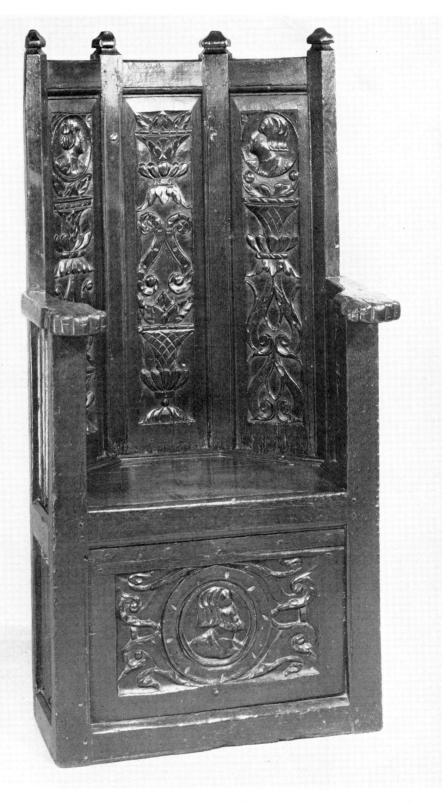

A Henry VIII carved oak joyned chair of Renaissance influence.
4 ft. 0½ in. high by 2 ft. 1 in. wide; height of seat 1 ft. 5 in.
London £5,200 ($12,480). 27.XI.70.
From the collection of Mrs S. H. Barnett, Claverdon Hall, Warwickshire.

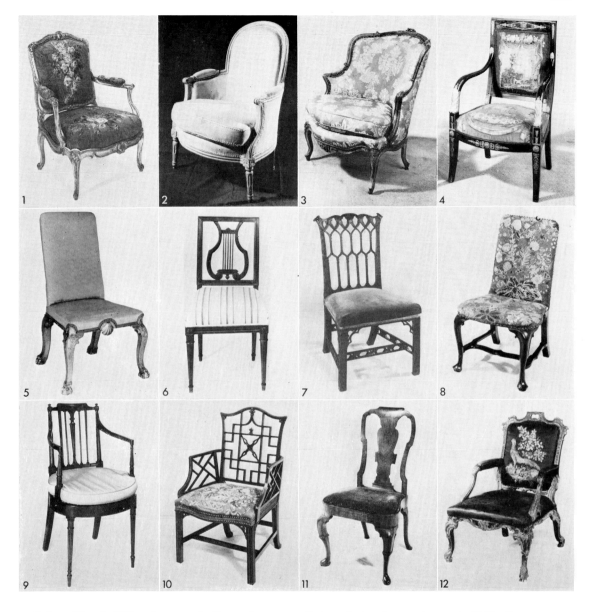

1. Suite of Louis XV-style carved giltwood furniture covered in Gobelins rose Pompadour tapestry, the tapestry *circa* 1770. $21,000 (£8,749). 8.v.71. **2.** One of pair of Louis XVI painted bergères. Signed: *J. F. N. Langdon, del.* 1775–1800 $2,100 (£875). 20.II.71. **3.** One of pair of Louis XV carved walnut bergères. *Circa* 1750 $7,250 (£3,020). 24.X.70. **4.** One of set of four Empire mahogany fauteuils. Early 19th C. $1,700 (£708). 6.II.71. **5.** One of set of eight George I giltwood chairs. £1,900 ($4,560). 30.IV.71. **6.** One of set of eight Louis XVI mahogany dining chairs. Signed: *P. Moreau.* 1775–1800 $5,200 (£2,166). 14.V.71. **7.** One of set of eight early George III mahogany gothic dining chairs. Seven stamped: *WH.* £1,400 ($3,360). 16.X.70. **8.** One of set of five Queen Anne walnut side chairs upholstered in floral needlework. Early 18th C. $2,600 (£1,083). 23.I.71. **9.** One of set of ten late 18th C. armchairs. £3,800 ($9,120). 28.V.71. **10.** One of pair of Chinese Chippendale mahogany armchairs covered in Soho tapestry. 1750–75. $11,000 (£4,583). 1.V.71. **11.** One of set of four Queen Anne walnut dining chairs. Early 18th C. $2,300 (£958). 23.I.71. **12.** One of pair of Thomas Chippendale Director armchairs in parcel-gilt mahogany. £6,400 ($15,360). 2.IV.71.

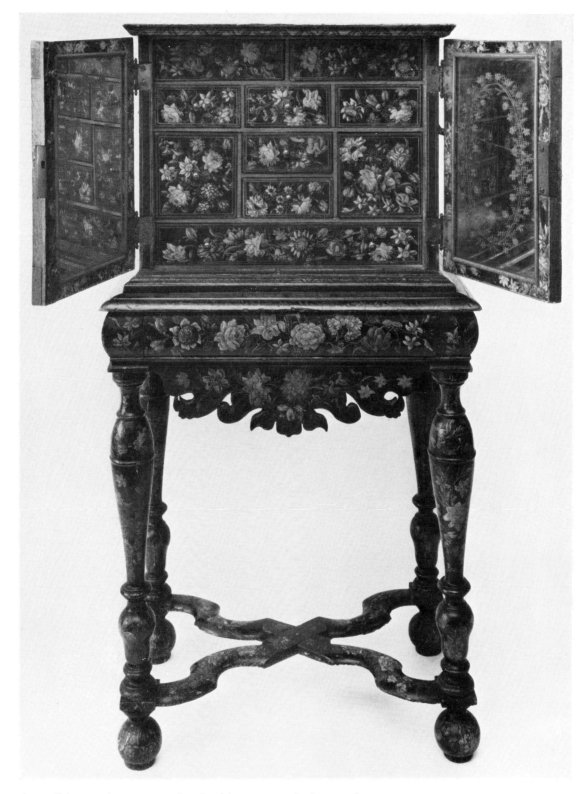

A small late 17th century painted cabinet on stand, the exterior
and interior painted with sprays of flowers on a black ground.
Dutch or English. 3 ft. 5 in. high by 1 ft. 10 in. wide.
London £2,000 ($4,800). 28.v.71.
From the collection of Lady Birley.

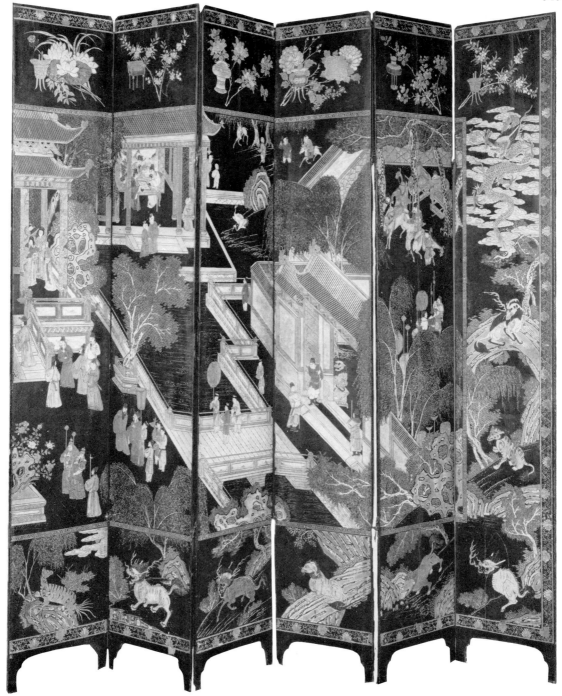

A Chinese Coromandel lacquer twelve-fold screen (six leaves shown).
First half 18th century. 8 ft. 4 in. high by 17 ft. 2 in. wide.
New York $23,000 (£9,583). 6.11.71.
From the collection of the late Mrs Ogden Reid of New York.

U

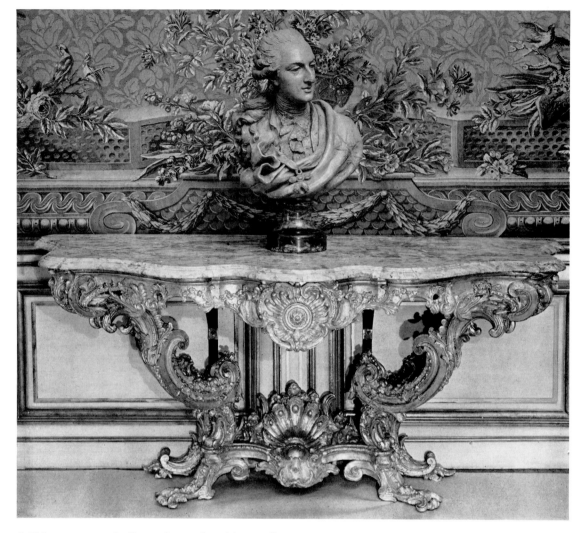

A Régence carved giltwood console table, attributed
to Jean Bernard Honoré Teurreau, called Toro.
1700–1725. 38 in. high by 7 ft. wide.
New York $10,200 (£4,249). 7.v.71.
From the collection of the Norton Simon Foundation.

1. French prisoner-of-war model of the man-o'-war *Alexander*. Early 19th C. 22 in. long. £1,250 ($3,000). 2.IV.71. **2.** Chippendale giltwood chandelier. 2 ft. 10 in. by 2 ft. 8 in. £2,100 ($5,040). 30.IV.71. **3.** Carved and polychromed pine eagle from Salem, Mass., *circa* 1800. 42 in. $9,000 (£3,750). 11/12.XII.70. **4.** Chinese mirror painting, George III carved giltwood frame, 1750–75. 26 in. by 29 in. $2,500 (£1,041). 17.X.70. **5.** Late Louis XVI ormolu candelabra, 1775–1800. 15½ in. $2,900 (£1,208). 24.X.70. **6.** Verre eglomisé painting of Copenhagen. Signed: *Zeuner fec.* 1785. 19½ in. by 26 in. £1,700 ($4,080). 28.V.71. **7.** Ormolu portrait busts of Louis XVI and Marie-Antoinette. 1775–1800. 12 in. $3,000 (£1,250). 24.X.70. **8.** One of five English embossed bird pictures in the manner of Isaac Spackman. 18th C. 10½ in. by 8¼ in. £1,250 ($3,000). 16.X.70. **9.** A pair of George III ormolu and Derbyshire spar perfume burners, attributed to Matthew Boulton. 1775–1800. 15½ in. $3,100 (£1,292). 1.V.71. **10.** One of pair of Louis XVI bronze, marble and ormolu plaques. 1775–1800. 28 in. by 22¼ in. $4,250 (£1,770). 24.X.70. **11.** French automaton snake charmer. 2 ft. 5 in. £850 ($2,040). 5.II.71. **12.** 1920 evening dress, printed pink crêpe covered in mirrored tubular beads. £20 ($48). 23.VII.71. **13.** One of pair of Chinese mirror paintings, lacquered frames. *Circa* 1800. 33 in. by 21½ in. $3,600 (£1,500). 17.X.70. **14.** Painted wooden doll. Mid-18th C. 17 in. £720 ($1,728). 2.X.70.

The Regional Schools of Early American Furniture

BY RONALD A. DESILVA

Interest in early American furniture did not manifest itself until the late nineteenth century. A dozen or so individuals, ranging from a newspaper vendor in Concord, Massachusetts, to a medical doctor in Baltimore, Maryland, began to amass collections, several of which now form the nucleus of some of our great public holdings. At a time when American collectors were solely interested in European and English furniture, and eschewing as crude, antique American examples, these few collectors were generally thought to be decidedly eccentric.

From 1900 and into the twenties interest in early American furniture expanded rapidly. The Hudson-Fulton Exhibition of 1909, the first important exhibition of early furniture, and the subsequent development of the American Wing of the Metropolitan Museum of Art contributed greatly to the growing interest in the furniture and artifacts of America's early years.

Many of these pioneer collectors often confused American with English furniture or ascribed much of it to a few known cabinet makers. Some discerning collectors and dealers such as Dr I. B. Lyon, Luke V. Lockwood, H. W. Erving, Wallace Nutting, C. L. Pendleton and others began to note the similarities within certain groups of furniture and on the basis of family history, a maker's label or a signature to assign them to specific regions. Luke Vincent Lockwood was one of the first chroniclers of early American furniture and craftsmen to rely upon primary source material, principally early probate records, examples of which he published in 1901 in his book *Colonial Furniture in America*.

There are a number of factors which fostered regionalization of design in the American decorative arts, some of which also aided in preserving important examples of regional furniture and prevented their wholesale dispersal or destruction. Geography was a major factor. The thirteen original colonies were scattered along the Atlantic Coast of the United States. These settlements were formed along the great coastal bays and river valleys and separated one from the other by great tracts of forest, and from the hinterland by the Appalachian Mountains. Travel from one region to the next was often easiest by water, therefore it is no wonder that ship building became one of America's first great industries. Massachusetts Bay, with Boston and its surrounding towns formed one region, Narragansett Bay in Rhode Island, with Providence and Newport formed a second region. The Connecticut River Valley and Long Island Sound was a region of great diversity; each town along the river constituted a distinct sub-region and produced unique furniture forms. New York and the Hudson River Valley produced an interesting blend of Dutch and English styles and influenced that part of New Jersey adjacent to it, while Philadelphia influenced southern New Jersey and the Delaware River Valley and Bay. Baltimore and Annapolis on the Chesapeake Bay produced distinctive furniture designs in the last decades of the eighteenth century. Prior to the Revolution the inhabitants of this

area had imported furniture from England and New England, as did most of the South. Charleston, South Carolina, another exception to the general rule in the South, did not rely upon importations but supported some one hundred cabinet makers in the eighteenth and early nineteenth centuries.

Another factor which contributed to regionalization of furniture design was the fact that although town life developed early, with the exception of Philadelphia, there were no large urban centres, such as London or Dublin, where artists and craftsmen could meet to exchange ideas. Neither were there craft guilds to set standards, and therefore, each craftsman or group of craftsmen within a region tended to produce highly individualistic designs or methods of fashioning furniture.

The problem of relative isolation contributed in some respects to the preservation of numerous examples of early furniture. The United States was a comparatively rural country until the 1920's. Urban life, as it is known today, did not come about until after 1850. In the first decades of the twentieth century many towns in the older sections of the United States were still somewhat isolated, serving either as farming centres, the role many had played in the eighteenth century, or small manufacturing centres whose period of prosperity had long since passed.

A number of these small towns contained seventeenth, eighteenth, and early nineteenth century dwellings, inhabited for the most part by descendants of the original owners, in which furniture, paintings, and decorative objects of an earlier day continued in use. This was fortunate for collectors and students of early American furniture, for, with the exception of the South, much of the furniture had been made in the region in which it was found.

Of great importance to the identification of early American furniture, and to the study of regional designs, has been the relatively large number of labelled or signed pieces which have appeared through the years. Examples of labelled or signed pieces exist for virtually every region and have served to identify unsigned examples. History of ownership is also an important factor, as is the identification of the secondary woods used in construction. The latter has been developed into a specialized technique by Professor Charles F. Montgomery of Yale University and Mr Gordon Saltar of the Henry Francis duPont Winterthur Museum. These men, among others, held that with the exception of imported woods such as mahogany, cabinet makers more than likely procured their material locally. They also noted that certain woods were used for special purposes, such as maple and walnut for turning and carving, or pine, chestnut and tulip poplar for drawer linings and backboards. Armed with the knowledge that certain species of trees grow in particular zones in the United States, these gentlemen examined microscopically thousands of wood samples taken from a broad range of known pieces of furniture and found that the technique was indeed valid. Wood analysis is a valuable tool in the identification of regional furniture. This technique does not always work, for occasionally Massachusetts or Rhode Island furniture is found which contains cypress from the deep South, or bilsted which was favoured in New York. In such a case one relies upon stylistic analysis and the known history of the object.

Early American furniture is divided into five periods which span the years from 1650 to about 1820. The earliest examples, produced between 1660 and 1700, are

Fig. 1
A turned maple drop-leaf
tuckaway table,
New York,
early 18th century.
$1,600 (£666). 13.v.54.

designated *Seventeenth Century* or *Pilgrim Century* furniture. Much of the furniture of this period is in the English Renaissance style which had already passed out of favour in England. Oak was the principal cabinet wood used, although maple and pine were also favoured. Most of the surviving furniture of this period is from Plymouth and Ipswich in Massachusetts, and the Connecticut River Valley. Seventeenth century furniture from New York, Virginia and Charleston has also been found. The most common survivals are simple board chests, drop-leaf tables, joint stools, wainscot and turned chairs and court cupboards. Six board chests, often with a single drawer below, were used for storage and occasionally as seating pieces. An elaborate example from Wethersfield, Connecticut which dates from about 1690, is here illustrated (fig. 2). It has a hinged top, the front is divided into twelve panels with incised rosettes and fleur-de-lys and ornamented with split spindles; the long drawer below is panelled as two with triglyphs at either end. Two other Connecticut River Valley chests from the same period are also illustrated (fig. 3). Both were made in Hartford, the first often called a 'Sunflower Chest' is attributed to Peter Blin. The second (fig. 4) which carries an inscription 'Mary Allyns Chistt-Cutte and Joyned by Nich. Disbrowe', is the earliest signed example of American furniture.

A New York drop-leaf table (fig. 1) is representative of the variety of 'flap' tables of the period. The solid board stretcher identifies it as New York. In New England examples, the gate supports are attached to a turned member.

Two court cupboards from Virginia, one dating from 1650, and a gateleg table from Charleston, South Carolina are the only known examples of Southern furniture of the seventeenth century.

Fig. 2
A Pilgrim oak chest, Wethersfield,
Connecticut, *circa* 1690–1720.
$7,000 (£2,916). 31.x.70.

Fig. 3
A Pilgrim carved oak and pine
sunflower and tulip chest, Hartford,
Connecticut, late 17th century.
$1,000 (£351). 13.v.54.

Fig. 4
The Nicholas Disbrowe carved oak
chest, Hartford, Connecticut,
late 17th century.
$4,000 (£1,403). 13.v.54.

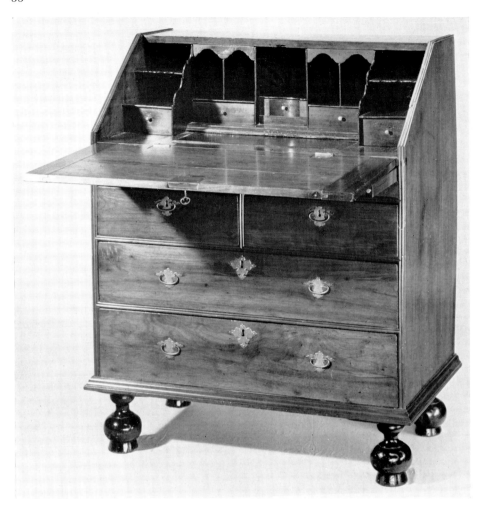

Fig. 5
A William and Mary butternut slant-front desk,
New England, early 18th century.
$650 (£232). 13.v.54.

The second style period is called William and Mary and dates from around 1700 to 1725. The broad date range, which extends well beyond the collective reign of both monarchs, is explained by the fact that in America styles tended to linger on.

Many basic furniture forms were developed during the period, including chests of drawers, high chests, dressing and tea tables, secretaries or desks, and easy chairs. More furniture of this period has survived, most of it being from New England. It is baroque in character, relying on the play of veneers, turned elements, and carving in the round. Cane, leather, and bannister back chairs are to be found, as well as high chests and dressing tables; though tea tables of the period are rare. A desk from Rhode Island (fig. 5) dating from around 1720 has incipient blocking in the interior, which in more elaborate form became a feature of a variety of case pieces produced

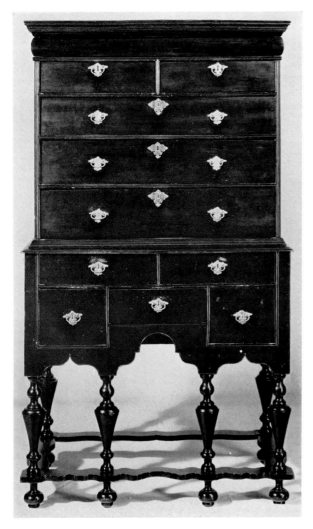

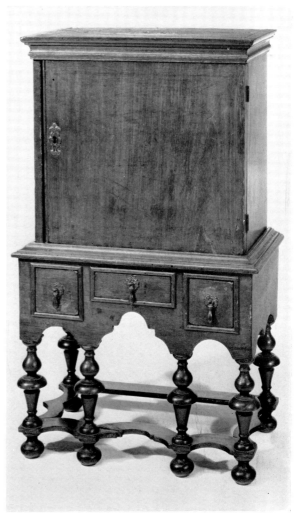

Fig. 6
A William and Mary turned maple six legged
highboy, New England, early 18th century.
$750 (£268). 13.v.54.

Fig. 7
A William and Mary walnut spice chest,
Pennsylvania, *circa* 1690–1720.
$9,000 (£3,750). 31.x.70.

throughout the eighteenth century in New England. A high chest from Massachusetts,
circa 1710 to 1720, illustrates a new furniture form. High chests remained popular in
America until the early years of the nineteenth century (fig. 6). The alignment of
the drawers in the base is characteristic of New England high chests and dressing
tables. In this case, the history of ownership indicated a Massachusetts origin. The
miniature spice chest shown (fig. 7) has separations between the drawers which is a
characteristic of Pennsylvania William and Mary high chests and dressing tables.

There are examples of early American furniture which contain elements of two
styles. These are labelled 'transitional' the commonest being combinations of the
William and Mary and Queen Anne or Queen Anne and Chippendale styles. They
were probably executed by craftsmen familiar with the older style but having a

U*

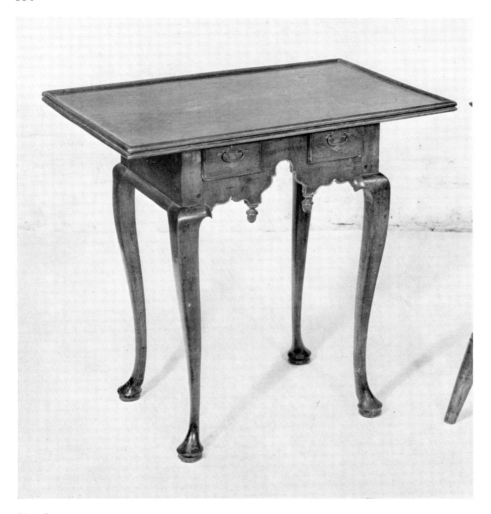

Fig. 8
A transitional William and Mary–Queen Anne maple
and sycamore dressing table,
New Hampshire, *circa* 1740.
$4,500 (£1,874). 31.X.70.

limited knowledge of the new. He may also have attempted to copy an object seen and only half remembered, or relied upon a verbal description. A dressing table, *circa* 1740, attributed to John Trefethern of Rye, New Hampshire, is an example of transitional furniture (fig. 8). The valenced apron, acorn drops, the small drawers, and the wide over-hanging top of the William and Mary style are combined with cabriole legs of the Queen Anne period. A transitional dressing table from New Jersey (fig. 9) also contains elements from both periods combining, among other features, cabriole legs with Portuguese brush feet. A number of dressing tables similar to the latter have been found in New Jersey and constitute a distinct regional style.

The Queen Anne style, which includes the early Georgian periods, ranges from 1725 to 1755. The furniture is baroque in spirit relying on a play of curves and such

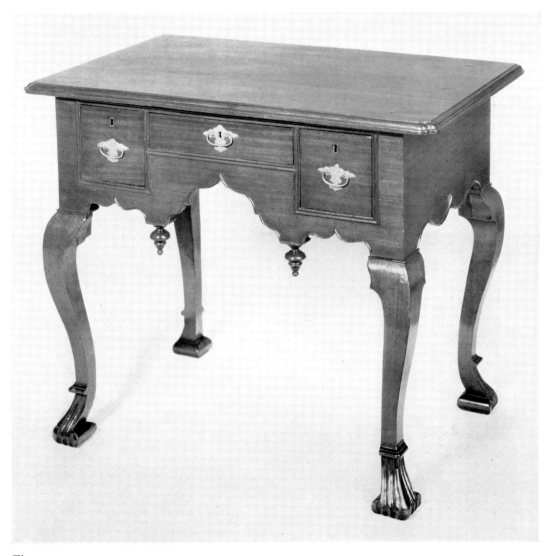

Fig. 9
A William and Mary–Queen Anne walnut lowboy,
New Jersey, *circa* 1720–30.
$6,000 (£2,500). 29.1.71.

naturalistic ornaments as applied or carved cockleshells, leafage and grasses. Walnut
and mahogany were the favoured woods, as well as native woods such as maple and
cherry, Chests on chests, desks with bookcase sections, sofas, upholstered stools and
gaming tables were introduced during this period. A slipper foot, pad foot, trifid foot,
and later in the period, the claw-and-ball foot, ornamented the newly introduced
cabriole leg. The trifid foot was favoured in Pennsylvania and New Jersey. The slipper
foot in Rhode Island, New York and occasionally in Pennsylvania. Regional dif-
ferences are seen in the way in which a foot is executed. The shape of the pediment
and finials of case pieces drawer alignment and construction, and the method em-
ployed in fashioning a chair are also regional indicators.

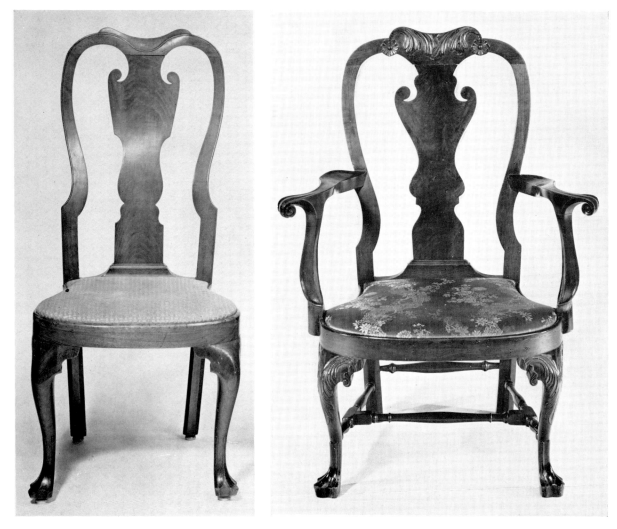

Fig. 10
One of a pair of important Queen Anne
walnut balloon seat side chairs,
Philadelphia, *circa* 1720–40.
$14,000 (£5,833). 22.i.66.

Fig. 11
A Queen Anne shell carved walnut
armchair, Philadelphia, 18th century.
$27,500 (£11,250). 22.i.66.

Queen Anne chairs produced in Philadelphia generally have a spooned back, solid splat, horseshoe-shaped seat, with the tenon of the seat rail generally piercing the stile, and the front legs morticed into the seat frame (figs. 10 and 11.). New York chairs often resemble English chairs, having a wide splat and shaped rear feet (fig. 12). Chairs made in New England usually have stretchers; two New England chairs, one from Newport (fig. 13) and one from Massachusetts (fig. 14) are illustrated. The vertical scroll of the arms of this wing chair and the turned stretchers below are features found on easy chairs throughout New England (fig. 15). Since it has a history of ownership in a Massachusetts family, it is therefore considered to be from that area. The next example contains design elements which signify that it was made in Philadelphia (fig. 16). The scrolling of the arms, the broad knees and the fact that the front legs are not located on the corners of the seat, but face forward, are sure signs of Philadelphia or Pennsylvania origin.

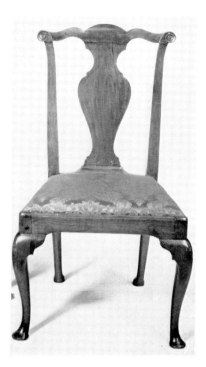

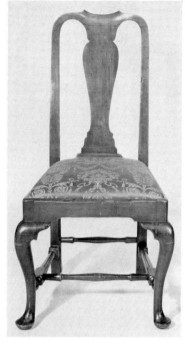

Fig. 12
A Queen Anne Chippendale
cherrywood side chair,
New York, *circa* 1755–65.
$400 (£166). 22.v.71.

Fig. 13
One of a pair of Queen Anne
walnut side chairs,
Newport, R.I., *circa* 1730–50.
$5,750 (£2,395). 29.i.71

Fig. 14
One of a set of four Queen
Anne walnut side chairs,
Massachusetts, *circa* 1740–60.
$3,750 (£1,562). 29.i.71.

Fig. 15
A Queen Anne walnut wing armchair,
Connecticut, *circa* 1710–30.
$5,400 (£2,250). 29.i.71.

Fig. 16
A Queen Anne walnut wing armchair,
Philadelphia, *circa* 1735–50.
$2,600 (£1,082). 31.x.70.

Fig. 17
A Queen Anne walnut stool,
Connecticut, *circa* 1740–50.
$2,250 (£937). 31.x.70.

Fig. 18
A Queen Anne pine and maple tea
table, Connecticut, 18th century.
$1,400 (£583). 29.i.71.

Fig. 19
A Queen Anne carved walnut
lowboy, *circa* 1720–50.
$8,500 (£3,541). 11.xii.70.

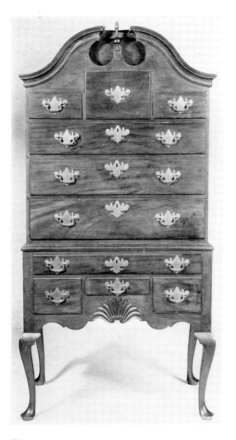

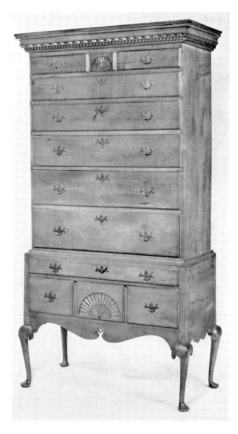

Fig. 20
A Queen Anne walnut highboy,
Newport, R.I., 18th century.
$20,000 (£8,333). 31.i.70.

Fig. 21
A Queen Anne fan carved maple
highboy, attributed to Samuel Dunlap
II, Salisbury, New Hampshire, *circa*
1775–90. $3,750 (£1,562). 22.v.71.

The way in which a cabriole leg is formed is often an indication of origin. A Connecticut Queen Anne walnut stool which descended in the family of Commander Isaac Hull of Saybrook, Connecticut (fig. 17) has the angular cabriole legs encountered in that area. The legs and skirt of this Connecticut pine and maple tea table exhibit similar features (fig. 18).

Examples of early American furniture are occasionally encountered containing design elements characteristic of a specific cabinet maker or school of cabinet makers. A Newport, Rhode Island, Queen Anne walnut high chest is shown here. The carved shell on the skirt immediately identifies it as the work of one of the members of the Goddard-Townsend family of joiners and is a chief characteristic of their work. (Fig. 20). The Queen Anne walnut dressing table shown is attributed to Benjamin Frothingham of Charlestown, Massachusetts (fig. 19). The carving on the centre drawer, the shaping of the skirt, and the notched corners of the thumb moulded top closely resemble several such dressing tables, one of which bears Frothingham's signature. The projecting cornice of a New Hampshire maple highboy is enriched with petal and dentil mouldings employed by the Dunlap family of cabinet makers (fig. 21) of New Hampshire. The carved fans, shaped skirt, and short cabriole legs

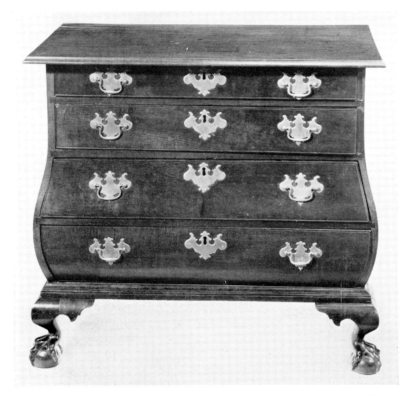

Fig. 22
Chippendale mahogany
kettle-base chest of drawers,
Boston, *circa* 1760–80.
$41,000 (£20,832). 22.V.71.

with curved appendages on either side of the knee are features found on a number of case pieces by them.

The Chippendale period extends from 1755 to 1785. The style is based, in many respects, on designs published by Thomas Chippendale in *The Gentleman and Cabinet-Makers Directory* 1754 and those published by Abraham Swan, Thomas Johnson, Robert Manwaring, and William Ince and John Mayhew.

Mahogany was the favoured wood of the period although such native woods as walnut, cherry, maple and curley maple continued in use. Furniture forms of the Queen Anne period remained in use, but were decorated with rococo, scrolls and Chinese and gothic ornament. The kettle stand, dressing chest, pembroke table and 'french' chair (straight backed upholstered armchair) were new introductions, as was the Marlboro' leg. The Cabriole leg remained popular throughout this period, but generally terminated in a claw-and-ball, French scroll or hairy paw foot. Case pieces with serpentine or blockfronts or of bombe form were popular, especially in New England.

The principal cabinet making centres were Philadelphia, Pennsylvania; Boston, Salem and Newburyport, in Massachusetts; Newport, Rhode Island; New York and Charleston, South Carolina. A small, but important school of cabinet making existed in the Norwich-Middletown area of Connecticut, influenced mainly by the Newport, Rhode Island school of cabinet makers.

A variety of shaped fronts were used on case pieces in Massachusetts and other parts of New England. Three examples from Massachusetts include a serpentine chest of drawers (fig. 23), a block-front writing desk (fig. 24), and a kettle-base chest of drawers (fig. 22), the latter form thought to be unique to the Boston area. The

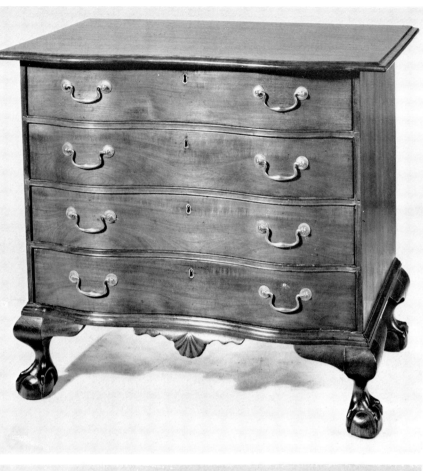

Fig. 23
A Chippendale
mahogany serpentine
front chest of drawers,
Massachusetts or
Connecticut,
circa 1760–80.
$6,000 (£2,500). 29.i.71.

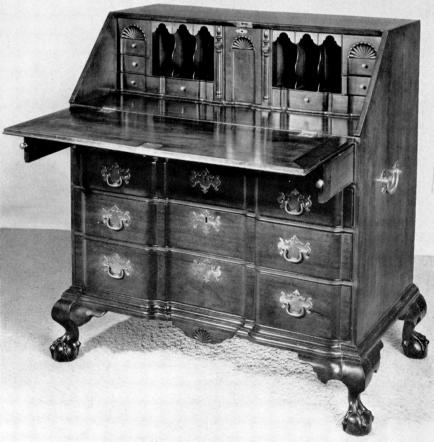

Fig. 24
Chippendale mahogany
block front writing desk,
Massachusetts, *circa*
1760–80. $10,500
(£4,374). 22.v.71.

Fig. 25 Detail

Fig. 26 Detail

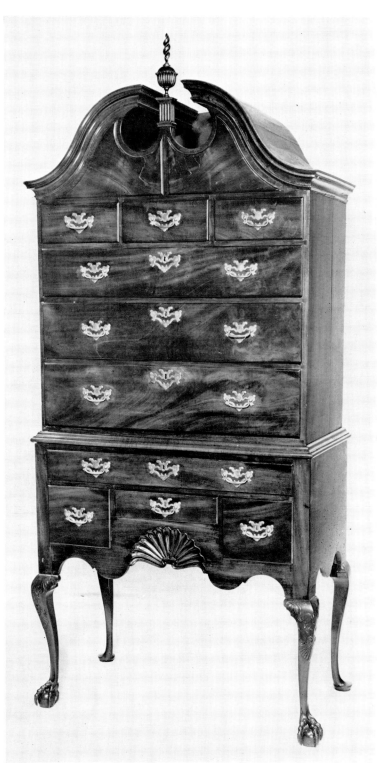

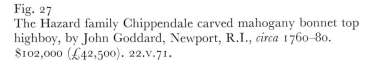

Fig. 27
The Hazard family Chippendale carved mahogany bonnet top
highboy, by John Goddard, Newport, R.I., *circa* 1760–80.
$102,000 (£42,500). 22.V.71.

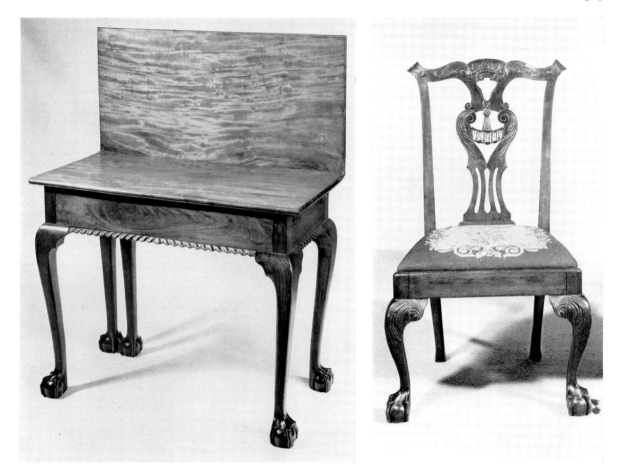

Fig. 28
A Chippendale carved mahogany card table,
New York, N.Y., *circa* 1760.
$2,100 (£874). 22.v.71.

Fig. 29
One of a pair of mahogany tassel back
side chairs, New York, N.Y., 18th century.
$7,000 (£2,916). 25.i.69.

claw-and-ball feet of all three specimens display backward raking side claws which
are characteristic of Massachusetts furniture.

The Goddard-Townsend family of joiners in Newport developed a claw-and-ball
foot found nowhere else in America. The talons of the foot are undercut, lightly
grasping the ovoid ball, as in the feet of this mahogany high chest by John Goddard
(figs. 26 and 27). The acanthus carving on the knees is also a Goddard-Townsend
feature (fig. 25).

Chippendale furniture from New York is to be seen in a card table with a gad-
rooned skirt (fig. 28) and a tassel-back side chair (fig. 29) from one of several sets of
chairs made for members of the Van Rensselaer family. The unarticulated rear talon
of the claw-and-ball feet of the card table is a regional characteristic developed by
New York cabinet makers.

The most elaborate examples of Chippendale style furniture in America were pro-
duced in Philadelphia. Rich carving characterises the furniture produced in this

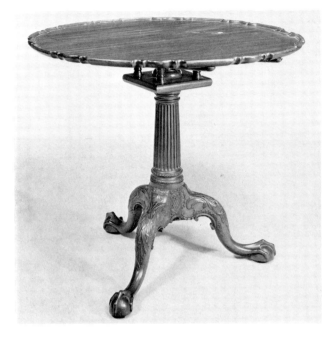

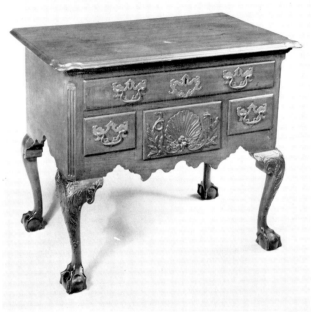

Fig. 30
A Chippendale mahogany piecrust table,
Philadelphia, 18th century.
$10,500 (£4,374). 31.1.70.

Fig. 31
The Beaver Chippendale carved walnut lowboy,
Philadelphia, 18th century.
$24,000 (£10,000). 31.1.70.

region. This can be seen in the handsomely carved base of a mahogany piecrust tea table (fig. 30) made in Philadelphia around 1770. The high chest became even more imposing, being more than eight feet high and ornamented with magnificent carved decoration as in the example shown here (fig. 32). High chests were generally accompanied by a matching dressing table (fig. 31) although few matched sets have survived. Philadelphia Chippendale high chests, along with Goddard-Townsend block-front furniture are the types of early American furniture most sought after by collectors.

A revolution in taste, set in motion by our emergence as an independent nation and by the influences from abroad mark the furniture of the Federal Period, which lasted from 1785 to about 1820. The style is based upon the designs of Hepplewhite and Sheraton, with the addition of design elements from ancient Greece and Rome. A strong influence is also to be found in the works of French emigré cabinet makers who fled to America, chiefly to New York, during and immediately following the French Revolution.

Furniture became lighter, of more delicate outline, relying chiefly on the play of simple geometric shapes and the contrast of light and dark veneers highlighted by line inlay or carving, reeding and fluting.

Regional differences are less apparent in this period due to a wide ownership of Sheraton's and Hepplewhite's design books and to the standardized price books adopted by cabinet makers and journeymen in all of the cabinet making centres of America. The price books were based on the *London Cabinet Book of Prices* of 1788 in which the rate of pay for all standard furniture forms is listed. Furniture forms became

Fig. 32
A Chippendale carved mahogany
highboy, Philadelphia, 18th century
$60,000 (£25,000). 25.1.69.

fairly standardized during this period, yet regional characteristics remain, though sometimes of so subtle a nature that the furniture historian has to rely on history of ownership or the analysis of secondary woods for positive identification. Inlays are often a clue to solving the puzzle of regional origins. Within each region one or a few inlay specialists did work for an entire group of cabinet makers. The contour of furniture legs or the type of carving employed are other clues to the area in which an article of furniture was produced.

Scholarly studies of the furniture of the Federal period have been done only within the last decade with much work remaining. There were five important regional schools of cabinet making in this period. Boston and Salem, Massachusetts, constitute two of the important regional centres. Distinctive and beautiful designs continued to be produced in New York and Philadelphia. Baltimore and Annapolis in Maryland became the great cabinet making centres of the South. Some of the most elaborate furniture of the period was produced in this area. Some of the smaller regional centres were Providence, Rhode Island; Hartford, Connecticut; and Portsmouth, New Hampshire.

Fig. 33
A Sheraton carved mahogany drop leaf table,
Duncan Phyfe, New York, N.Y., *circa* 1815.
$800 (£334). 22.1.66.

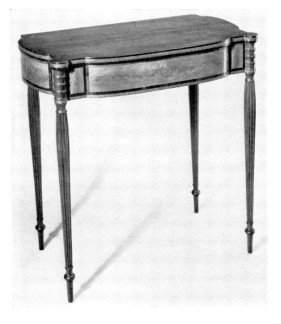

Fig. 34
An early Federal inlaid mahogany and
satinwood side table,
Boston, Massachusetts, *circa* 1790.
$900 (£375). 11.XII.70.

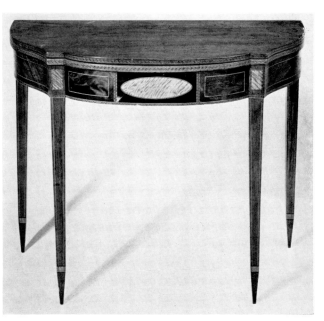

Fig. 35
A Hepplewhite inlaid mahogany card table with
original maker's label, Elisha Tucker, Boston,
Massachusetts, *circa* 1790.
$4,250 (£1,770). 11.XII.70.

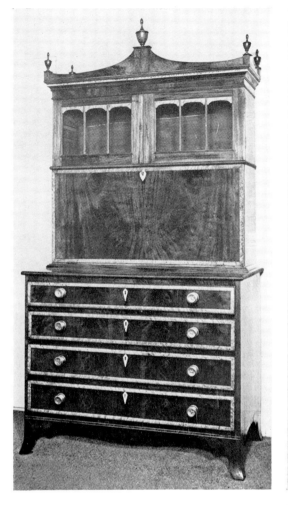

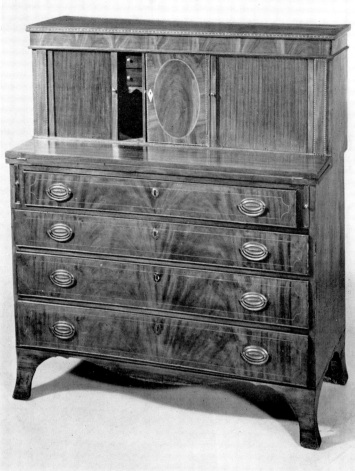

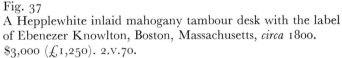

Fig. 36
A Hepplewhite inlaid mahogany secretary cabinet with label of John Seymour, Boston, Massachusetts, *circa* 1800.
$2,750 (£1,145). 2.v.70.

Fig. 37
A Hepplewhite inlaid mahogany tambour desk with the label of Ebenezer Knowlton, Boston, Massachusetts, *circa* 1800.
$3,000 (£1,250). 2.v.70.

Furniture from three important regions is illustrated here including several pieces which bear their original maker's labels.

Foremost among the many cabinet makers of Boston were John and Thomas Seymour. The secretary (fig. 36) and side table (fig. 34) shown here have lunette inlays, bird's-eye maple crossbanding, and satinwood veneers generally associated with their work. The label of Elisha Tucker of Boston is affixed beneath the top of this handsome serpentine card table (fig. 35). Characteristic of furniture produced in the Boston area is the pointing of the legs below the crossbanded cuff. Ebenezer Knowlton, also of Boston, skilfully employed crotch veneering and inlays in this tambour desk which bears his label (fig. 37).

New York furniture of the Federal period is frequently associated with the name of Duncan Phyfe who made the drop-leaf table (fig. 33), and sofa (fig. 40), although other New York cabinet makers produced similar forms. A shield-back side chair

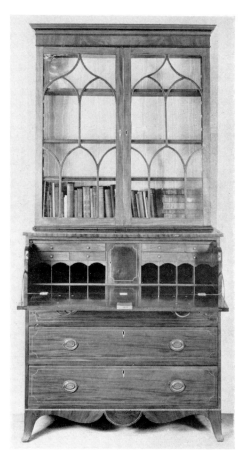

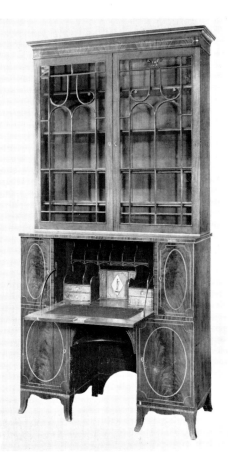

Fig. 38
A Hepplewhite inlaid mahogany
secretary cabinet, New York, N.Y.,
circa 1790.
$2,200 (£916). 29.1.71.

Fig. 39
A Federal inlaid mahogany gentleman's
secretary and bookcase with *verre
eglomisé* decoration, Baltimore,
1790–1810.
$5,250 (£2,187). 31.x.70.

(fig. 42) and a secretary-bookcase (fig. 38) were also produced in New York. The inlaid mahogany sideboard (fig. 41) and a gentleman's secretary and bookcase, (fig. 39) produced between 1790 and 1810, serve to illustrate the cabinet work of the Baltimore-Annapolis region. The elaborate fan spandrels, mock-fluted stiles, and oval and circular medallions are characteristic of Baltimore workmanship. The hinged fall front of the mahogany secretary and bookcase discloses an *eglomisé* panel on the small cupboard door. This is another mark of Baltimore work for *eglomisé* panels, generally ornamented with classical figures, were extensively used by Baltimore cabinet makers to ornament tables and case pieces.

In such a brief study of regional characteristics of early American furniture, many important items have had to be left out. Tall-case, shelf and wall clocks often reflect regional styles, and because most clock makers signed their work, have been of immense help in the identification of regional furniture. Regional styles in Windsor chairs, a very popular furniture form, are also apparent. Regional factors were at play in all of the arts in America in the seventeenth, eighteenth and early nineteenth centuries, in architecture as well as the decorative arts. Distinctive regional forms in silver and pewter developed as early as the seventeenth century and appear in tin ware, glass and ceramics as well.

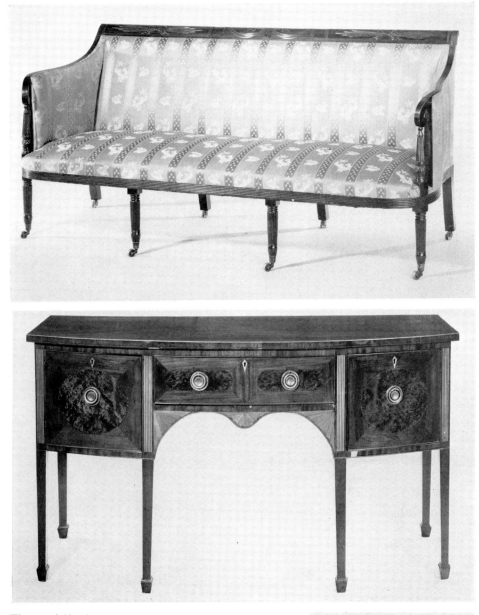

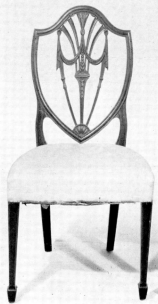

Fig. 40 (*Above*)
A Sheraton carved mahogany and green brocade
sofa, Duncan Phyfe, New York, N.Y., *circa* 1820.
$4,000 (£1,666). 22.1.66.

Fig. 41 (*Centre*)
A Hepplewhite inlaid mahogany swell front
sideboard, Maryland, late 18th century.
$1,650 (£686). 22.1.66.

Fig. 42 (*Below*)
One of a pair of Federal carved mahogany side
chairs, New York, N.Y., *circa* 1790–1810.
$2,500 (£1,041). 31.x.70.

Memories of Sotheby's First Girl

BY EDITH BOURNE[1]

Soon after the beginning of the First World War, I joined the firm (Sotheby, Wilkinson & Hodge in those days) in Wellington Street not very long after the first part-time girl had entered that monastic establishment. The grey inconspicuous building with the inscrutable Egyptian stone head over the entrance was symbolic of the discretion, almost secrecy, with which the business was conducted in those days. I had answered an anonymous advertisement (under cover of Suckling's, the old booksellers in the Strand), I was interviewed in what was known as the 'PRIVATE ROOM' by Sir Montague (then Mr) Barlow. I was put through the catechism emphasizing English origin, school life, family life, religion etc., and finally introduced to Mr Hobson, for whom I was to work. Those must have been urgent days because the following week I was a member of the staff.

In a few days I was plunged into an unfamiliar world of Incunabulae, being sent off for six weeks with Mr Phillips (the head book cataloguer) and Pilon the porter to Lord Ellesmere's home, Bridgewater House, near the Mall, whose valuable library was to be catalogued for sale. Helped by the Earl's Librarian and his secretary I somehow coped, and the cosy teas we had all together in the cellars among the Old Masters are a pleasant memory (the House was later closed and dismantled owing to the War). On the day the Library was safely packed into many cases and insured for removal to Sotheby's, Sir Montague arrived to take formal delivery from the Librarian, who insisted that Sir Montague for further security should drive with the van! Nothing loth Sir M. climbed briskly into the driving seat beside Pilon and turned to wave gaily to us as we stood on the steps of the old Mansion. Afterwards Pilon told us that immediately they were out of sight at Pall Mall corner, Sir Montague left the van and returned to Sotheby's by taxi.

I then returned to take up my work with Mr Hobson. I settled down enthusiastically with the pleasant and helpful companionship of my colleague, Miss Lachlan. We two girls seemed to be taking the place of four men who had joined the Forces. The loyalty of the remaining staff to these absent friends was wonderful; they were held up to us as models of perfection by the nice old cashier (spectacles and frock coat), who always dealt with us kindly but firmly, as though expecting some latent frivolity from two young girls.

Naturally our advent created a little stir in that man-made world. It was run like a ship of the fleet, no women allowed. The porters did all the cleaning and dusting. We were told that one of them, Addison, had to be kept working in the basement away from us because his language was too picturesque for ladies. Actually he was a friendly little man (the one[2] who had accosted Major Warre on the battlefield!), and

[1] Miss Bourne was Sotheby's first full-time female employee, as Miss Adriana Lachlan, who was employed a few months earlier by Sir Montague Barlow from a clerical agency, only worked part-time.
[2] See *Art at Auction* 1967–68, page 25.

Miss Edith Bourne, taken just
before she joined Sotheby's in 1914.

when we found our tables and typewriters immaculately dusted and office shoes warming by the fire on winter mornings we felt we were accepted. In fact, I have a happy memory of old Watkins, who peered through cracked spectacles secured behind his head with a rubber band, introducing me to another porter as 'my seckertary'.

Tom Hodge, however, the oldest director, was an uncompromising Victorian who could not adapt to the changing world. He had no contact with us, and after a few weeks he retired to Sussex, to keep bees. The hegemony of the hive, unaltered since creation, must have been pleasing to his intransigent spirit.

The oddly constructed building could hardly belong to any known architectural period – Dickensian perhaps. The 'Partners' Room' was reached by a double stairway where one could do a little skilful dodging if need be. In this room the Partners themselves opened the mail and apportioned the departmental work. Coins and Antiquities (not many of these) were kept for Major Warre to attend to on his occasional periods of leave from the Front. Apparently such sales could only be held between battles. A trapdoor in the floor of the sale room concealed a stepladder and moved creakingly up and down to facilitate transport of books, etc., carried by the porters.

The only separate rooms were those of the Partners. The Book cataloguers created walls of books round themselves. I perched on a high chair with my typewriter at the end of Mr Phillips' long book table. In my early weeks in that unfamiliar world, coping with Latin in the book section, Chinese in the Porcelain section, or occasional Japanese when these print sales took place – he was a great help to me. In moments of stress, hearing me breathing heavily and rubbing out energetically, he would silently offer me a bag of sweets (without which he never worked). On one occasion, when breathing had grown to muttering, he said 'Why don't you give a good "DAMN" instead of that blasphemous muttering'!

Being on the ground floor, property arriving for sale sometimes surrounded us. When the Brontë relics arrived from Haworth I worked hemmed in by Charlotte

Brontë's piano, and the rattle of my typewriter beside those silent keys seemed almost a sacrilege. Only the vibration of heavy traffic or bumping packing cases would raise an echoing vibration from the sad old instrument with the faded silk front. I was glad that it was made possible after the sale for all those relics to be returned to Haworth to form the Brontë Museum.

In those comparatively early years of Fine Art auctioneering there was a good deal of reserve and discretion about the disposal of private family treasures – the time had not yet come when the waste of War, and taxation, made the impoverished owners of anything of value realize that 'it pays to advertise'. Many collections were sold anonymously, 'The Property of a Lady (or Gentleman).' I often heard Mr Hobson lamenting as he made up a sale of various owners 'What a lot of Ladies and Gentlemen'!

The old sale room upstairs was a place of many literary memories. It was here that the love letters from Keats to Fanny Brawn were sold, causing some indignation in those days – ('These are the letters that Endymion wrote'). Mr Hobson recalled this sale in his 'Notes on the History of Sotheby's', regrettably out of print. Another sale of great interest, with which Mr Hobson was personally connected, was that of the Barrett Browning collections – letters, books and works of art from the Casa Guidi home. He went over to Florence to arrange about the sale – a visit which was in the nature of a pilgrimage. He often referred to it. An admirer of Browning, it must have been a moving experience to stand in the room once lived in by Browning and his wife.

The Drane Collection, a very fine collection of Jacobite Wine Glasses, also took place in Wellington Street in July 1916. These beautiful old glasses engraved with the Jacobite emblems, star, rose and bud, 'Audentior Ibo', etc., formed the largest such collection to have been sold at auction at that time. The catalogue described the various emblems as symbolizing the 'Old Pretender' and the 'Young Pretender', and immediately the Jacobite Society wrote and protested that the word 'Pretender' was incorrect, and asked that the catalogue should be withdrawn and reprinted, giving the correct status of 'Prince James Edward Stuart' and 'Prince Charles Stuart'. Old wars, old loyalties – these could not delay the publication of Sotheby's catalogues, but notices giving the 'amendment' were put in the sale room.

Some years afterwards a relic of Jacobite connection of gruesome and tragic memories, was entered for sale – the withered arm of Graham of Claverhouse (Bonny Dundee), said to have been hanged, drawn and quartered. The arm was mummified and preserved in a locked bevelled glass cabinet: it was said to have been taken down from York City Gate where it had been impaled. It was kept in our Strong Room. The usual routine was for Directors to approve the weekly list of auctioneers taking each sale, but on this occasion it was found that no one cared to offer for public auction such an unhappy relic, and the question was asked 'Who accepted this for sale?' By mutual agreement it was withdrawn from sale, and we hoped that, ultimately, it was interred in the family tomb.

A colourful visitor to the old Wellington Street rooms was Mrs Theodore Watts-Dunton. Her wonderful red hair, her animation while recounting her brief life on the films, or lively evenings at 'The Pines', Putney Hill (Swinburne lived there with her and her husband), kept us entertained much longer than was strictly necessary for the

arrangement of the sale of Swinburne relics. A refreshing companion for the two poets.

One of the last representatives of the Victorian era who brought an aura of courtly dignity into the old office was Lord Stamfordham, Queen Victoria's Secretary, who kept a watchful eye on all manuscripts concerning Crown and State which might appear in our sales. On one occasion a collection of such papers found in the home of a long-dead Foreign Minister was entrusted to us for sale by his descendants. The sale was, of course, stopped, and the papers removed to the Foreign Office, though the war which they concerned took place over a hundred years ago.

Speaking of old-world courtesy reminds me of Tom Hodge rebuking a clerk whose manner towards a somewhat shabby caller in Wellington Street had been rather casual – 'Even if a tramp called on us he must be treated with courtesy' – then with a touch of his caustic humour – 'he might have a First Edition of the Pilgrim's Progress in his pocket'. (We had recently sold a copy for £4,000.)

I came to associate the smile and the flourish with Sir Montague's alert movements. I think he loved to feel he was the centre of the whirlpool. A brisk tour of the Office then, 'If anyone wants me I shall be at the House' – a smile, a flourish, and a closing door. Or a sudden meeting with an unprepared member of the staff, 'Are you looking for me?' His was a life of many interests and he liked his enthusiasm to be shared. When the removal to Bond Street was decided upon he took Miss Lachlan and myself up to inspect the new premises, and hear our reaction – instant enthusiasm of course, when we contrasted the animated bustle of the West-end with the more intent and purposeful life of the City.

The two small attic windows which can be seen in the print of the old building show the room where the Letter Files were kept. Miss A.L. usually worked up there; it was a nice quiet retreat reached by a winding iron staircase which gave clanging warning of any approach. We had our tea there, and in 1916 were joined by the Girton Girl,[3] our new book cataloguer. She certainly combined humour with learning, to our enjoyment. She loved her work and invariably brought a book with her. In her inimitable voice with its gurgling laugh she read to us 'The Hunting of the Snark' during the tea break, which became a hilarious half-hour.

The first bombing of London took place before we removed from Wellington Street, but it was usually possible for us to get home before the Zeppelins arrived. Sotheby's suffered no damage beyond broken glass from falling shell, but a few bomb fragments were framed and treasured for a while.

Due to war-time staff shortage, on one occasion I remember Mr Wilder taking a sale with me acting as sales clerk. Mr Hobson passed through the room with an indulgent smile at this youthful set-up. Later what must be an auctioneer's nightmare happened; two men started to bid on and on for an unimportant item. Mr Wilder became increasingly bewildered until it was at last divulged that both bidders were acting for superiors who had simply said 'BUY', knowing that the lot could not fetch more than a few pounds.

In 1917 we moved to Bond Street. It must have been as formidable an undertaking, and as interesting, as the removal of the Ark. Thereafter, though we still lived and worked with history, the panorama of the twentieth century passed by our windows. Major Warre paused at my table one day and remarked 'Some people would pay

[3] Miss Millicent Sowerby M.A., author of *Rare People and Rare Books*, 1967.

374 MEMORIES OF SOTHEBY'S FIRST GIRL

me to work at this window instead of me paying you' – I loved my window on the world.

After the War the volume of sales of every description increased. Many needed to sell, many wanted to buy, particularly Americans, and the millionaires began to foregather. At one sale of old silver a noted American book collector (Gabriel Wells) had spent a considerable amount. We asked why he was buying Silver – 'No special interest; I came over to Europe to spend a quarter of a million', he replied, 'and this just makes it'.

Occasionally popular feeling voiced itself against the flow of treasures of particular English interest across the Atlantic. In the case of 'Alice in Wonderland' a dealer who had come over for the sale received an anonymous letter from a man who threatened to shoot him if he bought this charming manuscript and removed it to America. He consulted us, and an announcement was made from the rostrum that he would not bid against any English buyer, but considered himself free to bid when the English dropped out (? an ambiguous arrangement). He ultimately won 'Alice' at a high price; the MS was sold again in America for, I think, £30,000. Later it was given to the British Museum.

Sir Montague was interested in Etching, an art which he once studied himself. At one period there was a distinct fashion for collecting modern etchings and he was much interested to see the high prices obtained by the Scottish artists; 'The economy of line in etching seems to be attractive to the Scotsman' he remarked after a specially successful sale of works by McBey, Cameron, etc.

Including the Girton Girl we had seven book experts. It was work of an essentially scholarly nature, so the preponderance of old school ties was not surprising – Oxford, Cambridge, Eton, Harrow. Sir Montague was rather proud of this until something suddenly irritated him – 'There's too much of this academic atmosphere, this is a business house'. He thereupon engaged as new clerk-secretary a very determined young woman from the industrial north. For a while he hopefully upheld her drive and energy as a pattern to all of us, but she was a disturbing element who seemed to fit in nowhere, and eventually, after a short sharp wordy battle at the end of a specially trying day, they sacked each other.

The newly built galleries with their cleverly enhanced daylight became a world rendezvous for collectors, students, dilettanti. Here you might see Epstein, watching with interest the sale of some of his own sculpture; Lord Carnarvon and Howard Carter meeting friends and discussing their latest plans for the last expedition to the Valley of the Kings; or Mr Okada the Japanese Minister. Eastern collectors were very keen to buy the finest examples of Oriental art and take them back to the East.

One day a quiet, unassuming man with noticeable blue eyes, unusual in a man, asked me to take him to Mr des Graz with whom he had an appointment. I asked him his name and he replied briefly: 'Shaw'. When I returned to the office I was told 'You've been talking to Lawrence of Arabia'. A thrill? Yes, in spite of all the de-bunking by modern critics.

A pleasant event was the sale of the Log Book kept by Nelson on the Victory. The punctilious salute with which naval officers entered the Gallery to inspect the Log Book intrigued us. It is a rule of the Navy to acknowledge the spirit of Nelson, and

for that short period our Book Room was under a spell which transformed it into the Quarter Deck. And after the sale, when it was announced that the Log Book had been bought by a private buyer for the Nation, there was a murmured ovation – an unusual sound in that quiet room – and the Senior Service left with a final salute. Truly an impressive Naval occasion.

There was a mysterious flurry of Directors one evening after a confidential call of two unnamed strangers. I was given a brief note. The callers purported to have a document signed by Cortez (the Conqueror of Mexico), for which they expected a sum of twenty thousand pounds. They were not prepared to put the document up to public auction, and wanted cash privately. In rarity Cortez' signature must rival that of Shakespeare. However, after the early morning secret meeting to which they were asked to bring the document for examination, the transaction was turned down by the Directors.

I found the Manuscript and Autograph Letters department more romantic than any other – the personal touch I suppose. But what could be more poignant than Mary Queen of Scots' last letter from Fotheringay the night before she was executed? Or more fascinating to an historian than the love letter from Queen Elizabeth to the Earl of Leicester, in which she asked him to 'comit to Vulcanes safe keping without any longer abode than the leasure of the reding thereof . . . with no mention made thereof to any other wight . . . Your loving maistres, Elizabeth R.'? But Leicester could not bring himself to burn a Queen's love letter, and so it came to light four hundred years later, finally to be preserved in the Archives at the British Museum.

In the 20's Egyptology became very fashionable. At one sale Mr Hobson acquired a small mummy of a charming princess. However, when the van arrived to deliver this to his home near the British Museum, Mrs Hobson was waiting in the doorway. 'If that comes in, I go out', she said, so back came the Egyptian princess.

Mrs Hobson was a charming person who was, of course, interested in Sotheby's. It was she who suggested that we should break with tradition and have a splendid gold cover for the catalogue of the beautiful jewels of Marie Antoinette. For such a special occasion and for such a queen, it was an attractive and appropriate change from our usual sober gown of green.

Among Sotheby's present directors, Mr Kiddell is the only survivor from this period. For over half a century he has had a brilliant capacity for intuition, authority, and friendship for sorting out problems. I remember a missing Jacobite Claymore, and before the expected furore and insurance affairs were put into motion, he unerringly put his finger on the culprit. 'X', he said severely in his best parade-ground voice, 'I want that sword back tomorrow'. And sure enough there was the sword in the morning. Nothing more was said and a contrite X remained at his job until his retirement.

With their strict code of business integrity and courtesy, and dedication to the Old Firm, there was much to respect and admire about the old-time directors, surely prototypes of the Forsytes. 'Il Magnifico', Hobson was called by one of his friends. And they were an impressive sight when, at the appropriate social seasons, Eton, Henley, Harrow, Royal Garden parties, etc., they appeared in the grey top hats and tail coats of the period. For me this elegant generation created the Saga of Sotheby's.

Ceramics

Some very fine and rare pieces of Meissen porcelain have been sold throughout the season. In Sotheby's first sale of porcelain held in Zurich on 26th April, part of a beautiful dinner service, comprising fifty-eight pieces, similar in style to the famous service made for Baron von Münchhausen, was sold for a total of 89,900 Swiss francs (£8,973; $21,535). The same sale included an attractive pair of Augustus Rex vases and covers, with designs adapted from Chinese 'famille-rose' originals, at 70,000 Swiss francs (£7,070; $16,968) and a fine Meissen plate painted in the manner of J. H. Höroldt at 21,000 Swiss francs (£2,121; $5,090).

In London in March, a magnificent pair of coral-ground vases, superbly painted with a variety of insects and fabulous beasts, fetched £13,000 ($31,200).

Pieces of this type, with the decoration painted directly onto the ground, are extremely rare, indeed the only other known vases decorated in this manner, and the companions to this pair, are in the Metropolitan Museum, New York.

This same sale also contained a very attractive 'chinoiserie' Augustus Rex vase by Johann Ehrenfried Stadler which fetched the very high price of £9,500 ($22,800), and a pair of bowls, covers and stands also decorated with 'chinoiserie' scenes, after engravings by Petrus Schenk, which realized £7,200 ($17,280).

Amongst other German factories represented in the March sale, a superb Augsburg-decorated Nuremberg faience jug, colourfully painted with a parrot, insects and a large bouquet of flowers, fetched £5,600 ($13,440), whilst an exceptional piece of Italian porcelain, a Capodimonte white figure of the Mater Dolorosa by Giuseppe Gricc, and the only known piece signed by him, realized £11,500 ($27,600). Amongst the fine pieces of English porcelain sold this season, some 'Hans Sloane' Chelsea botanical plates that were part of the collection of the late Sir James Williams-Drummond, Bt. sold on the 21st February, made exceptional prices; three superb examples were sold for £1,550 ($3,720), £1,800 ($4,320) and £2,200 ($5,280), establishing a completely new level of prices for this type of porcelain.

An Augsburg-decorated Nuremberg faience jug (*Enghalskrug*), painted by Bartholomäus Seuter, the foot with an English silver mount of later date. *Circa* 1715–20. 10½ in.
London £5,600 ($13,440). 29.III.71.

A documentary Capodimonte white figure of the Mater Dolorosa by Giuseppe Gricc.
Signed: *G.GRICC.* 16⅛ in.
London £11,500 ($27,600). 30.III.71.
No other Capodimonte piece is known to be signed by Gricc.

A documentary istoriato dish possibly painted at Urbino by Fra Xanto Avelli
and lustred at Gubbio by Maestro Giorgio Andreoli, signed and dated
Mo Go da gubio, 1530, 10½ in.
London £6,200 ($14,880). 29.III.71.

1. Meissen armorial teabowl and saucer from the Scala service, painted in the manner of C. F. Herold, S.F.14,500 (£1,464; $3,514). 26.VI.71. **2.** Meissen armorial plate made for the coronation of Augustus III as King of Poland, Johanneum mark N=147 w. 23 cm. S.F.12,000 (£1,212; $2.908). 26.VI.71. **3.** Meissen documentary teabowl and saucer. Dated Dresden, 1739. $3,500 (£1,485). 6.XI.70. **4.** Gold-mounted Meissen snuff box painted with views after Bellotto, Dahlbergh and Dilichs. *Circa* 1750. 3⅛ in. £7,200 ($17,280). 8.XII.70. **5.** One of a pair of Meissen lions by J. J. Kaendler. 6½ in. £2,000 ($4,800). 30.III.71. **6.** Meissen marine-decorated bowl. *Circa* 1725. £1,650 ($3,960). 8.XII.70. **7.** Meissen teapot and cover. K.P.M. in underglaze-blue, *circa* 1725. 5¾ in. £2,000 ($4,800). 8.XII.70. **8.** Meissen plate in the manner of J. G. Höroldt. 22 cm. S.F.21,000 (£2,121; $5,090). 26.VI.71. **9.** Meissen plate with indianische Blumen 22 cm. S.F.21,000 (£2,121; $5,090). 26.VI.71. **10.** Meissen teapot painted in the manner of C. F. Herold, with quay scenes 11,5 cm. S.F.10,000 (£1,010; $2,424). 26.VI.71. **11.** Meissen Lady with two pug dogs by J. J. Kaendler. 11½ in. £2,500 ($6,000). 29.III.71. **12.** Nymphenburg Italian comedy figure of Dona Martina by Franz Anton Bustelli. 7¾ in. £2,100 ($5,040). 8.XII.70. **13.** Nymphenburg figure of Leda by Franz Anton Bustelli. 7⅝ in. £2,000 ($4,800). 8.XII.70. **14.** Meissen coffee pot. *Circa* 1725. 8¾ in. £1,750 ($4,200). 8.XII.70.

1. Isnik dish, *circa* 1540, 13¾ in. £4,200 ($10,080). 29.III.71. **2.** Isnik blue and white vase, *circa* 1520–30, 10 in. high by 5½ in. diameter at the neck. £1,300 ($3,120). 29.III.71. **3.** Deruta lustred armorial dish, *circa* 1520, 16 in. Lire 1,900,000 (£1,267; $3,041). 19.X.70. **4.** Deruta istoriato dish, inscribed *el fratti fecit* on the reverse and dated 1545, $3,8co (£1,583). 7.V.71. **5.** Faenza albarello incribed *o.bacis, lauri.*, *circa* 1520, 9¼ in. £800 ($1,920). 3.XI.70. **6.** Lustred Deruta dish, inscribed *Ece:Angiu: Dei Che:Tolis*, *circa* 1520, 17¾ in. Lire 2,000,000 (£1,333; $3,199). 19.X.70. **7.** Urbino istoriato tazza, inscribed on the reverse *Da lalto scoglio le gonfiate vele, Vede partir il suo signor crudele*, *circa* 1535, 10½ in. Lire 2,200,000 (£1,467; $3,521). 19.X.70. **8.** Faenza armorial plate, mark of Casa Pirota, *circa* 1525, 9½ in. Lire 2,300,000 (£1,533; $3,679). 19.X.70. **9.** Pesaro documentary istoriato dish, inscribed *Zenobia subieta aureliano imperaetor in sieme con li figli fato in pesaro*, 1552, 16⅞ in. £1,650 ($3,690). 3.XI.70.

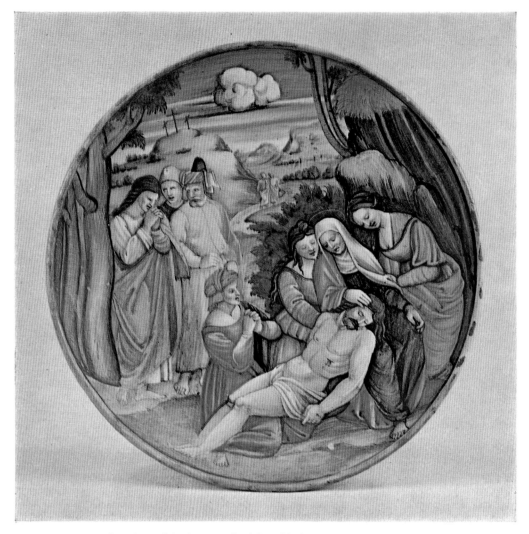

A Casteldurante istoriato dish decorated with a Pietà.
Circa 1525. 11¾ in.
Florence Lire 2,500,000 (£1,667; $4,001). 19.x.70.

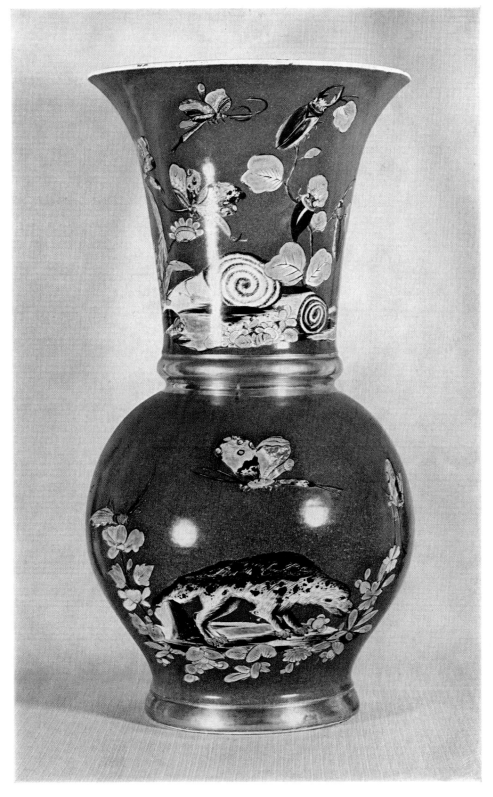

One of a pair of Meissen coral-ground vases, painted with fabulous animals and insects among *indianische Blumen*, the footrims and shoulders with wide gilt bands. AR marks in underglaze-blue. 18½ in. and 18⅛ in.
London £13,000 ($31,200). 30.III.71.

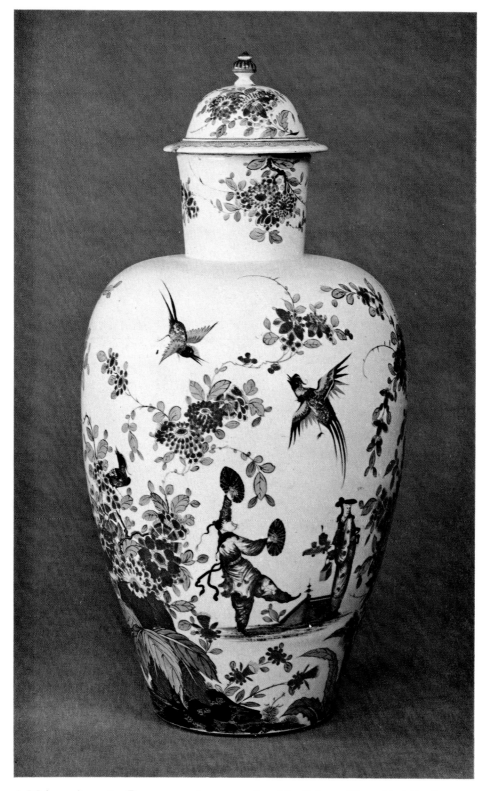

A Meissen Augustus Rex vase and cover, painted by Johann Ehrenfried Stadler.
AR mark in underglaze-blue. $15\frac{3}{4}$ in.
London £9,500 ($22,800). 30.III.71.

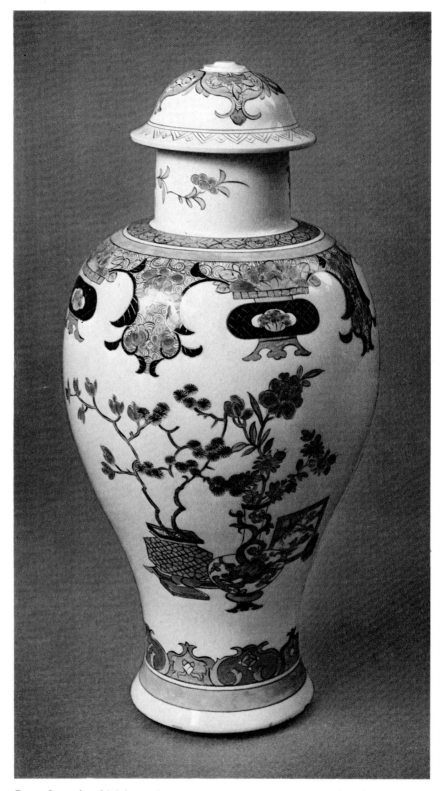

One of a pair of Meissen Augustus Rex vases and covers taken from
Chinese 'famille rose' originals. Large AR marks in underglaze-blue,
incised nicks inside footrim. $11\frac{1}{2}$ in.
Zürich S.F.70,000 (£7,070; $16,968). 26.VI. 71.
From the collection of Albrecht Freiherr von Tucher
of Schloss Leitheim, bei Donauwörth.

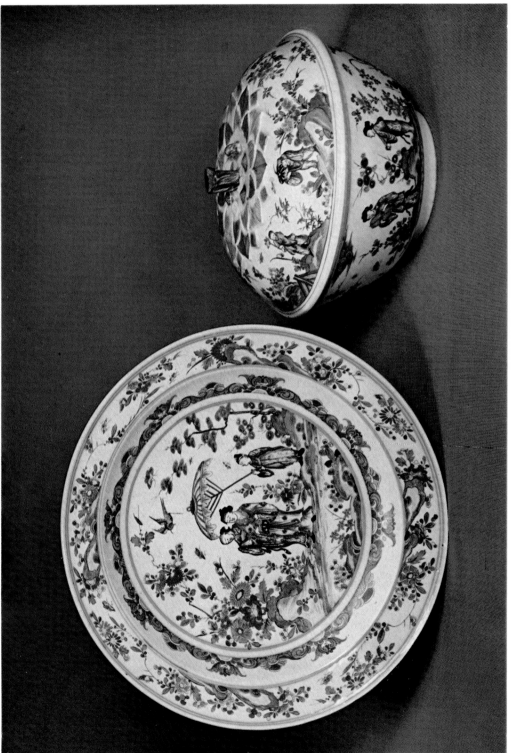

One of a pair of Meissen bowls, covers and stands, decorated after engravings by Petrus Schenk, with chinoiserie scenes showing Orientals at different pursuits.
Crossed swords marks in underglaze-blue. *Circa* 1725–30. Diameter of stand 10½ in., of bowl 7¼ in.
London £7,200 ($17,280). 30.III.71.

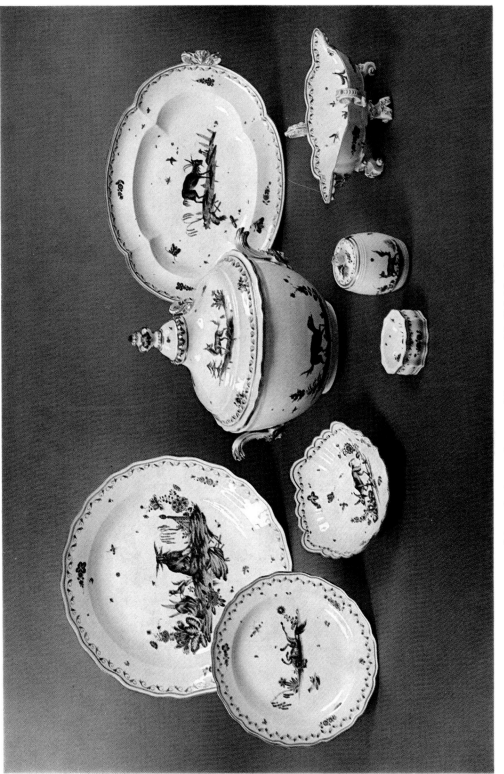

Part of a Meissen dinner service, comprising 58 pieces, decorated in puce with *Fabeltiere* in Löwenfinck style, closely related to the famous service made for Baron von Münchhausen, but without a coat-of-arms. Crossed swords marks in underglaze-blue. Sold in Zurich on 26th June, 1971, for a total of S.F.89,900 (£8,973; $21,535).

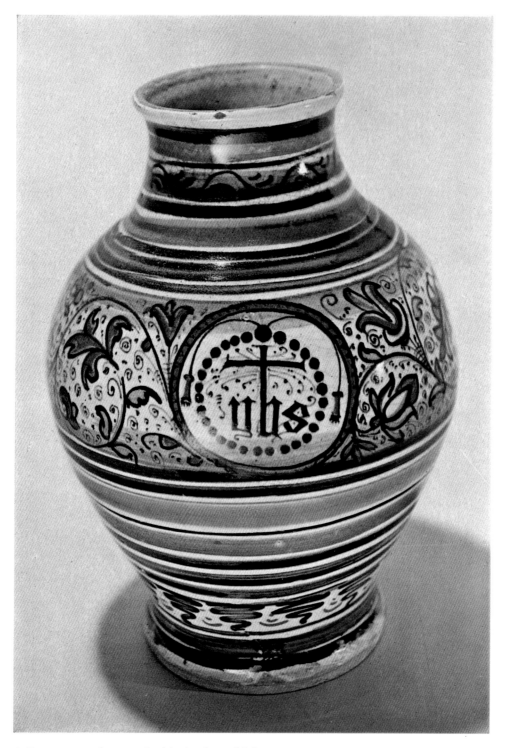

A Faenza vase decorated with the Sacred Monogram,
circa 1500. 11¾ in.
Florence Lire 2,100,000 (£1,400; $3,360). 19.x.70.

1. Frame of twenty-one London Delft tiles, with scenes from 'The Popish Plot' from engraved playing-card designs. £500 ($1,200). 15.III.71. **2.** Southwark Delft documentary charger. Signed: *REN* and dated 1657. $18\frac{3}{4}$ in. £2,200 ($5,280). 22.XII.70. **3.** Wedgwood creamware dish from the Imperial Russian service. Wedgwood mark, numeral 311 in black. $11\frac{1}{2}$ in. £1,300 ($3,120). 22.XII.70. **4.** Whieldon 'ling lung' teapot and cover inspired by a Chinese original. $5\frac{1}{2}$ in. £600 ($1,440). 29.VII.71. **5.** One of a pair of white saltglaze swans, probably after Meissen originals by J. J. Kaendler. $7\frac{1}{2}$ in. £1,350 ($3,240). 22.XII.70. **6.** Wedgwood caneware cassolette and cover. Wedgwood mark and incised I. £400 ($960). 15.III.71. **7.** Blue dash portrait charger. $13\frac{1}{4}$ in. £620 ($1,458). 15.III.71.

Above : Chelsea beaker painted in Kakiemon style, crown and trident mark in underglaze-blue, triangle period, 3 in. £1,600 ($3,840). Chelsea teapot and cover, painted by Jeffryes Hamett O'Neale, red anchor period, 6½ in. £450 ($1,080). A Chelsea acanthus leaf cream jug, crown and trident mark in underglaze-blue, triangle period, 3½ in. £2,500 ($6,000). *Below :* Chelsea scolopendrium teabowl and saucer, raised anchor mark, £540 ($1,296). Chelsea octagonal bowl and saucer, painted in Kakiemon enamels, raised anchor mark, 5¼ in. £500 ($1,200). Fable teabowl and saucer painted by J. H. O'Neale, raised anchor period, £900 ($2,160).
The objects illustrated above were part of the collection of Lady Corah
and were sold at Sotheby's on 7th July, 1971.

A Worcester pink-scale coffee-cup and saucer of fluted shape. First period. London £1,100 ($2,640).
A Worcester teapot and cover of barrel shape. First period. 5 in. London £2,300 ($5,520).
A Worcester turquoise-ground caudle cup and stand, painted in the atelier of James Giles. First period. London £1,000 ($2,400).
A plate from the Duke of Gloucester's service, decorated in the atelier of James Giles in Chelsea gold anchor style. Gold crescent mark. 9⅝ in. London £2,300 ($5,520).
These four items from the collection of Lady Corah were sold on 20th July, 1971.

Chelsea 'Hans Sloane' botanical plates from the collection of the late Sir James Williams-Drummond, Bt., of Hawthorden. *Above left:* brown anchor mark £180 ($432), *right:* red anchor £380 ($912). *Centre left:* red anchor mark £1,550 ($3,720), *right:* red anchor mark and numeral 17 £2,200 ($5,280). *Below left:* red anchor mark £600 ($1,440), *right:* red anchor mark and numeral 20 £1,800 ($4,320). London 23rd February, 1971.

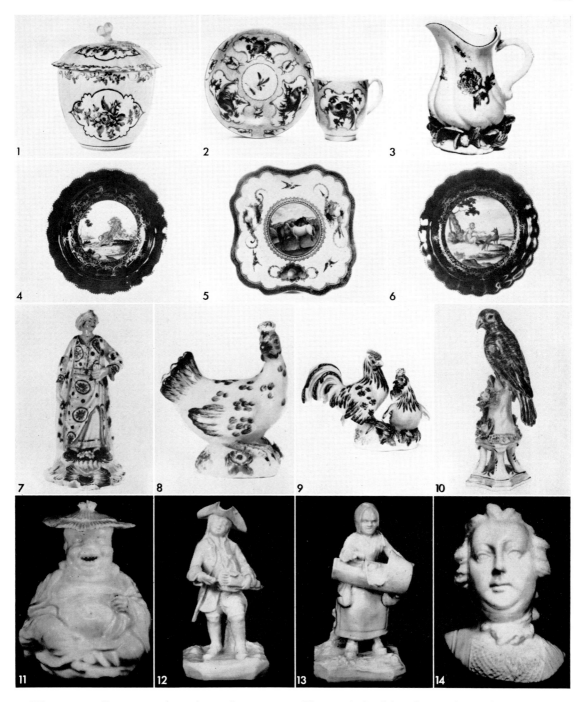

1. Worcester yellow-ground sucrier and cover. First period. 5¾ in. £1,150 ($2,760). 20.VII.71. **2.** Worcester yellow-scale coffee-cup and saucer. First period. £1,100 ($2,640). 11.V.71. **3.** 'Girl in a Swing' Chelsea cream jug. 3¼ in. £1,150 ($2,760). 24.XI.70. **4.** Worcester fable plate painted by O'Neale. Seal mark, First period. 7½ in. £1,400 ($3,360). 20.VII.71. **5.** Worcester dessert dish painted by Jeffryes Hamett O'Neale. Crescent mark. First period. 8 in. £1,050 ($2,520). 20.VII.71. **6.** Worcester fable-decorated plate painted by O'Neale. Seal mark. First period. 7¾ in. £1,850 ($4,440). 20.VII.71. **7.** Worcester coloured figure of Turkish woman.

First period. 5¾ in. £1,050 ($2,520). 20.VII.71. **8.** Bow figure of hen. 3½ in. £620 ($1,488). 20.VII.71. **9.** Bow farmyard group. 4¼ in. £1,100 ($2,640). 20.VII.71. **10.** One of a pair of Bow parrots. 6 in. £900 ($2,160). 11.V.71. **11.** Chelsea white 'Chinaman' tea jar and cover. Triangle mark. 6¾ in. £4,800 ($11,520). 20.VII.71. **12/13.** Pair of Bow white figures of a beggar musician and his companion. Arrow and annulet marks. 6¼ in. £620 ($1,488). 20.VII.71. **14.** White Chelsea bust of William Augustus, Duke of Cumberland. Raised anchor period. 5 in. £1,000 ($2,400). 20.VII.71.

Y

Clocks, Watches and Scientific Instruments

Unquestionably the most important horological item sold this season was the magnificent silver-mounted ebony bracket clock by Thomas Tompion and Edward Banger which fetched £26,000 ($62,400) at Sotheby's on 16th November, 1970, an auction record. Known as the Barnard Clock, this piece is described in greater detail on page 476.

In December, a rare and large sixteenth century gilt-metal alarum clockwatch, probably made in Germany about 1590, was sold for £6,800 ($16,320). Pieces of this kind of so early a date seldom appear on the market today and this example was in very good condition and with a fine case mounted with a pierced and engraved silver band.

A second clockwatch, in a silver case and by the French maker Louis Verdier, circa 1680, was sold for £1,100 ($2,640) in March 1971 and a third example, by Thomas Tompion, was sold the following May for £2,500 ($6,000). This latter piece was exceptionally interesting for two reasons, apart from its distinguished maker. The inner case was reminiscent of the French style of decoration, an unusual feature on an English watch of this period, whilst the absence of a number beneath the cock foot meant that it was made before 1682, in which year Tompion started numbering his pieces.

Watches in general do not appear to have suffered any market recession and prices this season have been extremely high for fine examples of many different types. An attractive nineteenth century Japanese gilt-metal inro clockwatch, with silver ojimi and gold-lacquer manju netsuke still attached, fetched £700 ($1,680) in March, whilst a large *chaise* watch made by Marwick Markham of London, *circa* 1780, for the Turkish market, fetched £780 ($1,872) in May.

Also in the March sale, an elaborate gold and enamel half-hunting-cased minute-repeating keyless lever fly-back chronograph was sold for £1,050 ($2,520). This piece, an extremely fine example of its type, was made circa 1910–20 by the *West End Watch Co.* of Switzerland for the Indian market and the enamel miniature, depicting a Tiger hunt, was surrounded by rose diamonds.

An outstanding French piece in the March sale was a silver open-faced independent seconds watch by Joseph Oudin, dated 1811. Its extremely high price of £1,850 ($4,440) is explained not only by its very good condition but also by the fact that the quality of the workmanship was almost equal to that of Breguet. Indeed, in the May sale, a good gold and silver-cased savonnette quarter-repeating cylinder watch made in 1829 by Breguet himself, was sold for £1,550 ($3,720).

THOMAS TOMPION

An early silver-cased alarum clockwatch
with calendar, the movement with pierced
Egyptian pillars and verge escapement, the
silver champlevé dial with roman numerals,
outer circle of arabic numerals for the
date indicated by a fleur-de-lys pointer
on a blued steel ring, rotating central
alarum disk with arabic numerals, arrow
head pointer and the signature *Tompion,
London*, single steel hand, 63 mm. diam.,
circa 1680.
London £2,500 ($6,000). 24.v.71.

A rare sixteenth century gilt-metal alarum
clockwatch, the verge escapement with
dumb bell foliot stackfreed and cam, the
backplate bearing the punchmark SV, the
gilt-metal dial with engraved foliate
border, outer ring of roman numerals I–XII
with touch pieces, inner ring of arabic
numerals 13-z4, the centre with revolving
alarum disk and four setting holes, single
iron hand, 78 mm. diam., *circa* 1590.
London £6,800 ($16,320). 14.xii.70.

1. Japanese gilt-metal verge Inro clockwatch, netsuke signed *Koma Kynhaku saku*, 19th C., 91 mm. £700 ($1,680). 22.III.71. **2.** Breguet No. 3773, savonnette quarter-repeating cylinder watch, signed, 52·5 mm. £1,550 ($3,720). 24.V.71. **3.** Breguet No. 1045, gold souscription watch, *circa* 1805, 62 mm. £820 ($1,968). 12.VII.71. **4.** Gold mailed fist containing a cylinder watch signed *Charles Oudin* No. 21612, 1835–40, 38 mm. £580 ($1,392). 26.IV.71. **5.** Gold virgule equation watch, by Samuel Roi & Fils, *circa* 1820, 58 mm. £2,800 ($6,720). 24.V.71. **6.** Thomas Earnshaw No. 567 gold pair-cased pocket chronometer 1800, 60 mm. £560 ($1,344). 12.VII.71. **7.** Benjamin Webb London No. 2 gold-cased duplex watch, 1805,

62 mm. £920 ($2,208). 24.V.71. **8.** Joseph Oudin No. 272 silver open-faced duplex independent seconds watch, 1811, 64 mm. £1,850 ($4,440). 22.III.71. **9.** Gold-cased quarter-repeating automaton verge watch, *circa* 1820, 58 mm. £1,050 ($2,520). 24.V.71. **10.** West End Watch Co. gold and enamel half-hunting-cased minute-repeating keyless lever fly-back calendar chronograph, 1910–20, 52 mm. £1,050 ($2,520). 22.III.71. **11.** Gold and enamel form watch, tulip-shaped, by Lechner of Vienna, 19th C., 23 mm. £560 ($1,344). 26.IV.71. **12.** Gold-cased quarter-repeating musical watch, *circa* 1820, 60 mm. £1,000 ($2,400). 24.V.71.

1. Silver pair-cased wandering hour verge watch, by Antram of London No. 2538, early 18th C., 56 mm. £650 ($1,560). 22.III.71. 2. Gold and enamel pair-cased repeating watch with late 19th C. Geneva movement with keyless winding and lever escapement, 41 mm. £780 ($1,872). 24.V.71. 3. Mudge & Dutton No. 983 gold pair-cased centre seconds cylinder watch, 55 mm. £660 ($1,584). 22.III.71. 4. Silver pair-cased verge alarum watch by Simon Decharmes of London, *circa* 1710, 56 mm. £440 ($1,056). 14.XII.70. 5. Pair-cased hour repeating alarum calendar chaise watch by Henry Massy of London, *circa* 1690, 100 mm. £1,000 ($2,400). 24.V.71. 6. Gilt-metal verge oignon, by Gaudron à Paris, *circa* 1700, 73 mm. £500 ($1,200). 24.V.71. 7. Louis Verdier No.

657 silver verge clockwatch with alarum, *circa* 1680, 120 mm. £1,100 ($2,640). 22.III.71. 8. Silver-cased verge watch by Arnolt of Hamburg, *circa* 1630, 34 mm. £1,050 ($2,520). 24.V.71. 9. A silver-cased grande sonnerie chaise watch, by Julien le Roy à Paris, No. 1522, *circa* 1730, 77 mm. £950 ($2,280). 22.III.71. 10. Repoussé gold pair-cased verge calendar watch No. 795 by Andries Vermeulen of Amsterdam, 1731, 54 mm. £520 ($1,248). 24.V.71. 11. Silver triple-cased quarter-striking verge chaise watch for the Turkish market, by Markwick Markham, *circa* 1780, 118 mm. £780 ($1,872). 24.V.71. 12. Silver verge watch by John Chamberlaine of Ipswich. Signed. *Circa* 1630. 46 mm. £640 ($1,536). 12.VII.71.

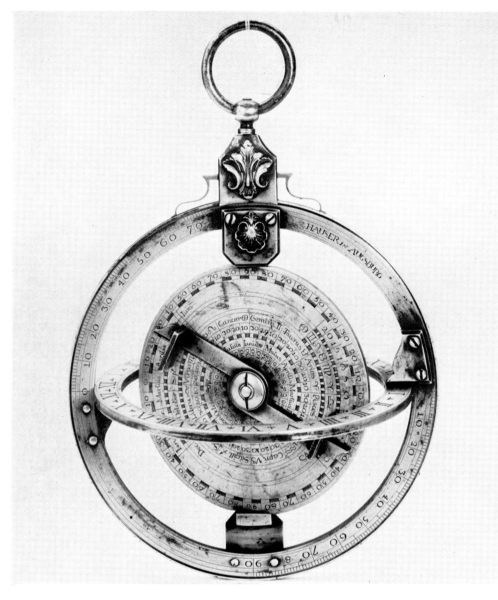

A late 17th century silver astronomical ring dial, by Hauser in Augsburg, signed
on the altitude ring, engraved with degrees 0–90 and 90–0, the reverse with sight
pin hole and scale of degrees from 0–90 for measuring angles, the dial with roman
numerals, 1–12 twice over, the pivoted centre plate marked with degrees of
longitude and of latitude for the sun's declination with a revolving scale of degrees
the reverse with revolving alidade with two sights and engraved with four times
90°, scales for the months, the Signs of the Zodiac, the degrees of the Zodiac, the
months, and numbers of days, the movable suspension ring mount decorated with
a cast fleur-de-lys in high relief, the pivots (for the centre plate) decorated with a
cast scallop shell. Diameter 124 mm. London £2,300 ($5,520). 12.VII.71.
The dial appears to be an adaptation of the astronomical ring of Gemma Frisius,
possibly following an earlier tradition.

A constant force clock, signed *Duval Invt. & Fecit à
Freville An 6*, the date refers to the sixth year of
the French Revolutionary Calendar. Height 235 mm.
London £1,100 ($2,640). 16.XI.70.

A silver and gilt-metal universal equatorial dial.
Signed Johann Willebrand in Augsburg.
Circa 1700–25. 64 mm. diameter.
London £500 ($1,200). 14.XII.70.

A gilt-metal gun elevation sight, *circa* 1600. 170 mm.
London £740 ($1,776). 24.V.71.

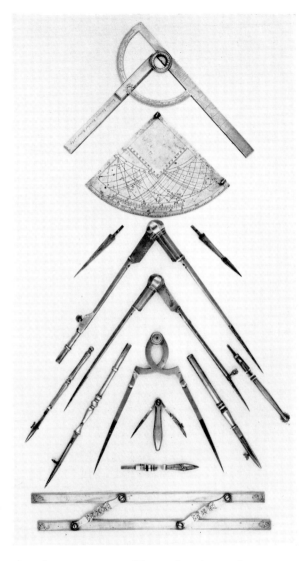

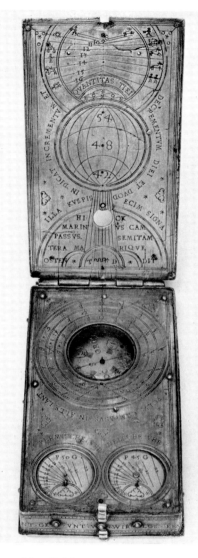

A 17th century case of brass drawing and
mathematical instruments. Signed Iacobus
Lusuerg faciebat Romae 1689.
Length of box 255 mm.
London £1,350 ($3,240). 14.XII.70.

A brass tablet dial by Thomas Tucher,
second half of the 17th century.
132 mm. by 77 mm.
London £2,600 ($6,240). 14.XII.70.

Arms and Armour

The upward trend in prices for really fine guns has continued this season. It is however, worth noting, that Continental pieces are now slightly more popular than English examples, although this should not be taken as a comment on the comparative merits of the two.

During the course of the season, outstanding guns from the four great arms and armour centres of Europe: Germany, France, England and Italy, have been sold at Sotheby's. On 12th October, a very fine German wheel-lock holster pistol of about 1590 fetched £7,500 ($18,000), one of the highest prices paid at auction for a single gun. This pistol was made for a boy, and of the very few examples of this kind which have survived, is probably the finest. The same day, a good wheel-lock rifled carbine of *circa* 1580 fetched £3,400 ($8,160). The superb quality of the staghorn inlay and the unusual shaping of the stock of this piece suggest that it was made by Melchart Schuster of Vienna.

Also on 12th October, a superb pair of early eighteenth century flintlock holster pistols by Franco Bigoni of Brescia fetched £6,000 ($14,400). The furniture of these guns was of gilt-bronze inset with numerous silver plaques chased in high relief; as was customary with pistols of the highest quality made at that time, the decorative details of both pistols differ throughout. Amongst the classical figures depicted are Hercules, Mars and Diana, Venus, Cupid and Laöcoon. Another important pair of Italian guns, was the pair of fine, but damaged, flintlock holster pistols by another great Brescian maker, Lazarino Cominazo, *circa* 1660–80, which, again in October, was sold for £1,200 ($2,880).

Of the French guns, the most important was a magnificent pair of percussion cap target pistols by Gauvain of Paris, one of the foremost mid-nineteenth century French gunsmiths. The carved butts of these pieces were especially interesting, being divided into panels in Gothic style; sold in a fitted case complete with all the accessories, they £4,400 ($10,560).

The finest English pistols to be sold were by John Manton, one of the foremost makers of the late eighteenth, early nineteenth century. The bore the serial number 1919, which date them to 1792. The pistols were superbly mounted in silver by Moses Brent, who usually made the silver furniture for Manton's pieces. Examples of this quality are now very rarely seen in the sale rooms and this particular pair fetched £3,800 ($9,120).

Good armour is again rare on the market today but the few fine examples that do appear usually fetch very high prices. This season, an exceptionally good Maximilian close helmet of *circa* 1520, fetched a £1,350 ($3,240), whilst a splendid damascened Mamluk turban helmet of the late fifteenth century was sold for £1,800 ($4,320). Edged weapons have also sold well and there has been a noticeable growth of interest in daggers. This was exemplified by an outstanding Saxon dagger of *circa* 1600 which realized £1,050 ($2,520) this season, having been previously sold at Sotheby's in 1967 for £400 ($1,120).

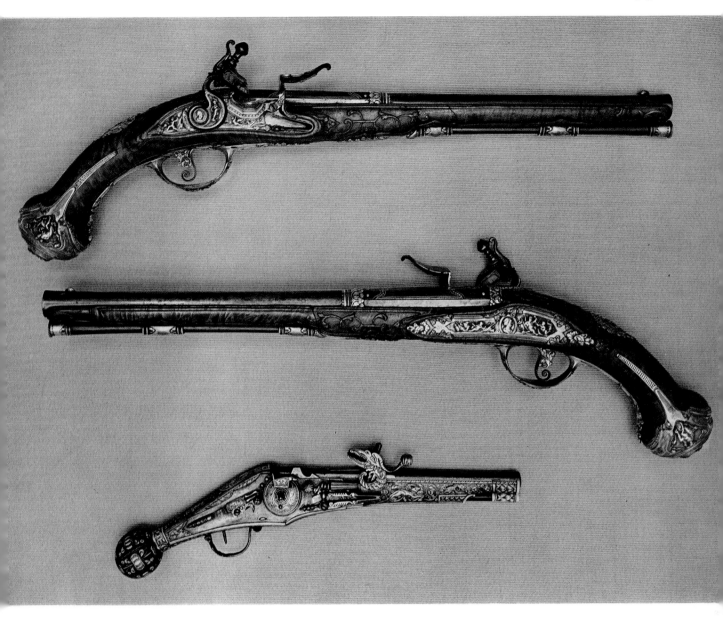

Above:
A pair of flintlock holster pistols, signed on the locks F. Bigoni and on the barrel, in Brescia.
First half of the 18th century, 21 in.
£6,000 ($14,400).

Below:
A German wheel-lock holster pistol made for a boy, *circa* 1590, 13 in.
£7,500 ($18,000).
These pistols were part of the Cummer collection of firearms
and were sold in London on 12th October, 1970.

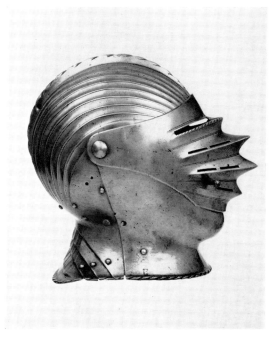

A Maximilian close helmet, the chin piece stamped with the Nuremberg town mark, *circa* 1520, 11½ in. high.
London £1,350 ($3,240). 17.v.71.
From the collection of Aubrey C. Burton, Esq.

A Mamluk turban helmet, struck with the arsenal mark of St Irene.
Late 15th century, 9¾ in. diameter.
London £1,800 ($4,320). 22.iii.71.

A half suit of Maximilian armour, South German, *circa* 1510.
London £1,700 ($4,080). 17.v.71.
From the collection of Aubrey C. Burton, Esq.

A garniture of Spanish cup hilt rapier and left hand dagger, the rapier inscribed on the fuller *AGHAE* on one side and *LHPHS* on the other, the dagger stamped with the bladesmith's mark TB on each side, *circa* 1750.
Rapier 44 in. long, dagger 23 in.
London £1,150 ($2,760). 12.x.70.
From the collection of Roy G. Cole, Hamilton, Ontario.

1. German late 16th century wheel-lock holster pistol, struck with maker's mark and initials H.R. 22½ in. £1,900 ($4,560). 14.XII.70.
2. French percussion cap breech loading target pistol, signed *Inven. Gastinne-Renette à Paris, circa* 1860, in fitted case with accessories 16 in. £1,350 ($3,240). **3.** Flintlock presentation pocket pistol, signed *Innes, Maker to His Majesty, circa* 1800. 4⅛ in. £1,300 ($3,120). **4.** A pair of percussion cap target pistols, signed *Gauvain à Paris, circa* 1850, in case with accessories. 16 in. £4,400 ($10,560). 19.VII.71. **5.** A .30 Mauser semi-automatic pistol, serial no. 13769, barrel stamped *Waffenfabrik Mauser Oberndorf A/N,* frame engraved *Westley Richards & Co., London,* and *W. L. S. Churchill.* 12 in. £4,100 ($9,840). 22.III.71. **6.** One of a pair of Dutch bronze

cannon, dated 1736. 41 in. £1,250 ($3,000). 22.III.71. **7.** German crossbow, *circa* 1600, 31½ in. and cranequin dated 1552. 16 in. £850 ($2,040). 12.X.70. **8.** Pair of silver mounted flintlock duelling pistols by John Manton, no. 1919, 1792. 15½ in. £3,800 ($9,120). 19.VII.71. **9.** Flintlock revolving rifle, signed *E. H. Collier 104 London, circa* 1820. 47 in. £1,350 ($3,240). 12.X.70. **10.** Pair of Brescian flintlock holster pistols, signed *Lazarino Cominazo,* maker's mark E.D., *circa* 1660–80, 22½ in. £1,200 ($2,880). 12.X.70. **11.** Wheel-lock rifled carbine, stock attributed to Melchart Schuster of Vienna, maker's initial CF, *circa* 1580, 34 in. £3,400 ($8,160). 12.X.70. **12.** Pair of Tuscan snaphaunce belt pistols, dated 1737, 41 in. £780 ($1,872). 12.X.70.

Cars

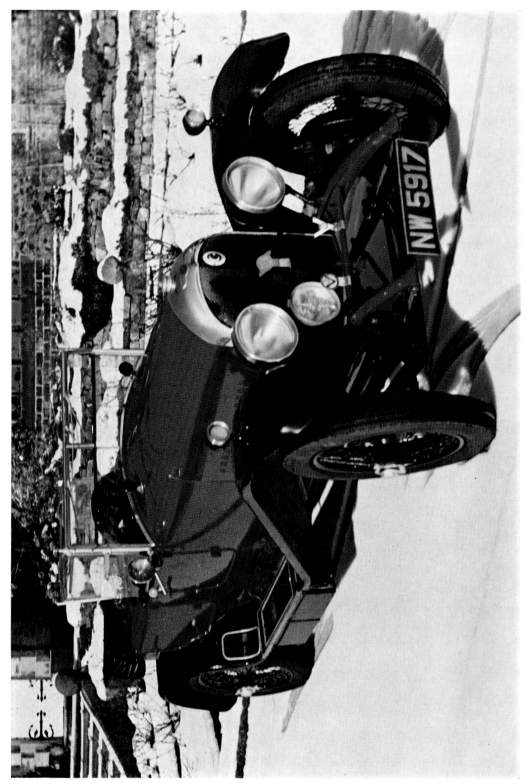

A 1924 Bentley 3 litre speed model sports tourer, body by Park Ward. Engine No. 505, chassis No. 500 London £4,300 ($10,320). 20.v.71.

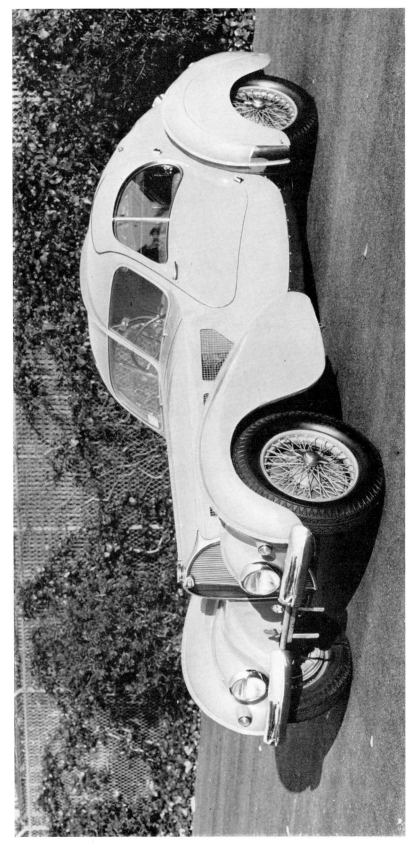

Bugatti type 57SC 'Atlantique' electron coupé, 1936, engine No. 57374–2S, chassis No. 5754
Los Angeles $59,000 (£24,583). 12.VI.1971.
From the collection of the late Robert B. Oliver, Rancho Santa Fé, California.

Miniatures and Silhouettes

One of the most significant developments this season has been the obvious growth of interest in collecting silhouettes. The interest shown in the fine collection sold at Sotheby's on 26th April, and the high prices paid for the best examples, show that there is now a very widespread demand. It should be remembered that silhouettes were originally produced to supply a less expensive form of miniature; they originally cost two or three shillings as opposed to anything up to £30 for a good miniature portrait. They began to be produced in the second half of the eighteenth century and survived up to the advent of photography in the middle of the nineteenth century.

In the April sale, an auction record price of £270 ($648) was paid for a portrait of a gentleman by Lea of Portsmouth, whilst a pair of silhouettes of the Reverend Dean George Stevenson and his wife Lydia by John Miers, generally recognized as the master of this type of art, fetched the same sum. Two other silhouettes by the same artist fetched £145 ($348) and £140 ($336) respectively.

The season has produced several distinguished miniatures by John Smart, the leading eighteenth century limner, including a very fine portrait of an artillery officer which fetched £1,900 ($4,560) in April. Two portraits of exceptional historical interest, those of Richard Cromwell by Samuel Cooper and Sir Kenelm Digby by Peter Oliver, made £1,100 ($2,640) and £1,550 ($3,720) respectively.

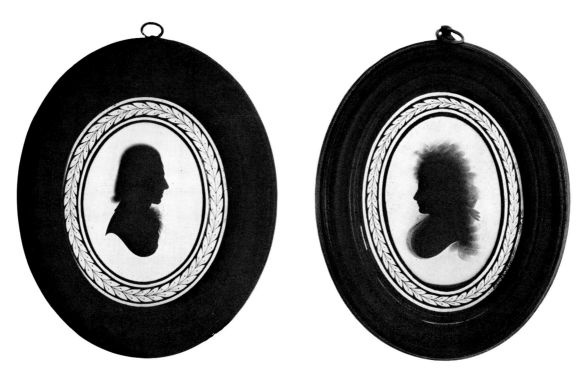

A pair of silhouettes of the Reverend Dean George Stevenson and his wife Lydia by John Miers, on plaster, London trade label, 3½ in.
London £270 ($648). 16.XI.70.
From the collection of the late F. T. Love, Esq.

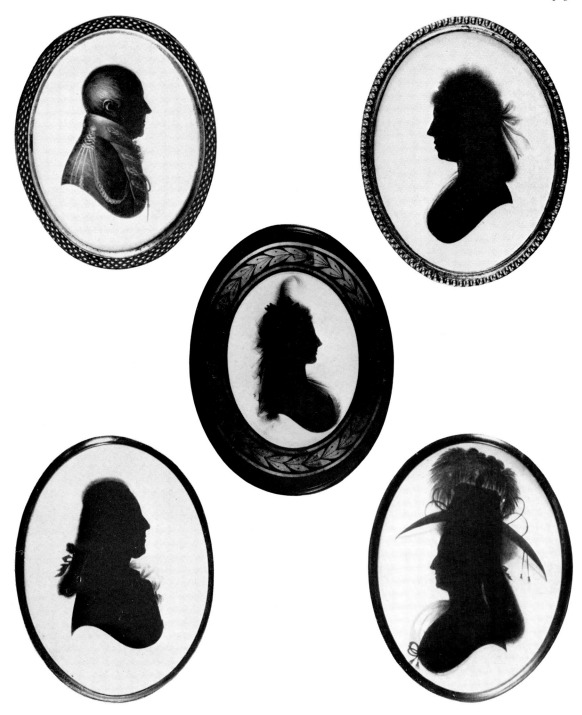

Above left: A bronzed silhouette of an Officer by John Miers, on plaster, trade label, *circa* 1801, 3⅛ in.
London £140 ($336). 26.IV.71.

Above right: A silhouette of a Lady by John Miers, on plaster, Leeds trade label, 1783, 3¼ in.
London £145 ($348). 26.IV.71.

Centre: A silhouette of a Lady by Samuel Houghton, on plaster, trade label on the reverse, 3½ in.
London £210 ($504). 26.IV.71.

Below: A pair of silhouettes of a Man and a Woman by Mrs Lightfoot, both on plaster, the reverse with Liverpool trade label, 3½ in
London £250 ($600). 26.IV.71.

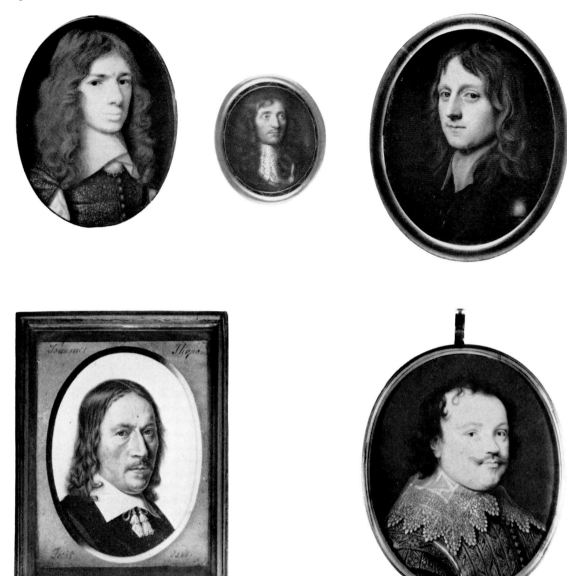

Above left: A miniature of a Gentleman by Samuel Cooper, probably a member of the Fairfax family painted in about 1640. $2\frac{1}{16}$ in. London £800 ($1,920). 15.III.71. From the collection of the Fairfax family of Bilborough and Steeton.

Centre: An enamel miniature of a Gentleman by Jean Petitot, signed and dated 1674, $1\frac{1}{8}$ in. London £1,350 ($3,240). 26.IV.71. From the collection of Mrs J. D. Dent-Brocklehurst.

Above right: A miniature of Richard Cromwell by Samuel Cooper, signed and dated 1657, in a turned ivory frame, $2\frac{1}{4}$ in.

London £1,100 ($2,640). 26.IV.71. From the collection of Mrs J. D. Dent-Brocklehurst.

Below left: One of a pair of plumbago miniatures of a man and his wife by Johannes Thopas, signed and dated 1649, each $2\frac{1}{2}$ in. London £1,250 ($3,000). 26.IV.71. From the collection of Mrs J. D. Dent-Brocklehurst.

Below right: A miniature of Sir Kenelm Digby by Peter Oliver, $2\frac{1}{2}$ in. London £1,550 ($3,720). 10.V.71. From the collection of Mrs Margaret Eastwood.

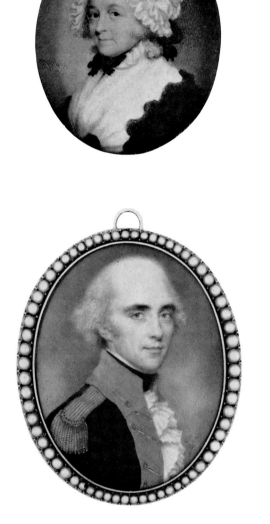

Above left: A miniature of Mrs Margaret Tyers, by Philip Jean, 2½ in.
London £480 ($1,152). 15.III.71.

Above right: A miniature of a Lady by John Smart, signed and dated 1776, diamond bordered frame, 1¾ in.
London £1,400 ($3,360). 10.V.71.
From the collection of Lady Longmore.

Below left: A miniature of an artillery officer, by John Smart, signed and dated 1791 I, 2½ in.
London £1,900 ($4,560). 22.II.71.
From the collection of Mrs Yvonne Barton.

Below right: A miniature of Sir Archibald Campbell, K.C.B., of Inverneill by John Smart, signed and dated 1786 I, 2⅜ in.
London £1,700 ($4,070). 26.IV.71.
From the collection of
Mrs J. D. Dent-Brocklehurst.

Jewellery

BY PETER HINKS

One of the most interesting and certainly the most delightfully idiosyncratic collections of jewels to be auctioned this season was that of Madame Ganna Walska sold at Parke-Bernet in April. A butterfly with wings cut from single diamonds made $24,000 (£10,000), an Indian carved emerald pendant $54,000 (£22,500), a diamond ring, the heart-shaped stone of 21·15 carats, $105,000 (£43,750).

In contrast the Collingwood jewels sold in London on 18th February were an exquisitely chosen collection of English diamond jewellery of the 1840's. The tiara, a garland of diamond flowers made £5,000 ($12,000) and a parure of a brooch and girandole earrings £4,000 ($9,600).

Interest in fine coloured stones is still growing and those sold in New York on Wednesday 2nd June were certainly no exception: a ruby ring of about $5\frac{1}{2}$ carats reached $41,000 (£17,082). A sapphire of approximately 6 carats, also in a ring made $10,000 (£4,166). Of a more specialized appeal the 'fancy' canary coloured diamonds in the same sale made good prices, the earrings $21,000 (£8,749) and the ring $18,000 (£7,500).

Diamond prices, which never show the spectacular increase we almost take for granted in the coloured stone market, continue to be excellent. A necklace by Cartier made £15,200 ($36,480) in London on 18th February and a 3-row collet necklace £13,500 ($32,400) on 12th November.

Antique diamond jewels generally fall into a different category simply because the value can lie as much in the age and prettiness of the jewel as in the value of the stones. An extremely attractive French eighteenth century necklace of foliate design realized £7,000 ($16,800) in London on 18th February and an early Victorian blue enamel and diamond brooch pendant in pristine condition reached a well deserved £1,200 ($2,880).

The pearl market has long been a difficult one, nonetheless two pearl necklaces, each of three rows, made £8,200 ($19,680) and £8,800 ($21,120) respectively in London.

Of more exotic gems a cat's eye of approximately 30 carats set in a ring with diamonds brought $9,000 (£3,750) in New York and in London an alexandrite and diamond pendant made £9,000 ($21,600). Recently, after more than thirty years of neglect in the West, fine jade is once again bringing prices which do justice to a gem which at its best can rival the emerald in colour and beauty. As Jadeite becomes rarer at the source, more and more buyers from the Far East frequent the London salerooms and at the last sale of the London season a small single row necklace of admittedly superb quality made £4,400 ($10,560). In the same sale was an Indian emerald carved with an episode from the Ramayana and weighing 369·24 carats, which made £25,000 ($60,000),

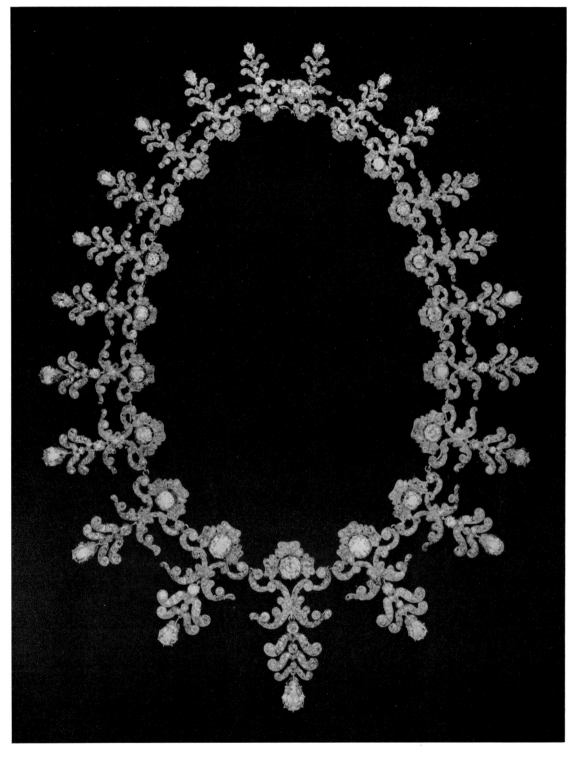

A French late 18th century diamond necklace, said
to have been the property of Marie Antoinette.
London £7,000 ($16,800). 18.11.71.
From the collection of Mrs Robin Kingsley.
(Reduced.)

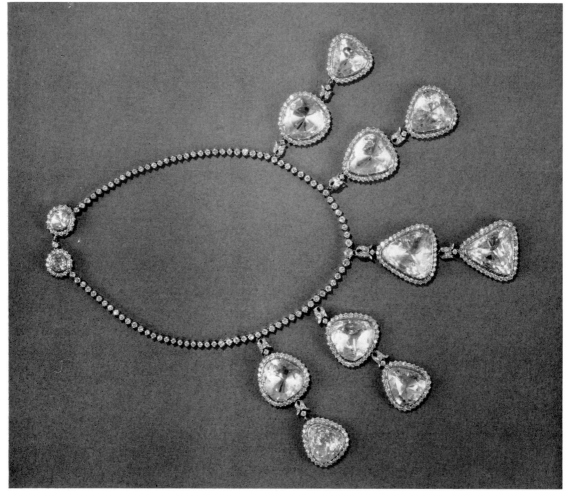

A diamond pendant necklace.
New York $62,500 (£26,041). 1.iv.71.
From the collection of Madame Ganna Walska.
(Reduced.)

A diamond necklace of three rows.
London £13,500 ($32,400). 12.xi.70.
(Reduced.)

A diamond necklace by Cartier.
London £15,200 ($36,480). 18.II.71.
From the collection of Lady Bridgett Poulett.
(Reduced.)

A three-row pearl necklace.
London £8,800 ($21,120). 12.XI.70.
(Reduced.)

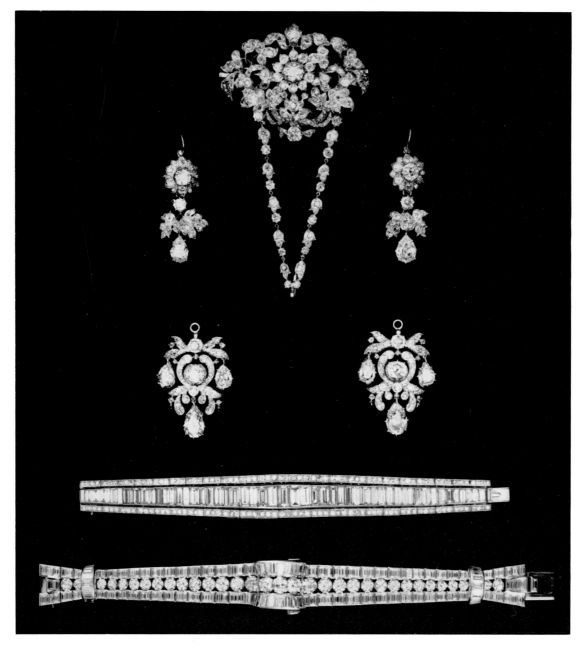

An early 19th century demi-parure, and a pair of diamond pendant earrings.
London £4,000 ($9,600). 18.II.71.
From the collection of the late Sir Edward Collingwood of Lilburn Tower, Alnwick.

A diamond flexible bracelet.
London £1,900 ($4,560). 12.XI.70.

A diamond flexible bracelet.
London £2,000 ($4,800). 22.VII.71.
From the collection of Mrs George Jackson.

(The jewels illustrated on this page are reduced.)

Captions for opposite page:
Above: A 20 carat emerald and diamond clasp. $125,000 (£52,082). A heart-shaped diamond ring of 21·15 carats. $105,000 (£43,750). *Centre:* A pair of natural pearl and diamond pendant earclips. $33,000 (£13,750). A natural black pearl and diamond ring, 162 grains. $16,000 (£6,666). A carved diamond and ruby *en tremblant* brooch in the shape of a butterfly. $24,000 (£10,000). *Below:* A sapphire and diamond ring, 39 carats. $37,000 (£15,416). A 95 carats briolet diamond pendant. $55,000 (£22,916). A cabochon sapphire and diamond ring, 44 carats. $59,000 (£24,583). From the collection of Madame Ganna Walska, sold in New York on 1st April, 1971.

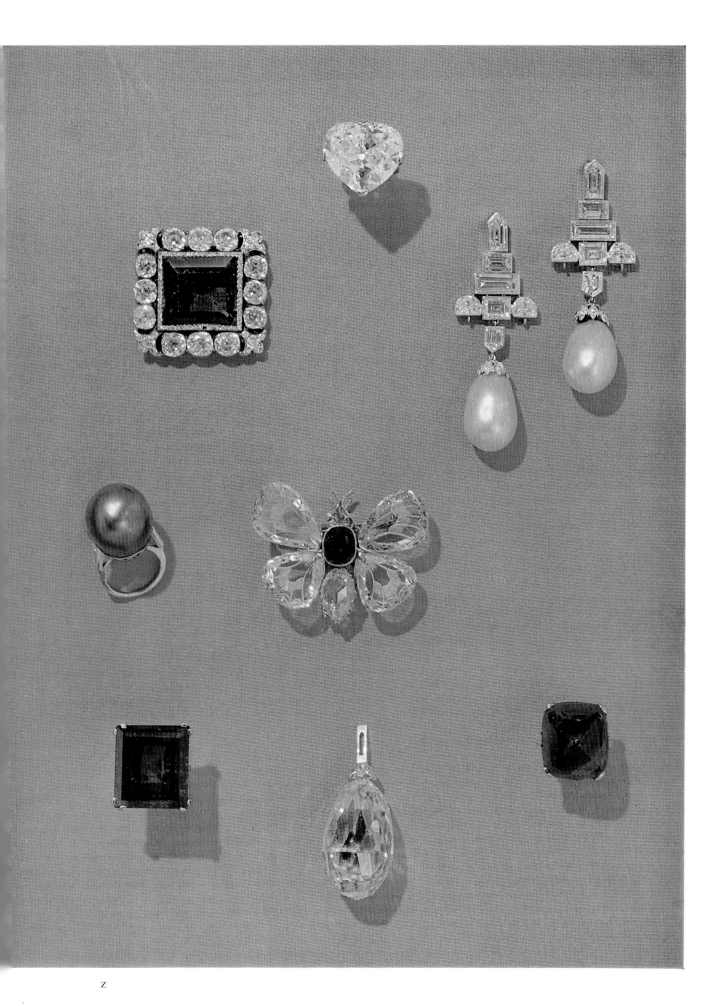

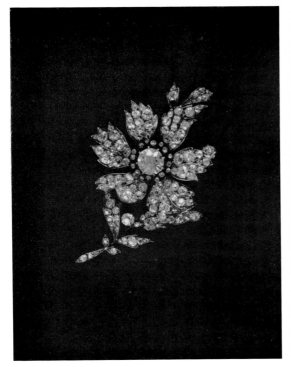

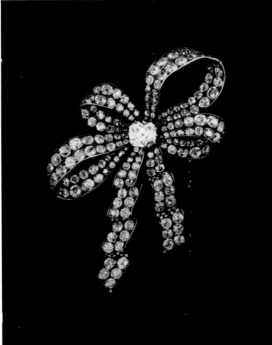

An antique diamond spray brooch.
London £1,800 ($4,320). 8.x.70.
From the collection of the late Mrs Nancy
Wilson Firth.

A 19th century diamond brooch.
London £3,000 ($7,200). 22.VII.71.

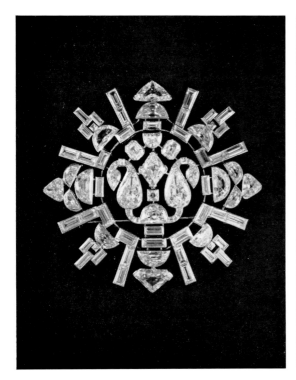

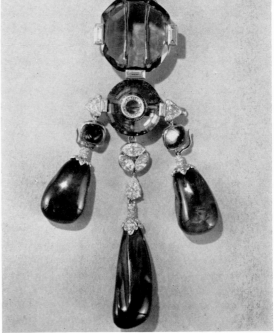

A diamond brooch.
New York $40,000 (£16,666). 1.IV.71.
From the collection of Madame Ganna Walska.

A sapphire, diamond and emerald pendant.
New York $40,000 (£16,666). 1.IV.71.
From the collection of Madame Ganna Walska.

(The jewels illustrated on this page are reduced.)

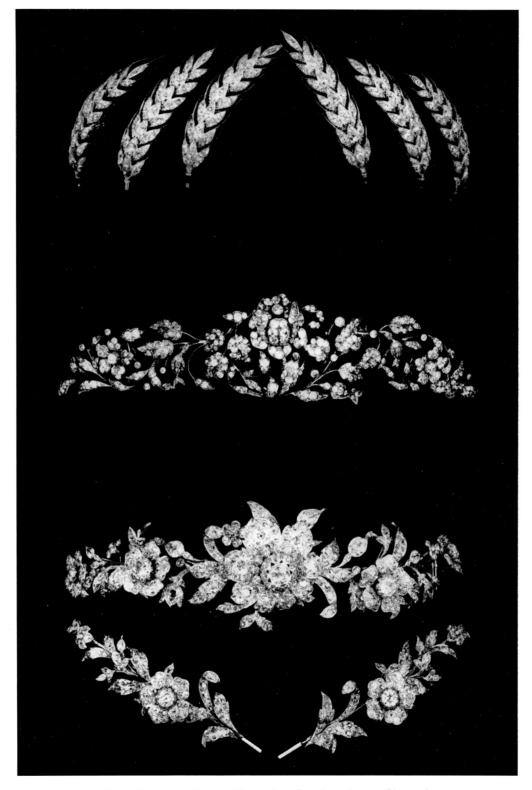

Above: A suite of six Victorian diamond brooches. London £1,750 ($4,200). 22.VII.71.
From the collection of Her Grace the Duchess of Beaufort.
Centre: A Victorian diamond tiara. London £1,100 ($2,640). 18.II.71.
From the collection of Mrs S. M. A. Heath.
Below: Early 19th century diamond tiara. London £5,000 ($12,000). 18.II.71.
From the collection of the late Sir Edward Collingwood of Lilburn Tower, Alnwick.

(The jewels illustrated on this page are reduced.)

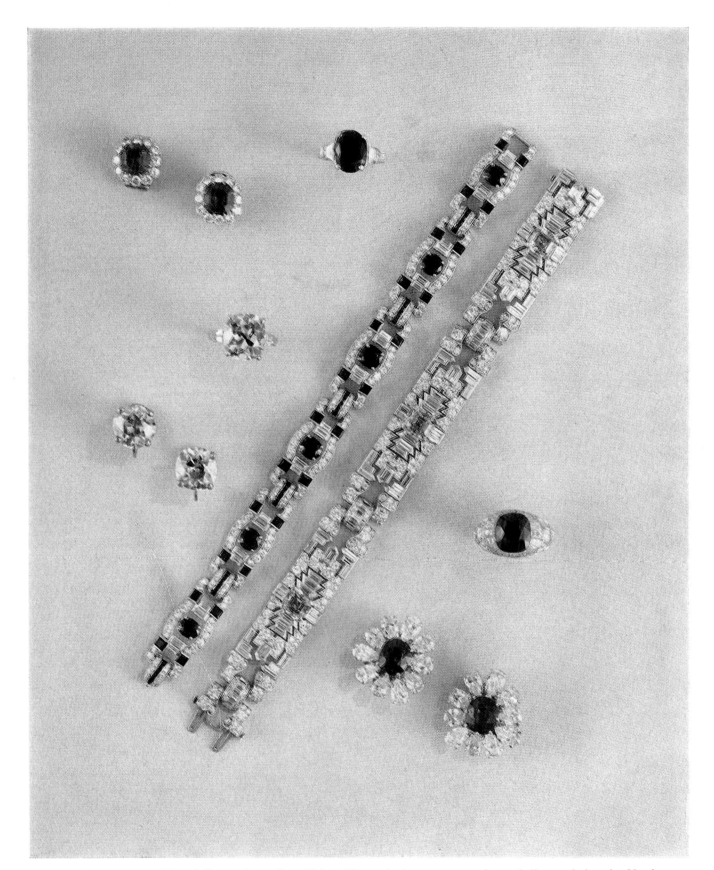

A pair of 4 carat emerald and diamond earclips. $6,600 (£2,750). A 5·50 carat ruby and diamond ring, by Yard. $41,000 (£17,082). A 7·20 carat coloured diamond ring, by Yard. $18,000 (£7,500). A pair of coloured diamond earrings of 11·25 carats, by Seaman Schepps. $21,000 (£8,749). A diamond and ruby bracelet, by Yard. $95,000 (£39,583). A coloured diamond bracelet, by Yard. $15,500 (£6,458). A 6 carat sapphire and diamond ring, by Van Cleef & Arpels. $10,000 (£4,166). A pair of 9·75 carat sapphire and diamond earclips, by Van Cleef & Arpels. $22,000 (£9,166). The jewels illustrated above were part of the collection of the late Cornelius Vander Starr, and were sold in Parke-Bernet on 2nd June, 1971. (All weights quoted are approximate.)

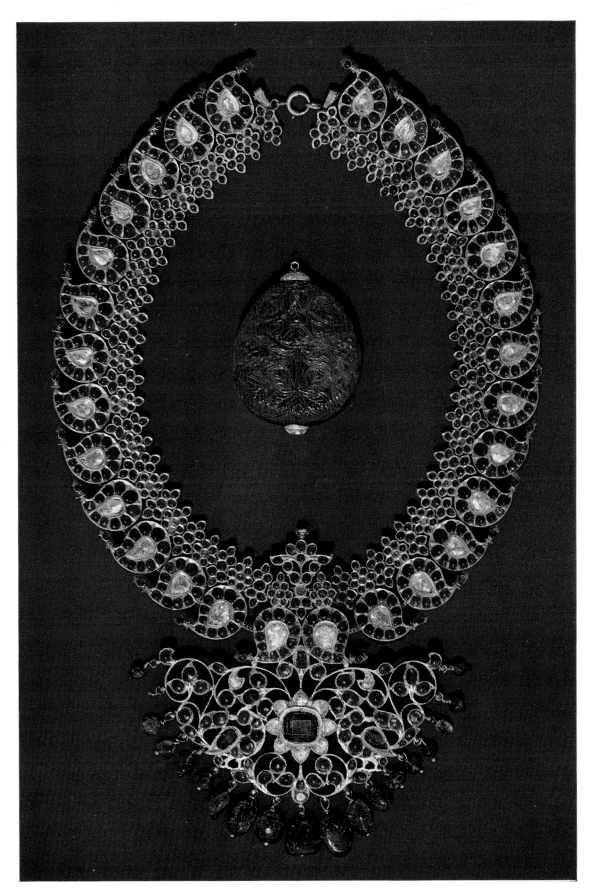

A necklace part of a suite of South Indian Thali jewellery (not illustrated a bracelet and a pair of earrings). $5,750 (£2,395). A Mogul emerald and diamond pendant of 200 carats $54,000 (£22,500).
The jewels illustrated above were part of the collection formed by Madame Ganna Walska, sold at Parke-Bernet on 1st April, 1971.

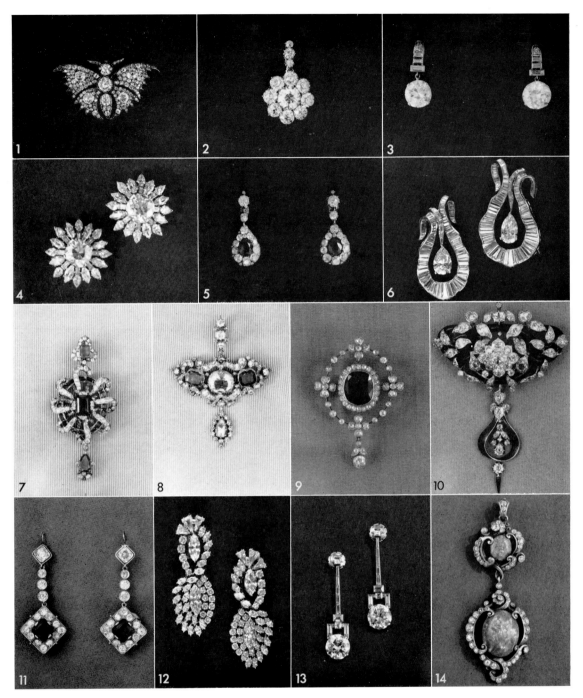

1. Diamond tremblant brooch in the form of a moth, 19th C. £750 ($1,800). 22.VII.71. **2.** Diamond brooch/pendant. £4,600 ($11,040). 8.x.70. **3.** Pair of diamond pendant earrings. £6,200 ($14,880). 8.x.70. **4.** Pair of diamond earclips, 16·75 carats. $17,500 (£7,290). 15.x.70. **5.** Pair of pendant earrings in rubies and diamonds. £2,300 ($5,520). 8.x.70. **6.** Pair of diamond brooches, 6·70 carats, pear-shaped centres. $9,250 (£3,854). 18.XI.70. **7.** Victorian emerald and diamond brooch/pendant. £3,000 ($7,200). 8.x.70. **8.** Late 18th/early 19th C. ruby, emerald and diamond brooch. £1,400 ($3,360). 8.x.70. **9.** Alexandrite pendant. £9,000 ($21,600). 8.x.70. **10.** Victorian enamel and diamond brooch/pendant. £1,200 ($2,880). 20.V.71. **11.** Pair of diamond and emerald pendant earrings. £4,000 ($9,600). 22.IV.71. **12.** Pair of diamond pendant earclips. $6,600 (£2,750). 18.XI.70. **13.** Pair of 10·35 carat diamond pendant earrings. $16,000 (£6,666). 16.IX.70. **14.** Opal, diamond and enamel pendant brooch. $4,200 (£1,750). 16.IX.70.

(All jewels are reduced, weights approximate.)

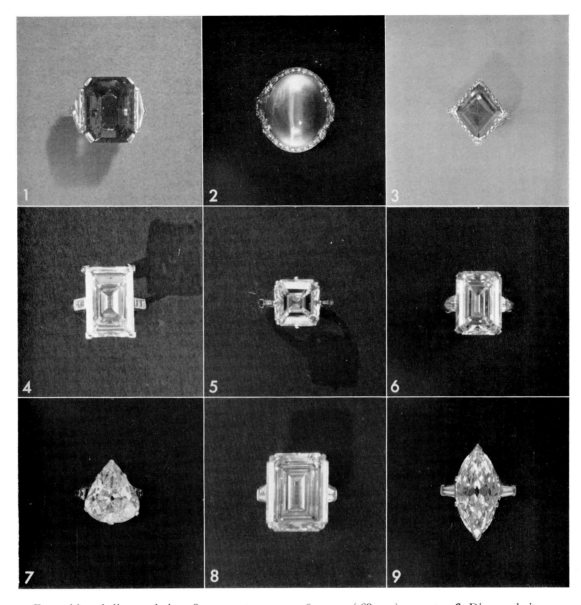

1. Emerald and diamond ring, 8·25 carats. $16,000 (£6,666). 15.x.71. **2.** Cat's-eye and diamond ring, 30 carats. $9,000 (£3,750). 18.xi.70. **3.** Emerald and diamond ring, 3·75 carats. $11,000 (£4,583). 16.ix.70. **4.** Diamond ring, 12·40 carats. $65,000 (£27,083). 15.x.70. **5.** Yellow coloured diamond ring, 9·45 carats. $19,500 (£8,124). 15.x.70. **6.** Diamond ring, 11·65 carats. $94,000 (£39,166). 18.xi.70. **7.** Pear-shaped diamond ring. £8,000 ($19,200). 8.x.70. **8.** Emerald cut diamond ring, 23·75 carats. $38,000 (£15,833). 15.x.70. **9.** Marquise-shaped diamond ring, 7·60 carats. $19,500 (£8,124). 18.xi.70.

(Actual size, weights approximate.)

Vertu

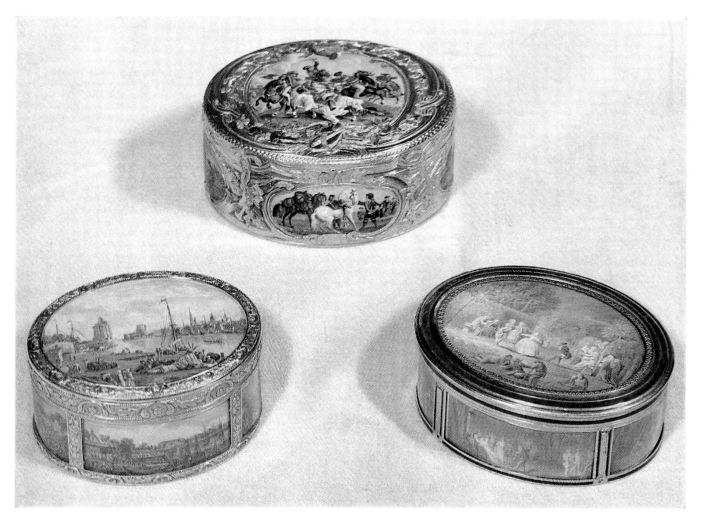

Above: A Swiss four-colour gold and enamel snuff box, with six cartouches depicting episodes from the Turkish Wars.

Maker's initials: *F.B. Circa* 1770. $3\frac{1}{8}$ in.

$5,000 (£2,083).

Below left: A Louis XV four-colour gold snuff box by Mathieu Coiny, set with miniatures by de Lioux de Savignac.

Miniatures signed: '*de Lioux de Savignac*, 1769'. $2\frac{3}{4}$ in.

$23,000 (£9,582).

In 1766 permission was obtained by Edme Charles de Lioux de Savignac from the Marquis de Marigny to study the views of ports of France by Joseph Vernet in the Palais du Luxembourg. De Savignac worked in the style of Blarenbergue, whose pupil he probably was and whom he rivalled in quality.

Below right: A Louis XVI gold and enamel snuff box by Adrien-Jean-Maximilien Vachette, set with miniatures after Watteau's *Fêtes Champêtres*.

Signed: *Vachette Bijoutier à Paris*. 1789. $3\frac{1}{8}$ in.

$4,000 (£1,666).

The boxes illustrated above were part of the collection of Miss Mary A. Boyle, sold at Parke-Bernet on 20th November, 1970.

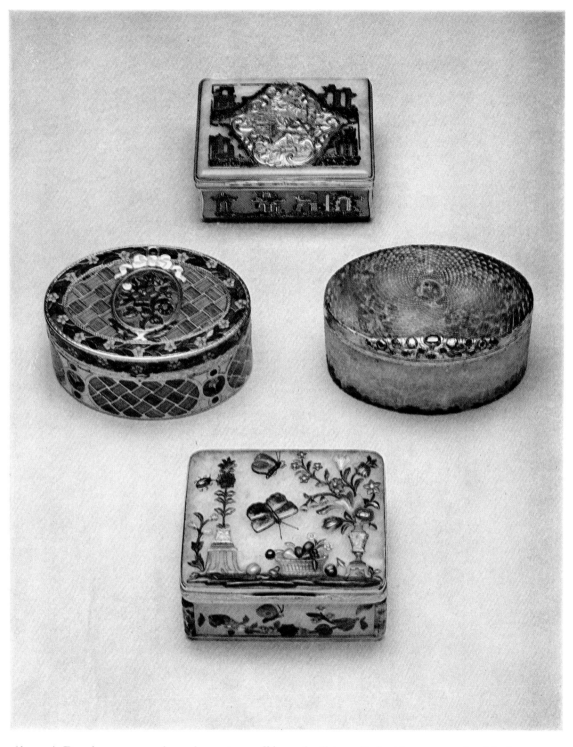

Above: A Dresden cream-coloured quartz snuff box, the lid applied with a repoussé gold plaque, lac burgauté surrounds in the manner of Heinrici. *Circa* 1760. 3⅛ in. £1,900 ($4,560).
Centre left: A Dresden hardstone snuff box by Johann Christian Neuber. Signed on the rim *Neuber à Dresde. Circa* 1770. 3⅜ in. £6,000 ($14,400).
Centre right: A Berlin amethystine quartz snuff box, the gold thumbpiece set with rubies. *Circa* 1770. 3⅜ in. £1,900 ($4,560).
Below: A translucent quartz Dresden snuff box, the lid decorated in the manner of Hoffman. *Circa* 1770. 3 in. £4,400 ($10,560).
The boxes illustrated above were part of the collection of Count Thure Bonde sold at Sotheby's on 7th December, 1970.

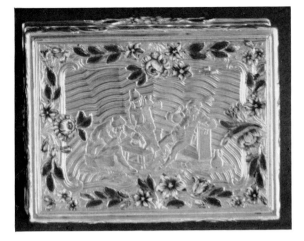

A Louis XV gold and enamel snuff box, decorated
with six cartouches engine-turned in an irregular
design and chased in low relief with two drinking
scenes after Teniers.
Maker's mark indistinct, but perhaps by
Pierre-François Delafons. 1748. 3¼ in.
New York $23,000 (£9,583). 20.XI.70.
From the collection of the Covington/ReQua
family trust.

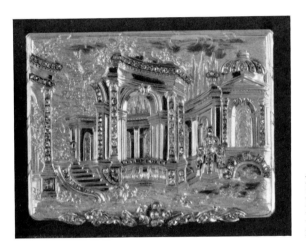

A Louis XV diamond-set gold architectural snuff
box. 1755. 3 in.
New York $30,000 (£12,500). 20.XI.70.
From the collection of the Covington/ReQua
family trust.

A Louis XV gold and mother of pearl snuff box
by Dominique-François Poitreau, opening to reveal
a miniature of Marie Leczinska after Nattier.
1747. 3⅛ in.
New York $22,000 (£9,166). 20.XI.70.
From the collection of Miss Mary A. Boyle.

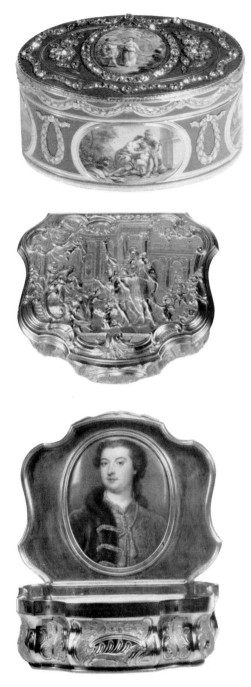

Above: A Louis XV gold, diamond and enamel snuff box, by Charles Le Bastier of Paris, the sides with four oval cartouches enamelled with mythological scenes after Antoine Coypel. 1772. 3½ in. New York $15,000 (£6,250). 20.XI.70. From the collection of the Covington/ReQua family trust.

Centre and below: A George II gold snuff box of cartouche shape, the lid repoussé and chased by Augustin Heckel, the interior set with an enamel portrait miniature by Zincke. Signed *A. Heckel fecit.* The rim inscribed *I. Cunst. Circa* 1740. 2½ in. London £3,700 ($8,880). 7.XII.70. From the collection of Peter Dearden, Esq.

Above: A Louis XV gold and enamel snuff box by François-Nicolais Genard, enamelled with six cartouches depicting *amorini.* 1761. 2¾ in. New York $20,000 (£8,333). 20.XI.70. From the collection of the Covington/ReQua family trust.

Centre and below: A Louis XVI gold and enamel boîte-à-mouches et à-rouge. 1778. 2⅛ in. New York $9,000 (£3,750). 20.XI.70. From the collection of Miss Mary A. Boyle.

Above left:
An enamel snuff box, the lid painted with figures in a garden, the sides with scenes taken from *The Ladies' Amusement*, the interior of the lid with a portrait of Mrs Brooks from the engraving by Richard Houston, after Thomas Worlidge. 3½ in. £420 ($1,008).

Above right:
A South Staffordshire enamel snuff box, the lid and sides painted with farming scenes. 3½ in. £350 ($840).

Centre:
A moulded enamel snuff box, the lid decorated with The Virgin and Child with St Joseph and St John under a purple canopy. 3¼ in. £140 ($336).

Below left:
A Bilston enamel snuff box, the lid painted with a candlelit scene of a man reading a letter over a lady's shoulder, with part of the letter legible, the sides painted with fishing scenes taken from *The Ladies' Amusement*. 3⅛ in. £380 ($912).

Below right:
A Bilston enamel snuff box, the lid painted with a portrait of Nancy Dawson, the sides with Italian quayside scenes and river scapes. 3 in. £300 ($720).
The celebrated dancer Nancy Dawson appeared at Sadler's Wells and Covent Garden in the middle of the eighteenth century and her career is thought to have ended in 1769.

The boxes illustrated on this page were sold at Sotheby's on 23rd November, 1970.

A Birmingham enamel casket, the domed lid painted after Watteau's *La Cascade* from an engraving by G. Scotlin, and *Les Amusements Champêtres* from an engraving by B. Audran, the front transfer-printed and painted with exotic birds after *The Ladies' Amusement*, the ends with birds after engravings by Hancock from drawings by C. Fenn, the interior painted in red monochrome after a painting by François Boucher of 1747 entitled *Pensent-ils au raisin*. $7\frac{3}{4}$ in.
London £3,200 ($7,680). 23.XI.70.

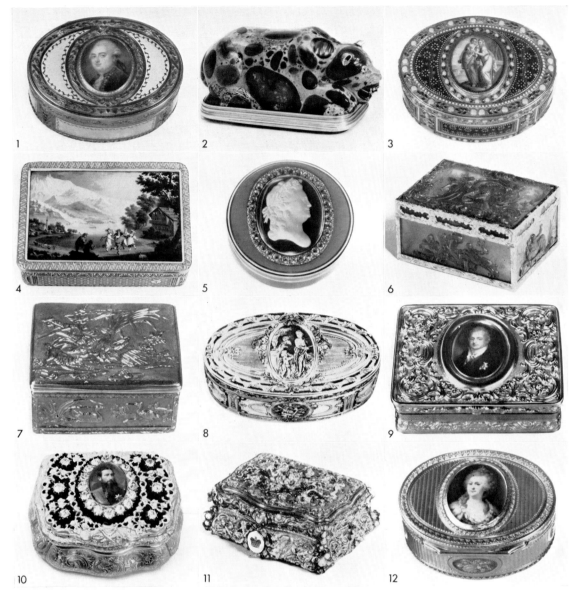

1. Louis XVI gold and enamel snuff box, Paris, 1775. 3 in. £1,150 ($2,760). 7.XII.70. **2.** Gold-mounted pudding stone dog snuff box, probably German, *circa* 1760. 3¾ in. $4,100 (£1,708). 25.V.71. **3.** Louis XVI gold and enamel snuff box by Joseph-Etienne Blerzy. Paris, 1783. 2¾ in. £1,900 ($4,560). 7.XII.70. **4.** Swiss gold and enamel boîte-à-musique. Early 19th C. 3⅝ in. £1,900 ($4,560). 7.XII.70. **5.** Russian enamel powder box with glass paste medallion of Catherine the Great by Leberecht. St. Petersburg, 1790. 3¼ in. £750 ($1,800). 2.XI.70. **6.** German gold and sardonyx snuff box. *Circa* 1760. 2¾ in. $6,000 (£2,500). 20.XI.70. **7.** George III gold snuff box, the lid repoussé and chased after Oudry. London, 1810. 3¼ in. £1,900 ($4,560). 7.XII.70. **8.** Louis XV three-colour gold snuff box by Jean Formey. 1768. 3½ in. £1,400 ($3,360). 7.VI.71. **9.** English snuff box by A. J. Strachan with miniature of William IV. 3½ in. £1,600 ($3,840). 7.XII.70. **10.** Diamond-set snuff box with miniature of Archduke Rudolph, Austrian, 19th C. 3½ in. £1,800 ($4,320). 7.VI.71. **11.** German gold and enamel snuff box, diamond-set. *Circa* 1840. 4¼ in. $6,000 (£2,500). 20.XI.70. **12.** Louis XV two-colour gold snuff box by Jean Joseph Barrière with gouache miniature of Catherine the Great, Paris, 1773. 3⅞ in. £1,650 ($3,960). 2.XI.70.

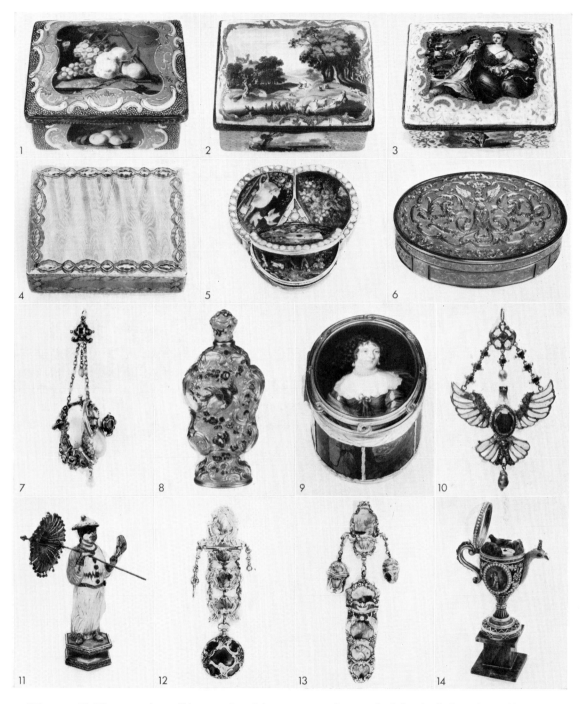

1. Bilston still life enamel snuff box, painted in the manner of Hancock. $3\frac{1}{2}$ in. £400 ($960). 23.XI.70. 2. Bilston enamel snuff box. $3\frac{1}{2}$ in. £330 ($792). 23.XI.70. 3. Bilston enamel snuff box, painted with Watteauesque figures. $3\frac{1}{2}$ in. £420 ($1,008). 23.XI.70. 4. Louis XV gold snuff box by Dominique-François Poitreau. Paris, 1762. $2\frac{7}{8}$ in. £1,550 ($3,720). 7.VI.71. 5. Swiss trefoil automaton enamel combined watch and vinaigrette. Early 19th C. $1\frac{1}{2}$ in. £1,250 ($3,000). 15.III.71. 6. Empire two-colour gold and enamel snuff box. $3\frac{3}{4}$ in. £1,100 ($2,640). 7.XII.70. 7. South German merman pendant, enamelled gold. 1550–1600. $3\frac{1}{2}$ in. £2,300 ($5,520). 2.XI.70. 8. George III gold and enamel scent flask by A. J. Strachan. *Circa* 1780. $3\frac{1}{2}$ in. £680 ($1,632). 7.XII.70. 9. Louis XV boîte-à-portrait with ivory miniature of Mme de Montespan after Petitot. Mid-18th C. $3\frac{1}{2}$ in. £1,200 ($2,880). 15.III.71. 10. Enamelled Polish pendant set with precious stones. 1600–50. £950 ($2,280). 2.XI.70. 11. Louis XV gold and rock-crystal chinoiserie mandarin. *Circa* 1760. 6 in. £2,200 ($5,280). 7.XII.70. 12/13. Pair of English gold and hardstone chatelaines, one suspended with an étui, the other with a verge movement by John Pepys, London. Mid-18th C. $7\frac{1}{4}$ and $7\frac{3}{4}$ in. £2,000 ($4,800). 7.VI.71. 14. Swiss gold and enamel singing bird urn. Early 19th C. 5 in. £5,200 ($12,480). 15.III.71.

A carved hardstone figure of a *Bogomoletz*, in the original fitted box.
Circa 1900. Height $5\frac{1}{4}$ in.
New York $27,000 (£11,250). 28.x.70.

A *Bogomoletz* was a religious pilgrim of Imperial Russia who travelled
to his place of destination by begging on the way. The plaque round his
neck indicated the church or monastery to which he was travelling.

Russian Works of Art

One of the most noticeable art market trends of the past year has been the shift in taste towards nineteenth century Russian cloisonné enamels. This new interest, marked by a succession of high prices for fine examples, may be due partly to the increased awareness of the importance of all late nineteenth century European decorative arts, although the popularity of this stylistically distinctive enamelled silver is in line with the current taste for Russian works of art generally.

On 27th October in New York, an 8-piece silver-gilt and enamel punch set by Ivan Khlebnikov, Moscow 1877, fetched $9,000 (£3,750) whilst on 14th December in London, an 11-piece punch set by Pavel Ovtchinnikov, one of the most distinguished makers, was sold for £6,600 ($15,840). In the October sale, two fine silver-gilt and shaded enamel caskets, one by the Fabergé workmaster Fedor Rückert, the other by Khlebnikov realized $4,500 (£1,874) and $3,500 (£1,458) respectively.

At Sotheby's on 21st June, a rare silver box, decorated in niello, the type of black enamelled decoration particularly associated with Russian craftsmen, fetched £420 ($1,008). Made in Moscow in 1772, possibly by Stephen Savelieu, it was an example of a Jubilee box on which were engraved the dates of some of the most significant anniversaries of Russian history, together with nielloed portraits of Peter the Great, born 1672 and the Empress Catherine II, whose reign commenced in 1762, and a double-headed eagle, first used as the Emblem of Russia in 1472.

Two outstanding pieces of Fabergé have been sold this season. In New York, a rare carved hardstone figure of a *Bogomoletz*, made in St Petersburg *circa* 1900, fetched $27,000 (£11,250). This strange ragged man represented one of the pilgrims of Imperial Russia who paid the way to their destination by begging. The other important piece was the gold and enamel cigarette box, made by the Fabergé workmaster Johan Viktor Aarne in 1899, which was sold for £10,500 ($25,200) in London in June. This magnificent piece had the added interest of having been made for presentation to The Grand Duke Alexis Alexandrovitch.

One of the finest icons sold this season was not in fact Russian but Greek. This was the extremely beautiful icon of *The Nativity* which was sold in London on 19th April for £5,400 ($12,960). This piece dates from the early sixteenth century and is extremely close to an example in the Greek Institute in Venice, which Professor Manolis Chatzidakis has dated to the mid-sixteenth century.

Amongst the Russian examples, unquestionably the most important was the late fifteenth century Novgorod icon of *The Annunciation* which was sold in New York in March for $13,000 (£5,417). Icons of this school and period, with their characteristic ivory-coloured ground, are amongst the most rare and desirable ever painted. The previous October at Parke-Bernet, an impressive large icon in two registers, the upper register depicting *The Baptism of Christ*, *The Raising of Hell* and *The Ascension* and the lower *The Birth of the Virgin*, *The Dormition* and *Saints Afanasi and Sergei Radonezhsky*, fetched $10,000 (£4,166). Although in colouring and style, this icon appeared to date from the fifteenth century Novgorod school, it was felt that the arrangement of the various subjects on one large panel denoted a slightly later period of execution in an area close to Novgorod, rather than in the town itself.

A Fabergé gold and enamel cigarette box, the lid centred with the Russian Imperial Eagle set with circular cut diamonds set against a panel of translucent blue enamel. Russian presentation inscription engraved on the base. Dated 1889. 5½ in.
London £10,500 ($25,200). 21.VI.71.

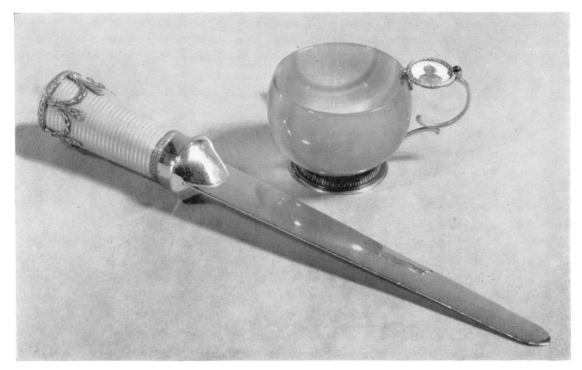

A Fabergé gold-mounted pale brown striated agate cup and a Fabergé gold, enamel and jewelled cane handle mounted as a paper-knife, both *circa* 1890. Workmaster Michael Perchin. The cup 3 in., the knife 9 in.
New York $2,900 (£1,208) and $2,100 (£874). 23.III.71.

A Fabergé gilded-silver and shaded enamel casket.
Circa 1900. Workmaster Fedor I. Rückert. $3\frac{3}{4}$ in. high by 7 in. wide.
New York $4,500 (£1,874). 28.x.70.

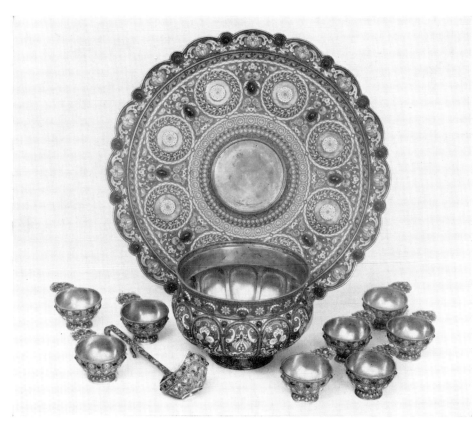

A Russian silver-gilt and enamel punch set by Ovtchinnikov.
Tray 21 in., bowl $9\frac{1}{4}$ in., cup $5\frac{1}{2}$ in.
London £6,600 ($15,840). 14.XII.70.

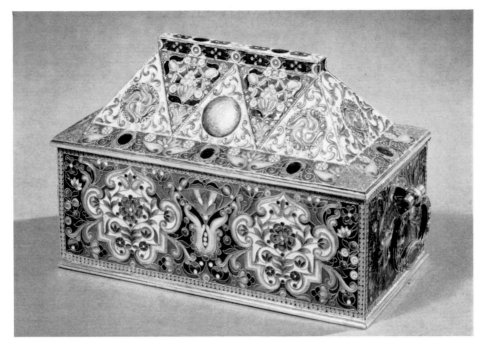

A Russian gilded-silver and shaded enamel casket by Ivan Khlebnikov.
Circa 1900. $4\frac{1}{2}$ in. high by $6\frac{3}{4}$ in. long.
New York $3,500 (£1,458). 28.x.70.

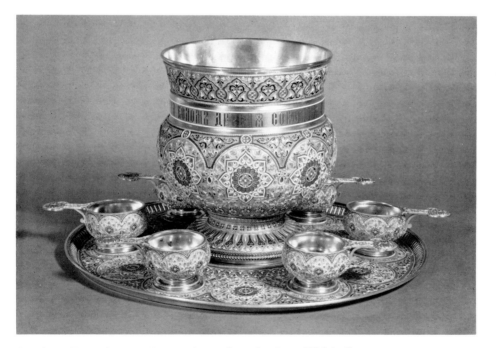

Russian gilded-silver and enamel punch set by Ivan Khlebnikov.
1877. Bowl 8 in. high, tray $15\frac{1}{2}$ in. in diameter.
New York $9,000 (£3,750). 27.x.70.

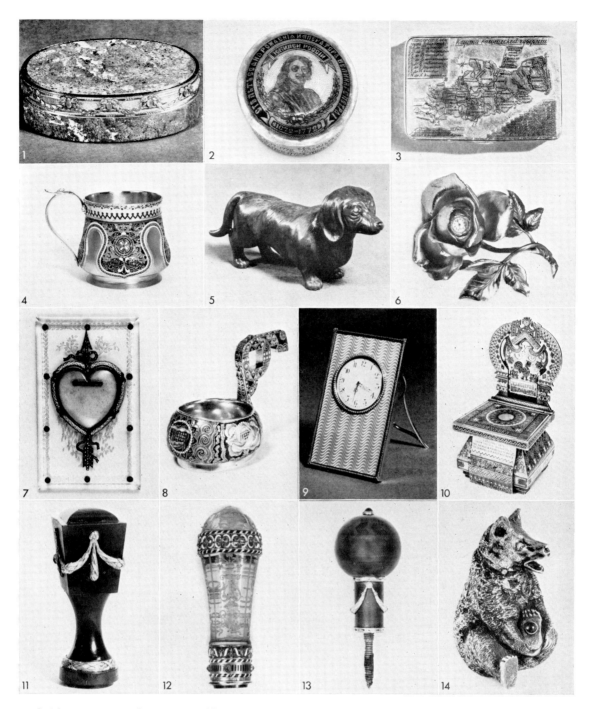

1. Gold-mounted opal matrix snuffbox. Last quarter 18th C. $3\frac{5}{8}$ in. by $2\frac{3}{8}$ in. $2,000 (£833). 27.X.70. **2.** Silver and niello Jubilee of Russia box, possibly by Stephen Savelieu. Hallmarked Moscow 1772. $3\frac{1}{2}$ in. £420 ($1,008). 21.VI.71. **3.** Gilded-silver and niello vologda governor's box by Fedor K. Bushkovsky. 1818. $3\frac{1}{2}$ in. by $2\frac{3}{8}$ in. $1,000 (£416). 27.X.70. **4.** Silver-gilt and cloisonné enamel cup. Maker's initials: *A.K.* £440 ($1,056). 21.VI.71. **5.** Fabergé carved jasper dachshund, *circa* 1900. 2 in. by $4\frac{1}{8}$ in. $4,500 (£1,874). 28.X.70. **6.** Fabergé silver rose-shaped desk clock. Workmaster Michael Perchin. 5 in. £1,200 ($2,880). 14.XII.70. **7.** Fabergé miniature frame, heart-shaped. Workmaster Michael Perchin. $4\frac{1}{8}$ in. £920 ($2,208). 19.IV.71. **8.** Fabergé gilded-silver and shaded enamel kovsh, *circa* 1900. $5\frac{1}{4}$ in. $2,300 (£958). 23.III.71. **9.** Fabergé gilded-silver and translucent enamel clock, *circa* 1900. Workmaster Michael Perchin. $5\frac{1}{8}$ in. by $3\frac{1}{8}$ in. $3,200 (£2,083). 28.X.70. **10.** Champlevé enamel chair salt. Maker's initials: *A.B.* $5\frac{1}{2}$ in. £400 ($960). 21.VI.71. **11.** Fabergé gold and nephrite desk seal. Workmaster Henrik Wigström. 2 in. £400 ($960). 19.IV.71. **12.** Fabergé enamel and rock crystal parasol handle mounted as desk seal. $2\frac{3}{4}$ in. Workmaster Henrik Wigström. £380 ($912). 7.XII.70. **13.** Fabergé enamel parasol handle. Workmaster Johan Viktor Aarne. $2\frac{1}{2}$ in. £350 ($840). 21.VI.71. **14.** Fabergé bear-shaped silver bell push. 4 in. £640. ($1,536) 14.XII.70.

NOVGOROD SCHOOL
Russian icon of the Annunciation of the Virgin.
Last quarter of 15th century. 31 in. by 25 in.
New York $13,000 (£5,417). 24.III.71.

Greek icon of the Nativity.
Later Latin inscription. *Circa* 1500. 26 in. by 25 in.
London £5,400 ($12,960). 19.IV.71.

NORTHERN SCHOOL
A pair of Russian royal doors depicting the Annunciation
and the four Evangelists.
Mid-16th century. 4 ft. 5 in. by 30 in.
New York $3,400 (£1,416). 24.III.71.

A large Russian icon in two registers,
from the Novgorod area,
circa 1500. 43½ in. high by 32 in. wide.
New York $10,000 (£4,166). 27/8.X.70.

A Russian icon of the Mother of God of Kazan, with a silver-gilt
and cloisonné enamel riza, by Ovchinnikov.
10½ in. by 9 in.
London £500 ($1,200). 14.XII.70.

A Russian icon of the Mother of God of Petrovskaya, with later
silver-gilt riza, the vestments of silver-gilt thread embellished
with river pearls and amethysts and paste. 16th century, the riza
dated Moscow 1859. Maker's mark: V.P. 12 in. by 10¼ in.
London £600 ($1,440). 22.II.71.
From the collection of Mrs. K. Archer.

AA*

Glass

One of the most important events in the glass market was the sale at Sotheby's on 14th April, of an extremely rare and beautiful Clichy rose weight which fetched a record £8,000 ($19,200). Only two other weights of the same construction, with a colour ground overlaid with white stripes, are recorded and this price reflects the fact that there has been no falling of interest for really outstanding examples.

Amongst German glasses, an extremely rare *Hochschnitt* covered goblet of *circa* 1700, carved with vignettes of huntsmen and landscapes, fetched the remarkable sum of $5,250 (£2,188) in New York, whilst in London, a late medieval Krautstrunk reliquary of *circa* 1500, one of only a small number known, realized £520 ($1,248) in November.

An English glass of considerable importance and rarity was the enamelled armorial ship bowl by William Beilby of Newcastle-on-Tyne, which was sold at Sotheby's in November for the very high price of £2,550 ($6,120). Only three such bowls are recorded – the present example, the one dated 1765 in the Victoria and Albert Museum and the smallest of the three, now in Colonial Williamsburg, dated 1764 which, by coincidence, was also sold by Sotheby's in 1964.

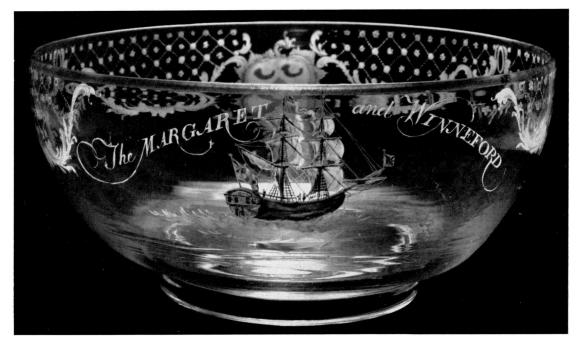

An enamelled armorial ship bowl by William Beilby of Newcastle-on-Tyne decorated in colours on one side with the ship 'The Margaret and Winneford' in full sail and on the reverse with the arms of Forster of Bamborough Castle, Northumberland. *Circa* 1765. 9½ in. wide by 4¼ in. high.
London £2,550 ($6,120). 23.XI.70.
From the collection of R. Bewley, Esq.

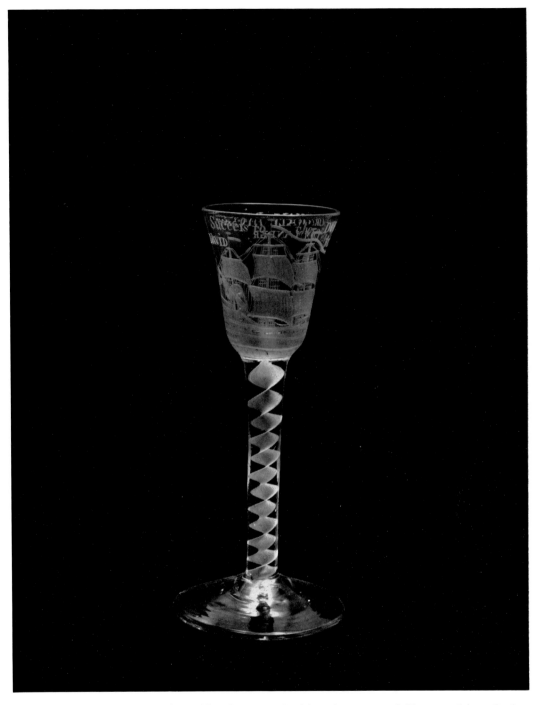

A privateer glass, the round-funnel bowl engraved with a three-masted frigate and inscribed above in diamond etching *Succefs to the DUKE of CORNWALL Privateer, DAVID JENKINS: COMMANDER* supported on an opaque-twist stem composed of a single spiral cable, terminating in a conical foot, 6 in.

London £860 ($2,064). 23.XI.70.

This glass was sold by the great-great-granddaughter of David Jenkins, who commanded this privateer from 1757 to 1760. In 1761 he commanded the *Boscawen* and for his actions with this ship he was presented with a piece of inscribed plate. A fuller account of this ship and her commander was sold with this glass.

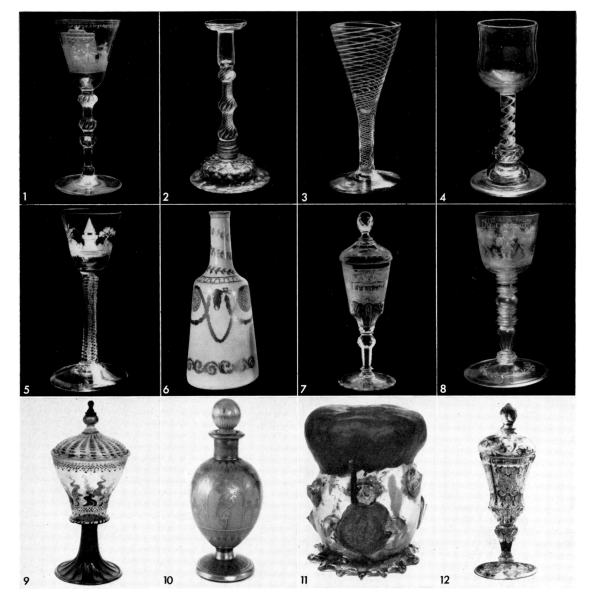

1. Dutch wheel engraved wine glass inscribed 'T WELVAREN DE IONGE GEBORNE', $8\frac{3}{8}$ in. £190 ($456). 21.XII.70. **2.** A taperstick, nozzle vertically ribbed, multi-spiral air-twist stem with three knops, domed honeycomb moulded foot, $6\frac{1}{4}$ in. £290 ($696). 10.V.71. **3.** Wine glass decorated with opaque-white spirals on funnel bowl and straight stem, $5\frac{1}{4}$ in. £250 ($600). 10.V.71. **4.** Mixed-twist composite-stem wine glass, 7 in. £260 ($624). 23.XI.70. **5.** Beilby enamelled wine glass, double series opaque-twist stem, $5\frac{3}{4}$ in. £230 ($552). 21.XII.70. **6.** Opaque-white decanter, gilt by James Giles, $9\frac{3}{8}$ in. £660 ($1,584). 23.XI.70. **7.** Silesian covered commemorative goblet (Pokal), engraved with a profile of King Frederick and views of various towns, $10\frac{3}{4}$ in. $575 (£240). 12.III.71. **8.** Nuremberg engraved goblet probably by Hermann Schwinger, inscribed DIE EINIGKEIT GRUNT ALLE ZEIT, $7\frac{3}{4}$ in. £750 ($1,800). 28.VI.71. **9.** Venetian enamelled goblet and cover, *circa* 1500, $10\frac{1}{2}$ in. £700 ($1,680). 28.VI.71. **10.** One of pair of *gorge de pigeon* opaline bottles and stoppers, gilt *à la cathédrale*, $9\frac{1}{2}$ in. £780 ($1,872). 28.VI.71. **11.** A Krautstrunk reliquary of pale green glass, applied with a double row of large prunts, *circa* 1500, $4\frac{1}{8}$ in. £520 ($1,248). 23.XI.70. **12.** Hochschnitt covered goblet, decorated in tiefschnitt and engraved, *circa* 1700, $11\frac{1}{2}$ in. $5,250 (£2,187). 6.XI.70.

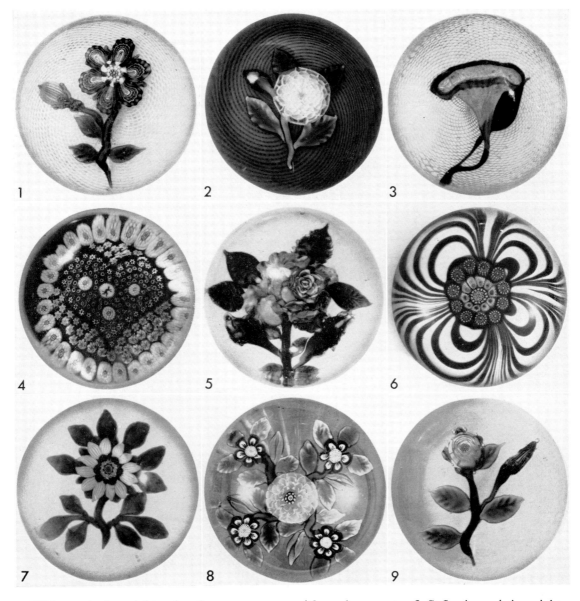

1. Clichy auricula weight, 3 in. £1,500 ($3,600). 5.VII.71. 2. St. Louis pom-pom weight, 3 in. £1,200 ($2,880). 5.VII.71. 3. Clichy convolvulus weight, 2¾ in. $3,200 (£2,083). 30.III.71. 4. St Louis patterned millefiori weight, 3 in. $2,100 (£874). 15.XII.70. 5. Mount Washington magnum weight, 4⅛ in. $3,000 (£1,250). 15.XII.70. 6. St Louis marbrie weight. 3¼ in. £920 ($2,208). 5.VII.71. 7. Baccarat double clematis weight, 2¹³⁄₁₆ in. $2,100 (£874). 30.III.71. 8. Baccarat cruciform flat bouquet weight, 3⅝ in. £1,400 ($3,360). 5.VII.71. 9. Clichy rose weight, 3 in. £580 ($1,392). 5.VII.71.

American Falls, Niagara, from the Canadian side.
Watercolour. Anonymous, early 19th century. 22 in. by 32¾ in
Toronto Can.$1,300 (£520). 27.x.70.

WILLIAM ARMSTRONG
On the Kaministiquia river.
Watercolour, signed and dated 1862. 20 in. by 29½ in.
Toronto Can.$1,900 (£720). 27.x.70.

L. S. HARRIS
Mountain range, Winter.
On panel. $10\frac{1}{2}$ in. by $13\frac{3}{4}$ in.
Toronto Can.$5,000 (£2,000). 4.v.71.

A. Y. JACKSON
Farms near Pincher Creek, Alberta.
Gouache. 30 in. by $39\frac{1}{2}$ in.
Toronto Can.$3,000 (£1,200). 4.v.71.

View of the front of The Pantechnicon, 19 Motcomb Street, S.W.1, where Sotheby's have recently opened their saleroom for 19th and early 20th century works of art.

The Pantechnicon

BY SIR JOHN BETJEMAN

'Pantechnicon' is a coined word. It means every process of workmanship. It was probably first used in 1831 to name the Parthenon-like building which to this day graces Motcomb Street and houses auction rooms for nineteenth century objects, run by Sotheby's. I suspect that the originator of the word, which has now come to mean a removal van as well as this building, was Joseph Jopling, an inventor, an architect and a theoriser about the proportions of the Parthenon. He designed the facade and the storerooms in Motcomb Street, which were opened in 1831. A pleasant land of little stucco streets with shops underneath, it is dominated by the three-quarter fluted-columns of the Pantechnicon and is an interesting piece of early social planning. When George IV in 1821 ordered John Nash to reconstruct Buckingham House and magnify it into a Royal Palace, the agricultural land west of it, which was mostly marshy, became of interest to speculative builders. The Georgian equivalent in these days of a 'tower block' or 'rent-collecting slab', was the square, terrace or crescent. The chief builder in London was Thomas Cubitt, a journeyman carpenter out of Norfolk, and his brother William, and a lazier and younger brother Lewis. Thomas Cubitt (1788–1855) belonged to the days when architects and builders were less separated by profession. He laid out what is now called Belgravia, having already designed and built some of the squares of Bloomsbury. His most famous creations are Belgrave and Eaton Squares on the Grosvenor Estate, and, less pleasant, most of Pimlico on the same estate. He also laid out and built much of Kemp Town and designed Osborne for Prince Albert and Queen Victoria. Cubitt built well and to last. He did not sub-contract, but employed his own builders, carpenters, joiners and glaziers, so that the yards of what became Holland, Hannen and Cubitt, were the biggest in the country. An extremely full book on the worthy Thomas Cubitt has recently been written by Hermione Hobhouse and published by Macmillan.

There was a corner, south of Knightsbridge, near Hyde Park Corner, where the estates of the three chief landlords of this area converged. The landlords were the benevolent and far-sighted Grosvenors, a Buckinghamshire Squire named Lowndes, and the astute Cadogans. Over this triangle of land, Cubitt worked with a builder of West Country origin, who sounds like a character from Hardy, and was named Seth Smith.* The triangle contained, and still contains not only the Pantechnicon, but shops in Motcomb Street with houses above. Opposite the Pantechnicon was a two-storey version of the Burlington Arcade with bridges linking the first storeys. The whole district was to be a shopping precinct of a genteel nature for the inhabitants of this part of Belgravia. And so it remained, though the arcade failed and became the offices of Trollope & Sons. The Pantechnicon was built to house carriages, hence

* The name became hyphenated later in the century and its owners rich and respected in the City and the Services. W. Howard Seth-Smith, a noted architect in the home counties, designed the art nouveau church of St. Luke, Maidstone (1896) which so much amused Goodhart Rendel.

the ramps by which it was entered from either side, and also it was to store furniture when people were going to the moors to shoot or to the Colonies to govern.

Both Seth Smith and Jopling as well as Thomas Cubitt and his brothers, were keenly interested in making buildings fireproof, and in flues and chimney stacks. Great trouble was taken over the construction of the Pantechnicon. Nevertheless a fire broke out in 1874 which was about the biggest since that of 1666. Even Captain Shaw, type of true love kept under, and his fire brigade took three days to quench it. Sir Richard Wallace lost much of his armour collection. Sir Garnet Wolseley, who had just defeated the Ashanti, lost his possessions, and the daughter of Dickens lost her collection of her father's letters. What had been intended as a carriage warehouse and saleroom had become also a strongroom for family jewels and valuable furniture, as well as stabling for over a hundred horses. Only the Doric façade on Mocomb, Street survived.

A new building was erected behind it with even more elaborate fire precautions, and jewels and horses and furniture returned. Between Motcomb Street and the warehouses and stabling at the back and the coach galleries, was a general office. This was brown and set with busts over its entrance door. With its tables and desks, it had become a general reading room for the sporting fraternity. It was obviously never as classy as the Turf Club, but then Belgravia was never as classy as Mayfair, until democracy came to stay in the mid-wars period. After the second world war was declared, and before the Germans had started their bombing, there was yet another fire at the Pantechnicon in October 1939, and this is very well described in a manuscript essay by Miss Henrietta Lawrence, one of Sotheby's staff.

The 'Pan', as it later became affectionately known, was used to its full advantage during World War I. The approach of World War II also led to increased business, from the Munich crisis onwards the gentry of Belgravia stored their valuable possessions there, but fire broke out – by accident, not as a result of 1939 enemy action, on 8th October.

The damage was not so extensive as in 1874 but the fire required at least fifty-five or more fire-engines to put it out and this time the fire-fighting activities were led by Mr Tim Clarke, who now is a senior director of Sotheby's. In October 1939 he was posted at Number 7 station at Basil Street as a fully-trained fireman. In the course of duty that night he had to climb a 55 foot ladder with a hose pipe in each hand; this feat was duly rewarded when later, while asking tenants in nearby houses to evacuate, he came across some friends who were giving a dinner party and had no intention of leaving it and their last case of Krug to the flames. Mr Clarke was then able to enjoy the last few bottles while watching the subsiding fires of the Pantechnicon. Three days later when going back to ensure that the fire had finally diminished, three firemen were found reading a copy of Burton's unexpurgated translation of The Arabian Nights – no doubt found among the debris.

A worse fate than fire threatened the Pantechnicon and its surroundings in 1965. 'Developers', too much of whose work may already be seen in Lowndes Square and on the Cadogan Estate, disrupting all scale and ignoring stucco, wished to take over the triangle. In fact there was a comprehensive development plan, and comprehensive development is another phrase for total destruction. This was foiled by two amicable

forces. The late Christopher Hussey wrote an admirable illustrated article in *Country Life* in 1966, and the Historic Buildings Committee of the G.L.C. produced a written report, scholarly, factual and yet readable, defending the preservation of Motcomb Street and its adjuncts. This was at the time when the Minister of Housing was beginning to realize that we shouldn't think of buildings for their intrinsic merits singly, but as groups.

Sotheby's, in turning the Pantechnicon into an auction room for nineteenth and early twentieth century work, is continuing a tradition Cubitt, Seth Smith and Jopling would have approved. The new building is plain and practical inside, as was the original. As an earnest of their business, the new shops in the district, originally intended for the humbler requirements of Belgravian households, have now become knowledgeable antique shops.

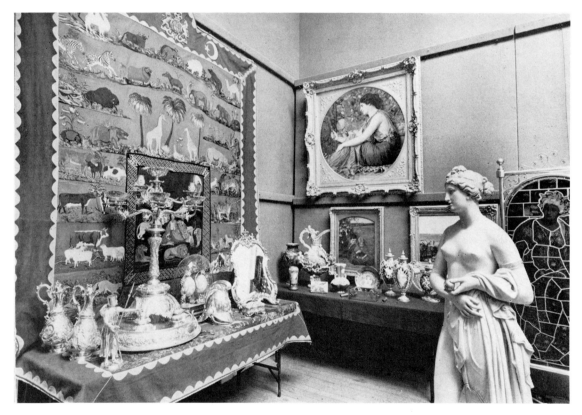

Objects waiting to be sold at Sotheby's Belgravia.

19th and 20th Century Decorative Arts

In October 1971, the first sales devoted to the Fine and Applied arts of the Victorian period will take place at Sotheby's Belgravia newly opened sale rooms at 19, Motcomb Street. These will be the first auction rooms anywhere in the world specializing exclusively in nineteenth and early twentieth century art and a few words of explanation as to why it was felt both necessary and logical to establish such sale rooms are perhaps necessary.

Two years ago, in a study of Victorian and art nouveau silver, I wrote: 'In the last forty years, no period or style has been the subject of such collective vilification as that which existed between 1837 and 1901'. 'Victoriana' has for long been a word reeking of contempt and 'Victorian' is partly defined in the Oxford Dictionary as 'Out-of-date, antiquated'. In recent years, however, many people have realized that such a sweeping dismissal of all the arts created during the 64 greatest years of English history is ridiculous and betrays a blindness as manifest as that of which the Victorian artists and craftsmen are themselves accused.

Nevertheless, this revival of interest has not had entirely satisfactory results. In an attempt to focus attention on certain aspects of Victorian art, critics have tended to over-discriminate. 'We are aware', they have appeared to say, 'that "Victoriana" is rubbish, but this or that, which is not rubbish, cannot really be described as "Victoriana" '. The effect of such criticism has been to select out specific areas which are easily defined, giving the impression that everything else is totally unworthy of notice. Thus Pre-Raphaelite painting, Martinware ceramics, Webb cameo glass and Art Nouveau, have for some years been arbitrarily split off from the main body of Victorian art and treated in a way, which, by implication, has tried to ignore the artistic context in which they were created.

Allied to the appreciation of certain major areas of Victorian art, such as the ones which we have noted above, a few more minor fields have been subjected to an even greater degree of specialist collecting in the last four or five years. Such specific things as stevengraphs, Prattware potlids, Staffordshire figures and 'Fairings' have again been detached and probably for the same reasons; they are easily collectable and even more easily defined. They may not necessarily, however, be particularly worthwhile and some of them, in what can only be described as the first flush of a collecting 'fad', have certainly been overpriced.

In an historical sense, it is extraordinary that Victorian art as a whole should have been so utterly denigrated during the present century, although this is perhaps the normal rejection by one generation of another. Yet the nineteenth century was the age of Pugin and of Pater, of Ruskin and of Morris, when some of the most important aesthetic doctrines of any age were lucidly propounded. It was a period when, as can be seen on the following pages, a silver vase such as the one designed by Armstead could co-exist with the proto-functionalist wine jug made by Elkingtons and designed by that most revolutionary of aestheticians, Christopher Dresser.

Dresser was one of those designers who created styles which seem totally at odds with any preconceived notions of what the word 'Victoriana' really means. In his

JOHN MELHUISH STRUDWICK
Summer hours.
35 in. by 40 in. London £4,200 ($10,080). 23.VI.71.
From the collection of R. Henderson, Esq.

book *The Principles of Design*, published between 1871 and 1872, Dresser wrote: 'Silver objects, like those formed of clay or glass, should perfectly serve the end for which they have been formed'. This, the doctrine of Functionalism summed up in one succinct sentence, should, we imagine have been written by Gropius at the Bauhaus in the 1920s or 1930s.

Yet Dresser existed quite comfortably in the artistic milieu of his time. The number of unsigned pieces made during the 1880s and early 1890s, but which are clearly based

SIR LAWRENCE ALMA TADEMA,
R.A., R.W.S.
Greek potters.
On panel. Signed and dated 1871.
$15\frac{1}{2}$ in. by $10\frac{3}{4}$ in.
London £1,200 ($2,880). 17.II.71.

on his designs, testifies to his popularity. He himself used some of the great industrial firms of Birmingham and Sheffield, described by Pugin as early as 1841 in *The True Principles of Pointed or Christian Architecture* as 'Those inexhaustible mines of bad taste', to produce his extraordinarily advanced designs in large quantities.

For some time now, Sotheby's have been giving an increasing amount of attention to Victorian art. It was the first auction house in London to hold a sale of art nouveau nearly seven years ago and in more recent seasons, regular sales of nineteenth century paintings, silver, ceramics and glass have taken place. The success of these sales has unquestionably demonstrated that there are many things of high quality dating from the Victorian era outside the hitherto narrow limits of acceptability. Many of the pieces illustrated in the following pages would not have been considered worth selling ten years ago, not only because they would have had little or no commercial value but also because they would have been condemned as amusing curiosities of no real aesthetic merit.

JOHN MELHUISH STRUDWICK
The gentle music of a bygone age.
31 in. by 24 in.
London £2,600 ($6,240).
17.III.71.
From the collection of
R. A. and A. M. Budgett.

The time is therefore right to devote a sale room to nineteenth century art and by so doing, to demonstrate the tremendously rich and varied achievement of Victorian art as a whole. English paintings executed between 1840 and 1900 will be sold at Sotheby's Belgravia as will all European applied arts after 1830, with the exception of Russian works of art which will continue to be sold in specialist sales covering all periods at Bond Street, and French nineteenth century paperweights.

This does not mean, of course, that Sotheby's will be advocating complete indiscrimination. The Victorian period, like any other in history, produced some extremely bad art, much of it poorly made and appallingly designed. What is intended is a sale room dealing with all aspects of Victoriana without prejudice, where pieces which are usually relegated in obscurity to poor sales, will receive the sympathy and critical attention they deserve. The thoroughly unworthy equation of Victoriana with junk will, through the consistently high quality of the works sold at Motcomb Street, be shown to be inarguably false.

THE HON. JOHN COLLIER
The white devil.
Signed. 35½ in. by 27 in.
London £1,050 ($2,520). 17.III.71.
From the collection of R. A. and A. M. Budgett.

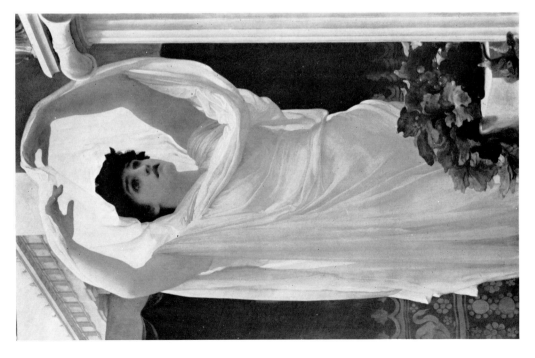

FREDERICK LORD LEIGHTON, P.R.A.
Invocation.
53 in. by 33 in.
London £5,200 ($12,480). 17.II.71.
From the collection of Sir Gerald Gordo Ley, Bart.

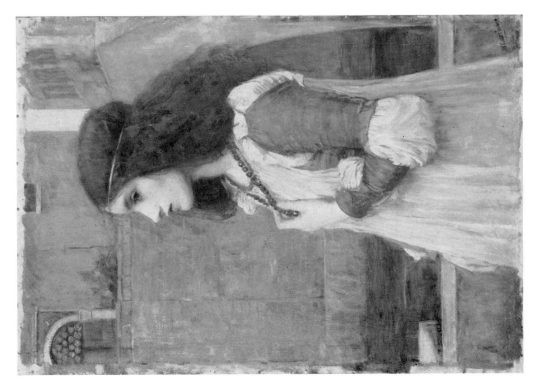

JOHN WILLIAM WATERHOUSE, R.A.
The blue necklace.
Signed 27½ in. by 18¼ in.
London £1,700 ($4,080). 21.X.70.
From the collection of Lady Allison Hayter.

DANTE GABRIEL ROSSETTI
Girl playing a lute.
Signed with initials and dated 1853.
8¾ in. by 4 in.
London £3,000 ($7,200). 24.VI.71.

SIR EDWARD BURNE-JONES,
B.T., A.R.A.
A study of a girl.
Red chalk, signed with
initials. 18 in by 16 in.
London £750 ($1,800).
24.IV.71.
From the collection of
W. Leslie Bundey, Esq.

SIR JOHN EVERETT MILLAIS, BT., P.R.A.
Pre-Raphaelite sketching inconvenience in windy weather.
Pen and sepia ink and wash, on grey paper,
inscribed with the title and signed with
monogram. 1853. 8⅞ in. by 7¾ in.
London £1,000 ($2,400). 18.III.71.
From the collection of Sir Ralph Millais.

ALPHONSE MUCHA
Portrait of a young woman in a chair.
Coloured inks on paper, signed.
16½ in. by 11 in.
London £580 ($1,392). 9.III.71.

DANTE GABRIEL ROSSETTI
The harp player, a study of Annie Miller seated.
Watercolour, heightened with bodycolour and signed with monogram. Executed *circa* 1857.
13 in. by 10 in.
London £5,400 ($12,960). 18.III.71.

Annie Miller, aged fifteen, was working in a public house when discovered by William Holman
Hunt in 1850 and subsequently became a popular model. Later she was to be the cause of the
break in friendship between Holman Hunt (who was paying for her education) and Rossetti
because of the latter's liaison with her during Hunt's visit to the Middle East between 1854 and 1856.
From the collection of Mrs. A. W. Hammond Headey.

JOHN MORGAN
The tug-of-war.
Signed and dated 1860. 30 in. by 60 in.
London £1,900 ($4,560). 19.v.71.
From the collection of Mrs Charles Buckley.

GEORGE BERNARD O'NEILL
The children's party.
Signed and dated '71. 30½ in. by 45 in.
London £4,500 ($10,800). 17.II.71.
From the collection of Mrs M. H. Scully.

SIR GEORGE CLAUSEN, R.A.
Harvesters setting up sheaves.
Signed and dated 1899 and
inscribed on the reverse.
21 in. by 23 in.
London £1,200 ($2,880).
17.II.71.
From the collection of
Cecil Stevens, Esq.

MYLES BIRKET FOSTER,
R.W.S.
The smithy.
Watercolour, heightened with
bodycolour, signed with
monogram.
Executed *circa* 1881.
30 in. by 26 in.
London £2,200 ($5,280).
18.III.71.

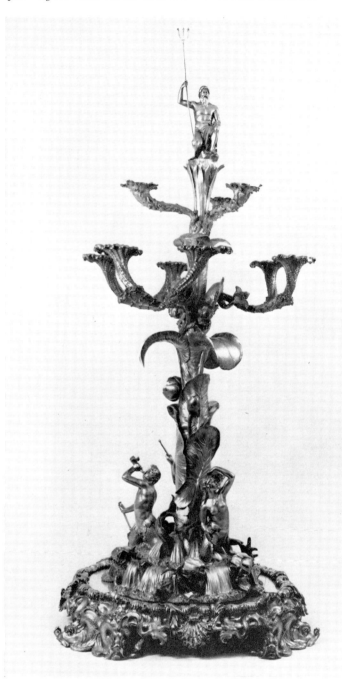

Detail

An early Victorian nine-light centrepiece and
mirror plateau, by Paul Storr, 1838. 45 in.
London £2,800 ($6,720). 25.II.1971.
From the collection of Vernon Hayes, Esq.

Detail

A Victorian parcel-gilt oval jewel casket, by Elkington and Co., Birmingham, 1865, probably based on a design by A. A. Willms. 10¼ in. wide.
London £380 ($912). 25.II.71.
From the collection of Mrs Simone Wilson-Heathcote.

A Victorian silver gilt presentation vase chased in relief with a scene depicting the crowning of Henry VII after the battle of Bosworth Field, 1485, from designs by H. H. Armstead, by C. F. Hancock, 39, Bruton St., London, C.44. 1866. 25¾ in. high.
London £480 ($1,152). 25.II.71.

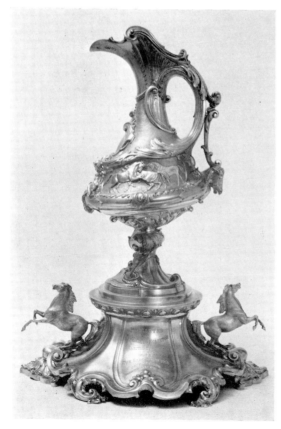

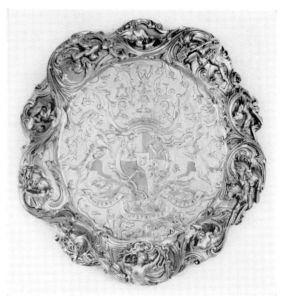

One of a pair of early Victorian wine coasters by R. & S. Garrard, Panton St., London, 1845. 9½ in. diameter.
London £460 ($1,104). 12.XI.70.

A Victorian ewer on stand. Howth Races 1859, by E. and J. Barnard, 1858. 21 in. high.
London £500 ($1,200). 12.XI.70.

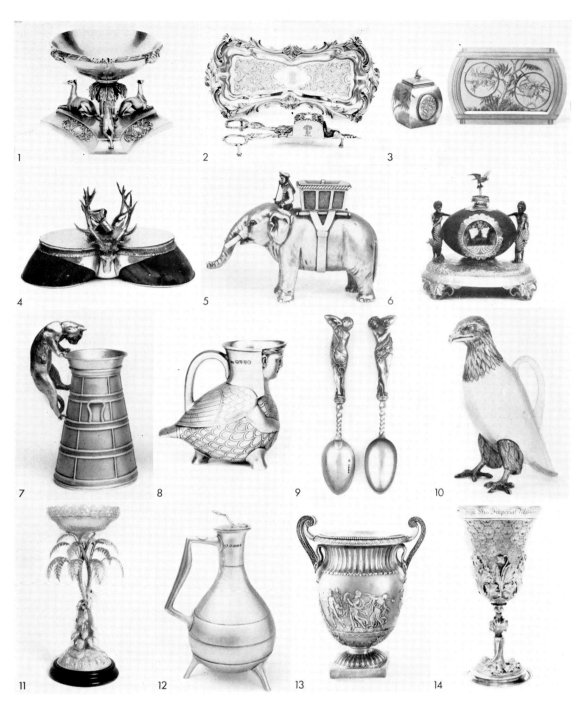

1. One of pair silver-gilt sweetmeat stands by Emes and Barnard, 1827, and E., E., J. and W. Barnard, 1834. 3½ in. £290 ($696). 27.V.71.
2. One of pair Victorian snuffers and trays by E., E., J. and W. Barnard, 1840. 9¾ in. £175 ($420). 27.V.71. **3.** One of pair of silver gilt tea caddies and stand, by Messrs Barnard, 1878. 9¾ in. wide £310 ($744). 25.II.71. **4.** Victorian inkstand by Benjamin Smith, 1845. 11¼ in. £90 ($216). 12.XI.70. **5.** Victorian table lighter by J. B. Hennell, 1879, 5¾ in. £195 ($468). 12.XI.70. **6.** Australian table centrepiece by H. Steiner, Adelaide, *circa* 1860. 8 in. £480 ($1,152). 12.XI.70. **7.** Victorian milk jug by George Angell, 1868. 6¼ in. £200 ($480). 12.XI.70. **8.** Victorian milk jug, by J. B. Hennell,

1877. 3½ in. £95 ($288). 12.XI.70. **9.** Part of a 36 piece set of Victorian silver-gilt dessert table silver, by Francis Higgins, 1872. 7½ and 8 in. long £370 ($880). 12.XI.70. **10.** Victorian silver mounted glass claret jug in the form of an eagle, by S. Mordan and Co., 1881. 11½ in. high. £320 ($768). 25.II.71. **11.** Australian centrepiece by Henry Steiner, Adelaide, *circa* 1860. 18½ in. £220 ($528). 25.II.71. **12.** A Victorian wine jug by Elkington & Co., 1885. 8¼ in. £185 ($444). 25.II.71. **13.** One of pair of vase shaped wine coolers, by John S. Hunt, 1845-55. 12¼ in. £950 ($2,280). 12.XI.70. **14.** William IV silver-gilt cup presented from Tzar Nicholas I to Edward Thomason, by John Bridge, 1830. 13½ in. £600 ($1,440). 12.XI.70.

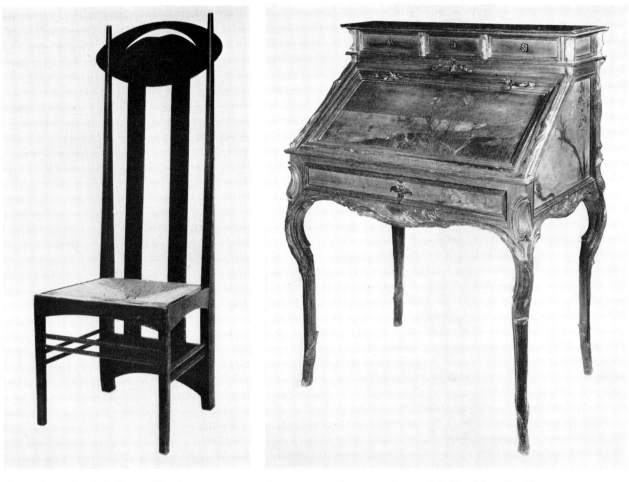

One of a pair of chairs by Charles
Rennie Mackintosh, 1899–1900.
London £700 ($1,680). 15.VII.71.

A marquetry bureau, the top inlaid with a line from
Baudelaire '*forêt lorraine tout y parlerait à l'âme en secret sa douce
langue natale*', the desk panel inlaid with the signature
Emile Gallé 1900. 42½ in. high.
London £950 ($2,280). 15.VII.71.

A gilt-metal and ivory figure by D. H. Chiparus, signed, *circa* 1925, 24 in. wide.
London £270 ($648). 9.III.71.

Oberon, an arts and crafts panel in mother-o'-pearl and gilt gesso by Frederick Marriott. Signed and dated 1901. 13¾ in. by 10¼ in. London £1,700 ($4,080). 10.XI.70.

Con Brio, an ivory figure by F. Preiss, signed, 13 in.
London £520 ($1,248). 15.VII.71.

A pâte-de-verre vase, by G. Argy Rousseau.
5¾ in.
London £550 ($1,320). 15.VII.71.

A marqueterie-de-verre vase by Emile Gallé,
6 in.
London £460 ($1,104). 15.VII.71.

A Tiffany Studios wisteria lamp, signed and
numbered 350, 16½ in. high.
London £3,300 ($7,920). 15.VII.71.

A Tiffany and Fabergé vase, the base signed
and numbered 07233, the mount by
workmaster Johan Viktor Aarne, 7¾ in.
London £1,450 ($3,480). 11.XI.70.

Tiffany red Favrile reactive glass vase, signed and numbered Favrile, 6503M, 6½ in.
New York $4,000 (£1,666). 30.x.70.
From the collection of Theodore Rosenberg.

Three Steuben intarsia glass pieces, signed Frederick Carder.
The glasses $2,600 (£1,083) and $2,500 (£1,041); the bowl $2,550 (£1,061).
From the collection of Mrs Francis P. (Mabel B.) Garvan, sold in New York on 28th, January 1971.

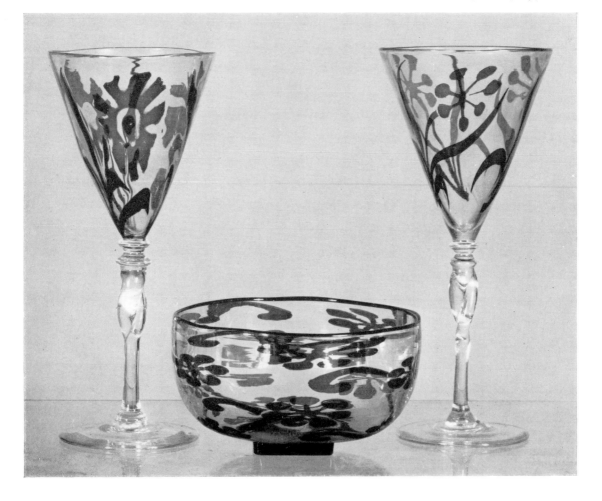

A four colour cameo glass vase. $10\frac{1}{2}$ in.
£1,650 ($3,960).

A double overlay cameo glass vase, signed G. Woodall. Thomas Webb & Sons, Gem Cameo. 12 in.
£3,250 ($7,800).

A cameo double gourd vase in Chinese style, cut by Kretschman and coloured by Jules Barbe, circa 1888. Thomas Webb & Sons, Gem Cameo. 9 in.
£1,900 ($4,560).

The glass illustrated above was sold in London on 26th October 1970.

A Royal Worcester vase, designed by James Hadley in eastern taste, impressed and printed marks in puce and date numeral for 1874. 16¼ in.
London £305 ($732). 10.XI.70.
James Hadley (1837–1903) was the most influential Worcester designer and modeller of the period, finally setting up his own firm in 1875, but continued to work on commission almost exclusively for the Worcester factory.

A Minton's pâte-sur-pâte vase by M. L. Solon, signed, mark in gilding, 1895–1900. 16½ in. London £700 ($1,680). 9.III.71. Marc Louis Solon (1835–1913) was trained at Sèvres, moving to Mintons in 1870. Although pâte-sur-pâte had been evolved in France, Solon brought it to its greatest perfection at Mintons where the softer body proved more sympathetic than the Continental higher fired hard paste.

1. Fairyland lustre dish, Wedgwood, marked Z 5494 in red, $8\frac{1}{2}$ in. £175 ($420), similar beaker marked Z 5157 $8\frac{1}{2}$ in. £175 ($420). 9.III.71. **2.** Part of a Paris porcelain and ormolu clock garniture, by Aubert & Co., Regent St. £800 ($1,920). 15.VI.71. **3.** Wedgwood fairyland lustre stem bowl, marked Z 5443. 13 in. £250 ($600). 15.VI.71. **4.** Part of a 67-piece Spode 'stone china' dinner service, No. 3067 £600 ($1,440). 15.VI.71. **5.** A Minton porcelain dessert service of 19 pieces, by John Mortlock No. 1870, 1875–76 £260 ($624). 9.III.71. **6.** Martinware figure of lion modelled by R. W. Martin, Southall Pottery, 1877. 14 in. £250 ($600), a similar figure, $14\frac{1}{2}$ in.

£290 ($696). 9.III.71. **7.** Minton pâte-sur-pâte vase and cover by Marc Louis Solon, 23 in. £650 ($1,560). 15.VI.71. **8/9.** Pair of Minton candlestick figures, $8\frac{1}{2}$ and 9 in. £200 ($480). 15.VI.71. **10.** Minton pâte-sur-pâte vase and cover by M. L. Solon, October 1898, $14\frac{1}{4}$ in. £270 ($648). 9.III.71. **11.** Berlin porcelain urn and cover, mark 5084, IH. 47 in. £200 ($480). 15.VI.71. **12.** Dresden vase and cover, Marcolini crossed swords in underglaze blue 32 in. £155 ($372). 9.III.71. **13.** Minton jardiniére, cypher for April 1866, 25 in. £88 ($211). 9.III.71. **14.** Royal Worcester porcelain vase by George Owen, dated 1909, $8\frac{3}{4}$ in. £380 ($912). 15.VI.71.

Musical Instruments
The Lady Blunt Stradivari of 1721

BY GRAHAM WELLS

The number of violins by Antonio Stradivari which have survived is surprisingly large when compared to that of his contemporaries. As many as five hundred are known to exist. His working life was extraordinarily long. He died at the age of ninety-four in 1737 and was still making instruments in that year.

His life is generally divided into four periods. In the first, up to about 1690, known as the 'Amatise' period, his instruments still bore the influence of his teacher, Nicholas Amati and it was only during the last decade of the seventeenth century that his own particular style was evolved. However, most of Stradivari's finest instruments were made between 1715 and 1725. Known as the 'golden' period, it was then that he raised violin making to an art which has never been surpassed. Instruments from these years are the most prized, and the Lady Blunt was made in 1721 in the middle of this period.

The superiority of Stradivari's instruments does not lie in any one feature but in the combination of finely chosen woods, worked and assembled by a man who was both a brilliant craftsman and an artist. The formula for his beautiful varnishes is now lost but was probably similar to that of other contemporary Cremonese makers. Although a contributory factor, it is not the secret of the Stradivari tone. The tonal qualities of his instruments have been recognized from the time he made them. As a result of their perfection the instruments have seen much use and bear many signs of wear.

The Lady Blunt can be counted amongst the two or three most important Stradivaris in existence today. Besides its fine tonal qualities, what impresses one most is its condition. Even now, it retains much of the original varnish except for some early wear on the right of the tailpiece, while the edges are as sharp as when they were made. Even the black lines with which Stradivari picked out the edges of the scroll are intact. The violin bears the initials P.S. in ink on the mortice at the base of the pegbox and is thus believed to be one of the instruments left by Stradivari on his death to his third son, Paolo.

The violin's history is unknown from 1740 until it was discovered in Spain by the famous French violin maker and dealer J. B. Vuillaume. He adapted the neck and replaced the fingerboard and bass bar to suit modern requirements but wisely retained the originals which still accompany the instrument. In 1864 Vuillaume sold the violin to Lady Anne Blunt, the grand-daughter of Lord Byron, a remarkable traveller and linguist as well as musician. It remained in her possession until 1895 and since then has been in several important private collections. During the last twenty years it has belonged to Sam Bloomfield a well known patron of music and amateur musician living on the West Coast of America.

The Lady Blunt
A Violin by Antonio Stradivari, Cremona 1721, the original label
inscribed *Antonius Stradivarius faciebat Cremonensis Anno* 1721.
London £84,000 ($201,600). 3.vi.71.
From the collection of Sam Bloomfield, Esq.

An Italian Viola d'Amore by
Domenico dall'Oglio, Padua
labelled *L.D.S. Domenico
dall'Oglio in Padova L'Anno*
(date missing), *circa* 1750.
Length of back 13⅜ in.
London £540 ($1,296). 13.v.71.
Domenico dall'Oglio was born
in 1701 and died at Narva in
1765. He went to Russia and
was Director of the Royal
Orchestra at St. Petersburg
from 1735–63.

A French Horn by William Shaw, London, stamped in relief on
the bell rim *William Shaw, Red Lyon St. Holborn, London*, with
four coupler crooks, two master crooks and four bits, *circa* 1790,
diameter of bell 10¾ in.
London £380 ($910). 16.iii.71.

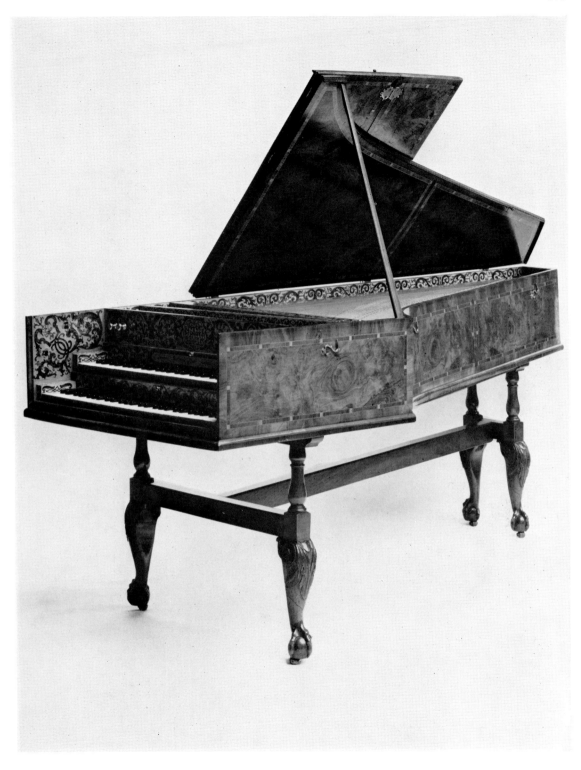

A two manual Harpsichord by Jacob Kirckman, 1755
signed on the nameboard *Jacobus Kirckman fecit Londini*, 1755
7 ft. 11½ in. long by 3 ft. 1 in. wide.
London £8,000 ($19,200). 22.x.70.
From the collection of the late Raymond Russell, F.S.A.

The Barnard Tompion

BY RONALD A. LEE

It would seem that the passing of each year heralds the appearance on the art market of at least a dozen major objects in one department of the Arts or another and by the law of averages each section has its day. It may be said that in 1970 one of these objects concerned the department of Sotheby's dealing with clocks. It was an example of the work of Thomas Tompion, that inspired clockmaker who together with his pupil 'Honest' George Graham were honoured on their decease by interment in Westminster Abbey.

Some fifty years ago the clock collector was regarded as a man of highly specialized interests, perhaps a fanatic, and more likely to be associated with the crafts of the bench than an appreciator of something more readily to be included amongst the arts. The engraving of backplates, the designing of dials and the cases containing clock movements are surely to be included in the arts, and although collectors can be placed into various groups with their own particular interests, it is now not uncommon to find that the man who takes enormous pleasure and pride in the possession of a fine clock also has his Cezanne landscape, his Nymphenburg figure by Bustelli, his Lamerie silver, his Martin Carlin table or the forward thinking object which has not yet hit public recognition.

Looking back into the past, it could be said that collectors generally have been very slow in appreciating the exciting aspects of a really fine clock. Perhaps thanks to articles in art magazines, those sometimes rewarding chats with knowledgeable dealers and the relevant publications available, clocks have now taken a very definite place in the art scene. This is substantiated by the fact that the House of Sotheby now conducts separate sales of horological interest.

The clock which prompted this article is known as The Barnard Clock by Thomas Tompion and Edward Banger sold in November 1970 for the sum of £26,000 ($62,400). It is numbered 460, and from the present information known regarding the numbering of Tompion's movements it can be dated between the years 1708–10.

Unfortunately no contemporary accounts survive which are dated and refer to any specific clock which would give actual proof of the date of numbering but according to design it seems at least that they were made in fairly strict numerical sequence. Numbering started *circa* 1685 and continued until Tompion's death in 1713, having reached the so far latest recorded number of 545.

Edward Banger married Tompion's niece and as far as the clocks signed with the dual names are concerned, they tend to come from the period when quality of finish was very high indeed. Although at one time some collectors thought that they ought to have a clock signed with the lone name of Tompion in order to have the best, proper appreciation now exists and here we see the record price reached by the partnership over all other clocks.

The Barnard Clock is really quite unique as it has all the ingredients which one

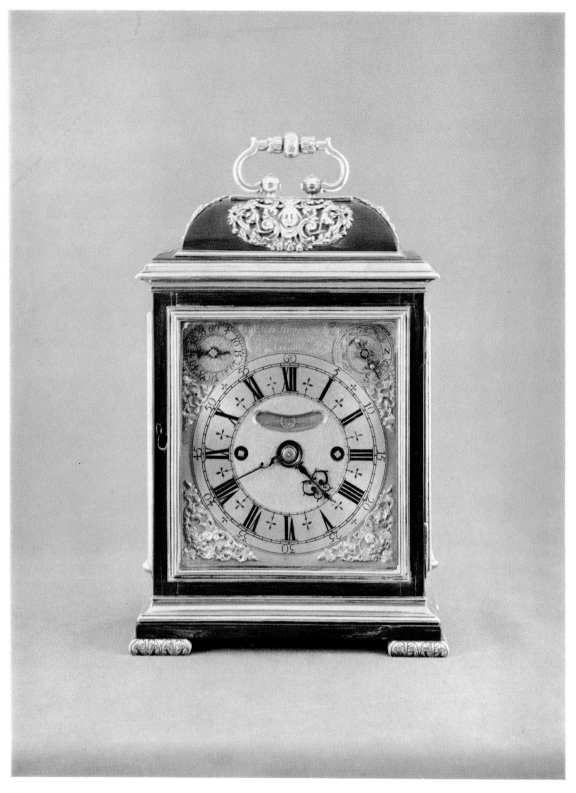

A silver-mounted ebony bracket clock,
signed *Tho. Tompion & Edw. Banger, London, no.* 460.
Height to top of dome 9 in., maximum width 6¾ in.
London £26,000 ($62,400). 16.XI.70.

could wish for if such clocks could be ordered from the workshops today. It is of a small and attractive size; its restrained ebony veneered case is enriched to a nicety with silver mouldings and chased silver mounts; it retains its original wainscot oak travelling case with metal fittings and to complete the picture, it has a very neat winding key with ivory handle.

Its traditional history from the Barnard Family, although not supported by documentary evidence, seems readily acceptable as having been made for Queen Anne, as the clock is so outstanding in importance and made at a time when Tompion was supplying to the Royal Household some of his finest examples. It could be identified with an account dated 1708 when Tompion was paid £126. 4. o. 'in full of his bills for a new spring clock and for work done for Her Majesty 1702–1708'.

The clock was traditionally given by George II to Andrew Stone and later inherited by his sister who was the wife of William Barnard, Bishop of Londonderry whose descendants retained it in the family until 1970, hence its appellation 'The Barnard Clock'.

There are, of course, several other Royal clocks which are now either in the possession of museums or private collectors. The so-called 'Record' Tompion longcase clock made for William III and given by Queen Victoria to her cousin the Duke of Cambridge and subsequently sold by auction. It is now in the Governor's Palace at Williamsburg, Virginia.

The year table clock by Tompion with splendid silver mounts was left by William III to the Earl of Leicester who was Lord Chamberlain of the Household. It was in turn given to Lady Yonge through whom it descended to the present owner, Lord Mostyn.

Another instance of Royal presentation of a clock was as recently as 1910 when the Royal Librarian was given a most interesting seventeenth century longcase clock by Samuel Knibb.

The Barnard Clock, be it originally a Royal commission or not, is mainly outstanding in respect of the design of its case and the fact that it is so complete with its travelling case and original winding key.

The movement does not differ in design or quality of execution to the general run of Tompion's clocks of this period. He maintained his standards throughout his years of production and was not tempted to be prostituted by commerce or the fame which he had gained by patronage from the eminent. It would not be possible even with the aid of modern precision tools to exceed the standards which he achieved and this seems remarkable in an age regarded by many in the twentieth century as one of rude mechanics. The best was not too good for him and this maxim he maintained, leaving no circumstances wherein the Barnard Clock could exceed others mechanically.

Very little is known about casemaking of the period as to whether these clockcases were made 'on the premises' or elsewhere by specialists. One can recognize the work of certain casemakers, as one can pick out a Tompion case amongst hundreds of others fairly similar. With some certainty it can be said that Tompion had his man on the premises right under his wing, one reason being that his casemaker did not supply to other clockmakers, and if he had been in a completely separate workshop he would surely have been persuaded to make an odd case or two for other makers.

It is blatantly obvious that Tompion took a great deal of interest in the cases made for his clocks as, apart from timekeeping qualities, most patrons would be impressed

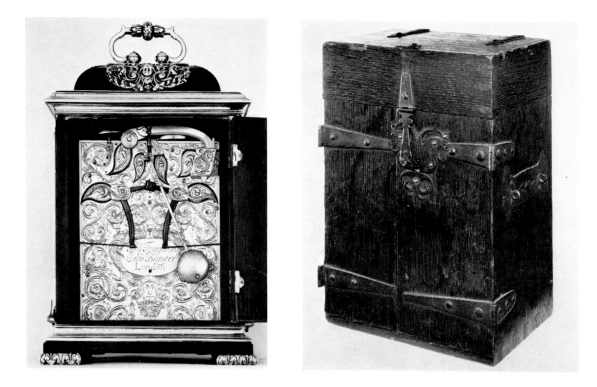

or otherwise by the look of the clock, and on the occasion of Royal commissions he had made for him a clockcase of regal appearance.

He uplifted the Barnard Clock by the application of superbly designed silver mounts to the dome of the case and the pierced and chased panels in the sides completing the harmony with silver mouldings and that masterly touch of chased silver feet.

It would be immensely interesting to know who was actually responsible for the designing of these mounts, it being, of course, a specialist's job. At this date one of the few names handed down to us in connection with the designing of silver decoration was Simon Gribelin, a Huguenot refugee who came to England in 1680 and published *A Book of Severall Ornaments* in 1682 and another in 1722. Gribelin came from a family of clockmakers and he joined the Clockmakers Company in 1686 which lends credence to the possibility of his cooperation with Tompion regarding case mounts and perhaps backplate engraving.

Tompion produced several other silver mounted clocks, the most famous being the one year clock made for William III and now in the possession of Lord Mostyn. A very small example is now on loan to the Victoria and Albert Museum. The movement of this clock was at one time divorced from its case but the case with another movement in it passed through Sotheby's auction rooms and both were happily re-united. Another fine example has recently come to light but this unfortunately has its movement entirely missing. A further example may be seen in The Science Museum, South Kensington which has had drastic alterations to the movement and yet another example is the now famous Grafton or Lady Castlemaine clock, the movement of which is divorced from its case.

This trail of vandalism is inclined to accentuate the importance of the Barnard Clock as one of the few outstanding clocks by Tompion which is in a good original state.

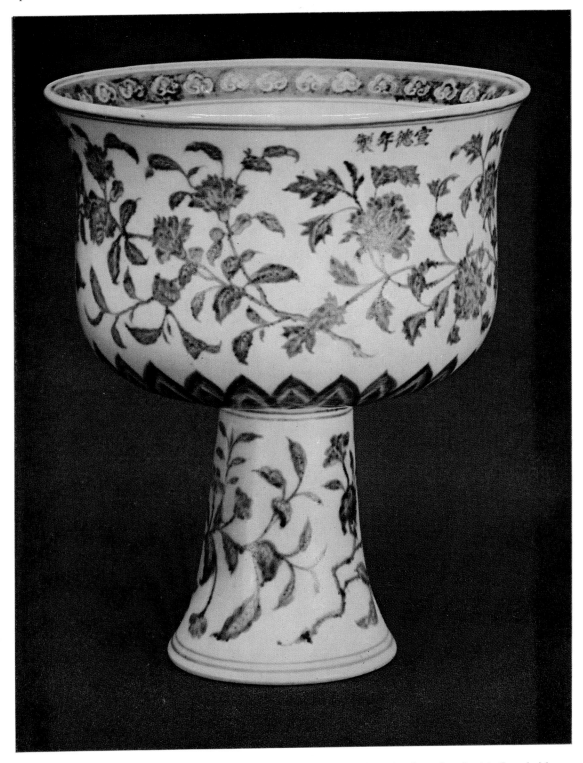

An early 15th century blue and white stem-cup of exceptional size, the deep bowl with flared sides painted on the exterior with four flowering branches of chrysanthemum, pomegranate, peony and camellia. Four-character mark of Hsüan Tê in a line below the lip. 8¾ in. high by 6¼ in. wide. London £44,000 ($105,600). 2.III.71.

The Hsüan Tê Stem-cup

BY JOHN TALLENTS

To most people 'Ming', if it means anything more than 'Chinese' means blue and white, as this dynasty undoubtedly produced the finest blue decorated porcelain that the world has seen. The Ming dynasty, however, cannot claim the credit for the invention of underglaze decoration. This must go to its formerly much under-rated and short-lived predecessor the Yüan or Mongol dynasty (1279–1368). Although by the middle of the fourteenth century vases and vessels of prodigious size with vigorous designs were being produced, surface decoration does not seem to have found imperial favour until the early fifteenth century.

Not until the reign of Yung Lo (1403–24) is there any evidence of an imperially supervised kiln at Ching-tê Chên in Kiangsi province. By the succeeding reign of Hsüan Tê (1426–35), however, the kilns were well organized and fulfilling colossal orders for the Court. The dazzling red-glazed stem-cups seem to have been the most highly-prized ware at the time, followed by the stem-cups in underglaze blue.

For blue and white porcelains the nine-year reign of Hsüan Tê is held to be the classic period. Although in sheer technical perfection they were surpassed half a century later by the delicate palace bowls of Ch'eng Hua (1465–87), by the latter period the power and vigour of both the forms and drawing had begun to fall away.

Hsüan Tê himself was a connoisseur and painter of no mean talent, his detailed rendering of animal fur being particularly admired. His personal interest in the fifty-eight kilns which supplied the court was such that his death at thirty-six must have been a disaster to Ching-Tê Chên.

The stem-cup which was sold at Sotheby's was made in this reign. It had been in the possession of the vendor's family for fifty years or more, but not until two years ago was its true identity revealed. How or when it found its way from China is unknown and will probably remain so. However, we do have evidence regarding the period of its manufacture and possible use.

It was made in the reign of Hsüan Tê (1426–35). The powerful case of the drawing, the delicious rippling variation in tone of the blue, partly due to the difficulty still experienced in controlling the powdered cobalt oxide used to produce the colour, the slightly pitted surface of the glaze whose texture the Chinese describe as resembling orange-peel in contrast to the glassy clarity found fifty years later, are all typical of this period. The orange-peel texture of the glaze is the result of bubbles bursting on the surface during firing. It was successfully imitated in the eighteenth century, but can occur accidentally, depending on kiln conditions in other periods and is thus not a wholly reliable guide to dating. Nor for that matter is glaze texture in general to be relied on exclusively in attributions.

Recent research has shown that until the early fifteenth century the blue was achieved by the exclusive use of the pure cobalt oxide imported from Persia, but that about the beginning of the reign of Hsüan Tê, native Chinese cobalt with a

high manganese content was mixed with the imported ore. The manganese had a stabilizing effect on the blue which had previously tended to smudge in the firing concentrating in blackish blobs and spots resembling soot, an accidental but most attractive effect known as heaped and piled. Cobalt fluxes (i.e. lowers the melting temperature of) the glaze immediately over it causing it to run and allowing some of the blue to ooze to the surface, where it turns black if oxygen is allowed into the kiln above a certain temperature. The manganese, acting as an anti-flux, prevents this, thus allowing the artist to paint in serenity, with the prospect of his inspired design soon slithering earthwards in an inky mousse reduced, if not eliminated.

This sureness is reflected not only in technique, but in the drawing which is neater and slightly more restrained than that of the preceding reign of Yung Lo (1403–24), where a certain brazen optimism, much needed in view of the unpredictability of the colour, is expressed in the abandoned way that leafy tendrils scroll their way lazily round the curved surfaces. Under Hsüan Tê a lighter tone of blue than the smoky black shades of Yung Lo was preferred but by no means universally achieved, and heaped and piled effects continue though in a less pronounced form. Strong variations in tone of colour were still favoured, unlike the smooth even blue of fifty years later. The presence of the manganese does not as was widely believed result in an inferior shade of blue.

Stem-cups vary considerably in size and shape and, with very few exceptions were intended for use in Buddhist ritual, although later they were more commonly used for wine. In this period stem-cups filled with clear water would have stood on an altar before an image of Buddha. The decorative motifs of Hsüan Tê wares in general are of Buddhist inspiration.

This particular stem-cup, however, is exceptional in more ways than one. First it is extraordinarily big. At $8\frac{3}{8}$ inches it stands roughly twice as high as nearly all other known stem-cups. Secondly its bowl is of a much deeper and squarer shape than is usual. (Bowls of this shape are known, but without stems. Percival David Foundation. Catalogue of Porcelains decorated in Underglaze Blue and Red. B670 and B671.) Thirdly the decorative scheme is something apart from the neat formality of that more usually found on Hsüan Tê wares. Flowering branches of peony and chrysanthemum, pomegranate and camelia spread idly over the surface and envelop it, painted with the sure tranquillity of the master, who alone can evoke in a medium so hard and inflexible all the bending, yielding, crushable qualities of rustling destructible nature.

Painting is mastery of brushwork from which also stems mastery of calligraphy. This is displayed in the reign mark written just below the lip on the outside and this mark provides the fourth peculiarity which places this piece in an élite group apart from its contemporaries. Normally a reign-mark ('nien-hao') refers to the dynasty and to the emperor in whose reign the piece was made. In later periods it was a regular practice to use the mark of an earlier reign, out of deference to tradition rather than fraudulent deceit, resulting in much enjoyable confusion! A Hsüan Tê mark normally has six characters which read thus, 'Ta Ming Hsüan Tê nien chih', which, reversing the word order somewhat, means 'Made in the period of Hsüan Tê in the Great Ming dynasty'. However, as the photograph shows, the mark

on this piece consists of only four characters, omitting the usual first two, which refer to the dynasty. Four-character marks as such are quite common, and even four-character Hsüan Tê marks are not unusual but nearly all of the latter occur on provincial wares of the sixteenth and seventeenth centuries. Pieces of imperial porcelain of Hsüan Tê period with this mark are exceptional.

Only two other stem-cups of exactly similar size, decoration and mark are known. One came to light at the same time as the Sotheby piece. The other was exhibited in Philadelphia in 1949. (It is illustrated in the Philadelphia Museum Bulletin, plate 51 and by John Pope in Oriental Art. Vol. III, No. 1, 1950, p. 24, plate 4, and by Cornelius Osgood in 'Blue and White Chinese Porcelain. A Study of form'. Plate 45.) Both these pieces are damaged. A stem-cup with very similar decoration, the same mark and of related shape, though smaller, $5\frac{1}{8}$ inches, is in the British Museum, from the Brankston Collection. (Illustrated by him in 'Early Ming Wares of Ching-tê Chên' plate 9b and by Jenyns in 'Ming Pottery and Porcelain' plate 30b.) Brankston (p. 29 op. cit.) states that he knew of other stem-cups resembling the last mentioned piece, which he describes as 'tall goblets with bell-shaped bowls, corresponding in shape and size to those of Yung Lo' (the previous reign) 'which have incised decoration'. He does not say if they were marked.

To return to the question of the mark, it is reasonable to presume that the omission of any mention of the dynasty had some significance since it apparently exalts the emperor at the dynasty's expense. The most intriguing theory is that advanced by A. J. B. Kiddell concerning a pair of colossal Mei-p'ings (prunus-blossom vases) now in the Rockhill Nelson Gallery of Art, Kansas City, which both have this four-character mark, and were supposedly looted from Hsüan Tê's tomb. (Transactions of the Oriental Ceramic Society 1945–46, vol. 21, page 17.) Each one is extremely heavy and superbly painted with a terrifying dragon lashing round the vase amid clouds and flames, brilliantly rendered in all his scaly fury, while four ferocious lion-masks look down from above in vicious glee. This theory suggested that pieces with this mark might have been specially made to be placed in the tomb. However, Soame Jenyns (op. cit. page 68) states that they are 'lopsided with long firecracks. There is a strong possibility that they are only kiln-wasters and if this supposition is correct one wonders how they found their way into Hsüan Tê's tomb, if indeed they ever did'. Not having seen them it is difficult to judge how lopsided they are, but they look quite passably sober in various photographs. Some lopsidedness is pardonable in view of their remarkable size – $21\frac{3}{4}$ inches. The cracks, however, are a blemish and might well occasion surprise at such pieces being in an emperor's tomb always assuming that they are firing cracks. However, there is evidence to suggest that the cracks occurred later, in which case there could be no objection to them at the time of manufacture.

The tomb is known to have been rifled in 1938. Soon afterwards a London dealer bought from the robbers a quantity of treasure of various periods including gold, among which were these two vases, which the robbers insisted they had taken from Hsüan Tê's tomb. As the dealer later pointed out they had no reason to lie to him since he was paying them a fine price. However, of particular interest was their statement that they had found ice formed inside both vases. Doubtless water had dripped from the roof of the damp tomb, or there was a flood. Either way a certain

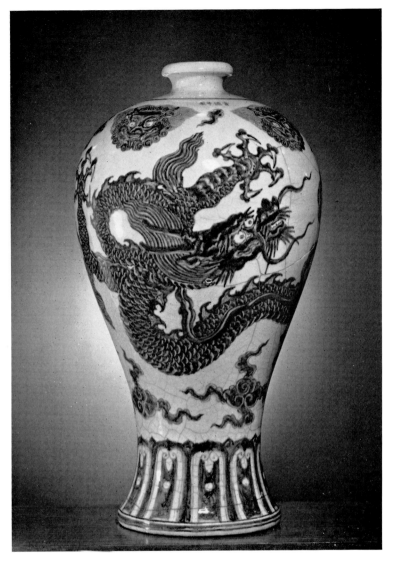

One of a pair of Hsüan Tê
Mei-p'ings (prunus blossom
vases), 21¾ in. high.
Reproduced by permission
of The Nelson Gallery–
Atkins Museum (Nelson
Fund), Kansas City, Mo.

quantity of water had gathered in each vase and frozen. One need not be a scientist
to know that water expands when it freezes, or to envisage the consequences when it
does so in a confined space. The resulting cracks vary from two or three body cracks
to a network of crackle in the glaze, most pronounced over the lower third of the
vase. The body-cracks look too clean-cut to be firing cracks. The glaze crackle by
itself could be a result of a firing defect, were it not for the fact that all the little glaze
fissures radiate out from the body-cracks, like tributary streams from the parent
river, and are thus just a further stage in the same destructive process. A similar
body-crack appears in each piece running horizontally an inch or more above the
foot in each case. The shape of the splayed foot is such that water freezing inside
would be particularly constricted at that point, thus exerting the greatest pressure,
and producing a similar crack in each vase.

Unless the cracks really did occur in the firing, which looks most improbable, how
else could they have occurred? Could both vases have been dropped with such con-

summate skill as to occasion a near-identical pattern of cracks on each piece? Alternatively could damp and burial, so often blamed for the presence of brown-stained glaze-crackle be responsible? Surely no water however stagnant and foul smelling could cause the body of the ware to crack.

Accepting, if we may, that the cracks were caused by ice, it still does not prove that it happened in Hsüan Tê's tomb. But it does tidily corroborate one part of a hitherto discounted story, and in so doing lends substantially to the credibility of that story.

Other pieces with this mark are known. The 1949 Philadelphia Museum Bulletin illustrates two more such pieces, apart from the other stem-cup and the two vases above. One is a Mei-p'ing vase, similar in decoration to the above two but smaller ($13\frac{1}{2}$ inches). The other is a massive jar (Kuan) (illustrated in Oriental Art, Vol. III, 1950, No. 1, page 23) 19 inches high and 19 inches in diameter, weighing 50 pounds. Its decoration is virtually identical to that on the two tomb-vases above, although the four lion masks wear a slightly more surprised expression. It came to America from London, and was bought in 1911 by Ralph M. Chait who soon sold it, but bought it back in 1930. After being loaned to the Brooklyn Museum for an exhibition in 1937 it was sold to a client who donated it anonymously to the Metropolitan Museum of Art.

Many will doubtless pose the question raised by John Pope in a letter to Oriental Art (Vol. III, 1950, No. 2, page 128) namely how if Hsüan Tê's tomb was only rifled in 1938 could this jar have been in the West in 1911? – a question that also applies to the Sotheby stem-cup which has also been in Britain for at least fifty years. Mr Pope considered that this history going back to 1911 'conclusively disposes of the legend of the Hsüan Tê tomb, as far as this piece is concerned'. However, there are flaws in this view despite its apparent common sense. First, it does not admit the possibility that a tomb may be rifled more than once. Any of a number of reasons may prevent a band of tomb-robbers finishing the job at one stroke. They may be disturbed, they may quarrel and, like most people, are limited in what they can carry. Secondly, and from another angle, it considers the theory or 'legend' linking the mark with the tomb, conclusively disposed of once a single piece with this mark can be shown never to have been near the tomb. But the theory does not state that all pieces so marked were actually put in the tomb; it merely suggests that they might have been made with a view to putting them, or some of them, in the tomb.

The same jar poses a more puzzling problem. Despite its intimate resemblance to the two tomb vases, it is apparently not an imperial piece. The dragon on it is only three-clawed, whereas imperial dragons are always supposed to have five. This is most disconcerting! Here is a piece with the mark of a group, whose exceptionally close association with the emperor's sacred person we are trying to show, and we find that it is not even nominally imperial, or so it seems. With its writhing three-clawed dragon it recalls the finest blue and white wares of the previous reign, which were not imperial.

Here we must let the imagination run. It is indisputable that this apparently non-imperial piece is intimately related to the two highly imperial tomb-vases, the similarity of painting being such that it is tempting to attribute them to the same

hand. Until now we have assumed that if this group was destined for the emperor's tomb, it must have been made at his death. This need not be so. The emperor Wan Li (1573–1619) had his tomb constructed at the age of twenty, and invited people to inspect it, much as each pharaoh started on his pyramid as soon as he succeeded. Hsüan Tê could have had his tomb constructed and the treasures to adorn it made early in his reign. This would allow for a number of pieces with this mark never finding their way to the tomb. Alternatively these wares might have been made for the emperor on some other highly important occasion (such as a coronation?), which would cause them to be so intimately associated with his person throughout his reign, that some of them at least might have been placed in his tomb at his sudden and premature death. Certainly the overwhelming power and drama manifested in both the shape and decoration of most of the pieces with this mark, and in their exceptional size, is consistent with a date early in the reign when the unbridled vigour of the preceding reign of Yung Lo was still fresh in the memory. Blue and white porcelain it is now thought, did not receive imperial favour until Hsüan Tê's reign. Is it possible that the jar with its non-imperial three-clawed dragon, could have been so admired at the outset of his reign by the new emperor, who took great interest in porcelain production, that he ordered imperial pieces to be made in similar style? That does not explain the four-character mark, unless we draw conclusions from the fact that when Yung Lo porcelain was marked at all it was often with four characters not six, a practice which might have spilled over into Hsüan Tê's reign.

This leads us to a final select little group of three pieces in the Palace Collection in Taiwan, two stem-cups and a monk's cap jug, so-called from the shape of the mouth, each of which has the four-character mark, on the base of the jug and inside the stem of each stem-cup (see Taiwan Blue and White, Book II, part I, plate 11 and part II plates 39 and 40). The upper part of the jug is vigorously painted with dragons amid scrolling lotus, identical in style to the decoration on one of the stem-cups, so that it is reasonable to assume they were used together in Buddhist ritual. However, the truly remarkable thing about this group is the presence of a Tibetan inscription on each piece. As it happens it is the same inscription in each case. It is painted around the bulbous lower part of the jug, round the inside of the dragon-stem-cup, which also has a Sanskrit character in the bottom of the bowl, and round the outside of the other. It also appears inside the last piece incised in the paste, but this is not visible in the photograph. (Also John Pope in 'Chinese Porcelains from the Ardebil Shrine', plate 66 illustrates a late fifteenth century bowl with a double row of Tibetan script on the inside.)

The inscription, alas, provides no clue to the significance of the four-character mark. It is a prayer for eternal peace appropriate to a variety of rituals, whether festive or funeral.

But perhaps the most intriguing aspect is the very presence of a Tibetan inscription on imperial Chinese porcelain at all, less than sixty years after the expulsion of the Mongols from China and Tibet. The Tibetans were linked by race and religion to the Mongols and had influenced the latter's script, and were not too popular in China at the time. Nevertheless there was some contact. Certain Chinese porcelain shapes such as the monk's cap jug were inspired by Tibetan bronzes. Also Chinese

marks of Ming emperors are known on Tibetan bronzes, though whether these were made in Tibet by Tibetan or Chinese workmen, or in China by travelling Tibetans or Chinese who knew Tibet is not known. But to find Tibetan script on Chinese porcelain, particularly a select group of imperial wares must signify something. It smacks of international diplomacy, though who was currying whose favour is hard to say. Was the use of porcelain bearing Tibetan script at an important ceremony, intended as a compliment to a Tibetan delegation which was present?

Whatever the significance of this Tibetan trio there are some grounds for attributing the four-character mark pieces as a whole to the earlier rather than the later part of the reign. It is now thought that the imperial factories closed on Hsüan Tê's death. This group would have been a grand finale indeed before the thirty chaotic and unproductive years that ensued if it was made on his death. The energy unleashed in the drawing of the dragons on the tomb vases and the huge jar, the loose naturalistic treatment of the foliage on the stem-cups and the unashamed flamboyance of their sheer size all hark back to the preceding reign of Yung Lo (1403–24), as do the very noticeable heaped and piled effects on some pieces, particularly pronounced inside the Sotheby stem-cup, where the blue has concentrated in sooty spots reminiscent of the imperfect control of the blue under Yung Lo, before the greater stability achieved early in Hsüan Tê's reign. Similarly, in a further note on the tomb vases (T.O.C.S. 1946–47, Vol. 22, page 39) Mr Kiddell reports that 'the blue is dark, uneven and rather poorly controlled, the glaze is blue-white, thick and with bubbles where it is thickest about the neck and shoulders.' This tendency of the glaze to run is noticeable on several pieces, particularly on the stem-cup discovered at the same time as the Sotheby one, where the glaze thickens to a misty blue pooling on the lower half of the stem. The same effect occurs at the mouth of the monk's cap jug, and on the Brankston stem-cup in the British Museum so markedly as to impair the clarity of the whole design. Finally the glaze texture though as stated above an unreliable guide, is not as consistently 'orange-peely' as might be expected in most Hsüan Tê wares, varying at times even on one piece. In places the more finely pitted buttery surface of Yung Lo recurs, on the stem and inside walls of the stem-cups, and, it would appear on the tomb vases.

We cannot pretend to draw any firm conclusions about the early years of the stem-cup or even about the group to which it apparently belongs. It is next to impossible to prove whether or not a piece was in a certain tomb thirty years or more after it allegedly left it. All that can be done, as so often in this field, is to assess possibilities.

Footnote

Other known pieces with the four-character Hsüan Tê mark are illustrated as follows:
1. Percival David Foundation Catalogue of Porcelains decorated in Underglaze Blue and Copper Red. No. B688.
 A cup with a double ring in blue below the rim inside and outside and round the foot, the mark on the bottom inside. On the base the character 'tan' = altar. Diameter $4\frac{3}{10}$ in. (10·9 cm.).

2. Adrian Joseph. Ming Porcelains. Their Origins and Development. Page 48. No. 29.
 Stem-cup decorated in underglaze blue with the Three Friends, pine, prunus and bamboo, the mark under the bowl inside the stem, as on the Tibetan-inscribed pieces. Height: $4\frac{3}{4}$ in. (11·25 cm.). Diameter: $6\frac{5}{8}$ in. (17 cm.).

3. Hobson. Wares of the Ming Dynasty. Plate 3, Fig. 1.
 Small squat water-pot for the writing table glazed red outside, the inside and base glazed bluish white, the four-character mark on the base faintly incised in the paste under the glaze. Diameter: $2\frac{7}{8}$ in.

1. Edward VII, halfcrown, 1905. £420
($1,008). 30.IX.70.

2. U.S.A., Assay Office, 50 dollar piece, 1852.
£770 ($1,848). 30.X.70.

3. Oliver Cromwell, 'broad' of 20 shillings,
1656. £460 ($1,320). 30.X.70.

4. Australia, Assay Office, £5 piece, only
7 known. £4,600 ($9,744). 17.II.71.

5. Germany, Augsburg box medal, mid-18th
century. £40 ($96). 16.XII.70.

6. U.S.A., five dollars, 1800. £180 ($432).
17.II.71.

7. Charles I, Pattern halfcrown? in gold. £480
($1,152). 24.III.71.

8. Henry III, silver penny, Ex. Colchester
Hoard. £55 ($132). 24.III.71.

1. James I, rose ryal of 30/–. £270 ($648). 24.III.71.

2. Ancient Rome, Nero, aureus, *circa* A.D. 65. £270 ($648). 24.III.71.

3. Victoria, Indian Peace Medal, 1840, in copper. £115 ($276). 5.V.71.

4. Hungary, Transylvania, 10 ducats, 1652. $650 (£270). 2.II.70.

5. Ancient Rome, Claudius, 'Conquest of Britain' aureus. £310 ($744). 23.VI.71.

6. Russia, gold medal for the completion of Isaac Cathedral, 1858. $1,400 (£583). 27.X.70.

CC*

1. Mexico, 4 reales, 1733, first year of issue. £1,100 ($2,640). 21.VII.71.

2. U.S.A., Massachusetts, 'oak tree' shilling, 1652. £105 ($252). 21.VII.71.

3. Russia, Nicholas I, platinum six roubles, 1831. £400 ($960). 21.VII.71.

4. Elizabeth I, milled half-pound, 1560–66. £200 ($480). 21.VII.71.

5. William III, five guinea piece, 1701. £400 ($960). 21.VII.71.

6. Scotland, William III, gold pistole, 1701. £220 ($528). 21.VII.71.

7. Victoria, Pattern Crown, by Wyon, 1888. £720 ($1,728). 21.VII.71.

8. Aquitaine, Edward the Black Prince, pavillon d'or. £260 ($624). 21.VII.71.

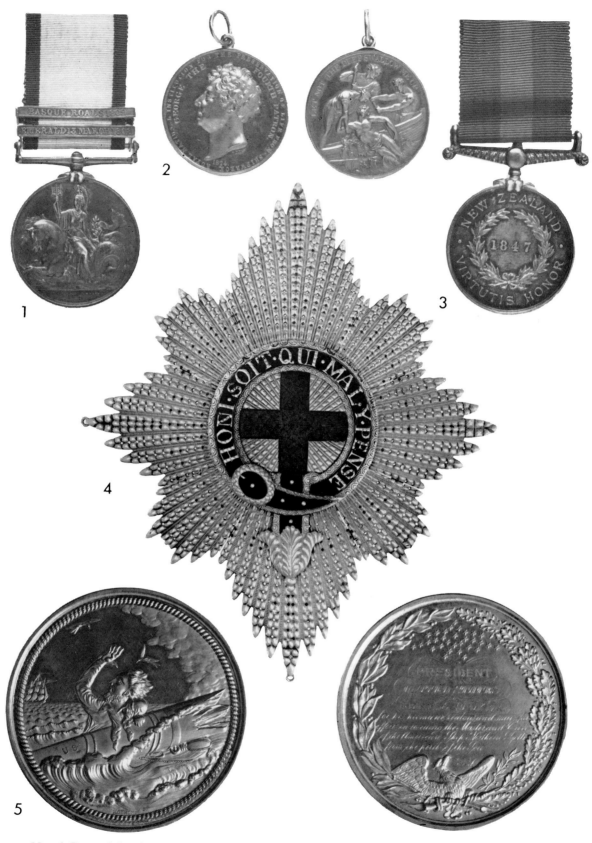

1. Naval General Service Medal, 1793–1840, 2 bars, awarded to Lieut. E. Wylde. £430 ($1,032). 30.ix.70.
2. Royal National Lifeboat Institution's gold medal for saving Life (Lieut. D. Rymer, 1838). £190 ($456). 30.ix.70.
3. New Zealand Medal, 1847 (Col. T. B.

Collinson), the only medal awarded to the Army for this campaign. £280 ($672). 30.ix.70.
4. The Most Noble Order of the Garter, breast star, worn by the Duke of Sussex (1773–1843). £1,100 ($2,640). 23.vi.71.
5. U.S.A., Presidential Life Saving Medal, 1857, to Jeremiah Walker. £400 ($960). 23.vi.71.

A Great Auk, *Alca impennis*, in summer
plumage, standing 22·5 in. high, taken
circa 1821 from Iceland.
London £9,000 ($21,600). 4.III.71.
From the collection of Baron Raben-
Levetzau, removed from Aalholm Castle,
Denmark.
The Great Auk was a flightless North
Atlantic sea bird, finally exterminated
on Eldey, Iceland in 1844. It became
extinct through hunting. In the British
Isles it has been extinct since about 1840.
It last bred in St. Kilda some years
before 1697, possibly the Calf of Man
up to 1692, and Papa Westray, Orkney
up to 1812. The last British records of
sightings were Co. Waterford in 1834
and St. Kilda, *circa* 1840.

Natural History

Two of the most outstanding items sold this season were the Great Auk from Aalholm Castle, Denmark, which fetched £9,000 ($21,000), an auction record for a natural history specimen, and the egg of *Aepyornis maximus* which realized £1,000 ($2,400). The Greak Auk specimen was the first to have appeared on the open market since the 1930s and was purchased on behalf of the Natural History Museum of Iceland. The egg was from a bird of great historical interest. The *Aepyornis* (Greek for 'tall bird') survived from the Pleistocene age, about 1 million years ago, to the advent of man. *Aepyornis maximus*, the largest species of the genus, standing approximately 10 feet high, was the heaviest of all birds and was probably the origin of the Arabic legend of the Roc-Bird or Rukh. All the eggs which have survived have been found in Madagascar and it is interesting to note that between 1893 and 1916 about 10 *Aepyornis* eggs were sold at auction in London for prices ranging up to 70 gns.

Prices for shells have been very high this season. Sotheby's sale on 4th March produced one fine specimen of the extremely rare shell, *Conus bengalensis* Okutani, from North-West Thailand, which fetched a record £1,350 ($3,240). Cone shells are probably the most popular genus and this particular species, amongst the most handsome known, was first described in 1968; the specimen sold at Sotheby's, found in December 1970, is thought to have been the fourth such shell recovered. Other fine shells in the same sale included two *Strombus listeri* from the Andaman Sea which fetched £100 ($240) each.

A fine collection of butterflies formed by Dennis Ward, Esq. was also sold on 4th March. Once again, the highest prices were paid for *Ornithoptera* and a good pair of *Ornithoptera paradisea*, male and female, from New Guinea, fetched £125 ($300); this price compares favourably with the £55 ($132) paid for a single male specimen in July 1970. In the same sale, a rare pair of *Papilio homerus*, male and female, from Trinidad, were sold for £100 ($240).

In October 1970, a collection of rare minerals, many obtained through exchanges with the Smithsonian Institute, fetched £6,851 ($16,402). Outstanding was a magnificent specimen of native copper, mined in Michigan in 1876, which fetched £560 ($1,344). Pieces of this quality are almost never seen on the market today. Native copper is found at the surface of a mine and is the first ore to be excavated; for this reason, few specimens have survived.

An almost complete specimen of the ichthyosaur *Eurypterygius dorsetensis* from Lyme Regis, Dorset. 5 ft. 6 in. long by 18 in. This specimen was found in 1969.
London £1,050 ($2,520). 7.XII.70.

A large specimen of crystallized native copper, from Houghton
County, Michigan, U.S.A. 23 in. high by 17·5 in. by 10 in.
London £560 ($1,344). 15.x.70.
Originally from the United States National Museum collection.

1. Desert rose, Chihuahua, Mexico. 20 in. by 13 in. by 11 in. £95 ($228). 4.III.71. **2.** Haematite *var.* kidney ore, Alston Moor, Cumberland. 7·5 in. by 6 in. by 5 in. £22 ($53). 15.X.70. **3.** Ammonite *Asteroceras obtusum*, Lower Jurassic Age, Lyme Regis, Dorset. £210 ($504). 4.III.71. **4.** Footprint of the extinct reptile *Chirotherium*, Keuper Sandstones, Cheshire. 14 in. by 9 in. £65 ($156). 15.VII.71. **5.** A semi-fossilized egg of the extinct bird *Aepyornis maximus*, Madagascar. 15 in. long. £1,000 ($2,400). 4.III.71. **6.** Oreodon skull, Bad Lands, South Dakota, U.S.A. 8·5 in. by 5 in. by 4·5 in. £105 ($252). 7.XII.70. **7.** Ornithoptera paradisea, male and female, New Guinea. £125 ($300). 4.III.71. **8.** Conus bengalensis *Okutani* 1968, North-West Thailand 1970. 4 in. £1,350 ($3,240). 4.III.71. **9.** Strombus listeri *T. Gray*, Andaman Sea 1970. 5.2 in. £100 ($240). 4.III.71. **10.** Papilio homerus, male and female, Trinidad. £100 ($240). 4.III.71. **11.** Norfolk Island Parrot, extinct, Philip Island Western Pacific. £190 ($456). 4.III.71. **12.** Apatite crystal, Renfrew County, Ontario, Canada. 5·7 in. by 2·1 in. by 2 in. £40 ($96). 15.X.70. **13.** Tourmaline *var.* Rubellite, Pala, California. 5 in. by 2·5 in. by 1·2 in. £160 ($384). 15.X.70. **14.** Huia, male and female, probably extinct, North Island, New Zealand. £320 ($768). 4.III.71.

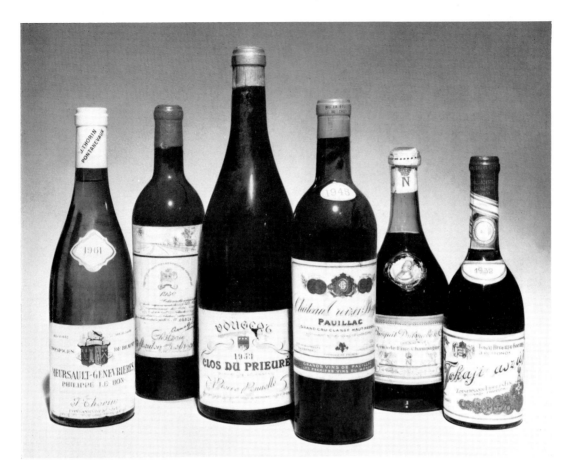

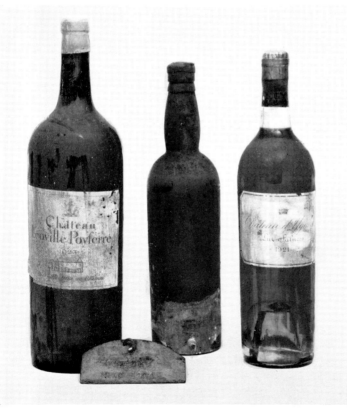

Above:
1. Meursault Genevrières 1961.
£17 ($41), per 12 bottles.
2. Château Mouton Rothschild 1950,
sold with equal quantity of Château
Margaux 1957. £37 ($77), per 12
bottles.
3. Vougeot, Clos de Prieuré 1953.
£23 ($55), per 6 magnums.
4. Château Croizet Bages 1945.
£38 ($91), per 12 bottles.
5. Bisquit Dubouché, Grande Fine
Champagne Cognac 1811.
£29 ($70), per bottle.
6. Tokaji aszu, 3 puttonos 1932.
£5 ($12), per bottle.
The bottles illustrated above were
sold in London on 7th July, 1971.

Below left: Château Léoville Poyferré
1923. £144 ($346), per 6 magnums.
Centre: Sandeman 1904, sold with
Cockburn 1904. £75 ($180), per
12 bottles.
Right: Château d'Yquem 1921.
£456 ($1,094), per 12 bottles.
The bottles illustrated below were sold
in London on 5th May, 1971.

Sotheby's Wine Department

BY CYRIL RAY

Sotheby's wine department was set up in June 1970, in time to hold its first sale (in Glasgow, on behalf of British Transport Hotels) on 16th September.

It is interesting that its staff of three all learned their trade at Harvey's of Bristol, for the Harvey's of pre-merger days had the same sort of reputation as a training ground for scholarly wine-merchants that the old *Manchester Guardian* had as a school for serious journalists and that the Savoy Hotel still has for turning out highly professional restaurateurs and hoteliers.

Colin Fenton, indeed, the head of the department, a Master of Wine, was at Harvey's for no less than seventeen years (still only 42, he went straight to Harveys after Marlborough, Oxford and the Coldstream) – for ten of them a close friend and colleague of Michael Broadbent, M.W., now his distinguished (and still friendly) opposite number as head of Christie's wine department.

John Lloyd, his number two, who went to a French university after Eton and Christ Church, once looked after Harvey's Pall Mall shop, and David Berry, still only 24, had seven years at Harvey's after leaving Clifton, and studied German wines in Germany on a Harvey's scholarship.

The new team, then, brought scholarly traditions of their own into the scholarly atmosphere of a fine-art auctioneers: after all, they had been recruited to catalogue and to sell by auction items – fine wines, great brandies and the like – that in a sense are as much works of devoted craftsmanship as pieces of French furniture or of Irish glass. The only ways in which the items handled by the wine department differ fundamentally from those being catalogued elsewhere in that rabbit-warren of rooms in New Bond Street is that they have a recognizable life-span, and are consumable.

Much of the skill, therefore, in cataloguing wine lies in researching into the history of a bottle before it reaches the saleroom: how often it has been moved; in what cellars it has lain – damp or dry, at an even temperature or not; how deeply it is ullaged (ullage is the air-space between the cork and the top of the wine: it tends to increase with age, but the warmer the cellar the more quickly, and the greater it is, the likelier that the wine is well past its best); all this in addition to a knowledge of the wine's individual character, and the character of its particular year.

The cataloguers taste, therefore, whenever possible, and they like potential purchasers to have the opportunity to taste, too. Clearly, this is *not* possible when the lot offered is, say, half a dozen magnums of a historic port, or a dozen claret of a good year in its unopened original wooden case. This is where scholarship comes in as a protection to the consumer – the catalogue gives as much information as can be discovered or deduced, but always cautiously – I read, for instance, in the catalogue of the sale of James Hawker & Co's wines on 28th October 1970: 'BARRIASSON GRANDE CHAMPAGNE COGNAC, REPUTED 1922 . . . James Hawker fully believe this to be of the 1922 vintage. Under current French Law, however, the claim needs qualification'.

Or in the catalogue of the great sale of 'Fine and Rare Wines mainly from Private Cellars' on 5th May 1971 that some of the wax seals of the Cockburn 1935 were chipped; that ullages are narrowly defined ('to mid-shoulder', 'close to mid-shoulder', 'vary from $\frac{3}{4}''$ to $2'''$', and so on); and that this cork is shrunken or that label torn. (To say nothing of this particular catalogue's charming misprints, themselves collector's items, that suggest that perhaps the type had been set up in the tasting-room: 'Excellent villages' for the 'ullages' of the 1945 Yquem, and the 'POET, UNKNOWN SHIPPER, 1820' – Byron, slipping overseas incognito, perhaps, for who knows what assignation. . . .)

I have often wondered, and I asked Colin Fenton, whether West-end auctions are not forcing up the prices of the finest wines – whether some of the glamour of the constantly increasing record prices for French Impressionists, say, or for Baccarat paperweights does not rub off on to the already sufficiently legendary (and expensive) great years of Lafite and Yquem, Taylor's port and Tokay essence.

Certainly, Sotheby's wine department has achieved plenty of world records in its first year, among them £144 ($346) a case for Léoville-Poyferre 1923, £75 ($180) a case for Cockburn 1904, £130 ($312) for a case of Veuve Clicquot 1928, disgorged in 1971, and two bottles of the celebrated Yquem 1921 at £38 ($91) a bottle – the previous record being just over £20 ($48).

But these are rarities, unobtainable over a shop counter – and rarities competed for by wine-merchants for special customers, or by merchant banks for directors' reserves or board-room luncheons, will inevitably command rare prices.

Naturally, an auctioneer likes to get a good price for a vendor, and thus a good commission for his firm, but results such as these, though exciting, and good publicity, have their drawbacks. They attract vendors who may eventually be disappointed, because a wine may not always fetch what the same wine, of the same year, has fetched in a previous sale. And they can frighten off potential purchasers, who think that every lot is going to fetch a record high price.

In fact, says Colin Fenton, rarities apart, the saleroom tends to stabilize prices. Merchants buy their wines at different times and from different shippers, so that retail lists show wide variations of price for the same year: auctions establish a norm – and on an international scale, at that.

One of the many causes, anyway, for the rise in price of the finest wines is that many wine-merchants have not increased the price annually, as they should have done, of fine wines maturing in their own cellars – ignoring, in fact, both interest on their capital and replacement costs. (Hence the many lamentable financial failures in recent years among splendid old-established firms.)

The auction rooms now make it possible for wine-merchants to sell their wines young into private hands, the customer in his turn knowing that he can sell his surpluses later at auction, almost invariably at a profit, and then go back to the merchant for more recent vintages.

(It is worth recording here that Sotheby's will buy young wines, or advise on their purchase, not necessarily from their own saleroom, but from growers and shippers. They do not charge commission, for they know that some of the wine will eventually come to auction. That lady in the Cotswolds who, only the other day, asked Sotheby's to invest £500 for her in the 1970s is undoubtedly on to a good thing.)

All of which is not to say that there are no bargains to be found in the saleroom.

Buyers are shy of old or oldish vintages of hock, yet those who tasted the 1937 and 1947 Forster Jesuitengarter Rieslings before recent sales realized how well they had retained their freshness – and bought them for £15·50 ($37) and £8·50 ($20) a dozen respectively.

Non-vintage champagne (and *sekt*) often goes more cheaply than at retail – sometimes at less than wholesale. Sotheby's indicate the landing date whenever they can be certain, and wine with two or three years' landing age should be absolutely right for drinking. He is a wise man who, with a daughter's wedding in prospect, looks out for a three-dozen lot at Sotheby's: he will do better than he would at a professional caterer's.

Then, although the good years of distinguished second-growth clarets, château-bottled, are moving up the price-scale, narrowing the gap between themselves and the great first growths, the bourgeois growths are still, if anything, undervalued. This is certainly true of those that are English-bottled, though many are of very high quality indeed, and they can usually be tasted. The 1967s that went recently at £7 to £9 ($17 to $22) a dozen were bargains indeed. Even the relatively few *crus classés* that are still being shipped in wood can be bought, English-bottled – good years of them, at that – at as much as 25 per cent cheaper than retail, the older vintages at a bigger discount still.

Fortunately, there seems no end to the availability of wine for auction. As I have already explained, private buyers are constantly exchanging their surpluses of old vintages, in order to buy the finer recent ones, and there is always someone, somewhere in Britain, who has just inherited a bigger cellar than he can hope to drink his way through in his lifetime.

Not too many of them, Colin Fenton is happy to record, like the old friend of his who, along with a baronetcy, inherited an ancient abbey which he remembered as having a vast cellar crammed with bottles. He took his auctioneer friend down with him and, with a flourish, flung open the doors to the cellar. True enough, it was crammed with bottles. . . . They were empties.

Seal on a single magnum of Vieux Cognac 1811.
Bottled about 1830–50, the emblem is an allusion to the famous comet of 1811.
London £105 ($252). 9.XII.70.

Man's bicycle from the film *Butch Cassidy and the Sundance Kid*.
Los Angeles $3,100 (£1,458). 28.11.71.

Sotheby Parke-Bernet Los Angeles

BY EDWARD J. LANDRIGAN III

The building was overgrown with ivy, mostly dead. The grounds lay covered in a tangle of green and brown ice plant – a succulent commonly used to prevent erosion along the banks of California's endless freeways. Six olive trees gently waved their unkempt silver-green branches in front of the bunker-shaped facade. Beneath this shabby exterior slept a 1947, almost *Art Moderne* building of unusually solid construction, even for earthquake-conscious California. Some walls of brick, others concrete up to twelve inches thick, reinforced with iron bars! Five of the large rooms had no windows and could be entered only through steel reinforced doors. Labels on these doors indicated that these restricted rooms had once held classified documents and books; one room was still stacked with survival supplies in case of a nuclear attack.

Hanging crooked everywhere and scattered about the floor were photos and drawings of exotic experimental aircraft and rockets. The huge entrance hall, like all the other rooms, was painted a dreary civil service green. The only distinguishing feature was in the centre of the foyer floor, which, as in the rest of the building, was covered in mottled brown lino tiles that were coming unstuck in a haphazard way like witch's teeth. This was a large blue medallion containing the yellow letters AIAA, also in tile, right in the centre of the foyer. AIAA stands for American Institute of Aeronautics and Astronautics.

This strange building had been vacant for several years. Its huge auditorium (seating 500) hired out to various organizations for meetings, dances and parties. CBS TV Studios, located next door, often rented the AIAA building for rehearsing shows when their stages were full. CBS also used the vast asphalt AIAA parking lot to land huge Navy jet helicopters. These were outfitted and tested with equipment for photographing the return of American astronauts from the Apollo flights. A large fading white circle still in the parking lot with the AIAA monogram reminds one that the previous tenants travelled to work by helicopter.

Our real estate agent told us quite candidly that the AIAA building at 7660 Beverly Boulevard ('On $3\frac{1}{4}$ acres, a 500 person auditorium, parking for 200 cars and a helicopter landing pad') was termed a white elephant by other real estate brokers. 'Excellent value,' he said; 'a marvellous location, so close to Beverly Hills and still easily accessible to all the freeways – but who needs such a building? It would cost a fortune to tear down its concrete walls which are built like a bomb shelter'.

That hot day in May when we first saw the site of our new Los Angeles auction house, it was difficult to visualize it as a place people would want to visit. Yet the more we looked the more certain we became that if indeed this was a white elephant for other's business needs, it was tailor-made for ours as an auction gallery. Peter Wilson took less than three hours to look beyond the dead ivy and dull green paint to jot down precisely our next six months' work. His ideas were simple but brilliant. The saleroom should be Sotheby green ('some tradition won't hurt'). Up to seven feet

Pumper with three-horse hitch.
14 ft. 7½ in. long by 6 ft. 10 in. wide by 9 ft. 3 in. high.
Los Angeles $11,500 (£4,791). 28.11.71.

the walls are to be covered in fabric over board ('order extra material in case a panel gets torn'). 'The stage curtain can wait until we decide on a colour for the lobby. The ceilings are very high, probably twenty-five feet; that is good but they must not appear to be so high, paint them black and install light fixtures at about fifteen feet – it will create a cosier atmosphere. The carpets must be very wearable – an oatmeal colour won't show the dirt easily and will complement the green walls. Now the lobby – it is such an unusual shape, a long hexagon. Here we should perhaps concentrate on earth colours. The dry earth in California is so much in evidence. Why not attempt the colour combination of a Greek vase. Terra-cotta and black should be right. The walls should be terra-cotta, the doors and ceilings black. Those built-in display cases in the lobby don't need anything but dusting; the natural wheat hop-sack lining goes with terra-cotta'. And so it happened. Some problems with the decision as whether or not to plant grass around the building. A tan pea-gravel was chosen to cover the front both for its easy maintenance and for its aesthetic link with the naturally barren land.

Neat evergreen hedges line the walkway and are planted in rectangles round the ancient olive trees. Each tree is an oasis in a broad expanse of gravel.

Amid hoards of painters, plumbers, plasterers, carpenters and their accompanying din, clutter and general chaos, we began to do business. Our first clients, those brave people who came to SPBLA (as it is becoming known) in the months before our

Brown toy teddy bear, mounted on wheels.
26 in. high by 21 in. long.
Los Angeles $450 (£186). 28.11.71.

official opening, were given hot coffee to fend off the chill since our heating system would not work. All talk was in the future tense: 'We'll be in touch as soon as the paint is dry in these storage bins.'

SPBLA's first sale and the biggest to date was held in February 1971 for 20th Century Fox. Fox's decision to sell some of its 'inactive' props and movie *memorabilia* was particularly good news – for two reasons. We were eager for business, and the publicity of the Fox name was an ideal starting point.

The props were unlike most of our New York and London consignments in their strange variety. It was not really a collection, although all the items had a film background. To combine thirty-eight foot models of the Japanese Navy (*Tora! Tora! Tora!*), the bicycle from *Butch Cassidy and the Sundance Kid*, Shirley Temple's teddy bear from *Captain January*, stage coaches, fire engines and stuffed apes was a challenging task. Our new staff was enthusiastic and the monumental catalogue began to take shape once we became accustomed to the incongruity of materials. The catalogue was arranged according to general categories: furniture and decorations (three sessions), posters and set sketches, carriages, ships and other models.

The first evening of the Fox sale was like a movie première. As the first people arrived for the 8 p.m. auction on 28th February, the gravel in the front garden was still being levelled. Our newly painted sales room attracted such stars as Debbie

LARRY BELL
A wisp of the girl she used to be.
Oil on canvas and glass. Executed in 1963. 48 in. by 48 in.
Los Angeles $8,000 (£3,333). 17.III.71.

ROBERT INDIANA
Red Sails.
Signed. 50 in. by 50 in.
Los Angeles $10,500 (£4,375). 17.III.71.

Reynolds, David Hemming, Raymond Massey, Zsa Zsa Gabor, Cornel Wilde, Natalie Wood and Hugh O'Brien. We were pleasantly surprised when prices were in keeping with our estimates. Of course there were some exceptions, such as $3,100 for the Butch Cassidy bicycle. Composer Burt Bacharach ('Raindrops Are Falling on My Head') was bidding against producers Bert Rosen and David Winters who wanted to present the bike to Joanne Woodward, Paul Newman's wife. Rosen and Winters won the battle, but not before the crowd was on its feet, cheering on the enthusiastic bidders. Raymond Massey bid on a portrait of himself. He lost it at $165 to a news writer who was heavily booed by the pro-Massey audience. The Massey fans gave the actor a full minute of applause when he rose to leave. A reporter asked Massey why he wanted the portrait, and he replied that he felt it was such a dreadful picture he had hoped to take it home and burn it.

The large model ships did well considering the difficulty they offered for storage. Most of them went to maritime museums and shopping centres. Eleven American Navy training aeroplanes converted to look like Japanese Zeroes, Vals and Zekes for *Tora!*, fetched an average of $2,350 each to private collectors. The total for SPBLA's first auction was over $364,000.

It was rather an anti-climax returning to every-day auctions after the star-dust covered props. But March saw the regular business begin – from snuff bottles to American furniture, the contents of the bi-weekly sales have varied greatly in quantity and quality.

Our first painting sale was of contemporary American works, including several California artists. It was indeed a test sale since only a few such sales had been held before at Parke-Bernet. The results were good. West Coast collectors and museums crowded the green salesroom to bid for the works. The Pasadena Museum paid $8,000 for a Larry Bell composition with a mirror at the centre; it was the first time a painting by this artist had ever been sold at auction.

While SPBLA continues regular furniture and decorations sales, the rapidly changing motion picture industry continues to rid itself of unnecessary trappings. 5th–8th June appeared to be a gala dress-up party; in fact it was an auction of 907 costumes from the distinguished costumiers, Max Berman and Sons Inc., who are closing the rental portion of their business. Costume rental is a dying business in Hollywood; most of the big films today are being made in Europe. The $47,000 sale total was not as spectacular as the SPBLA staff modelling the costumes in the catalogue and during the auction. The audience enjoyed it almost as much as the models.

For three weeks SPBLA's lobby was the garage for a rare type of 57SC Bugatti automobile. On 12th June in the glare of news cameras and flashing press bulbs, 150 people watched us conduct a three-minute single lot auction for the world record price for an automobile of $59,000. As the applause which followed the fall of the hammer died down, a reporter asked the buyer Dr. Peter Williamson, a Connecticut neurosurgeon, for a comment. 'I never paid that much for a Bugatti before', he said, 'I'm in a state of shock.' The under-bidder was Rodney Clarke, a London collector and a familiar face at Sotheby's antique car sales. Clarke had originally sold the Bugatti to its late owner Robert Oliver, in 1947 for $5,000.

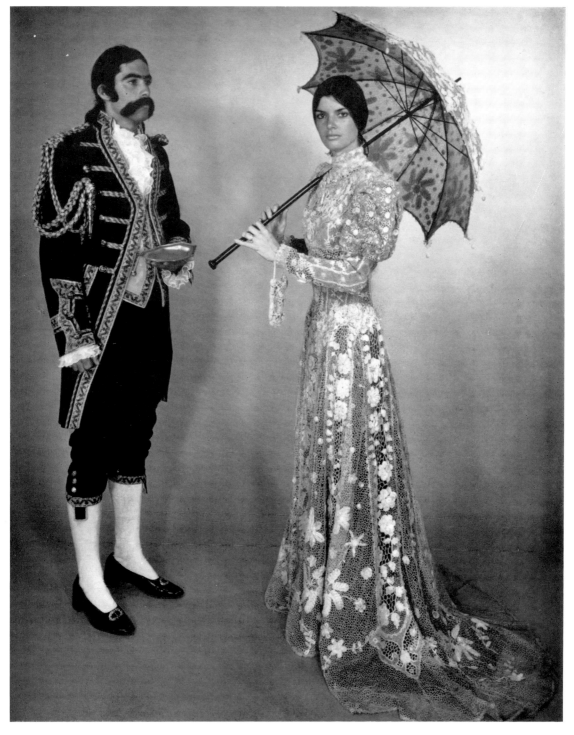

An English footman uniform comprising jacket, waistcoat and trousers,
and with crested silver buttons. *Circa* 1880.
Los Angeles $45 (£18). 6.VI.71.
Maureen O'Hara. An Irish lace tea gown over green taffeta;
together with matching lace purse, umbrella and straw hat.
Los Angeles $225 (£93). 6.VI.71.

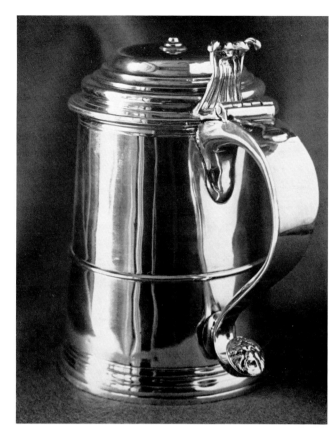

A gold-cased repeating verge watch, by Daniel Quare. Signed. *Circa* 1720. Los Angeles $1,300(£540). 20.IV.71.

An American silver tankard by John Burt, Boston, Massachusetts. *Circa* 1740. 7 in. high. Los Angeles $3,600 (£1,333). 20.IV.71.

SPBLA's first whirlwind six months has been for us a weird pot-pourri of extra-ordinary objects, fascinating events and undreamt-of opportunities: world records for a car, a bicycle and a teddy bear; new kinds of sales from pop paintings to movie memorabilia and star costumes; the promise of more nostalgic movie property; fields of collecting indigenous to California such as Western Americana; and new ideas for sales of things that stagger the imagination of regular Sotheby or Parke-Bernet auction goers.

I wish Samuel Baker could have been looking over my shoulder as I pointed out Peter Wilson and Peregrine Pollen to a Los Angeles Times reporter covering the opening of our new auction gallery. They were having a race in invalid chairs, darting about the parking lot between model battle-ships, fire engines, stage coaches, carousels and other items from the Fox sale.

'There goes the Chairman of Sotheby's,' I said, 'just past the stage coach and if you'll look quickly that's Parke-Bernet's President rolling between the Planet of the Apes Wagon and a whale boat'.

Acknowledgements

Messrs Sotheby & Co. and Parke-Bernet Inc. are indebted to the following who have allowed their names to be published as the purchasers of the works of art illustrated on the preceding pages.

M. Abram Ltd., London, 422(9); A. C. A. Galleries, New York, 191 above, 194(1); Arthur Ackermann & Son Ltd., London, 121; Mrs Christa Ackermann, New York, 105(2), 297 right; The Acquavella Galleries Inc., New York, 171; Thos. Agnew & Sons Ltd., London, 6, 116, 127, 129 below, 130, 133 above, 136 below, 141; Mr & Mrs J. W. Alsdorf, Winnetka, Ill. 261(13, 14), 281(9); Albert Amor Ltd., London, 392 centre right, 393(5); Antiken. H. Herzer & Co., Munich, 260(7); The Antique Porcelain Company, London; The Antique Company of New York, 279(9), 286 below, 380(3, 5, 7), 392 above right, below left and right, centre left, 393(2, 8, 9, 11); J. R. Aron, New York, 287(7); Ash, London, 418 above left; H. Ashenden, St. Osyth, Essex, 471(12); Asprey & Co. Ltd., London, 292 above right, 411 below right; Private Collection, Claude Aubry, Paris, 79(9);

Herman Baer, London, 292 above left, 294, 295, 296 right, 298(2, 3, 12), 299(2); Bailey Minerals, Madrid, 495(2); A. H. Baldwin & Sons Ltd., London, 489(5); 491(3); Balfour, Williamson & Co. Ltd., London, 112 below; Georges Baptiste, Brussels, 397(12), 398; Baskett & Day, London, 73 left, 74 above, 117, 119 below, 129 above, 132 below, 133 below; Joseph Batiste, London, 445(6); Collection of Mr and Mrs David Bellis, Bronx, New York, 468 above; Jack C. Benardout, London, 315 below; Bentley & Co., London, 396(10, 11), 437(7, 10); Pierre Bères, Paris, 253; Dr Robert A. Berger, New York, 111(5); Heinz Berggruen, Paris, 188; L. M. Berker, O.B.E., London, 437(4); Georges Bernier, Paris, 75 above, 202 right; Herbert N. Bier, London, 195(1), 219, 292 below left, 404 above right; Bihler & Coger, Ashley Falls, Mass. 318; P. Binder, Zurich, 10; H. Blairman & Sons Ltd., London, 347(4, 13); N. Bloom Ltd., Bishopsgate, London, 306, 309 above left, 464(2, 13); Bluett & Sons Ltd., London, 266, 268, 274 above right, 276 below, 279(6); Mrs Audrey Bowley, London, 471(6); Bernard Braverman, Wilkinsburg, Penna. 405(1); Martin Breslauer, London, 218, 225 above, 234, 240, 246 below left and right; Brod Gallery, London, 51, 79(2); W. G. T. Burne (Antique Glass) Ltd., London, 444(3, 5); The Butterfly Centre, Canterbury, 495(10);

C. & J. Carpets Ltd., London, 319; Mr and Mrs Henry B. Caldwell, Allentown, Penna. 437(11); W. Casebourne, Birkenhead, 287(12); Cavendish Galleries Ltd., London, 122 below; H. Beecher Chapin, Batavia, New York, 112 above; Cheshire Antiques, Macclesfield, 471(1, 3); C. A. Chiesa, Milan, 102, 105(9); J. Christie, London, 464(6); Ciancimino Ltd., London, 298(7); Cleveland Museum of Natural History, Cleveland, Ohio, 493; Roy G. Cole, Hamilton, Ontario, 119 above, 263(3, 9, 14), 405(6); Philip Colleck, New York, 343(11); D. M. Collins Antiques, London, 336; P. & D. Colnaghi & Co. Ltd., London, 52, 78 below, 95 above centre, 105(1, 11), 111(2, 3); Commonwealth of Australia, 263(13); Ted and Lillian Conway, Hewlett, New York, 466 above; Craddock & Barnard, London, 97, 105(5).

Mrs Alexander Dankin, Norfolk, Conn. 343(2); B. Davidson & Co., London, 464(1, 5, 7); Mrs E. W. Davidson, 416 above; J. H. Davies, Aberystwyth, 409 above right and centre; M. de Botton, London, 164; Mrs Hanita E. Dechter, Los Angeles, 260(13); Denis de Ferranti, Beylongue, France, 135; Delamosne & Son Ltd., London, 299(10); Alain Delon, Paris, 71; Paul Delplace, Brussels, 13, 299(11); Denning

Fourcade Inc., New York, 346; Richard Dennis, London, 470 left; Dr O. Dettmers, Bremen, 444(9); J. & S. S. de Young Inc., Boston, Mass. 422(13), 423(3); Dia Diodato, New York, 263(7); D. Drager, London, 422(5, 10), 430(12), 431(8); Duits Ltd., London, 64.

Editions Graphiques Gallery, London, 111(8), 467 above left; Francis Edwards Ltd., London, 215 left, 248 left; Jerome M. Eisenberg, New York, 495(1, 8, 9); George A. Embiricos Collection, London, 92, 93; Erasmus & Co., London, 249 right; Eskenazi Ltd., London, 265, 269, 287(8); R. Esmerian Inc., New York, 418 below right.

Faerber & Maison Ltd., London, 467 above right; Faggen Enterprises Inc., New York, 153 below; E. Fairclough (Arms) Ltd., London, 396(4), 404 above left; P. Falanga, Milan, 343(1); Nuri Farhadi, New York, 261(2); Richard Feigen & Co. Inc., New York, 178; Ronald Feldman Fine Arts, New York, 111(12); John Fleming, New York, 244 left, 245 left; H. M. Fletcher, London, 239 left, 246 above left; Carl Foreman, C.B.E., London, 405(5); I. Freeman & Son Inc., London and New York, 307, 309 above right, 464(4, 10); French & Co., New York, 259, 260(10), 313; John H. Frisk, Philadelphia, 149 below left; Frost & Reed Ltd., London, 144; Fugendo & Co. Ltd., Tokyo, 287(9); Mary Ralph Lowe Fuller, Atlanta, Georgia, 111(11).

John R. Gaines, Lexington, Kentucky, 198, 285 above left; Galerie du Lac (Peter Zervudachi), Vevey, Switzerland, 491(4); Malcolm Gardner, Sevenoaks, 397(3, 4, 9); D. Ghigo, Turin, 335 below; Christopher Gibbs Ltd., London, 343(5); W. Gidwitz, Highland Park, Ill. 285 below left; J. Gijsbrechts, Elewijt, Belgium, 193(11); K. Gillies, 380(12); Helen Glatz, London, 275 below, 276 above, 277 above, centre and below, 279(8, 10, 12); Gooden & Fox Ltd., London, 194(4); Elinor Gordon, Villanova, Penna. 279(11), 347(3); F. Gorevic & Son Inc., New York, 299(3); Graham Gallery, New York, 299(1); Richard Green (Fine Paintings), London, 79(1, 3), 118 below, 460 above and below, 461 below; Jerome Greene, New York, 201; Gregoire Galleries, New York, 159 above, 468 below centre; Grover Antiques, Cleveland, Ohio, 468 below left and right; Abbott Guggenheim Collection, New York, 299(6), 400 below.

Stephen Hahn Gallery, New York, 170; M. Hakim, London, 430(8), 431(4, 6); M. W. Hall, Abinger, Surrey, 411 below left; The Armand Hammer Foundation, Los Angeles, 72 above, 79(6), 82, 84, 85, 86 above, 88 below, 89, 90, 143, 165, 168, 173, 176, 197, 200; The Hon. Mrs V. Harmsworth, London, 419 centre; S. H. Harris & S. J. Phillips, London, 412(1); Hartnoll & Eyre, London, 455, 456 left, 458; J. B. Hayward & Son, London, 491(1); G. Hearn, London, 488(8), 490(3, 4, 5, 7); Daniel Neal Heller, Miami Beach, Florida, 202 left; G. Heywood Hill Ltd., London, 241 left, 248 right; Eliot Hodgkin, London, 111(4); Hofmann & Freeman, Sevenoaks, 238 right, 251; Elisabeth-Brigitte Holzapfel, Berne, 214; House of Milner, Philadelphia, 418 below left, 422(14); How of Edinburgh, London, 301; Cyril Humphris, 8, 23, 58, 59, 296 left, 298(11), 299(4), 379, 381(1, 2, 3).

Iceland Rotary, Lions & Kiwanis Clubs, presented to the Natural History Museum, Reykjavik, 492; Roger Imbert, Paris, 3, 445(9);

Jerry Jacobs, Secaucus, New Jersey, 437(8); Jellinek & Sampson, London, 389(7); Jellinek & Vermoutier, London, 389(2); Richard H. Jenkins, Hartford, Conn. 437(3); C. John, London, 321; W. J. Johnson, New York, 72 below.

Kasser Art Foundation, Montclair, New Jersey, 206 right, 207 below left; Charles Kearley, Langstone, Hampshire, 192; Kennedy Galleries Inc., New York, 145, 150; Roman Norbert Ketterer, Campione, Switzerland, 186; M. Knoedler & Co. Inc., New York, 142; Martin Koblitz, London, 308 below; David M. Koetser Gallery, Zurich, 57; H. P. Kraus Inc., New York, 226, 227, 228, 231; Kunstsammlung, Nordrhein-Westfalen, Duesseldorf, 159 below.

Harold Landsberg, London, 431(1); Steingrim Laursen, Copenhagen, 193(12); D. S. Lavender, London, 424 below left, 427 centre and below left; Gordon Lawrence, London, 425 centre left, 430(9); P. Lazarus Glass Collection, Wraxall, Bristol, 444(4); Ronald A. Lee, London, 304; The Lefevre Gallery, London, 137; The Hon. and Mrs Samuel Lefrak, New York, 185; The Leger Galleries, London, 126, 128 below, 453, 456 right; Leggatt Brothers, London, 118 above, 128 above; Leicester Museums, Leicester, 495(4); M. P. Levene Ltd., London, 308 above; Mr and Mrs Joseph Levine, Greenwich, Conn. 148 above, 174; R. E. Lewis Inc., San Francisco, 99, 284 right; Collection of Sydney and Frances Lewis, Richmond, Virginia, 467 below left; R. M. Light & Co. Inc., Boston, Mass. 79(10), 83, 94, 106, 107, 108, 110 above; Gil Lipton, London, 262(10); Mrs Stella Bancroft-Livingston, Hitchin, 495(13); Lock Galleries, New York, 55; London Gallery, Tokyo, 287(6a, 11); D. R. Lord, The Antique Gunshop, Birmingham, 405(2); G. Ruxton Love, Greenwich, Conn. 286 above right, 462; S. Lubliner, London, 416 below, 419 below; Thomas Lumley Ltd., London, 260(2), 464(3).

Dr John J. McDonough, Youngstown, Ohio, 343(6); Maggs Bros. Ltd., London, 113 below, 230; N. Manoukian, Paris, 466, below left; Maple & Co. International Ltd., London, 273, 278, 279(4), 281(2, 14), 480; Albert Maranca Antiques, Philadelphia, 343(4); S. Marchant & Son, London, 279(3); Marlborough Fine Arts (London) Ltd., 138, 182; Marlborough Rare Books Ltd., London, 247 below; Peter Matthews Ltd., London, 180; Mr and Mrs Robert B. Mayer, Winnetka, Ill. 280; The Mayor Gallery Ltd., London, 413; Mayuyama, Tokyo, 279(5); Mrs Yehudi Menhuin, London, 131; Meridian Coin Co., London, 489(2); Metropolitan Museum of Art, New York. Purchase Estate of Florence Waterburg, 1970, 317; Stavros Mihalarias, Fine Arts Restorer, London, 439; Minerals Engineering, S.A., Geneva, 495(12); John Mitchell & Son, London, 132 above; Modarco Modern Art Collection S.A., London, 183, 184 left, 193(9); D. C. Monk & Son, London, 471(4); B. A. Morrison, London, 110 below; Hugh M. Moss Ltd., London, 281(4); Sydney L. Moss Ltd., London, 275 above, 279(1), 281(11); Münzen und Medaillen A.G., Basle, 488(5); Mr and Mrs Arthur Murray, Rye, New York, 194(6); The Department of Egyptian Art, Museum of Fine Arts, Boston, Mass. 260(11).

W. Keith Neal, Warminster, 405(8); Kenneth Nebenzahl Inc., Chicago, 235 left; G. Nehmad, Milan, 193(2); David Newbon, London, 389(5); Newport Restoration Foundation, Newport, Rhode Island, 362.

James R. Ogden & Sons Ltd., London and Harrogate, 1 centre below; George Ortiz, 263(6); S. Ovsievsky, London, 332 above, 337;

Frank Partridge & Sons Ltd., London, 309 below, 334, 347(5, 7), 378; J. S. B. Pearson, London, 464(8, 9); David Peel & Co. Ltd., London, 26, 27, 260(9), 298(5); Donald Pellar, Temple, Texas, 297 left; F. Peretti, London, 193(14), 194(13); Howard Phillips, London, 445(8); S. J. Phillips Ltd., London, 11, 21, 25, 30, 302, 305 above, 309 below, 393(14), 410 below left and right, 411 above left and right, 422(7, 8), 425 above and below, 427 above, 430(6), 431(11),

464(11); Pickering & Chatto, London, 209 left and right, 252; E. Picket, New York, 262(11).

Bernard Quaritch Ltd., London, 229, 241 right, 250, 495(3, 5, 11).

Robert L. Rader, Anna, Ill. 147; Mrs H. Recanati, London, 193(6); Redburn Antiques, London, 341, 343(12); Mrs Emery Reves, 32; E. Rokhsar, New York, 314; Dr Sergio Romagnoli, Genoa, 267, 281(13); Collection of Dr and Mrs Robert Rosenbaum, Scarsdale, New York, 474 left; Rosenburg & Stiebel Inc., New York, 330; J. R. Rudikoff, New York, 109 above; Squadron Leader Rush, A.F.C., Fulbeck, Morpeth, 442.

Safani Gallery, New York, 261(9); Saint Cecilia's Hall, University of Edinburgh, 475; Arnold A. Saltzman, Great Neck, New York, 193(4); Spencer Samuels & Co. Ltd., New York, 120, 195(8), 316; Robert A. Sangerman, Columbus, Indiana, 169; Chas. J. Sawyer, Bookseller, London, 211, 216, 217, 245 right; Leonard Sax, Chicago, 397(2); H. Schickman Gallery, New York, 105(12); John Schorscher, Toronto, 320; David R. Schwartz, Beverly Hills, 396(1); Schweitzer Gallery, New York, 148 below; J. S. M. Scott, London, 464(12); L. S. Scott, London, 400 above, 444(8); B. Seitz, Kassel, 397(6); Mr and Mrs Neil Sellin, New York, 347(1); Joseph U. Seo, Oriental Art Gallery, New York, 287(4); Seven Gables Bookshop Inc., New York, 236–237, 239 right; Manfred Seymour Ltd., London, 415 left, 418 above left, 422(11), 423(7); Christopher Sheppard, 444(11); Simpson's Jewelers, Philadelphia, 422(4); Mrs Marvin Small, New York, 109 below; Mrs R. C. Smith, Darien, Conn. 152; R. Duncan Smith, London, 471(14); Smiths the Rink Ltd., Harrogate, 333; L. Soames, London, 458 below right; Ira Spanierman Inc., New York, 123 above left; John Sparks Ltd., London, 272, 274 above left, 281(12); Edward Speelman Ltd., London, 61; Spink & Son Ltd., London, 281(5), 303 left, 445(2); Marshall Spink Ltd., London, 247 above; N. Stelman, London, 437(2); Stendhal Gallery, Milan, 103, 105(6, 7, 8); Jacob Stodel & Anthony Embden, London, 380(11), 383, 386; The Stone Gallery, Newcastle-upon-Tyne, 134 above and below, 458 below left; John Nicholas Streep Collection, New York, 78 above; Studio Antiques Ltd., Bourton-on-the-Water, Gloucestershire, 471(5); B. Stutz, Liestal, Switzerland, 404 below right; Swiss National Museum, Zurich, 299(9); R. J. Symes, London, 1 centre, 258.

Miss Yvonne Tan Bunzl, London, 73 right, 76, 79(5, 7); Temple Gallery, London, 438, 440 left and right; Mrs Daniel J. Terra, Kenilworth, Ill. 149 above and below right; Tilley & Co. (Antiques) Ltd., London, 444(6); Alan Tillman (Antiques) Ltd., London, 443; The Time Museum, Rockford, Ill. 395 right, 396(8), 399, 401 right; Arthur Tooth & Sons Ltd., London, 193(1), 194(8); Charles W. Traylen, Guildford, 235, 242 left and right, 244 right; Charles W. Traylen and W. F. Hammond, 238.

Andrew R. Ullmann, London, 430(10), 435 below.

J. & E. D. Vandekar, London, 279(7); C. J. Vander (Antiques) Ltd., London, 303 right; Vartanian & Sons Inc., New York, 423(1); Robert Vater, Frankfurt, 384; The Curator of Furniture, Victoria and Albert Museum, London, 338.

The Waddington Galleries, London, 136 above, 193(7), 195(7, 9, 14); W. W. Warner Antiques Ltd., Brasted, Kent, 409 above left; Wartski, London, 19–20, 28, 467 below right; Julius H. Weitzner, London, 56; William Weston Gallery Ltd., London, 111(7); R. J. Wigington, Stratford-on-Avon, 405(9); Daniel Wildenstein, London, 199; Winifred Williams of London & Eastbourne, 380(4, 6), 390 above left, 392 above left, 393(1, 7, 10, 12–13), 429; Wolpe Gallery, Capetown, 139; Charles Woollett & Son, London, 408, 410 above right; E. A. Wrangham, Northumberland, 287(13); Douglas J. K. Wright Ltd., London, 283.

Collection Jean Zimmermann, New York, 444(7).

Index